PENGUIN CLASSICS ⦿ DELUXE EDITION

KEITH HARING JOURNALS

KEITH HARING was born on May 4, 1958, in Reading, Pennsylvania, and was raised in nearby Kutztown, Pennsylvania. From an early age he developed an appreciation for art and cartoons like those of Dr. Seuss and Walt Disney. In 1978 Haring moved to New York City and enrolled in the School of Visual Arts (SVA), where he found a thriving alternative art community. As a student at SVA, Haring experimented with performance, video, installation, and collage, but retained his loyalty to drawing. His desire to reach a wider audience led him to create drawings in white chalk upon the blank paper panels throughout the subway system. Happy to have found such an effective medium, Haring produced hundreds of these public drawings from 1980 to 1985, sometimes creating as many as forty "subway drawings" in one day. Having achieved international recognition for his works, Haring also participated in gallery exhibitions, and in April 1986 opened the Pop Shop, a retail store in SoHo selling T-shirts, posters, and accessories all bearing his famous drawings. Between 1982 and 1989 he produced more than fifty public artworks in dozens of cities around the world, often for charities, hospitals, children's day-care centers, and orphanages. The now-famous "Crack is Wack" mural of 1986 has become a landmark along New York's FDR Drive. Keith Haring died of AIDS-related complications on February 16, 1990. He was thirty-one years old.

ROBERT FARRIS THOMPSON, Master of Timothy Dwight College at Yale, has devoted his life to the serious study of the art history of the Afro-Atlantic world. His first book, *Black Gods and Kings,* was a close iconographic reading of the art history of the forty million Yoruba people of southwestern Nigeria. He has published texts on the structure and meaning of African dance, *African Art in Motion,* and a reader on the art history of the Black Americas, *Flash of the Spirit,* which has remained in print since its publication in 1983. Thompson has published two books on the bark cloth art of the pygmies of the Ituri Forest, plus the first international study of altars of the Black Atlantic world, *Face of the Gods,* and most recently *Tango: The Art History of Love.* In addition, he studies the art of José Bedia and Guillermo Kuitca and has been anthologized fifteen times. Some of his works have been translated into French, German, Flemish, and Portuguese.

SHEPARD FAIREY is the man behind Obey Giant, the graphics that have changed the way people see art and the urban landscape. What started with an absurd sticker he created in 1989 while a student at the Rhode Island School of Design has since evolved into a worldwide street art campaign, as well as an acclaimed body of fine art. In 2003, Fairey founded Studio Number One, a creative design firm dedicated to applying his ethos at the intersection of art and enterprise. Fairey's art reached a new height of prominence in 2008, when his "Hope" portrait of Barack Obama became the iconic image of the presidential campaign and helped inspire an unprecedented political movement.

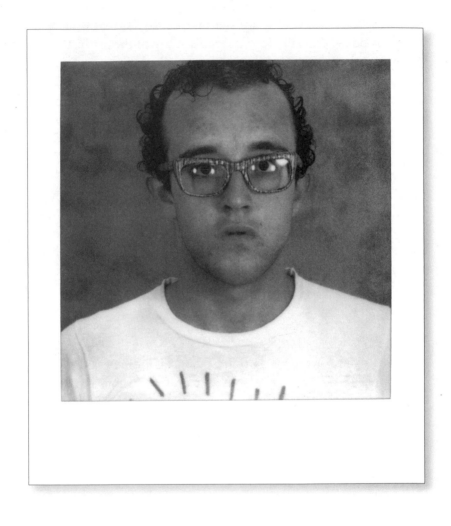

KEITH HARING JOURNALS

INTRODUCTION BY
Robert Farris Thompson

FOREWORD BY
Shepard Fairey

PENGUIN BOOKS

PENGUIN BOOKS
Published by the Penguin Group
Penguin Group (USA) Inc.,
375 Hudson Street, New York, New York 10014, U.S.A.
Penguin Group (Canada), 90 Eglinton Avenue East, Suite 700, Toronto,
Ontario, Canada M4P 2Y3 (a division of Pearson Penguin Canada Inc.)
Penguin Books Ltd, 80 Strand, London WC2R 0RL, England
Penguin Ireland, 25 St Stephen's Green, Dublin 2,
Ireland (a division of Penguin Books Ltd)
Penguin Group (Australia), 250 Camberwell Road, Camberwell,
Victoria 3124, Australia (a division of Pearson Australia Group Pty Ltd)
Penguin Books India Pvt Ltd, 11 Community Centre,
Panchsheel Park, New Delhi – 110 017, India
Penguin Group (NZ), 67 Apollo Drive, Rosedale, North Shore 0632,
New Zealand (a division of Pearson New Zealand Ltd)
Penguin Books (South Africa) (Pty) Ltd, 24 Sturdee Avenue,
Rosebank, Johannesburg 2196, South Africa

Penguin Books Ltd, Registered Offices:
80 Strand, London WC2R 0RL, England

First published in the United States of America by Viking Penguin,
a division of Penguin Books USA Inc. 1996
Published in Penguin Books 1997
This edition with a foreword by Shepard Fairey and
a new selection of artwork published 2010

1 3 5 7 9 10 8 6 4 2

Grateful acknowledgment is made for permission to reprint the following copyrighted works:

"Taking Pictures of the Sky" by Allen Ginsberg.
Copyright © the Allen Ginsberg Trust. By permission of The Wylie Agency, LLC.

Excerpt from David Hockney's introduction to Keith Haring Journals (Viking, 1996).
Copyright © David Hockney, 1996. By permission of The David Hockney No. 1 U.S. Trust.

Excerpt from "Brokedown Palace" by Robert Hunter.
Used by permission of Ice Nine Publishing Company.

Excerpt from "Mirror Man" by Graham Nash. Copyright 1970 Nash Notes.
All rights administered by Sony/ATV Music Publishing LLC, 8 Music Square West,
Nashville, TN 37203. All rights reserved. Used by permission.

ISBN 978-0-14-310597-8
CIP data available

Printed in the United States of America
Set in Sabon • Designed by Elke Sigal

CONTENTS

KEITH HARING JOURNALS

A NOTE ON SOURCES AND ACKNOWLEDGMENTS

It is clear from Keith Haring's comments in his journals that he expected they would ultimately be read by others. He left dozens of handwritten notebooks, with line drawings, containing a wide range of material—from extended thoughts on work in progress to minimal notations, sketches, quotes, and reading lists. Sometimes the writing concentrated on his work, other times on relationships and the events of his daily life. As his career took off and his life became increasingly complex he wrote less frequently—often in the peaceful sanctuary of airplanes—and there are substantial chronological gaps as a result. In some instances material he wrote for other purposes has been inserted to aid in continuity. The editing and publication of these journals was initiated and overseen by Julia Gruen and David Stark of The Keith Haring Foundation, with the assistance of editor Ellen Williams and Viking Penguin editor David Stanford. For ease of reading there are no ellipses to indicate where material has been left out. Ellipses and arrangement of material in the finished book reflect Haring's own usage. Obvious errors of spelling and punctuation have been corrected throughout.

SPECIAL THANKS TO

Jeffrey Deitch • Shepard Fairey • Suzanne Geiss
Julia Gruen • David Hockney • Madonna • Annelise Ream
Elda Rotor • Robert Farris Thompson

SHEPARD FAIREY

Though Keith Haring died only two years after I started making street art, his art and practice had already had a profound impact on me. Haring demonstrated that one could create art on the street that differed from the more pervasive lettering-based graffiti. He also showed me that the same artists could not only affect people on the streets, they could also put their art on T-shirts and record covers, as well as have their work respected, displayed, and sold as fine art. Inspired by Keith Haring's achievements, I pursued my art career with the optimism that my goals could be attained.

Anyone familiar with the career of Keith Haring knows he was a prolific artist with a distinct style that was simultaneously refined and primitive, deliberate yet lyrical and energetic. Clearly he aspired to create art with purity and integrity, but to do so in an accessible way so it could be shared with people. He was also widely known to pursue his art with a deeply personal vision, as a champion of social justice and a believer in the interconnectedness of humanity. The worlds Haring deftly navigated and the barriers

he attempted to break down have been extensively noted by art critics.

However, it's one thing to see an artist's work and hear critical analysis, and another altogether to hear an artist's own thoughts, ideas, hopes, fears, questions, and most profound philosophies in his own words. Haring, as viewed through the prism of success, cannot compare to the thoughts revealed in his journals as they follow his evolution as an artist and human being, his rise to fame, and his eventual diagnosis as HIV positive.

One of the many insights Haring shares in his journals is that fame changes people's perceptions. In 1989, Haring wrote, "People keep asking me how success has changed me. I always say that success has changed people's responses and behavior toward me and that has affected me, but it has not really changed me. I feel the same on the inside as I did 10 years ago." Through Haring's journals, one bypasses the detached academic evaluations of his work as art history and finds the artist's own documentation and catharsis as he develops his identity and philosophy.

It's nothing short of remarkable how developed and sophisticated Keith Haring's worldview was at a very young age. Upon arriving at the School of Visual Arts in New York in 1978 at only twenty years old, Haring begins to lay out his ideas about art and life. Haring's populism is demonstrated early on, and eventually manifests in many forms. "The public has a right to art" and "Art is for everybody" are ideas that can be found in his journals from that time, and remained consistent throughout his career.

Traveling the New York subways, Haring immediately took note of the surrounding visuals. The graffiti and advertising posters seen on and around the subways influenced Haring as not only aesthetic references but also as accessible images in the public right-of-way. He engaged with the pervasive forces of advertising as repetitive and graphically engaging, and graffiti as free-spirited, fluid transgression, sometimes interacting with or commenting on the advertising. Haring illuminated his transition from an observer of these visuals to a participant, adding his own work into the

negative area in ads and other spaces of opportunity in the public environment. He discusses his idea of his paintings as visual poems, with hieroglyphics or pictograms open to interpretation by the viewer. His journals provide ample evidence that the visual language he developed was not simply justified by retroactive intellectualization, but evolved from a desire to fulfill a very clear vision.

Haring had an unwavering belief in individuality, that no two human beings are alike. He didn't want to be categorized as part of an art group or movement, yet he believed we are all part of a whole, and his empathy with humanity was strong and consistent throughout his career. He states, "I don't think art is propaganda; it should be something that liberates the soul, provokes the imagination and encourages people to go further. It celebrates humanity instead of manipulating it."

It isn't surprising that Haring chose to tackle social issues in his art. Children's health, the fight against the crack and AIDS epidemics, and the battle to end apartheid in South Africa were just a few causes Haring championed. Haring discusses money and charity, saying, "Money itself is not evil, in fact it can actually be very effective for good if it is used properly. You have to be objective about money to use it fairly. It doesn't make you any better or more useful than any other person. Even if you use your money to help people . . . that doesn't make you better than somebody who has no money but is sympathetic and genuinely loving to fellow humans." Haring cared about people.

As the prices of his fine art escalated, Haring sought ways to keep his art accessible. He continued to do public art murals, but as a fan of pop culture he wanted an outlet for consumers to acquire his work. This desire to make and sell products that were an affordable extension of his art yielded Haring's Pop Shop, opened in New York's SoHo neighborhood in 1986. Haring explains his rationale for the Pop Shop and his embrace of pop culture by saying, "That was the whole intention of the art: to affect and enter the culture by understanding and reflecting it; to contribute to and

broaden the concept of art and the artist as much as possible." His equal—or possibly greater—respect for the commercial world over the art world is evidenced by a journal entry from January 23, 1988, in which he states:

> Sometimes I'd rather not deal with the "art market" at all and just do my own work. There isn't much difference between the people I have to deal with in the art market and in the commercial world. Once the artwork becomes a "product" or a "commodity," the compromising position is basically the same in both worlds. Some "artists" think they are "above" this situation because they are "pure" and outside of the "commercialization" of pop culture, because they don't do advertising or create products specifically for a mass market. But they sell things in galleries and have "dealers" who manipulate them and their work the same way. In fact, I think it is even more deceptive to pretend you are outside of this system instead of admitting it and actually participating in it in a "real" way. There is no more "purity" in the art world than on Madison Avenue. In fact, it is even more corrupt. The Big Lie.

Keith Haring's journals reveal a plethora of ideas, emotions, and experiences, but permeating almost all of it are his underlying populism and humanity. These qualities manifested themselves in his belief that the public has the right to art, his chosen visual language, his use of public space, his embrace of commercial projects and art products, and his devotion to messages of social justice and change. Through these journals, Haring displays intense energy, focus, and conviction, but also adventure, whimsy, and insecurity. They provide a unique window into his profound intellect, humanity, drive, and complexity that goes beyond any third-party insight into his nature—these journals *are* his nature.

ROBERT FARRIS THOMPSON

Nothing is an end because it always can be a basis
for something new and different.

—Keith Haring Journals

Keith Haring's diaries open, on April 29, 1977, with a neo-Sinatra manifesto: ". . . live my life my way and only let the other [artists] influence me as a reference, a starting point." He swore, in other words, to live a life of creative independence. Even at a Grateful Dead concert (May 10, 1977) he was cutting through the words in a selective way:

In a bed, in a bed
by the waterside I will lay my head
Listen to the river sing sweet songs
to rock my soul.[1]

This chorus, from "Brokedown Palace," a kind of farewell blues by Robert Hunter, challenged Haring. He wrote the words down, slightly changed, into his diary.

Ten years later—when Haring realized that he had AIDS—he went down Houston Street, in Manhattan, until he reached the East River. There, before the water, and its own sweet song, he let himself weep for the longest time. Purified by this, he went on to complete a life to the last full moment.

Cut to the last entries of his diaries, mid-September 1989. Five months left to live. Keith did not know this—he was far too busy. He was swept up in the myriad commissions of a major world artist.

For by 1989 he was as famous as a rock star, with friends and admirers everywhere: in the back streets of Shinjuku in Tokyo; in the Casino and the "Dragon" at Knokke, Belgium; in the hip-hop epicenters of early-eighties New York City; at the Beau Rivage Palace in Lausanne; at SOB's in SoHo; in a suite at the Ritz; in the subways of New York; in the Stedelijk Museum of Amsterdam; in the galleries of New York; and, continually, at his own gleamingly neat studio on Broadway near Great Jones.

Sometimes he got impatient, when overworked. But most of the time the leitmotif was generosity: all over the world there are persons with Haring buttons, Haring-decorated T-shirts, Haring-illuminated pages torn from notebooks—spontaneous gifts of the artist.

Many remember him as did a youth in Chicago named Joe Asencios, summer 1989: "the nicest person he ever met in his life."[2] Five years later, on the other side of the planet, at the Breidenbacher Hof Hotel in Düsseldorf, Erwin Gruber, the concierge, remembers him above all guests. Keith caused a sensation when he checked out of this hotel in December 1989, making drawings for bellboys, staff members, and the concierge, Gruber remembered, commenting: "He was a wonderful guy. I hope you say good things about him."[3]

The last entry: September 22, 1989. Haring writes from Pisa, Italy, where he paints a mural on the Church of Sant'Antonio and reads the local monument for humor as well as art: "the [Leaning] tower is remarkable. We saw it in daylight and then in the light of the full moon. It is really major and also hysterical. Every time you look at it, it makes you smile."

From Pittsburgh to Pisa an American spiritual odyssey unfolds, a document of the life and mind of an artist who symbolized America in the eighties to the world. Thousands wore his T-shirts, millions knew his style. He was probably one of the few artists of our time who could cross the Atlantic on a jet and see his art included in *both* in-flight movies.

How did he get there? By being restless, being ceaselessly ambitious. By inventing a line "both archaic and universal and futur-

istic (with its computer capacities)." Had he lived longer, he would have undoubtedly moved beyond the styles that made him popular: "If they are representative of a specific time, then they are possibly the purest we are capable of at that point, but after that point we have [to] progress. . . ."

The text, in short, is a mirror of an extraordinary life: creativity, thought, and the vernacular, jousting in the crucible of contemporary time. In this regard it is not unlike "the *Journal* which Dürer kept as a strictly personal memorandum . . . notes on the death of his mother burst from the page in the midst of his financial accounts and descriptions of wayside lodgings, and we are haunted by the mixture of sketches and incomplete phrases he jotted down when he awoke from a nightmare."[4]

Haring's diaries cover similar ground, nightmares and dreams included. On an early page, notes on art history compete with a practical matter:

> Romanesque—St. Pierre
> Early Ren—Donatello (Bronze)
> 475-6222 SAL
> 18 1st Ave.
> 3 rm. apt. $150.00/mo.
> "Since the number of colors and forms is infinite,
> their combinations also are infinite. . . ."
> —Wassily Kandinsky,
> *Concerning The Spiritual in Art*

But if the Haring journals sometimes recall Dürer in their episodic texture, they differ from the famous diary of Andy Warhol.

The latter's testament is a fascinating compound, fat as a telephone book, essentially involving celebrity action and precisely noted cab and restaurant tabs, as if Warhol were writing half for posterity and half for the IRS.[5]

The journals of Keith Haring are richer. Reflection, self-assessment, and evidence of growth crowd out the mere diaristic.

Rarely would you get a page in Warhol like this: "Usually the people who are the most generous are people who have the least to give. I learned this first-hand as a newspaper carrier when I was 12 years old. The biggest tips came from the poorest people. I was surprised by this, but I learned it as a lesson."

Nevertheless, Haring, like Basquiat, loyally presents Warhol as his master: "Andy's life and work made my work possible. Andy set the precedent for the possibility for my art to exist. He was the first *real* public artist in a holistic sense. . . ."

Haring wrote these journals on planes, on the bullet train to Nagoya, waiting in airports, in a strange dragon-shaped guesthouse of patrons in Belgium. Yet regardless of setting, he always found ways of communicating to himself, in a quest for "less talk and more doing."

Time and circumstance sometimes savaged that ambition. There are breaks in the narrative and lapses into telegraphic haikus: "Eat, champagne—stars—quiet—think." But most of the time he wrote with responsibility to the future, demonstrating, in turn, the intellectual underpinning to the flow and substance of his art. Chance, he loved to say, favors the prepared mind.

THE STRUCTURE OF THE DIARIES

The text unfolds in two main formations, linked by a bridge in the middle. Both formations are rich with experience and practice. I call them formations to honor the buildup of insight and experience.

The first formation, 1978 to 1980, documents, essentially, a period of apprenticeship, or, as he himself puts it, "the records of a search." Haring adds: "I should be open to everything . . . I am merely gathering information."

As he works his way through forms and precepts, he stresses the provisional nature of it all: "Do not place too much emphasis on my current experimentation and investigations."

The power behind the questing was Haring's strong and vivid

taste. With taste he was able to select and learn from the highest sources, including poets. Two citations from John Keats's letter to his brothers, December 1817, entered his journals: "The excellence of every Art is its intensity, capable of making all disagreeables evaporate, from their being in close relationship with Beauty and Truth." And again: "Coleridge . . . would let go by a fine isolated verisimilitude caught from the Penetralium of mystery, from being incapable of remaining Content with half knowledge."

It was a level of discourse that Haring wished to call his own—and did, later, with the very finest chalked and painted figures.

Keats taught him also that poetry "should strike the reader as a wording of his own highest thoughts." Noticing a hunger, all around him, for substance in communication, however advanced by technology, Haring did just that: he tackled the issues of his times, the threat of thermonuclear annihilation, the obscenity of apartheid, and the horror of AIDS. He drew, also, on the need of women and men for emotional response from others, for variety of experience, for security of the long-term sort, striking sparks with the thoughts of his fellow women and his fellow men. Jonathan Fineberg sums up this gift: "Haring created icons of mass culture to which everyone could relate."[6]

Haring ensconced his visual thinking in a tough-minded vernacular, so that all could share and understand, and see their minds reflected, in the ideal Keatsian sense. He taught himself how to talk intellectual and talk technology and still talk regular.

Haring sometimes drew real issues in imaginary television sets, "broadcasting" his concerns, while at the same time stealing fire from media. Doing this, he fulfilled one of the ambitions of his apprenticeship, "to form a situation of communication, a transformation of energy."

On another level, the diaries reveal that retrospective exhibitions of major artists were spurs to accomplishment. A Rothko retrospective, for instance, challenged him to his bottom guts. For in such settings he could see how "ideas . . . increase in power as they are explored and rediscovered." He takes us with him into a

room in the National Gallery in Washington where five Rothkos hang: ". . . grouping of these works in a single room centralized their energy and heightened their impact. . . . It was a solid statement, perhaps taken to its fullest extent."

Haring himself was getting ready, like Rothko, to pursue key ideas to the fullest extent. Increasing his arsenal of formal means, he experimented with a double brush, with different inks and papers. He tried cutting, as well as drawing, forms: "The completeness, accurateness, finalness of a cut may allow me to be more direct, more spontaneous and therefore more interesting."

And he tried to explain to himself how frames provided order for the tumult of his thought: "possibly the reason I insist on spending the first few minutes of a painting drawing a border around the area I am about to paint is because I am familiarizing myself with the scale of the painting I am about to paint. I am physically experiencing the entire perimeter of a given space."

Thoughts, borrowed and self-generated, were steadily studding his visual imagination. Beuys, in a lecture at Cooper Union, taught him this: "Poverty means nothing to a man with a dream." Haring, in addition, hoped that he was studying objects in the manner of Matisse, i.e., "for a long time, to know what its sign is."

Harbinger after harbinger of what he would become crowd the pages of this first section of his journals, like the day in 1978 when he took notes on an Egyptian drawing: "There is within all [these] forms an indication of the entire object within a minimum of lines that becomes a symbol."

Haring's records reveal that, in a strong mixture of Keats, artistic biography, retrospective exhibitions, and many, many other sources, he worked out his own philosophic take on line, form, and color. Remorselessly questing, he let his creativity bide its own sweet time.

And then, bam! All sides to his psyche, all sides to his training, all sides to his spirit, coalesced in a single week in 1980.

A whole vocabulary of forms streamed from his hand, hieroglyph after hieroglyph, all freshly minted, curing, with meaning, an age that dared to call itself post-modern, as if the apocalypse

were a mere matter of style. When the smoke cleared, Haring had invented, by means of sexual aliveness transmuted into line and gesture, a hundred interlacing bodies in a score of social situations. And also from his hand, luminous and innocent, emerged soon thereafter the "radiant baby" and the "family dog," crawling, barking. These were his stabilizing themes. He drew them together with images from science fiction, spaceships and ray guns; technology, robots, computers, and television; and antiquity, pyramids, and never–never canopic urns upon which he drew telephones and pyramids and acrobatic dancers.

Haring was constantly worried about the proliferation of nuclear weapons at the end of the Cold War. Drawing the family dog, barking at televised nuclear explosions, was a way of both expressing and dealing with his fears. All of which lead to an incredible moment in Hiroshima when he notices a photograph of President Carter's daughter, Amy, as she viewed photographs of the vaporization of the city in August 1945: "The terror in her eye is so real and so sincere that it riveted me to tears."

Babies took the sting out of feeling obsolete in the age of the smart machine. They healed, as well, atomic dread. Voicings of social conscience pulled in those who might have balked at subway venues for philosophic reflection—for he worked out many of the best ideas of his early style on black advertising paper on the walls of the New York underground. It was a brave and gutsy proving ground for his later museum masterpieces. Now, with the first part of his diaries, we have a clearer reading of his emergence into world fame, and the steps that led to it.

BRIDGE VERSE: A FRAGMENT FROM ZAVENTEM, MAY 4, 1982

The phenomenal success of his personal ideographs blasted his private life, leaving no time for writing. When Haring comes up for air, on May 4, 1982, in the Brussels airport at Zaventem, Belgium, two years have gone by since the last written entry.

He is wry and self-conscious as he briefly returns to self-assessment minutes before his plane takes off: "It has been a long time since I have written anything down. A lot of things have happened. So many things I have been unable to write them. . . . In one year my art has taken me to Europe and propelled me into [the] limelight. . . . I don't know what I want the world to be. But only I can make these 'things.' These things that are called the works of Keith Haring."

And then up, up, and away, and we scarcely hear from him over the next four years.

THE FINAL FORMATION: THE QUEST CONTINUES

Haring takes up his pencil again in Montreux, Switzerland, on July 7, 1986. Claiming that artistic biography was "probably my main source of education," he told himself that if he did not return to his journals the rest of his tale might disintegrate in compilations of airline tickets and random, fragmentary notes from catalogues and interviews.

Once he thought his journal pretentious and self-important. But this was no longer the case in 1986: "For almost everything I write about 'wanting to do,' I actually did in the four or five years that followed."

Take his sensible view of photography as ancillary to his art. In the early journals, he dreams out loud—"I can be made permanent by a camera." By 1986 he had done just that, often with the help of a colleague in photography, Tseng Kwong Chi, and the results were fabulous—"photography and video [have] made the international phenomenon of Keith Haring possible."

By now, in sheer logged hours and places visited, he rivaled Bruce Chatwin as an ethnographer of the night. He hung out the world over, enjoying "neon like you can't believe" in Tokyo, savoring an odd party in Switzerland where the "music" was a recording of the sound of trains in Grand Central Station, and collaborating in Kansas with Allen Ginsberg and William S. Burroughs.

Puerto Rican, with whom he has a platonic relationship. He travels the world with Vazquez during his last two remaining years.

Before these loves, moments of loneliness yielded haikus of yearning: ". . . thinking about the smile exchanged on the street and nothing but a second glance and lots of dreaming." And he answers rejection with tough-guy humor: "—don't feel sorry for yourself—read Nietzsche, right?"

Keith's sexuality, continuous and wild, clearly sparked his visual daring. He took, in his own words, "[sexual] energy into another form." Sex lights up, directly or in code, his intermeshing forms. This was especially true when executing overall art, like a prick-arabesque he dreamt up for a painting colleague in 1979. No Freudian veil there.

Call this dimension to his work erography, as opposed to pornography. Erography transforms sex into a script of liberation, so that many can benefit, partaking of the freedom and the energy, whereas porn plays for single consumers.

INNOCENCE: THE COUNTER-TROPE

Sex is not the only subject matter of his art. As Bruce Kurtz points out, it is only one of many facets.[7] The diaries confirm this. There are powerful glints of desire, again and again, but Haring also writes about art, work, and play, with important digressions into artistic criticism and philosophy. Plus, something else happens.

Dare we say it, the counter-trope to sex in Haring's life and art is innocence. This comes out in his respect for infants and for children. With the sincerity of children he builds himself a fallout shelter against cynics in the atmosphere: "Re-reading this last page I have to add the possibility of purity during the moments of working with children. When I do drawings with or for children, there is a level of sincerity that seems honest and pure."

In Belgium he writes, again, of the "purity" of children, with whom he sat at a formal dinner. He found their "conversation al-

Nevertheless, from time to time, Haring gets the blues: "I am wondering if the museum world will ever embrace me, or if I will disappear with my generation." But it's just a mood. He cures depression by adding on the work, "to stay busy and keep my mind and body occupied—and keep my mind off of what is disappearing around me. After Bobby Breslau died in January, I had to start to deal with a new situation of aloneness." And so, more labor, more travel, more commissions: "I really love to work," he notes on the run in Tokyo, "I swear it is one of the things that makes me most happy and it seems to have a similar effect on everyone who is around me while I work. Now Juan and Kaz and Sato and I are all joking and talking and really sort of 'wired.' "

Naive, sophisticated, sexy, puritanical, confident, troubled, a man of the people who, at the end, had his last apartment designed in the style of the Ritz—the contradictions in the final sections of his diaries become acute. Where they most accumulate, there Haring is most alive. As in the case of sex and innocence.

HARING AS EROGRAPHER

Explorations of the night logically include Keith's sex life, which, as it comes through the pages, taunts the prurient—with brevity and wouldn't-you-like-to-know foreclosures—and challenges the conventional—with post-Stonewall confidence: "I'm glad I'm different." The text, for example, does not linger on a night in London when Keith and a friend and two male strippers come together for safe sex in a single room, but you get the general idea. He documents himself at peace with Juan Rivera, New York Puerto Rican, his lover of the middle eighties, and he documents their arguments, both real and petty. Rivera helped him complete an important mural for the Necker Children's Hospital in Paris—"we both paint at the same time, I outline, he rolls." He leaves us a quick-study cameo of Rivera: "Juan: forever handsome with a chameleon face that adapts to every place we go, making him look Brazilian, Moroccan, or in this case part Japanese." Then he meets Gil Vazquez, another

ways entertaining, and the humor fresher," as opposed to the bankers, dealers, and collectors at the other end of the table.

Haring also believed that "you can do whatever you want in the privacy of a gallery or in a book," but did not execute sexually explicit drawings in his public subway work "because of children."[8]

Babies to Haring were sacred: "Babies represent the possibility of the future, the understanding of perfection, how perfect we could be. There is nothing negative about a baby, ever."[9] In his diary he adds: "The reason that the 'baby' has become my logo or signature is that it is the purest and most positive experience of human existence."

When Haring painted a crib for the child of two friends in 1983,[10] the design, consequently, radiates belief that "children are the bearers of life in its simplest and most joyous form."

Perusing this crib, you see Haring in action, you see that he can draw. But love made him jump, suddenly, from his own creations to Mickey Mouse. Fugitives from his subway series dance on the panels. Most of the figures are minted fresh, for the pure amusement of his tiny "client."

As Laura Watt, a young art critic in New York, put it: "There is no ego in this painting whatsoever; the activity is pure, like the way you'd go about decorating a Christmas tree—for children, not for self."[11]

At his best, when line and purity took over, Haring could move swiftly from a drawing of an athlete with a tank for a head, denouncing militarism, to a pileup of bodies, denouncing Idi Amin, then to myriad infants, a blessing on the edges of the world. In the process, he was able to give us Eden, the Fall, and the return to Eden, all at once.

In short, the richness of contrast in his work, babies and nuclear explosions, guys getting it on and angels swimming with the dolphins, a barking dog in the midst of technology, is unprecedented in twentieth-century art.

In the pages of his diary, where he alludes to this tension between terror and decorum, the tone is even. He fluently transcribes his dreams, fears, and aspirations. All of which facilitates recognition of the mind behind the art.

HARING AND TWENTIETH-CENTURY ART

Keith's toughness, combined with taste and spontaneity, was to serve him well in combat with rival painters of the twentieth century. Haring was always competitive. He could not, for instance, note the hanging of one of his works near A. R. Penck in the Cologne Art Fair of 1987 without commenting "I blew him away."

All of which fits well Harold Bloom's feisty vision of how the strong artist sets up shop and reputation. In his *Western Canon: The Books and School of the Ages,* Bloom writes that "originality becomes a literary equivalent of . . . individual enterprise, self-reliance, and competition."[12]

Part of Haring's genius, part of his pathway to recognition, was becoming strong through battle with masters of midcentury modernism, especially Frank Stella, but also, at a quieter level, Léger, Olitski, Alechinsky, plus Pollock, too, when Keith worked on the floor in an all-over mode. His use of line made him spiritual kinsman to the work of Jean Dubuffet and Stuart Davis, an affinity he himself mentions in his journal upon completion of an important mural on the coast of Belgium.

With a series of metal masks, particularly one with a twisted nose and expressive eyes, Haring once consciously answered the challenge of Picasso's two right-hand faces in the *Demoiselles* of 1907. But this was more of a sport, a divertissement, and not important to his strongest works of 1988–89. Here he took, for example, what Frank Stella had thrown away, concentric pinstripes, and beat them into novel shapes answering the splendor of the moves of black vernacular dance of the early eighties.

Hogarth is part of the canon because of how he saw and documented the social life of eighteenth-century London; Goya for cap-

turing not only the atrocity of war but the benisons of peace. *Los Desastres de la Guerra* are a cultural given; but how many know the other side of Goya, where he paints Spaniards at play—with kites (*La Cometa*), or bouncing a mannequin on a sheet of cloth (*El Pelele*)?

Haring, similarly, insinuates mushroom clouds, apartheid, and popular dance into our consciousness. In 1988 and 1989 he also recoded the silhouettes of New York break dancing and electric boogie dance in terms evoking the richness of classical modern art. In so doing, certain key steps of the Paradise Garage collided incredibly with the squares of Albers, the lush curves of Jules Olitski, even a trace of color, like red lacquer on galvanized iron, from Don Judd in 1967. Haring cracked the whip of beat-box rhythm over the "relentless sobriety"[13] of Frank Stella's concentric pinstripes, restoring flexibility, and made them do his bidding.

How do we parse this formidable array of artistic perceptions, hidden as they are in transformations?

By returning to the diaries. Haring is explicit where he discusses his relation to the art of Léger and the challenge of Stella, as well as his passionate commitment to the dancing of the Paradise Garage, in SoHo, in New York. The latter, a most important font of inspiration, recalls Toulouse-Lautrec's relationship with the Moulin Rouge, particularly where he drew a famous Parisian black dancer of that era in action, *Chocolat Dansant* (1896), caught in a Kongo pose.[14]

Turn, now, to these challenges and sources.

1. Haring and Pierre Alechinsky. When Pierre Alechinsky, the Belgian member of the Cobra group, exhibited his works at the Carnegie Institute in Pittsburgh in 1977, Haring was in town. He saw the show: "I couldn't believe that work! . . . It was the closest thing I had ever seen to what I was doing with these self-generative little shapes. Suddenly I had a rush of confidence."[15]

Haring was impressed by Alechinsky's transformation of the framing edge "into a detailed commentary on the center. This black-and-white sequence of notations developed frame by frame."[16]

Haring did not directly copy Alechinsky's framing of a central painting with illuminated squares of action. Nevertheless, with their theatricalized darks, lights, and grotesqueries, Alechinsky's frames read like a comic strip penned by a Gothic artist. That very power of strangeness gave Haring the courage to go his own way in bending comic frames to serious purpose.

Haring was proud of his encounter with Alechinsky and the confidence it gave him. He occasionally showed his regard for the Belgian artist by way of homage, as in a 1982 composition, *Painting for Tee,* where Jonathan Fineberg detects direct citation of one of the heraldically coiled serpents characteristic of the work of the Belgian master in the seventies.[17]

2. Haring and Léger's style of 1942–55. In his diaries, Haring summarizes Léger's last style as "color blocks with black lines on top." He sometimes painted in his own reworking of this mode, in quest of variety, or muralizing reach, and perhaps also, when in Europe, as a salute to continental vision.

In Brussels, at a school for graphic design run by Haring's friend Pierre Staeck, a teacher suddenly asked Haring if "it bothered him" that compositions where he used "color blocks with black lines on top" seemed heavily in debt to Léger. And Haring answered that no, it didn't, and that he was flattered by the comparison.

But later, in the privacy of his diary, he commented much more extensively on the point. That very style, late Léger—black figurations over color blocks, dating from 1942 to the death of the artist in 1955—reflects, the story goes, the French artist's fascination with the creation of "free color" in the flashing lights of Broadway:

> When I was in New York in 1942 [Léger states] I was struck by the advertising spotlights that sweep the streets around Broadway. You are there talking to someone and all at once he turns blue. Then the color changes and he turns red or yellow . . . the color of the spotlights is free.[18]

Black-lined figurations over "free" segments of blue, gold, green, and red appear almost immediately thereafter in Léger: *La Danse* of 1942, *Still Life with Two Fish* of 1948, *Polychrome Acrobats* of 1951.[19]

In separating color from design, Léger gave Haring an instrument. Haring re-Americanized it and brought it on back home, in a sense, to the commodity crucible colors of the streets of New York.

But, as the diaries remind us, Haring "Légerizes" lightly, essentially to cover large areas, "usually on murals," and only in terms of his own strong voice. Two fine examples: a painted surfboard for Xavier Nellens in the Dragon in Knokke and a mural on the exterior stairwell at the Necker Children's Hospital in Paris in 1987.

In the process of completing the latter work, the American makes the Broadway-inspired French technique his own. Léger's statuesque faces and heavy acrobatic gestures vanish. Haring replaces them with his own genericized children, reaching and gesturing through gold, red, blue, and green segments of color. The children touch, kick, and traverse these shapes, as if they were balls or other instruments of play. This breaks the seal of Léger's abstraction in favor of something closer to the vision of a child. The color blocks themselves strongly recall Miró. But, as in the mobiles of his fellow American, Alexander Calder, Haring sets Miró's shapes in motion. Finally, in his journal, Haring cannot resist adding that Léger "was quite disappointed when the 'workers' in the factory rejected his offer. This is not the case with me."

3. Haring and Stella. On January 3, 1988, Haring visited Frank Stella's second retrospective at the Museum of Modern Art in New York. This stimulates a long and thoughtful passage. There is an edge to the writing. Haring is jealous. And so what he has to say does not exactly match William Rubin's eulogizing catalogue. From Haring:

> The viewer is overwhelmed and consumed by the scale alone.

Colors geometrically, mathematically chosen. A kind of "making fun" of the painting process. . . .

He knows there is no more "risk" for him, so he tries to create "risk." . . . A well-planned practical joke? Actually "practical" joke is perfect.

It is "practical" in that it follows all the right rules and breaks all the right rules. . . . But it is infuriating for [certain critics] to say how Stella was the only artist capable of translating the "graffiti-like" use of garish colors and gestures into a successful art work. . . . I refuse to be forced to believe that this is "quality" and I am not. . . . I'll grant [Stella] that he knows about constructions and shapes and space and the surface. . . . There are several pieces that seem to "make fun" of my patterned surface. . . . Yes, this is Frank Stella's second retrospective at MoMA. They have not even shown one of my pieces yet. In their eyes I don't exist.

The Stella show was a slap in the face. But it made him work harder. He told John Gruen that with Jean-Michel Basquiat and Andy Warhol gone, it was time for him to prove something. But this partial truth concealed a spirit of rivalry and competitiveness unleashed by the Stella retrospective.

The man who could face rejection with a humorous command to himself to "read Nietzsche," who never gave up in spite of what the mirror told him every morning about his health, targeted the weaponry of Stella and other modernists, seized them, made them his own, transforming 1988–89 into his finest hour. In short, he won. Recently the Museum of Modern Art acquired one of his works, thus ending what Haring considered a long siege against his reputation.

Still and all, the cause of Haring has not been furthered by publications which uncritically crowd his works together, the good

and the bad. This is not what Haring himself would want. Explicitly criticizing such procedures, he once wrote that "the idea of the show is great, but the choice of works starts to be muddled by too many inferior pieces."

The ideal Haring retrospective will edit out second-level works, warm-up exercises, and off-moments, and concentrate on where he was *engagé* and brilliant, such as certain drawings and paintings about AIDS, fluent work done in Knokke, Belgium, and where he was exalted, bending modernism into new shapes by fusion with the steps and silhouettes of black and Latino dancing of the early eighties at the Roxy and, even more so, the Paradise Garage.

HARING AND AIDS

Never knowing, after 1988, when AIDS might take him, Haring painted in the late eighties to save others and keep himself alive. Characteristically, he enriched the documents of alarm with variations of astonishing strength.

First, there are paintings and posters which are straightforwardly activist, like his famous *Silence=Death* composition, dated May 7, 1989. Haring fills a pink triangle with ghostly silver figures, covering their eyes or closing their ears.[20]

Haring states in his diary that he wants danger declared: "There really can't be any more anonymous sex." And so, in a memorable composition, he probes the terror in extreme promiscuity: a machine of desire that gives itself to death, achieving completion by means of grasping, coiling, licking, and opening. And from this carnal culmination hang victims from their penises. Their heads topple earthward, their eyes are crossed out, and one of their tongues lolls lifeless on the ground. These are beings who have fucked themselves to death.

Haring dared to personify the virus—as demonic sperm—in a series executed in red and black sumi ink on blocks of paper, on April 24, 1988.[21] There are many ways of confronting the crisis.

Luis Cruz Azaceta, in a powerful series illustrating ravaged bodies marked with KS, shows effect. Haring shows cause, the virus itself.

"Demon sperm" (the phrase is Haring's) bursts from an egg, like a giant horned insect. Its horns break the frame of crimson, as if escaping from the paper. Haring locates the lairs of the virus: drug addicts' needles, uncovered penises and vaginas. In the best of these compositions, Haring stops his incessant "drawing," achieving a Zen-like emptiness of space crossed by a calligraphic line.

If this series is important, it is because the artist expressed the presence of a killer by a radical combination of elegance and shock.

And having shocked us to save us, Haring breaks depression with a strong and moving work. Clearly aware here of the Mexican folk-handling of the theme of death, Haring defies the terror. He shows that in the spirit of his art, not his doomed body, his durability must be sought.

And so we have Haring's untitled "diptych" (for James Ensor), acrylic on canvas on two panels, completed May 5, 1989.[22] Ensor, of course, himself painted skeletons, deepening the allusion.

Haring numbers the panels, to indicate sequence. In the first, a skeleton with closed jaws and constricted rib cage touches a key, strangely luminous, while ejaculating over a bed of flowers. This could be the key that locks us to our doom, but it disappears. In the second panel, the sperm of the dead man has caused the flowers to flourish. They reach for the sun, higher than his head. This is "pushing up daisies" in an elegiac sense. The skull is smiling. His ribs relax and open. Haring accepts his death. For in his art he found the key to transform desire, the force that killed him, into a flowering elegance that will live beyond his time.

KNOKKE: LIFE IN THE DRAGON

Haring certainly lives on in Knokke, on the coast of Belgium, where one of his best murals graces the Casino near the center of the town. Palm Beach with a Flemish accent, Knokke-le-Zoute is a

treasure of the European summer, sited between Amsterdam and Dunkirk, in Belgium, very near the Holland border.

Of all the places where Haring worked, Knokke was his favorite, with the sole exception of New York. In the whole of his recorded voyaging, Knokke is the only place where, upon return, he jots down "home again." His Knokke journals show how richly he lived in Europe, in terms of giving and receiving affection, where artists like Tinguely, museums like the Stedelijk, and aristocratic patrons like Princess Caroline of Monaco, recognized and accepted his genius years before major New York museums finally got around to purchasing his works.

Haring loved Knokke. His hosts, Roger and Monique Nellens, gave him moral support and privacy at a critical point in his life.

On June 6, 1987, Monique Nellens, whose husband organizes the summer exhibitions of the Casino, came to Antwerp, picked up Haring and Juan Rivera, and drove them to Knokke, to an incredible structure built in the east corner of their garden: "We put our things in 'the Dragon' (the Niki de St. Phalle/Tinguely sculpture we are living in)."

Niki de St. Phalle designed the Dragon in 1971. Tinguely, her former husband, added sculpture. It is a wild, out-of-control sculpture habitat with offbeat eyes, a heavy claw that anchors the leviathan to the earth, and a marvelous red mouth with tongue as never-never fire escape. St. Phalle, in a sense, took Gaudí one step further with her characteristic mixture of architectural space and humorous eroticism: The scale is right, the tempo is right, and the flowing white skin, embellished with painted figures and painted stars, superb.

Inside, a crocodile skull wired by Tinguely snaps at all visitors with electrified jaws, and a free-form staircase, leading to the bedroom, bears a Haring mural that starts with a sign of love, carries through male bodies, including one on a dolphin, and ends with an acrobatic *mise-en-scène* honoring the swimmers and surfers of Knokke. On the wall, in fact, is a surfboard Haring painted for the Nellens' son, Xavier, in the Légerizing substyle, on June 22, 1987.

The bedroom in the Dragon is like living in a body underwater, punctuated with various organic openings in unexpected places.

Haring loved it. It was an enormously stimulating place in which to live and work—he completed, in addition to the staircase mural, scores of drawings within the Dragon.

Apparently, among all the Nellenses' guests, no one except Haring loved living in the belly of this monster: Niki de St. Phalle actually came to Knokke to see her genial sculpture-building at last inhabited and accepted. Meanwhile, Roger Nellens ("the best chef in Europe") cooked Haring inventive gourmet meals and Tinguely called him and "told me he talks of me almost every day. This makes me feel quite proud."

Haring, after a trip to Düsseldorf—where he saw a duck cross the street—returns to Knokke on June 18 and admires the wild boar that Roger shot the night before. "It is really like a country house here and kind of timeless in a way." On to the major purpose of his visit:

> Saturday, June 20: 12:00 NOON. To Casino to begin big mural. Wall is about 14' × 50'. I do drawing with black acrylic of detailed "gambling scene." Big brush and pretty quickly. Very Dubuffet, or something, with a little hint of Stuart Davis. I finish at 3:30 PM to applause.

Haring is being humorous when he compares his line with Dubuffet and Stuart Davis. The convergence with the intensity of Dubuffet's line in, say, the latter's "hourloupe" drawings and constructions of the late seventies presents an intriguing coincidence.[23]

The same point applies to Stuart Davis's broad planar cubist style. Davis's *Anyside* of 1961 boldly outlines shapes and patterns with a strong black line not unlike the armature of the Knokke mural.[24]

Nevertheless, Haring was, in the Knokke mural, operating completely in terms of his own self-minted alternative style, differ-

ing from the dolphins, dogs, and radiant children in the return to facial and anatomic detail, and in the handling of that in terms of rhythmized parallel lines and "dangerous" eyes made of tubes. The latter evoke one kind of Dan and Grebo mask in West African sculpture, which he knew both from the handbooks and from Picasso's versioning of this trait in his *Guitar* of early 1912.[25]

Three of the gamblers are dragons, likely reflecting the impact of his lodgings. They and the other fantastic personae read like fugitives from the famous "cantina scene" on the planet Tatooine in *Star Wars*. They are busy smoking, laying down cash, and playing cards while Death rolls dice and another figure indicates a wheel of fortune. This musing on art and gambling is climaxed by an homage to René Magritte in the upper left-hand corner. There Haring restates and frames Magritte's "masked apples," a mural which adorns a room next to that which shelters the Haring mural.

On the following day, Haring goes "to Casino to finish mural with everyone from lunch. Fill in color inside all the black shapes—one color at a time. Very 'Cobra' brushwork and very drippy. Finish around 9:30. . . ." He evokes complicating comparisons to Alechinsky, and the Cobra school, as he did to Dubuffet and Stuart Davis. However, as Haring himself later points out in his journals, "this is because of the quality of drawing, not imitation." The linear elements recall, if anyone, Picasso. But the information being conveyed, and the way he mixes it with fear of his own death plus respect for his colleague, Magritte, is pure Haring.

Haring thought and dreamt a lot in the Dragon. One of his musings tantalizes us, dropping a hint as to what his style might look like now: "I think thoughtful and aesthetic creative humor is needed. This could be the vehicle I am searching for to make the next transition from the subway works."

On the Fourth of July the Nellenses had fireworks in Keith's honor. They even put up an American flag in the backyard. Sunday, July 5, Haring executes four vases for Monique Nellens. "It is great using ink on terra-cotta because it soaks it up really fast and

makes a line like on paper." Wednesday, July 8, Haring does a "big three-eyed face painting on the refrigerator for Roger with oil paint." All of these works are still in Knokke. In sum, summer 1987 in the Flemish resort restored Haring's zest and prolonged his life, as he leads us to understand: "I feel more optimistic after being in Europe and I think it might be a good idea to live longer."

Haring came back to the Dragon early in October: "The moon was almost full last night and sleeping inside the Dragon at the Nellens' house was really strange . . . light was pouring through all the round holes in the windows. . . . Sleeping in Niki's dragon is a lot like a dream anyway." Haring's last visit to Knokke was in November 1989, when he brought his parents to Europe. Monique Nellens remembers Haring painting contentedly in the Dragon, his mother watching.[26]

HARING AND THE DANCE: BREAKING

One of the more dramatic registers of Haring's ambition, seeking affinity of line with the contours of the world around him, was his finding, in break dance and electric boogie, icons of late-twentieth-century American civilization.

The new dances represented a sudden synthesis of steps and acrobatics going back, through documented midpoints in the pages of Charles Dickens's *Notes on America* and an early kinescope attributed to Thomas Edison, to ancient sub-Saharan sources. The mix exploded, in the late seventies and early eighties, on the dance floor in time to double-disc DJ music, the "wheels of steel" and their extended breaks, hence the title, break dance.

Haring knew the gist of the break dance sequence—entry—swipes (floor acrobatics)—spin—freeze—exit. He especially celebrated the Antaeus-like spins, dancers in combat with gravity and the laws of physics.

Just as he knew what to pick from Keats, so Haring made points with the moves that he chose to draw: for instance, with young men, spinning on their heads, he silhouetted poise and valor.

He also interrogated the spark of colleagueship within the break dance, those portions of the choreography depending upon close cooperation between two or more dancers. Witness his versioning of the "spider move," which demands a swift and instant sense of how to share space with an incoming person. Compare, also, man-over-man "totem pole" sequences. Here the safety of those on top depends on the brawn and agility of the man at bottom. This communal form of dancing, strong and genial, lights up a remarkable silhouette-sculpture of 1985: four persons balanced on a barking dog.[27]

This in turn mirrors two men balanced on a third in a breaking move known as "the helicopter."[28] Parenthetically, Haring's inclusion of the animal in the dance extends the positive, protective nature of the icon of the barking dog.

Haring was equally intrigued with "the bridge"—where one breaker arches his body upward while both arms and feet stay flat on the ground—and turned it into metal sculpture.[29] Even this move, seemingly individualistic, was a call for colleagueship—another crew member often answering it by doing a flip over a body in this low position.

Haring thus saluted the range of poetic methods by which the blacks and Latinos of the early eighties found strength and community in the break dance. The participants themselves recognized their moves in Haring's subway drawings:

> [1983, 1984] . . . it was almost like a dialogue going on back and forth, and the subways were a way to continue the dialogue and put [out] images which I would get sometimes specifically from dance moves that I saw . . . you know, [persons who would] bend over backwards [to the floor] or somebody going underneath [in the "spider move"], things that I was seeing in dances and literally putting them right into the work . . . [the break-dancers] knew, when they saw it, right away what it was.[30]

Breaking centers on the horizontal. But electric boogie, the matching dimension to hip-hop choreography, is a stand-up dance. It brilliantly mimes the activating powers of electrical current:

> A dancer would begin an electric wave in his right arm, touching another dancer's arm, which vibrates with the received energy, and then pass it on to as many dancers as could play this game of electronic call-and-response.[31]

Two critics, Edit deAk and Lisa Liebmann, sensed Haring's meanings when he began to portray aspects of the electric boogie both in his subway drawings and paintings on canvas:

> . . . a current of energy transmitted by and to male creatures ever-readily recharging themselves or one another . . . the act of recharging appears to be both praxis and erotic principle.[32]

Haring also saw, in the electric boogie, both social truth and spiritual transcendence. At home in the style, Haring even drew a dancer who lights up a light bulb with current in his hand.[33]

To a wall of metal on FDR Drive near Ninety-first Street, Haring brought in 1984 all of his breaker/electric boogie expertise:

> Break head-spinning, body propelled by one hand, legs pretzeled. Kicking and rolling shoulders. Two-partner balancing act. Vertical electric boogie, the elasticity of which, sending waves, has magically lengthened the dancer's body. Breaker falling on his back, body supported with the palms of the hands and feet, building the pose called the bridge.

Wave dancers passing modified lightning to one another. Electric boogie locking, hand right-angled to wrist.[34]

This was Haring at his best, the master documentarist in search of taste and fellowship, showing persons in the dance acquiring value through stealing fire from the age of electronics. He showed them bending, delaying, and transgressing a march toward a post-hominid future. He saw the life force, the subtle medicine, coded in electric boogie, hidden by its very popularity.

FINAL QUINTESSENCE: DANCING AT THE PARADISE GARAGE

In the pages of his journals Haring mourns the closing of the Paradise Garage in 1987.

Haring dealt with the passing of this club by immortalizing certain moves which had impressed him there. At the same time he had come in contact with *capoeira,* an Afro-Bahian martial art as taught in New York and witnessed in Brazil. These styles, too, left traces in his imagination.

In 1987, Haring and Juan Rivera drove me to the Lippincott Foundry in North Haven, Connecticut. There they showed me Haring's sculpture of two men playing *capoeira,* dovetailed in combat and self-assertion.[35]

Haring's eyes flashed as he decoded a statue standing with arms curved before its chest, fists nearly touching. It was a classic move of the Paradise Garage, a sign, he explained, of metrical encirclement. Haring demonstrated. One dancer would capture, for a millisecond, a partner within this fleeting fence, right fist in left, and then move on to other moves.

This partial cage, encircling arms in the Paradise manner, haunts the best compositions of a one-man exhibition that Haring mounted at the Michael Kohn Gallery in Los Angeles in June–July 1988.

In his conscious pursuit of museum attention, Haring decided to test the impact of the Paradise Garage choreography at monumental gallery scale. And the outcome of this risk was the Los Angeles 1988 dance paintings. In this self-selected genre, Haring pitted himself against the masters: Albers, Olitski, possibly Judd, but certainly Stella. He had placed his faith in the strength of the moves to bring off a triumphant vernacularization of museum art. And his style was changing. Spaceships and barking dogs were nowhere to be seen.

Now he was complicating fine art qualities of line and color with street extravagance meant to level hierarchical distinctions. First, he piled dancer on dancer in the totem-pole image characteristic of group break dancing. But as he did so, he fused two dancers in one. He painted, as well, their bodies in metallic red, not unlike a Don Judd series.[36]

He showed, again, the close relationship binding key Paradise Garage dancers by fusing in another composition four performers to form a square of one.[37]

The men join hands but "break" into difference: one bends his knees outward, one runs, and two are on the floor, upside down, flaunting hip-hop/*capoeira* legs, the former (at left) pretzeled, the latter (right) with one leg straight, the other bent, a *capoeira* move called *negativa*.

Then he repeated this Afro square dance omitting the legs, squaring the torsos, and coloring the bodies white lined in russet. Four frames emerge, Albers-like squares in green and gold and pink and blue.[38] These capture our gaze with asymmetric phrasing, like the north wall windows of Le Corbusier's 1955 chapel at Ronchamp in southeastern France.

Pollock is thus not the only twentieth-century artist whose critical vocabulary is that of rivalry.[39] For, having taken on Albers (and perhaps Don Judd as well), Haring elaborated a further quintessence of the B-boy spider move with a lushness of color at heroic scale in the manner of Jules Olitski. The total absorption of lush

coloration, red-lined olive dancers vertically poised against a jet black field, was a marvel of cultural transposition.[40]

In another work (*Untitled No. 7*), Haring's characteristic "action lines" deepen, again, into something like the strokes of Jules Olitski. This strategy enhances gold-tinted break-dancers performing on a gray-blue field.[41] Their bodies fuse to form an abstract lozenge. Head over lozenge we have seen before: it is the structural gist of the famous Kota brass-plated (hence the yellow?) reliquary figure, alleged organizing principle behind the right-hand *Demoiselles* of 1907.

Next, Haring targeted dark Stella pinstripes of the sixties. Haring showed how it was possible to respect the master's sobriety and self-control and still, within all that tight suppression, discover black sound and motion. Haring causes Stella's concentric squares to curve, regroup, and ultimately form a body, bull's-eye of pink burning in the head, rectangle of pink stoked near the heart. The right leg descends and bends to the beat; the left prepares a kick. Right arm celebrates the dancer's state of being, reaching for heaven. Action lines, fat with pleasure, again take on roles as abstract units of design.[42]

The left hand's reach and angle are culturally exact: electric boogie right-angle bending at elbow, wrist, and fingers.[43]

And so Haring conquers his rivals, masters their media, in the name of the eroticized fire of New York eighties dance.

One more time, in 1988, he deliberately disturbs the optical neatness of his powerful rival with the trace of black bodies in action.

The composition, monumental in scale, is a Haring masterpiece.[44] Two fugitives from the Paradise Garage take possession of the pinstriped line and turn it into dance. They celebrate their celebration, arms curving up in affirmation. So decisive is their fusion they become a pair of scissors. Their legs cut through ribbon. This frees a person, bound and immobilized, at the right.

Haring, at the end, confers a metaphor of liberation upon bod-

ies debated by intensities of sweat and spirit. Black dance becomes a medium of transcendence: "Dancing [at the Paradise Garage] was really dancing in a way to reach another state of mind, to transcend being here and getting communally to another place."[45] It was lights and disco, but something else was happening.

Haring assumed, as he wrote in his diary, that the Paradise Garage and his dearly mourned friend, Bobby Breslau, had both gone to heaven. Now he is with them.

KEITH
HARING
JOURNALS

1977

This is a blue moment . . . it's blue because I'm confused, again; or should I say "still"? I don't know what I want or how to get it. I act like I know what I want, and I appear to be going after it—fast, but I don't, when it comes down to it, even know. I guess it's because I'm afraid. Afraid I'm wrong. And I guess I'm afraid I'm wrong, because I constantly relate myself to other people, other experiences, other ideas. I should be looking at both in perspective, not comparing. I relate my life to an idea or an example that is some entirely different life. I should be relating it to my life only in the sense that each has good and bad facets. Each is separate. The only way the other attained enough merit, making it worthy of my admiration, or long to copy it is by taking chances, taking it in its own way. It has grown with different situations and has discovered different heights of happiness and equal sorrows. If I al-

ways seek to pattern my life after another, mine is being wasted re-doing things for my own empty acceptance. But, if I live my life my way and only let the other [artists] influence me as a reference, a starting point, I can build an even higher awareness instead of staying dormant. If I can take this and apply it, it will help, but again I am afraid. Afraid I'll just ignore this whole revelation and remain in the rut and rationalize and call it human nature or some shit. But, I've been living like this for so long that it seems I'm doomed to continue. Although I realized it now, so that is encouraging. If I can do this, then it should not be hard to answer my questions and doubts about my forthcoming adventure. If I am all that is in question, then I should be able to answer all. Like past experience, there is always a certain magic that some call "Fate." Lately it hasn't been as evident, or perhaps I am just more ignorant of it, but I know that I'll end up somewhere for some reason or no reason, but with some answers or at least be a little clearer on why I am and what I am aiming to do or what I am gonna do or just "do." If this fate is negative, that isn't negative because that is what happened and that then *was* the fate. I only wish that I could have more confidence and try to forget all my silly preconceptions, misconceptions, and just live. Just live. Just. Live. Just live till I die.

Today we got to Interstate State Park and camped and met people and sold T-shirts. Tripped. Met people going to see the Grateful Dead in Minnesota. The Grateful Dead in Minnesota! We're going to see the Grateful Dead!

I found a tree in this park that I'm gonna come back to, someday. It stretches sideways out over the St. Croix river and I can sit on it and balance lying on it perfectly.

Today we awoke at sunrise, walked out of the park and hitchhiked to Minneapolis. We saw the school. It's so big! Giant studios and facilities for silk-screen, etching, lithography, sculpture and giant sun roofs. They have a big library with "Pioneer" receivers, tape decks and a large selection of music (even Frank Zappa). We saw the downtown area and a really modern mall that I can't begin to describe. We got a dorm apartment for two nights for $10 and bought Grateful Dead tickets. (Only $5.50 apiece and it's not sold out yet.) Also I met people that go to school here and asked a lot of questions and got a good idea of what this school is like.

The Dead were great. We saw the people we met at the campsite, sold T-shirts, got high. The Dead even did an encore from *American Beauty*, "By the waterside I will lay my head, listen to the river sing sweet songs to rock my soul."

FRIDAY, MAY 13, 1977

After we left Minneapolis, we took a bus to I-94 and caught a few little rides and then a truck ride all the way to the border of N. Dakota where we ate three cheeseburgers and drank some beers. It was all farmers and when I went to the bathroom they all talked about my hair . . . Rednecks! Then we got a ride from a pilot who likes Bachman Turner Overdrive and then a truck ride into N. Dakota.

SATURDAY, MAY 14, 1977

I am in Miles City, Montana, sitting in the sun. Thinking about the Grateful Dead, 'cause the last ride was 77 miles of AM Radio. Suzy said my hair looks like there are dead animals living in it. At least they're dead.

You have to stand *before* the ramp in Washington, so it was real hard to get rides. So we went down onto the Interstate, illegally, and finally got a ride, seconds before a sheriff came down the ramp. This guy is going all the way to Sacramento. I'm in his car now. We drove till around 10:00 last night and then stayed in a motel, watched *Paper Moon* on TV and took showers. Today he bought us breakfast in Medford, Oregon, and now we're on our way to Sacramento in a '62 Chrysler with a dome dash and plastic slipcovers. It's a really neat car. Also, he is blind in one eye and has a cataract in the other and the radio doesn't work right 'cause he spilled a glass of Coke down the front of the dash a few years ago. But we'll get there . . .

WEDNESDAY, MAY 18, 1977

Yesterday we woke up, got out of the tent and there were cows standing 20 feet away just looking at us. They kept coming closer and closer till they were right in front of the tent, and Suzy is saying, "Hurry up, they're gonna charge us," so we hurried up and left and hitchhiked to I-80 and got a ride in a van and then a ride with a guy named Peter who took us to Berkeley. The school is really amazing. Better than Minneapolis, and not even comparable to Ivy. Then we went by Rapid Transit (space transit) to San Francisco to a place to eat and sleep for free advertised in an "alternative" Yellow Pages we found in Berkeley. The guy who ran it was gay, I think, and his friend took us to Polk Street, where we saw more faggots than I saw in my entire life. It was weird, but we got fed well and no hassles. Now we are at a laundromat and we'll head for Santa Ana.

We went to Newport Beach today. It was nice. I wish I

could live here ... It's like N.J. shore. I got high and met
someone from Boston and from Michigan.

I am sunburned. We saw the ocean today, one month af-
ter seeing the Atlantic Ocean.

MONDAY, MAY 23, 1977

Yesterday me and Suzy took a bus to Disneyland. What a
trip! It was like another world. We did everything we could
possibly do in nine hours. I expected it to be a letdown after
seeing it on TV and hearing about it, but it was better. Except
the castle is only about three stories high and it always looks
gigantic in pictures. We went to the Haunted Mansion two
times.

SATURDAY, MAY 28, 1977

We are camped in a National Forest (for free) in the Rocky
Mountains. We put our tent up last night and drank Coors

this morning and we woke up and there was snow every-where! I got up and walked farther down the creek, and found a good place to make a shelter. It was snowing. This is the nicest place we've been to yet. Last Saturday we were getting sunburned at Newport Beach, and now we're in snow! I built a shelter out of pine trees and we put the tent under it. Now I am sitting across the creek from our tent drinking a beer and getting high on the scenes. Rocky Mountain High!

MEMORIAL DAY 1977

We slept under a train bridge last night and woke at sunrise and signed the bridge along with the other people that had slept there. We got a family ride that was very comical, and then a ride to Des Moines, Iowa, with a really neat guy who had tame raccoons.

Now I'm on the North Side, and Suzy is making French toast. This is the end of the first part of my trip. Or should I say the beginning of another "trip." Through all the shit, shines the small ray of hope that lives in the common sense of the few. The music, dance, theatre, and the visual arts; the forms of expression, the arts of hope. This is where I think I fit in. If it's alongside a creek in the Rocky Mountains or in a skyscraper in Chicago or in a small town called Park City,

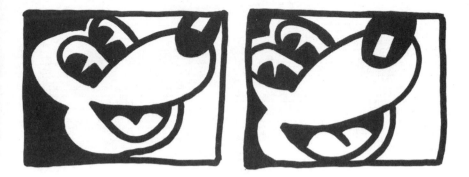

Utah, it is always with me. Art will never leave me and never should. So as I go into the next part of the trip I hope it will be more creative and more work involved and less talk and more doing, seeing, learning, being, loving, feeling, maybe less feeling, and just work my ass off, 'cause that, my friend, is where it's at!

> It's the Image I'm seeking, the Image I see
> when the man in the mirror is talking to Me.
> —Graham Nash

1978

As I sit here and write I feel comfortable. It is somewhat unusual to feel comfortable in Washington Square Park. There are so many different ways to experience the phenomena of the city. A given situation can have an unlimited number of different effects on a person's thoughts, depending on the state of mind and attitude. Something that affects me today will not necessarily affect me tomorrow. Nothing is constant. Everything is constantly changing. Every second from birth is spent experiencing; different sensations, different interjections, different directional vectors of force/energy constantly composing and recomposing themselves around you. Time (situations in a visible logical progression) never will and never can repeat itself. None of the elements involved in the experience of time will ever be the same because everything is always changing. Physically humans are constantly changing (cell division)

and one is never in the same state of existence mentally or physically.

The physical reality of the world as we know it is motion. Motion itself = movement. Change. If there is any repetition it is not identical repetition because (at least) time has passed and therefore there is an element of change.

No two human beings ever experience two sensations, experiences, feelings, or thoughts identically. Everything changes, everything is always different. All of these variables merging, interacting, destroying each other, building new forms, ideas, "realities," mean that the human experience is one of constant change and, as we label it, "growth."

My source of amazement comes from the fact that most living human beings build their lives around the belief that these differences, changes, don't exist. They choose to ignore these things and attempt to program or control their own existence. They make schedules, long-term commitments, set up a system of time and become controlled by their system of controls.

People don't want to know that they change.

Unless they feel it is an improvement, and then they are all for "change," and will go to great lengths to "make changes" or contrive situations or force a change that is unnatural. There are so many aspects of this one concept that it is hard to write them all down.

Some attitudes I see all around me are:

Change is acceptable as long as it is controllable.
Change can be predicted.
Changes can be contrived and/or altered and/or
 planned.

If I stand in front of my mirror and gaze at my image, I see an endless number of different conceptions of how I look. I feel as though I have many different faces. I put them on and take them off, and my conception of other people is the same. People look different at different times. I mean completely different. It may have something to do with how *they* feel, but more likely is controlled by *my* feelings, my emotions, my reality at the time I am looking at them.

Usually the underlying fact that change is reality, that we are constantly changing and constantly in difficult situations, different states of mind and actually different realities

 is ignored
 or misunderstood
 or misinterpreted
 or confronted.

Most simply, people know to some extent that they feel different at different times or look different to themselves different days, but few people really try to experience this or question it or really investigate its reasons or its implications. People tend to try to control this by living an opposite life

pattern. It is like superimposing a grid on top of a patch of grass that is alive and constantly changing, and then trying to make the grass fit the predetermined design of the grid.

People, I realize, cannot live like a patch of grass. They could, I suppose, at one time, but we are so far removed from that time that it is hard to conceive. People can, however, live their lives with the realization that they are constantly changing, products of their changing environment and changing situations, and time. They can live, at least, in harmony with the knowledge and co-exist with it instead of working against it.

There is a point, I'm sure, where the modern man can confront this reality, question it, explore it, and live with it and actually become part of it and lead a much more comfortable life. To live in harmony with an idea. To live in harmony with an uncontrollable reality that we are subject to

whether we choose it or not. There is no choice except the choice of how to deal with it.

I keep writing because before I try to explain how I feel I am living with this "reality," I want to try to explain (to myself) that it really is a reality, that it exists, and that I'm doing things in a way that is not totally without reason.

To be a victim of your own knowledge is not understanding what your knowledge is and what its result is.

To be a victim of change is to ignore its existence.

To be a victim of "living by what you think" is to ignore the possibilities of "another way to live" or the possibility of "being wrong about the way it is" or ignoring the possibility of "not knowing what you think."

Thinking you know the answer is as dangerous as not thinking about the possibility of no answers.

Poetic sentences that make no sense might as well be poems.

Keith Haring thinks in poems.
Keith Haring paints poems.
Poems do not necessarily need words.
Words do not necessarily make poems.

In painting, words are present in the form of images. Paintings can be poems if they are read as words instead of images. "Images that represent words." Egyptian Art/hieroglyphics/pictograms/Symbolism. Words as imagery.

Can imagery exist (communicate) in the form of words?

Foreign languages, undeciphered alphabets can be beautiful, can express without a knowledge of the meaning of the words.

Looking at a book printed in Chinese can be as beautiful as looking at pictures. Images that represent words.

All of this in the context that everything is always changing. That is why, for me, painting, as I know it, can be imagery as words. Because I am different at different times. I believe I have never lived two days that were the same in *any* way. Similar, maybe, but not the same. I think, feel, act, conceive and live differently every day, every instant. And if I am different at different times, my imagery also changes.

I paint differently every day.

every hour.
every minute.
every instant.

My paintings are a record of a given space of time.

They are recorded patterns of thought.
Duplication is impossible without a camera.
Repetition, without a camera (or machine) is not
 repetition.

To paint differently every day makes it impossible to paint a consistent composition over the period of more than one session.

It is done, but not without pain, needless changes, de-evolution, false repetition (duplication), over-working, collage (piling different ideas on top of each other and calling them a "whole"), etc. Pure art exists only on the level of instant response to pure life.

I am not trying to say that art up to this point has been useless or any less pure than art done in this context. I am saying that art has evolved. Has changed faster than we have. Has been with humans from the beginning of time as a helpful companion. Each artist (person) of a given time has had a different life and therefore different attitude toward life and art. Although much art history is composed of "movements"

and style unique to a *group* of artists, it always was and always will be a product of the *individual*. Even if a "group mentality" or "cultural grouping" of artists has existed, the act of art itself is individual or has (in collaborated efforts) an individual's conception or a mixture of individual inputs toward a group effort.

However, after seeing these many "movements" and "group styles" and "periods" of art history, I believe we have reached a point where there can be no more group mentality, no more movements, no more shared ideals. It is a time for self-realization.

Being tested by the media and mentality of this anti-individual society, where stereotypes are the reigning power and overpopulation has forced us to believe that we exist as "kinds of people" or "types of people" or "generalizations," has produced artists with the realization that individuality is still the base of it all. Individuality is the enemy of this mass society. Individuality speaks for the individual and makes him a significant factor. Art is individuality. I feel this is the underlying message of modern art. It is the lesson that must not be ignored. It is what modern art has been screaming at us since its beginnings. It is what *all* art has been saying since the beginning of time.

Where an artist has destroyed his own goals (or had them destroyed for him, and sat by and done nothing), is when he has let himself be part of groups, follow movements, make group manifestos and form group ideas. Matisse had a pure vision and painted beautiful pictures. Nobody ever has or ever will paint like him again. His was an individual statement. No artists are parts of a movement. Unless they are followers. And then they are unnecessary and doing unnecessary art. If they are exploring in an "individual way" with "different ideas" the idea of another individual, they are making a worthy contribution, but as soon as they call themselves followers or accept the truths they have not explored as truths, they

are defeating the purpose of art as an individual expression— Art as art.

Art in 1978 has seen numerous attempts at classifying or labeling and then exploiting an idea until the idea itself is lost in the process, and now I feel it is time to come out against group mentality. I don't know if this is a shared opinion, but by the lack of any existing movements or new movements or new directions, it looks and feels as though we are seeing individual artists, individual ideas. They have been influenced, of course, and many are probably not sincere in their endeavors, but this void of "group movements" after the over-emphasized, unquestioned "movements" of the last ten years that happened so fast—Pop, Conceptual, Minimal, Earth Works, post-this and anti-that—it seems like it is high time for the realization that art is everything and everywhere. That the conception of art occurs in *every* individual in day-to-day life in endless forms and ideas and is undefinable *because* it is different for each individual. That life is art and art is life. That everybody on every level identifies with art, regardless if they are aware of it or admit it or realize it. That the importance of the "individual idea" in a society of this size and mentality is the only reality. That it is important to the future existence of the human race that we understand the importance of the individual and the reality that we are all different, all individuals, all changing and all contributing to the "whole" as individuals, *not* as groups or products of "mass identity," "anti-individual," "stereotyped groups of humans with the same goals, ideas and needs."

I am me. I may look like you, but if you take a closer look you will realize that I am nothing like you at all. I am very different. I see things through a completely different perspective because in my life I had experiences that you didn't have, and I had feelings you didn't have, and I've lived places and seen places and experienced life from a completely different point of view than you have. I may be wearing the same

shoes and the same haircut, but that gives you no right to have any preconceived notions about what I am or who I am.

You don't even know me.
You *never* will.

Art as a personal exploration.

Art as an end to the question "what is it?" or "what does it mean?"

The meaning of art as it is experienced by the viewer, not the artist.

The artist's ideas are not essential to the art as seen by the viewer.

The viewer is an artist in the sense that he conceives a given piece of his own way that is unique to him.

His own imagination determines what it is, what it means.

The viewer does not have to be considered during the conception of the art, but should not be told, then, what to think or how to conceive it or what it means. There is no need for definition.

Definition can be the most dangerous, destructive tool the artist can use when he is making art for a society of individuals.

Definition is not necessary.

Definition defeats itself and its goals by defining them.

The public has a right to art.

The public is being ignored by most contemporary artists.

The public needs art, and it is the responsibility of a "self-proclaimed artist" to realize the public needs art, and not to make bourgeois art for the few and ignore the masses.

Art is for everybody. To think that they—the public—do not appreciate art because they don't understand it, and to continue to make art that they don't understand and therefore become alienated from, may mean that the artist is the

one who doesn't understand or appreciate art and is thriving in this "self-proclaimed knowledge of art" that is actually bullshit.

Art can be a positive influence on a society of individuals.

Art can be a destructive element and an aid to the take-over of the "mass-identity" society.

Art must be considered by the artists as well as the public.

The public will not, however, say what they want for fear of seeming uneducated or not understanding art. Therefore, the responsibility rests predominantly on the consciousness of the artist.

The artist cannot, however, make his decisions without considering the public, why they won't "come out" about the arts, why they need art, and how to help them fulfill their essential roles as viewers, how to experience art and why.

The decision is basically, is art for an educated few, or is art for all people of the time?

Is art successful without the input of the public?

If the public is afraid of art, should we be afraid of what we have done to make the public afraid of art?

Were they always? Do they matter? Is art for the individual, by the individual only for viewing and appreciation of the individual?

Is art for self? Is art simply fulfilling an artist-ego relationship?

I am interested in making art to be experienced and explored by as many individuals as possible with as many different individual ideas about the given piece with no final meaning attached. The viewer creates the reality, the meaning, the conception of the piece. I am merely a middleman trying to bring ideas together.

I have nothing specifically to communicate but this: That I have created a reality that is not complete until it is met with the ideas of another human being (or, I suppose, animal), including myself, and that the reality is not complete

until it is experienced. It has infinite meanings because it will be experienced differently by every individual.

This is my message. The medium is unimportant.
It is art as I know it.
It is life as I know it.

The medium is a tool of the message.
The medium is not the message.
The message is the message.

Art is life. Life is art. The importance of both is over-exaggerated as well as misunderstood.

The destructive element exists in all art, but ultimately is determined only by the ideas of the viewer.

Art has no meaning because it has many meanings, infinite meanings. Art is different for every individual, and is definable *only* by the given individual.

There are no set answers, only questions.

When I go to SoHo, I come away with so many visions of new ideas for my own work that I wonder if that's why I go.

I start to look at the gallery spaces as spaces for my art instead of looking at the art being shown.

There is a lot of shit being shown in spaces that deserve more than shit.

I realized today that one of the main reasons I am here is because it is one of the only cities in the world that has gallery space big enough for my anticipated works.

I saw so many spaces today that look like they were made for my art.

But my art makes itself fit the space, any given space. It defines the space and experiences the space. It changes space and can be part of any given space.

I saw today walls that I could hang paper panels on and make a 30 × 400 foot painting.

It's wonderful. But how do you get there?

Today I imagined a gallery full of equally spaced video monitors (spaced as painting would be exhibited) all playing different tapes of my video paintings. I want to do it, but I am up against myself. I am up against the fact that I will have new ideas, different attitudes, different feelings and possibly never carry out this vision because another one will appear that seems more important. This gallery, however, existed today in my mind. I was at the opening and it was a nice show.

After the completion of my first video piece—me painting myself into a corner—I am becoming much more aware of movement. The importance of movement is intensified when a painting becomes a performance. The performance (the act of painting) becomes as important as the resulting painting.

Movement as painting. Painting as movement.

Moving toward a work of art that encompasses music, performance, movement, concept, craft and a reality record of the event in the form of a painting.

Almost a kind of diagram of the previous experience (i.e., blueprint, choreography).

Painting as performance.

Video—a medium capable of reaching higher levels of communication—more direct, more involved than painting/sculpture.

It's not necessarily true that New York is an impersonal city. In fact, I think it is quite friendly if you let it be. I have had a really nice walk home, exchanged smiles and even a few words. People are open to other people on a certain level, but there is still a barrier of fright (apprehension) on other levels. It can be a wonderful place. I say that now from first-hand experience.

It's strange, I curse my painting class 24 hours a day except when I'm in class, and then it seems like it might be valuable to my education in some way. But when I leave, I start cursing again.

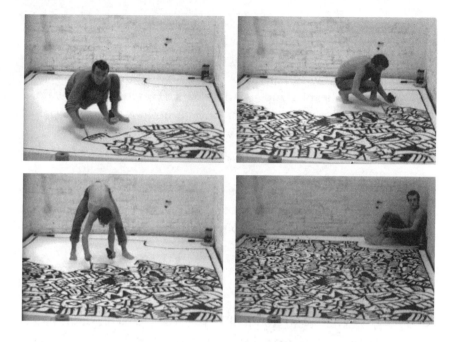

I'm enjoying the theory and principles discussed in my painting class. I can see how repetition and a controlled vocabulary (symbol vocabulary) could be helpful in the sense that it is a discipline you experience and then later use as a reference point, but for some reason the canvas and oil paint repulse me. I hate them more the more I use them. I love the rich colors of the paint, but the vehicle for the color is so primitive, so restraining. In oil paints, the oil is the vehicle to hold and transport the color. In video, it is light. I guess the use of paint is inevitable. However, if there is a better way I want to know it. Maybe I would enjoy the paint if I could experience it, control it, experiment and play with it. But it is hard to have an experience with oil paint when you are working in pre-drawn areas of shape and painting and re-painting and trying to control it instead of letting it control itself or control you.

Canvas as a material is wonderful. It is sturdy and can be sold and is somewhat permanent. But I am inhibited by it. I

pay $8.00 for a 30 × 40 canvas and oil paint, and then I'm paranoid about what it will look like 'cause I spent $12.00 on the painting, and I think it should be worth something. However, when I paint on paper that I have found or purchased cheaply, and use ink that is watered down, I do a whole 4' × 9' painting for next to nothing. I love to paint. And you can see it in the work.

I don't care if it is a painting/drawing/sculpture performance.

I don't care if you don't like it.

I don't care of the paper is wrinkled, torn.

I don't care if somebody walked across it and got dirt on it.

I don't care if the lines vary and there are drips and splatters.

I don't care if I don't paint on it.

If I don't care about all of the lesser elements of the painting; if it is not regarded as "sacred" and "valuable," then I can paint, without inhibition, and experience the interaction of line and shapes. I can paint spontaneously without worrying if it looks "good" and I can let my movement and my instant reaction/response control the piece, control my energy (if there is any control at all). Maybe control is a bad word. I can "work" with all these elements and not be worried about the result and whether the finished (nothing is ever really finished) product conveys that whole feeling. It is pleasing to look at. A vacation from order. Or a different kind of order that emerges only from these conditions. It requires individual interaction and individual response—possibly individual interpretation.

It is loose, natural, real, uninhibited, beyond definition. It is temporary and its permanence is unimportant. Its existence is already established. It can be made permanent by a camera. I don't have to make it permanent.

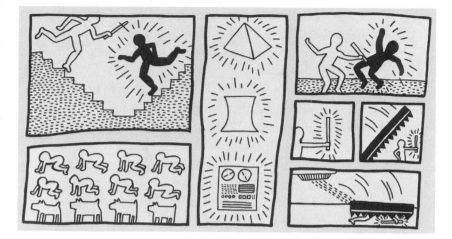

Chances are, even my raw-paper paintings will last as long as any works in canvas that are being done. Atomic blasts destroy canvas just as fast as paper.

The silicon computer chip has become the new life form. Eventually the only worth of man will be to service and serve the computer. Are we there? In a lot of ways we are. Computer banks control information that we are incapable of dealing with. Are we controlling computers, or are we merely helping them to control us? This is "1984" and it has been for the last ten years. If the computer continues to make the important decisions, store information beyond our mental capabilities, and program physical things (machines), what is the role of the human being?

To service our computer?

And what is the role of an artist?

Should the situation be resisted or accepted?

It appears to me that human beings have reached an end in the evolutionary process. We will, if we continue on the same path, eventually destroy ourselves. We are creating technolo-

gies to destroy ourselves. We are self-destructive. Possibly the computer will save us. Maybe it is a good thing that we have created a life form that can continue to evolve and grow beyond our capabilities.

The major question is, though, are we going to be able to control the evolution of the computerized mind, or can it evolve and grow by itself? Will computers be able to decide their future and make it happen without our aid? Computers can do more and more every day. I think we are capable (with our minds, our technologies, our computers) of creating computers as a form of life that can function more efficiently than us in almost every aspect of life.

Machine aesthetic?

Do computers have any sense of aesthetics? Can an aesthetic pattern be programmed and fed into a computer so that it reasons and makes decisions based on a given aesthetic? Why not?

The role of the arts in human existence is going to be tested and tried. It is possibly the most important time for art the world has ever seen. The artist of this time is creating under a constant realization that he is being pursued by the computers. We are threatened. Our existence, our individuality, our creativity, our lives are threatened by this coming machine aesthetic. It is going to be up to us to establish a lasting position of the arts in our daily lives, in human existence.

If humans are expendable, then emotions, enjoyment, indulgence, creative aesthetic, and personality of human beings are expendable.

Question: As an artist aware of this situation, what should my position be?

I agree, to an extent, that if human beings are incapable of evolving further, we should evolve in the form of creating a new life form that can survive the human condition and transcend it. The question that I have trouble with is: Should the new life form be completely oblivious to the aesthetics of

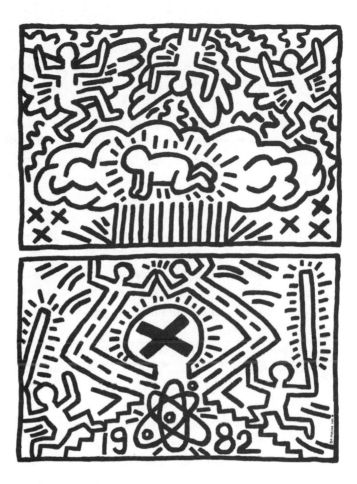

human beings? Is it forced, because of its very nature, to be a new life form with no traits of the human being? Have we created a life form "in our own image" or is it a completely different form?

This is the question that the artist of our times has to ask, because it is we who will have to lead the fight against a machine aesthetic or prepare people for it.

Minimal art leans toward the machine aesthetic. It is, in a sense, preparing us for the coming of the machine age—boxes, metal, geometric shapes, sculpture devoid of sculptural aes-

thetic, ideas devoid of a traditional aesthetic consideration. It influences people's ideas, and our daily life.

Or there is the possibility that minimal art will have a shocking effect. A warning of the possibilities of the future. Punk rock.

By being negative are you being positive? Is this the approach we should take? Do people see the absurdity, or will they *accept* it as the future, and will it defeat its purpose? Being negative for the sake of trying to reveal the absurdity of the negative act—is that a positive act? Dada—positive or negative?

This is for me the question that will decide my position in the arts. In life . . .

How do you help the human race to realize its predicament? And if you do not see it as a predicament, how do you help to prepare humankind for the reality of a machine-aesthetic world?

Am I a comrade to the computer or to the entire history of humanity? The history of art rests on our shoulders.

Can we abandon it now?

Is it being "abandoned" or is it "evolving," or "de-evolving"?

Is it our duty, as human beings, to see the importance of an alternative life form? Isn't the new life form based on all our past discoveries and the result of the entire history of human beings?

Isn't this a product of the human race, a way to save the human race and continue the evolution of life itself?

Life is not only definable in human terms. It is time that we realize this. We (humans) are a necessary step in an evolutionary process. We cannot know what the end of the evolutionary process is or if there is an end.

For us to stop the evolutionary process of life simply because we are so vain that we believe we are an "end," and to

believe that we can evolve no further, would be disastrous. Life is more valuable than human beings. It is the living force that is within human beings as well as other animals, sky, water, energy, gravity, space. It must be continued at any cost.

The destruction of this planet, this solar system, by human beings would not be an end to life. It would go on without us.

We have a choice, whether we wish to continue evolution on this planet or not.

I vote "yes."

ELECTION DAY. NOVEMBER 7, 1978

Everything in this notebook is subject to change.

When I re-read an idea two or three days later, sometimes (usually) I have a more defined, altered, or more simple version of the original idea, or a new interpretation of the idea, or a totally new idea that develops as a result of the first one.

This book contains thoughts that are spontaneous. Every day I think differently, re-evaluate old ideas, and express my ideas in different terms.

If I still believe any of the theory or philosophy I have written here next year at this time I will be surprised.

I'm waiting.

I'm waiting for the ink to dry.

I have just completed another landmark (for me, that is) painting. It is the first time I ever tried to utilize both arms to control two brushes. This afternoon I bought three brushes that are approximately three feet long. It is amazing to hold them in your hands and move them about. I feel like I am doing a "ceremonial stick dance." They were very awkward at first. I tried to manipulate them several different ways: both working together side by side, both making the same motion while being held several feet apart, both moving si-

multaneously, moving alternately, and one at a time. When you fling ink on the paper by swinging them wildly, they make a wonderful "whooshing" sound as they cut through the air. It was a very intense experience. I found myself much more aware, more involved with every movement, especially with the left hand. Although I was making spontaneous gestures, the forms seemed to be somewhat contrived. It was frustrating not to have full control of my faculties. The first painting is understandably crude and experimental, but I managed to unify all the brush experiments in one total composition by repeating certain actions.

For me it has an interesting feeling of conflict. The left hand fights to be as controlled as the right. The right hand fights the left to make all of the important judgments of line. The two hands are constantly trying to work together, but because they are so distinctly different, they tend to struggle with each other to find common ground, to find unity/consistency.

When I have mastered the ability to use both arms interchangeably; when I can control each arm separately and perform different movements at the same time, as a piano player can; when I can unify my movements so that I can paint consistently at a very high rate of speed on a very spontaneous, natural, spiritual level; then perhaps I will have exhausted the possibilities of the kind of "body-involvement" painting I am currently involved in.

Probably by that time, if I ever reach that time, I will have many more ideas or possibilities for this kind of painting. The road is endless. There is no end, except an end of my physical capabilities. Unfortunately I will probably never have time to explore the possibilities of this "body-involvement" idea of painting because I frequently acquire new knowledge, new ideas, new theories, new approaches, and inevitably new priorities.

I feel in some way that I may be continuing a search, continuing an exploration that other painters have started

and were unable to finish because they advanced to new ideas, as I will also, or perhaps because they were unable to carry out their ideas because of the cruel simple fact of death. It seems that artists are never ready to die. Their lives are stopped before their ideas are completed. Matisse making new discoveries up until the time he could hardly see, using scissors, creating ideas that sparked new ideas until death interrupted. Every true artist leaves unresolved statements, interrupted searches. There may be significant discoveries, seemingly exhausted possibilities, but there is *always* a *new* idea that results from these discoveries.

I am not a beginning.

I am not an end.

I am a link in a chain.

The strength of which depends on my own contributions, as well as the contributions of those before and after me.

I hope I am not vain in thinking that I may be exploring possibilities that artists like Stuart Davis, Jackson Pollock, Jean Dubuffet and Pierre Alechinsky have initiated but did not resolve. Their ideas are living ideas. They cannot be resolved, only explored deeper and deeper. I find comfort in the knowledge that they were on a similar search.

In some sense I am not alone. I feel it when I see their work. Their ideas live on and increase in power as they are explored and rediscovered. I am not alone, as they were not alone, as no artist of the brotherhood ever was or ever will be alone. When I am aware of this unity, and refuse to let my self-doubt and lack of self-confidence interfere, it is one of the most wonderful feelings I've ever experienced. I am a necessary part of an important search to which there is no end.

NOVEMBER 12, 1978

After experiencing the Mark Rothko retrospective I feel enlightened. I had seen Rothko's work before, but the clarity

and unity reflected in a retrospective exhibition gives each piece an added intensity. The first time I had really experienced his work was in the National Gallery in a room with eight paintings on paper from the "Brown and Grey" series. The grouping of these works in a single room concentrated their energy and heightened their impact. I stayed in that room for a long time becoming completely involved with his work.

I had a similar experience at the Guggenheim. Being in the company of such a large body of work provokes ideas and realizations that are not generated by a single painting. His work left little unanswered. It was a solid statement, perhaps taken to its fullest extent.

The development of his painting style can be easily traced back to his early figurative works. As early as 1938, rectangular considerations appeared in his work. Although they were merely backgrounds for his increasingly surreal imagery, there was a specific division of the canvas into rectangular planes. In a painting from 1944, *Horizontal Processions*, the influence of Gorky was evident. He appeared to be more and more making the bridge between surreal and expressionist imagery. Through the 1940s his interest in painting leaned more toward the quality of the brush strokes, his sensitivity toward composition, and the abandonment of line for more abstract solid fields of color. In 1946 planes began to dominate the paintings. There is a logic of layers. In 1947 the first painting appeared with the edges of the canvas treated as a frame. The use of the edge creates the sensation of colors floating above the surface. The use of color frame and field become more and more evolved through the remaining years. He works with a minimum of elements to produce maximum effect. The limitations he creates for himself by restraining his imagery to pure fields of color only heighten his creative powers.

The most prevalent feelings I experienced throughout the show was one of unity. The work presented spanned almost 50 years of his life. Looking at one piece, you realize that it

is an essential step in the evolution of an entire body of work. Each painting builds upon the previous accomplishments. His work represents a commitment to an idea that he pursues to its fullest extent. It proves once again that there can be an infinite number of variations on any given idea. There is no end to possibilities. The only end is the physical one, which he chose to create for himself.

In the floor piece (sculpture) I am constructing:

To get maximum use out of positive/negative space relationships in this particular piece, keep this in mind: Shapes that contain no inner components of positive/negative relationships will function better with other shapes of the same nature.

Shapes that have positive/negative relationships existing within their own structure (besides the obvious one: shape related to space as a whole) may be less functional when placed within the context of a multiple group of shapes.

Shapes that contain positive/negative components already may distract viewer from viewing piece as a whole, when this shape is set aside of another shape or in a large group of shapes.

(A) Eye tends to be drawn to "individual" shapes instead of the structure created by an entire "group" of shapes.

(B) If each shape operates only in a positive/negative relationship when viewed as a member of a group, the effect is one of more unity and more flowing movement. Eye tends to view as a whole, instead of grouping individual shapes.

Both of these principles can operate effectively on separate levels or on a combined level, but consideration of these facts is important.

To use these structures without any understanding of their specific effect is less effective and possibly confusing.

Drawing pictures in the snow is the most perfect example of my attempts to create a perfect form. Inevitably the snow

is in constant change: There is no way to control its permanency or its form. Drawing in the snow is like trying to paint a picture that will record specific thoughts at a specific time. You draw fast and you are always aware that you are creating something very temporary, very auto-destructive, very instant. It goes quickly and there is not time to worry about it. It is important for the experience, for the time it exists and the time it has occupied in a never-ending process of creation/construction and destruction. A circle. It is possible to reach the highest levels of instantaneous response recorded in spontaneous method and representative of purest thought when you are working with the knowledge that the work you create is temporary, insignificant in a broader sense, significant in an immediate sense, a perfect representation of time passing, time existing. Then you realize you are reacting instead of acting. Responding instead of contriving. Art instead of imitation. Primal response. Humanistic attempts at succeeding time.

This, I feel, is the advantage to creating art at this point in time: When we realize that we are temporary, we are facing our self-destruction, we are realizing our fate and we must confront it. Art is the only sensible primal response to an outlook of possible destruction (obliteration).

DECEMBER 1978

An environment by definition is the assemblage of surrounding things, conditions or influences. The environment that I have created in the room at the School of Visual Arts Student Gallery on 23rd Street is composed of paintings that I have done since I have been in New York, as well as a collection of paper paintings from the Pittsburgh paper-constructed box environment. Some of these pieces were hanging in the room I first used as a paper environment. So, in fact, some of the paper in the New York environment is third-generation.

The first piece I created was in a small, all-white room in the basement of the Arts and Crafts Center in Pittsburgh. This room had several pipes running horizontally across the ceiling. These pipes hung at different levels and different depths across the room. From these pipes I hung (with string) several pieces of paper: wallpaper, lithographs, discarded paintings I had done and then ripped in pieces, telephone-book pages,

KEITH HARING
PAINTED ENVIRONMENT
SVA STUDENT GALLERY
209 E. 23RD ST. N.Y, N.Y.
NOV. 17 ——— DEC. 6
MONDAY THRU FRIDAY 9 - 9

drawings, photo-backdrop paper and small paintings I had done. The floor was then covered with paper, and tempera paint was squirted on the paper from squeeze bottles. The colors were bright and created wonderful patterns. The most important aspect of this piece for me was the fact that for the first time I actually was able to live out a long-time fantasy: to throw paint in a room without worrying where it landed.

After the paint dried I removed the paper from the floor. Then I hung four pieces of bristol board (20″ × 30″) at eye level across the front of the space. This acted as a barrier in front of the painted papers. The bristol board had been painted previously with India ink in a tight, almost geometric style. They had been painted while placed side by side and functioned as one painting. However, when they were hung in the room there was two feet of space between each paper, so that the connection was less obvious, but discernible.

The pipes were arranged at different levels, so an interesting depth was created by the paper hanging on different "planes."

There are no remaining photographs of this work.

The second paper environment was done in my one-man show at the Arts and Crafts Center. I constructed a wooden frame and put nails into each side. This frame was then hung from the ceiling seven feet from the floor. String was wrapped from nail to nail, creating a grid. Then heavy paper (bristol) was hung from the sides.

The piece was in the corner so only two sides were covered on the outside. The inside walls were covered with metallic paper on all four sides. There was a doorway in the front.

The remaining paper pieces from the first environment were then hung from the strings in the false ceiling of the paper box. Also new paintings and pieces of paintings were added. The floor was covered with red vinyl.

It was interesting because you could walk around within it and move the paintings and play with the motion, etc. The hanging papers would all move if one string were pulled, because they were all attached to the same string grid ceiling.

The New York installation is a combination of these two effects with a new approach. Instead of hanging the pieces from the ceiling, they are all attached to the walls. The walls are quite large, approximately 20 × 25 feet, and required the use of several large paper paintings. I used all of the large paintings I had with the exception of three. Some of the paintings were ripped in pieces to distribute the imagery more evenly. There was metallic and bright red tape applied at diagonals in some places. The form of the paper makes it three-dimensional.

After the walls were completely covered, the floor was covered with white paper. The next day I placed a video monitor in the lobby outside the gallery. An R.F. unit was attached so that I could record while the image was being shown live. Drew Straub worked the camera inside the room, while the monitor showed the picture in the lobby. I had four gallons of white latex that I put into squeeze bottles and painted the room. This was all recorded on video tape. A few days later I removed the paper from the floor.

The most important idea involved in these three works is the freedom of will to rip, alter, obliterate images that I had created. The ability to tear up my paintings so that they can better serve me. The only consideration while creating the environment is the environment itself. If I need to rip up a painting, paint over it, or destroy images I enjoyed before, for the sake of creating a new piece with a stronger effect, I will. The paintings are not final statements. They can be changed, reshaped, combined, destroyed. There were three murals I saved because they were important to me, personally, and were representative of the paintings I used in the environment. However, if I had needed them to fill the space, I probably would have used them.

The ultimate consideration is the maximum effect. There is, naturally, a great risk involved in sacrificing many works for the completion of one unified work, but life is full of risks. Risks are what make the difference between new ideas and re-worked old ideas. If there is an idea that I feel is worthy of my undivided efforts, I will use whatever I have access to. Nothing is sacred to the point of being unchangeable. If a piece is final, that implies that it is perfect, or the purest form attainable. I do not believe I am capable of imitating the perfection of nature. The work I create is of a different reality. It is not created as nature is created. It is created out of my own

human attempts at creation, but can never reach perfection. Human beings are not capable of perfection. My work can only be a creation of the human mind and spirit. This act of creation or knowledge of creation changes with time. Nature is a constant. Human beings are in a constant state of change. At best, we can create works that represent our capabilities within a certain span of time. Granted, if they are representative of a specific time, then they are possibly the purest we are capable of at that point, but after that point we have already progressed because we learned something from the new piece.

Nature is operating in ways that, at least to our conception, are unchanged. It remains constant, with little variation that we can detect. Human beings can never imitate this or hope to achieve the same levels of perfection or timelessness. We are victims of change. We are constantly changing and evolving. At best, we can record that development through our art. Retrospective exhibits show this idea more clearly.

What I am proposing, or what I am practicing for myself, is a body of work that is in constant motion. I acknowledge the fact that my work builds upon itself, that it evolves and changes. I am eager to re-use a past work, re-interpret, develop further, build upon, change at my own free will.

There is no reason to limit yourself by abandoning old work or old ideas. Because even if you think you do, you never can. You can only build upon past experiences and past accomplishments.

Also, living under the threat of possible destruction in the form of nuclear war, etc., the most important thing to me is the present. Living day to day for each day as if it were the most important thing to think about. These environments were created to induce some reaction from the viewer. They evoke feelings, ideas, impressions. I want to let people experience art without having to feel inhibited. It can be touched, felt, manipulated, altered, experienced. It is art that is some-

what less "serious," less untouchable (sacred). It questions the use of the immaculate canvas, the use of dangerously fragile materials. It is against art that frightens people by its state of "perfection." It is against art that has a specific meaning of specific definition.

Its purpose, its meaning, is to communicate some feeling, any feeling. What that feeling is or how it is experienced depends on the viewer. The viewer should be able to look at art and respond to it without wondering whether he "*understands*" it. It does not aim to be understood! Who "understands" any art? If art is that easily labeled, then it is only existing for those who "understand" it and all the others are ignorant of it.

To define my art is to destroy the purpose of it. The only legitimate definition is "*individual* definition," individual interpretation, a unique personal response that can only be valued as an opinion. Nobody knows what the ultimate meaning of my work is because there is none.

There is no idea.

There is no definition.

It doesn't mean anything.

It exists to be understood only as an individual response.

These environments are not only for people who "understand" art. They can be experienced by anybody, anywhere. It is universal and is capable of reaching all levels of life. Every living organism responds to its environment. There is no previous knowledge of art necessary to experience the instinctive natural reaction that inevitably occurs when a human being is placed in an unfamiliar environment. It is spontaneous and automatic. The only possibility of a void of response is the possibility of a person stating that it did nothing or that they felt the same. This is a conditioned response of a closed mind, probably inhibited by the fear of being open because of the possibility of sounding unusual or ignorant. This attitude is very prevalent today and probably always was.

The attitude of artists and educators generally adds to it instead of trying to change it.

Art is for everyone.

To put abstract ideas into words . . .

DECEMBER 18, 1978
..

After reviewing the ideas in this notebook there are several that I feel are characteristic of my feelings today. The one idea that I touched upon lightly, but never write in depth about, is that my paintings and my recent sculpture deal more with space than with pictorial concerns. The images are the results of movements, manipulation within a given space.

For example, as an afterthought, possibly the reason I insist on spending the first few minutes of a painting drawing a border around the area I am about to paint is because I am familiarizing myself with the scale of the painting I am about to paint. I am physically experiencing the entire perimeter of the given space. After I have marked the given space and created a border, or boundaries, I am physically aware of all my edges. I've created my boundaries and my space. I then proceed to work from an area and build upon that until I have filled or considered the entire space that I had previously mapped out.

This is, as I said, at this point an afterthought, but that does not necessarily mean I was not aware of it while I created the paintings. It will be interesting to see if my awareness of this will affect my use of it in future paintings.

My concerns in all of my work may be more complex than I am aware of, or perhaps I am just becoming aware of how complex the thought process is and how important it is to utilize space and movement in harmony.

As I learn more or understand more about art history, about science and nature, about myself, I am becoming more

aware of what I am doing and why. That is my main question right now—why?

Questioning this is helping me to continue growing, thinking and inevitably doing more interesting work. My constant association with writers, dancers, actors, musicians, etc., forces me to see my intentions/concerns in relation to theirs. They are remarkably similar. I share the same concerns for space and movement and structure as contemporary dancers. I consider spontaneity, improvisation, continuity and harmony as musicians do. I feel a common bond with theatre people and performers as I do "painting as performance" (video tapes). I share visual concerns with film makers. I feel as though the arts have all gravitated to a central plane on which we all operate. The same (or similar) concerns apply to all of the arts.

My conversations with these people are helping me to understand my own reasons for creating art. The things that I am dealing with in creating images/objects are not new and they are not concerns that apply only to sculpture or painting. They are universal concerns that can be applied to many aspects of life.

One of the things that is an aspect of all forms of life, and that all art forms are derivative of, is structure. I was reading an interview with Douglas Dunn in which he is asked how much he wants his dance to be structure. This question seemed to me to be unanswerable. He said, "I think of everything I do about a dance as structure. By definition." Structure is underlying everything. No matter how "abstract" a piece becomes, it is never unstructured. There is order/structure within all matter, all action, all thought, no matter how unstructured it may appear. Time itself imposes structure. One can work from a structured idea or format, or find structure within any given thought or act, even if it was executed with no preconceived ideas or structural format.

Nothing is chaotic. Everything has relationships within itself that reflect the underlying structures. The structures are becoming more obvious, more opaque in modern-day life. Reducing form to its essential elements. Clarifying order by making it either more obvious or less obvious!

Somewhere within these groups of words lie the ideas within my head fighting to get out and be clarified/understood.

I think there may be many more structural forces and un-obvious considerations going on within my own work. What I am attempting to do is to bring them to the surface so that they can be explored (developed) further.

I am not making pictures anymore.

My disinterest in finished products and "final statements" illustrates this idea. I am more concerned with becoming involved with the area that surrounds the physical reality of my human body. I am constantly being bombarded with influences from my environment. I only wish to throw some of them back. To create energies/influences that will affect others, as theirs affect me. My paintings, themselves, are not as important as the interaction between people who see them and the ideas that they take with them after they leave the presence of my painting—the thoughts and feelings I have evoked from their consciousness as a result of their contact with my thoughts and feelings as seen through the physical reality of images/objects.

I was most aware of the success of my intentions the several times I did large floor pieces in the 22nd Street sculpture studio. The building has huge doors that open up onto 22nd Street. They were originally used for a loading dock. I would work near the doors to take advantage of the sunlight pouring in. The traffic on 22nd is light, but many people would take time out to stop and watch, or at least look once, or discuss it with me, or tell me what they thought it was. It was wonderful to hear vastly different opinions, ideas, comments

on the same piece of many different levels. The main thing that impressed me was the "kinds" of individuals who would stop and talk to me. They were *not*, for the most part, gallery-goers and not people who generally frequent MoMA, but they were interested. There is an audience that is being ignored, but they are not necessarily ignorant. They are open to art when it is open to them.

1978

Solo Exhibitions

..

Pittsburgh Center for the Arts, Pittsburgh, Pennsylvania
Westbeth Painters Space, New York City
P.S. 122, New York City
Club 57, New York City

1979

A few days after the last statement in this journal, I re-read much of what I had written and felt that it was not nearly accurate enough. It seemed shallow and understated. I was determined to throw away the previous pages. Instead, however, I just stopped writing in the journal because I felt certain that my efforts were destined to be fruitless, or at best would only hint at my "real" thoughts and motivations.

Tonight I re-read them again and found that some remain disturbing while others, much to my surprise, seemed to take on new meaning in light of my current thought and recently acquired knowledge.

The major influence, although it is not the sole influence, has been the work of William S. Burroughs. His profound realizations, which I encountered in radio broadcasts of the Nova Convention,

and in the book *The Third Mind* by Burroughs and Brion Gysin, which I have just begun to read, are beginning to tie up a lot of loose ends in my own work and thinking. Conversations with Barbara Buckner, Lucio Pozzi, introduction to the work of Gertrude Stein and Meredith Monk, writings by Van Gogh, John Cage, Richard Kostelanetz, conversations with my friends Mary Gleasen, Drew Straub, Kermit Oswald, Brian Warren, Frank Holliday, Nina Renna, listening to music by Steve Reich and Brian Warren, working with words and images as related to muscle patterns with Ellen Webb, spending the days, intensely, with a port-o-pak, playing my two video tapes of "Sound Web" simultaneously and becoming instantly amazed at possibilities of sound and image juxtaposition, hearing poetry by John Giorno read through a tape-delay system, video class with Barbara Buckner: All of these things are accumulating and defining each other and being interchanged and compared to each other, and I'm finally starting to realize that it is all one unit and that dramatic changes (of awareness) are taking place in my consciousness; a new understanding and interest in tacit knowledge, attempts at beginning to think in images as opposed to words, new meaning to all the previously misunderstood associations made between my choice of imagery and Aztec and Egyptian and Chinese symbolism, new directions, more reflection, new understanding and many, many more questions. Still, when I re-read, this seems to only touch on the surface. It seems impossible to record efficiently what I am thinking.

JANUARY 12, 1979 — 21 FIRST AVENUE APT. 18, NEW YORK CITY

Thoughts about the "effect" of art on the viewer.
Human response (instinctive): people respond

physically to size
psychologically to color
emotionally to recognizable objects
conceptually to ideas
emotionally to excessive negativism
physically to sound
physically to movement.

Actually, in varied situations all of these are probably interchangeable.

These thoughts are derivative of my personal quest for the source of my image/object making.

In questioning the reason "why" I make art and "what" I want to achieve by making "art," the question inevitably arises:

"What is the effect of my creation on the viewer?" and then, "What do people respond to, and how do you induce a specific response within these guidelines?" or "Am I seeking a conditioned response?"

This comes at a time when I have had to stop and ask myself a lot of questions, because it has become very important to me to know why I'm doing what I'm doing, for fear of not knowing, and continuing to make objects/images without any basis for their existence. I am aware that I cannot hope to fully understand what I am doing at the present because I am still in the present. Things make sense in time. However, it has been a pressing issue because I feel that if my ideas were clearer, then there would be no limits to what I could do with those ideas.

Today I awoke early, felt somewhat restless and decided to walk. When I got outside it was still dark. I decided to take a bus uptown to watch the city wake up. I got off the bus at 42nd Street and walked behind the U.N. to the river. I spent a long time walking and thinking and found I really do

have a pretty good idea about what I'm trying to do. I don't know where it will lead, but that is impossible to know.

I do think, however, that no matter how many ways I try to break away from it, I am still basically a painter.

My attempts at sculpture (if there is any need for distinction) have been through very painterly methods and concerns. I believed that my video, music, and movement endeavors are all stemming from my obsessive need to paint or to work with issues that have in the past been attributed to painting.

I think somewhere I lost sight of the fact that I am already working in ways that are new to painting. Although others have explored many of the same ideas, there is much left untouched. My painting at this point is mostly experimenting with limitations, or the destruction of accepted limitations. I do not wish to limit my personal exploration by following one direction. I have been working on the floor on paper in a number of different sizes. Each painting I do is different in that it has a different set of limitations and outlines. I do not repeat the same set of influences/reference points in more than one painting. I have explored using three-foot-long brushes and using two hands simultaneously. I paint from different directions within or without a border. The speed of execution varies with each environment it is created in, and is in that sense representational. It represents a specific time, place, and set of influences.

I believe that I am totally influenced by my immediate environment at any given time. One of my main interests has continued to be the viewer.

Although the act of painting itself is ultimately personal and private (unless there is an audience) and the result of only *my* own intentions and actions, as soon as another person has seen the painting there is an association and inevitable interchange of thought. The painting is then no longer in my hands. My interest in it is gone for the most part.

Although I believe that it is unimportant to consider the

viewer at all when working on an individual piece, when a body of work is being produced that is being viewed by others, I feel there is some responsibility for the artist to consider the viewer. How much that encompasses is not important, but some thought should be given to it.

I am intrigued by what people see as the function of art in their own lives. And as a creator or supplier of their art, it is necessary to consider their lives as well as my own.

That depends, I suppose, on what you personally believe the function of "art" is in our society. If you are uninterested in public interaction with your art, then there is no need to consider the public.

I find myself walking a thin line between doing what I think is important, personally, and what I think is important to stay in touch with the public, or wondering whether the public understands their own need for art or even has a function for art in their lives.

I think art is a necessary part of our environment, our society.

It is an idea, a way of life, of seeing and being, an attitude toward life, a respect and understanding of order. Physical attempts at communicating this idea result in what we call "art."

My attempts are mere records of my existence, records of my interaction within any given space and time. The result is just a result and alludes only to the idea. The result is not the idea. The idea is the idea.

My obsessiveness in creating images and objects has led me through many variations on image making. My most current work has been to dissect my paintings to derive essential forms and shapes that are interesting individually. Working with shapes, physical and painted, allows me to explore their characters and symbolism in depth. Trying to understand shapes or form. Exploring structure. Variations on any given idea.

Last night I painted over three paintings hanging in my room with more black ink so that the entire surface became black. There is, however, a lot going on within and underneath the black ink. They were very interesting for me and also somewhat liberating.

Finally breaking away from my strong inclination to be obvious.

I am interested in reacting to my environment, either my immediate surroundings or the influences that I pick up and carry along in my memory.

I saw beautiful Egyptian drawings today. There is a lot to be learned from Egyptian design concepts and their use of symbols.

I am intrigued with the shapes people choose as their symbols to create a language. There were several drawings showing how the symbols were derived from their previous forms, all the way back to picture symbolism. There is within all forms a basic structure, an indication of the entire object with a minimum of lines, that becomes a symbol. This is common to all languages, all people, all times. Possibly that is why I am so inclined to use calligraphic images, hieroglyphic forms, basic structures that are common to all people of all times and, therefore, interesting to us as well.

There is possibly within my paintings more meaning representationally than I would care to admit.

I paint images that are derivative of my personal exploration. I leave it up to others to decipher them, to understand their symbolism and implications. I am merely the middleman. I gather information, or *receive* information that comes from other sources. I translate that information through the use of images and objects into a physical form. The duty is then out of my hands. It is the responsibility of the viewer or interpreter who will receive my information to derive their own ideas or meanings from it.

In this way, I suppose, I am in constant contact with the viewer—the "viewer" as he feeds me information previous to the work, and after, when he becomes the "actual viewer," and responds to it with his own unique interpretation.

Cut-Outs

Now after all these words I want to work. I wanted to recopy some of these ideas by Matisse and then experiment with some paper cut-outs. I quote from Mark Stevens's article "Earthly Paradise" in *Newsweek*, September 19, 1977:

> Matisse himself said drawing was of the spirit and color of the senses and that the two were in eternal conflict. In his cut-outs Matisse believed he married the two enemies by drawing in color. He also believed that he had linked painting, sculpture, and drawing. His scissors bit into the gouache the way a chisel carves into stone or a pencil cuts into paper. One movement, he said, linked line with color and contour with surface.
>
> Gustave Moreau told Matisse he was born to simplify painting, and the artist labored to find what he called the sign, or es-

sence of an object. One must study an object for a long time to know what its sign is, he cautioned.

I suppose that the reverse is also true, that if you create a spontaneous sign that comes from your accumulated subconscious collection of objects, then one must study that sign for a long time to know what object it represents.

With this in mind, I proceed.

JANUARY 12, 1979

My room is in a constant state of change. Three days ago I had done two paintings, one of which was black ink on top of a "red tempera on brown wrapping paper" painting. The black ink covered everything on the original paper except one small triangle (red). Also I painted a small bristol board black with only a triangle left white.

There was also a black-on-white 9' × 5' painting done with two three-foot brushes and much black area. I was unable to adjust to this painting except without glasses. A day later I painted all three of these paintings with black ink so that none of the "images" remained obvious.

These "black" paintings hung on my walls for another day. I then had the idea for Matisse-inspired paper cut-outs. You must understand first of all that my room is very small and the only things in it are my clothes, stereo, supplies, etc., carefully arranged in one small section of the room. The rest of the space is white with huge sheets of clear plastic on two of the walls. One of the walls has a window covered with three layers of plastic. There are no permanent pieces in my room. The walls can be tacked into easily, and masking tape can be used on the plastic. When I hang art in the room it works as a unit. For instance, the three black paintings.

The entire room now operates as one unit since all the

pieces come from the same four sheets of painted paper. The reason I first wanted to write about this was to show the relationship between the room yesterday and the room today. The mood is strikingly different. Now as I sit here it seems as though the cut-outs are a direct reaction against the black paintings.

Plastics allow you to use multiple planes as one unit, therefore creating actual depth and perspective—in real space—physical space—the logic of layers, without being an illusion.

Recent exhibitions of what is termed "Abstract Illusionist" paintings make use of shadows to make surface images float. The effect of clear plastic with paper cut-out images taped to the surface has the same effect if the plastic is hung inches in front of the wall. The shadows add interesting "logical depth."

JANUARY 21, 1979

This journal is, for me, most helpful if it can portray a reasonably accurate account of the work I am doing and why I think I am doing it.

After the cut-outs, I spent a day with a tube of red gouache. I did one 9' × 7' painting on the floor, which was begun by drawing four or five red forms (similar to the cut-outs) with gouache. While these were drying I did a drawing on a set of four sheets of bristol board with gouache.

After this and the large painting had several coats of gouache, I returned to the large painting with black ink. Using a quarter-inch-wide brush I started out semi-controlled, but after becoming more influenced by the music (classical station on radio) I worked faster and used my hands as well as my brush. At that point I had lost control of the painting and it was painting itself. After that painting, I ran out of ink. However, I still had a quarter-cup of gouache (red). I began to paint 7" × 9¼" pieces of sketchbook paper with one

form on each piece of paper. I painted until I ran out of gouache. Approximately 25 pieces.

At this point I had started reading parts of Kandinsky's *Concerning the Spiritual in Art* and found that the part of the book I opened to was dealing with information directly related to these drawings and specifically dealing with the effect of the color red and color embodied in form, etc.

It is "coincidences" like this that make me continue in the face of prevailing doubt. I was constantly doubting the relevance of these drawings as I did them. They seemed at some points to be nothing more than stylized symbols from the English alphabet.

Another problem was: Am I painting or drawing? I don't think the distinction is necessary any longer. I use the terms interchangeably. I am, however, currently more concerned with form than color, although it is impossible to deal with them as completely separate concerns.

After these drawings I went to buy more ink. I also bought a jar of opaque red ink. When I returned to the "red form" drawings I thought I wanted to add a black form to each red. However, after doing three of these I didn't like the effect and proceeded to paint the remaining areas black: leaving three red-on-black drawings. The obvious next step was red ink on tar paper. I cut out several pieces of tar paper to 7″ x 9¼″ and painted with red ink on them, similar in scale and form to the "red on white" drawings. There were 10 of them. The next day I laid them out (black and white) to create a kind of checkerboard-floor piece (just another variation).

That day I was in SoHo and found a bright red poster printed with Oriental characters, several rolls of ripped paper, and about 200 pieces of white mat-board.

The Oriental poster I removed from the wall (it ripped in a few places) and put it on my wall across from the red and white bristol board drawing. The power of the intense red

and black images and the direct relationship it had with these drawings made it seem like another logical step in a process.

The ripped paper is not (or at this time does not appear to be) directly related to the red-white-black drawings. However, it was significant. I will explain later.

The thing that was the most amazing was that the 200 pieces of mat-board were 7¼" × 9¼" exactly. Coincidence?

I proceeded to draw black (ink) forms on the pieces similar to the previous red-on-white and red-on-black drawings.

At this point I had approximately 40 of these black-on-white drawings.

I stopped, temporarily, because of questioning their relevance, my motives, etc.

But now as I write this down it all appears to make sense. The implications are still unclear, but I have had several ideas about these drawings and about cycles, processes and evolving forms (in some way related to Dorothea Rockburne's "drawings that make themselves," in a different context, however):

The importance of "chance" and being open to outside forces and directives.

The artist as a tool, a vehicle, a victim.

The displacement of forms and the ability to change, re-arrange, group, isolate and control form for an infinite number of effects—never "final," never "finished."

The imposition of structure on form.

Structure in human terms—grid or linear structure; this idea led to ideas concerning music, dance, etc.

All things are measured by their adherence to or deviance from a given structure.

Difference is measured by sameness.

We "see" in terms of associate and relative structures.

The importance of these drawings at this stage is, for me, their dependence on a logical evolving process. Each one is derivative of the previous one. Each idea leads to another.

The cycle is complete, for me, when I have exhausted the possibilities to the point where I am no longer interested in them, and/or have proceeded to something else.

After the process, the resulting physical objects/images may be interchanged to create different variations and effects for different reasons, however unrelated.

Another issue:

One of the most successful recent drawings was one that was done because while I was removing the cut-outs from the plastic, I ripped one of my favorite shapes. I wanted to save it so I traced it onto a piece of graph paper and painted the image with the red ink. It has remained one of my favorite forms. My question is, "How important is the fact that it was cut as opposed to painted?" The completeness, accurateness, finalness of a cut may allow me to be more direct, more spontaneous and therefore more interesting. All of these drawings are derivative of the floor sculpture that was "cut." Perhaps the importance of the physical act of cutting (sawing) has been overlooked in my obsession with the resulting forms as forms.

Another issue:

My recent interest in the "grouping" of photo images. There are in my house, currently, three places where there are groupings of three rectangular images (all alike), and one grouping of two photos (alike in size and imagery, but not composition).

Perhaps it has something to do with the obvious reality that they are "reproducible" photo images and are all alike.

Possibly because I never create objects/images that are identical in my own work, my reaction or my interest in a photo image is that it is an exact reproduction and is based on duplication, repetition, etc. Groups of three, by preference.

The grouping is also related to my use of paper and the relationships between paper as a rectangular form.

Being aware of the form of the paper, as well as the images or forms on the paper.

This brings me back to the ripped paper that I found in SoHo.

This paper was significant to me because it made me aware of the importance of the continuing interest I have had in the physical form of paper. It is one of the factors that has been a major force in my art since 1977. I have often considered it, but never wrote about it. One of the first considerations was a reaction against the stretched canvas and framed or matted picture, the growing attitude of "everything happens for a reason, everything will happen inevitably anyway, therefore, there are not really any mistakes and no reason to exert unnecessary amounts of control." This attitude has prevailed to a certain extent, but has taken on different levels of importance and meaning. While in Pittsburgh, I began to be interested in "paper as paper" and using the physical form of paper as a positive factor instead of a restraint. I was becoming more interested in using many different materials and unrelated objects to create a unified piece. I created a "print sculpture," which consisted of a lithograph that was then rolled over with ink and hung with string from the ceiling. Two other pieces of paper were added and "asphaltum" (used in the litho process: ink thinned with lacquer thinner) was squirted on the one so that it dripped onto the other two. The piece was installed in the basement in the all-white room at the Arts & Crafts Center of Pittsburgh. The form of the paper as it was restrained by weight and string was the driving force. This was the piece that led to the first paper environment installed in that room. I was also working with "found" paper that would inevitably be wrinkled or torn. Or deliberately tearing paper (without control or preconceived intentions) and using the resulting pieces sculpturally. Also using the effect that ink or paint had on paper when it dried (unevenness and texture caused contraction).

These interests continued to be as important as the images I was painting on the paper. So, continually my interests

have been twofold—the forms on the paper and the form of the paper. They do not operate separately except in the case of unpainted paper used solely for the physical form of the paper. The piece on my wall now is seven pieces of paper that are, as I found them, ripped into one shape. It is a repeated form, but each piece has personal variations (small rips or wrinkles) and each hangs slightly differently. I have begun to work with clear plastic combined with paper and logic of layers. The reason that these recent pieces are important to me is that I have become more aware of these properties of paper, and have chosen to continue to use paper as a sculptural, physical consideration. It is becoming more apparent to me, through writing, that there is a strong underlying unity or framework within my work. This unity and/or clearness of intention/direction has been one of the main issues in my mind since I began to seriously question what I am doing and why.

The Mark Rothko retrospective has been a major influence on my current thought.

Also, the understanding that everything is related to something previous. When looking back at my use of paper as form and the evolution of this idea through many different aspects, the relationships are obvious.

Quoting from the *Village Voice* review of the "Grid Show" at the Pace Gallery in January 1979:

"Everything done well within a given medium will expand upon its possibilities, and also refer back to previous uses of it, however inadvertently."

JANUARY 22, 1979

Back to school and tying up loose ends. I had a drawing class today. I received much helpful advice and critique about the recent isolated-form drawings.

Things to be considered:

The importance of the individual forms. Do they transcend symbols and are they expressing my most creative powers?

There were some that did, however, most of them did not. Therefore, study the forms that interest me most, find out why, pursue that.

I then questioned whether they might not be interesting to different people: different people = different choices. However, I found that after asking several people to leaf through them, they almost unanimously chose the same ones as the "most interesting." They were also the ones I had chosen as my favorites, and the ones my drawing teacher had pointed out as her favorites. That poses a lot of new questions, and a lot of new answers.

Also, my teacher, Barbara Schwartz, suggested that monoprints could be helpful, and more work on tar paper.

Consider all of the space on the page.

Try my favorite shapes in a number of different scales, placements, mediums, etc.

Create images that reflect my own spirit more clearly, more precisely.

Trust my own taste, don't be so self-conscious.

It is important to understand the space relationships and compositional factors that I am investigating—know them—so that I can build upon them and go further.

In my Video Art workshop we started the class by hearing Barbara Buckner read a letter to Theo from Vincent Van Gogh. It was about the period in a painter's life (the beginning) when he is questioning everything he is doing and being disillusioned by his desire to master all that he undertakes. It came at an important time and was very helpful for me. I got the book out of the library, as well as Paul Klee's diaries.

She also discussed the importance of the existence of the spiritual involvement of the artist in his work. Art has be-

come as religion in the past few decades. Readings from Kandinsky, Van Gogh, Jung, Léger, etc.

Also, the importance of dreams. Explore the implications, problem-solving in the subconscious.

The phenomena of art as a secular act since the 13th or 14th century, before that a group endeavor.

It's good to be back in school, in conversation with other artists, being criticized, and in a working atmosphere.

I have become self-confident while on this vacation, not aware that I am still a student.

It is important to acknowledge that—that I should be open to everything, and that I am merely gathering information.

Do not place too much emphasis on my current experimentation and investigations. They are only records of my search.

> Nature is glamorous to the point of confusion, let the artist be truly taciturn.
>
> Moreover, in order to be successful, it is necessary never to work toward a conception of the picture completely thought out in advance. Instead, one must give oneself completely to the developing portion of the area to be painted. The total impression is then rooted in the principle of economy: to derive the effect of the whole from a few steps.
>
> —Paul Klee, from his diary

FEBRUARY 11, 1979
...

My interest in video is to explore the juxtaposition of words and images or sounds and images to formulate results that

require the participation and individual interpretation of the viewer.

My interest in painting is to explore the infinite variations of form and space relationships to produce objects and images that require the participation and individual interpretation of the viewer.

My interest in life is to explore as many of its infinite variables as I am physically able to, consciously as well as unconsciously.

MARCH 26, 1979
..

Proposal for installation at SVA Gallery, TriBeCa

My interest in this space is to continue the objectives that have been inherent in my past installations and hopefully to take them one step further. The significant difference between this space and the others I have worked in is that it already contains interesting structural qualities. My interest is, as before, to redefine the structural qualities of the space, therefore altering the viewer's perception of it.

The only mandatory supplies are white paint and painting materials so that I can paint the entire room white (including the floor). Also, the door would be removed from the hinges during the installation.

My procedure from that point would be to work within the given limitations (time, money, etc.).

> Since the number of colors and forms is
> infinite, their combinations are also infinite,
> and simultaneously, their effort. This mate-
> rial is inexhaustible.
>
> —Wassily Kandinsky, *Concerning*
> *the Spiritual in Art*

The fog begins to break.

I am in Kutztown, convalescing. Hepatitis a week before school resumed. So far I have missed one week of school; there may be a chance of going back to New York in time to start this semester, but it is unlikely.

What am I missing?

The two main classes that are timely and seemed important information sources that fit into place now are Semiotics with Bill Beckley and a Visual Science course that deals with universal coordinates/patterns and underlying connections between all forms of life.

I am also missing that wonderful New York City air. That deadening pace that won't quit. Derelicts and other human wastelands. The impending New York FEAR that is always a factor in whatever you are doing. Dirty air, dirty streets, dirty looks. I'm not missing all that much.

Kutztown has its good points. Kermit and his studio. Brian living with Kermit. Nam June Paik—visiting artist in September. Mimeograph machine. Excessive amounts of love and sanity. Precise order. Fresh air. A different background noise . . . still a hum but a softer, more natural buzz. Time to contemplate, time to reflect and dream. Time to read at a time when it may be more important to read than to do.

Somehow it works out that I read and experience things in big chunks. And the chunks are always closely knitted together. Cross-references and reaffirmation. Some of the parts of the chunk come to me by "chance" and others are sought after. Some were with me a long time but become new, while some appear to have been with me always at their first encounter. Almost always this chunk of information/awareness comes to me without much effort on my part. It is stumbling across a gold box on a deserted road while you may or may not have been looking where you were walking.

In 1977 when I was working in the cafeteria at Fischer Scientific Corp. I was exposed to a very thorough collection of "alchemy artifacts." Since the cafeteria was located next to their gallery and a conference room containing many artifacts, prints, and quotations by alchemists, I was in contact with these objects and ideas every day. The quote that struck me most then and that I still refer to often was one printed on a 5″ × 9″ card and hung beside a large painting of *The Alchemist's Studio*. The air was full of excitement. All of the paintings contained a feeling of mystery with confidence.

"Chance favors the prepared mind."—Louis Pasteur

Well, I have this new chunk of information that is shedding light on everything that came before it. That's always how it works. And it also binds itself to this larger accumulating chunk that kind of absorbs this new information and makes the whole chunk new and stronger and a little larger. Well, part of this new awareness is leading me toward a possible acknowledgment of the big chunk in the universe. The mind of the universe. All knowledge. And every time you tap that you get closer to a kind of computer hook-up where you can plug your own personal accumulation into this eternal universal information and feed into it and off it and then your chunk can really start to grow. Or maybe it doesn't grow . . . it functions. They grow together. They kind of throb.

A Vehicle of the Way (Wen Yi Tsai Tao)

And the way is as long as the mind is deep, comprising not only the personal "mind-system," but the huge memory storehouse of the "universal mind" in which "discriminations, desires, attachments and deeds" have been collecting "since beginningless time"

and which "like a magician" . . . causes phan-
tom things and people to appear and move
about. (Lankavatara-Sutra, 60, B, 300)

—Quoted from Preamble to

Towards a New American Poetics,

edited by Ekbert Faas

Anyway, this new information all came to me this sum-
mer under one big label: POETRY.

I have been enlightened. I have fallen into poetry and it
has swallowed me up.

I was [very large black rectangle] and when it spits me
back out, or when I leave its system through its bowels, I will
be [black rectangle] again.

THE CHUNK CALLED POETRY.

It started with JOHN GIORNO and BURROUGHS at the
Nova Convention in December 1978. It's reading CAGE and
starting my first recording with four cassettes at SVA in Feb-
ruary. It's the poetries of video-tape and BARBARA BUCKNER.
It's BURROUGHS and GINSBERG and GIORNO upstairs at the
MUDD CLUB. It's living with DREW B. STRAUB, who was read-
ing BURROUGHS thoroughly. It's VIDEO CLONES with MOLISSA
FENLEY. It's ART SIN BOY and CLUB 57 POETRY READINGS EV-
ERY WEDNESDAY NIGHT THIS SUMMER. It's reading SAINT
GENET by SARTRE on the subway going to work in QUEENS.
It's books from SVA library all summer and tape recorders
from SVA for most of the summer. It's BOOKS THAT YOU JUST
FIND IN A LIBRARY . . . BOOKS THAT FIND YOU. It's PATTI SMITH
ON THE *BIG EGO* ALBUM with GIORNO, MEREDITH MONK,
GLASS, etc. It's reading RIMBAUD, KEATS, JEAN COCTEAU, JOHN
CAGE, HEGEL, JEAN GENET, TALKING POETICS FROM NAROPA
INSTITUTE. It's meeting another like you and sharing every-
thing including your body but mostly your ideas. It's POETIC
UNDERSTANDING AND JUSTIFIABLE HATE. It's July 4 on the
top of the Empire State Building after reading an ART SIN BOY

mimeograph at Club 57 watching fireworks and thinking about the smile exchanged on the street and nothing but a second glance and lots of dreaming. It's KLAUS NOMI at Xenon. READING GINSBERG'S JOURNALS, READING SEMIOTEXT, READING GERTRUDE STEIN, READING "HOWL" FOR THE FIRST TIME. It's NOW-NOW-NOW and paintings I did in the fall of 1978. It's Chinese pattern paintings in KERMIT'S HOUSE. BARBARA SCHWARTZ ON 22ND STREET AND DREW AT JOHN WEBER GALLERY BUILDING A ROBERT SMITHSON. DREW'S RAIN DANCE IN LITTLE ITALY. It's listening to JOHN GIORNO read GRASPING AT EMPTINESS for the 27th time. It's letting records skip for ten minutes and thinking it's beautiful. IT'S HAVING DINNER ON AVENUE C WITH DINA, DOZO, AND FUGACHAN (A MAN). It's thinking about SEX as ART and ART as SEX. It's continued situations and controlled environments, B-52s, BATHS, AND SEX WITH FRIENDS. IT'S PAPA AND JOHN MCLAUGHLIN AND OUTER SPACE AND JET SET AND DELTAS AND THE ASTRO TWIST AND KENNY SCHARF AND LARRY LEVAN. It's being heckled reading what may be my favorite mimeograph piece with two tape recorders and being called a FAGGOT. IT'S LISTENING TO OTHER POETS AT CLUB 57. TALKING TO POETS. BEING A POET AT CLUB 57. It's painting on ST. MARKS outside of STROMBOLI PIZZA. It's having one night at Club 57 when everyone in the open reading was in top form and everyone knows it and everyone is smiling. It's HAL SIEROWITZ READING. IT'S BEING QUOTED IN HIS POEM AS SAYING, "'I CONSIDER MYSELF MORE OF AN ARTIST THAN A POET,' SAID KEITH." IT'S MAKING XEROXES and mimeographs. IT'S MEETING CHARLES STANLEY AND BEING APPREHENSIVE. IT'S TAPING UP XEROXES WALKING HOME DRUNK. It's looking in the window at BUDDHA. It's seeing a TRUCK THAT SAYS "BETTER METHODS." IT'S BUYING JEROME ROTHENBERG'S BOOK TECHNICIANS OF THE SACRED that BARBARA BUCKNER had lent to me in spring and now TIM MILLER has it out of the library and now I'm reading references to it in a new book I bought. IT'S ALL THOSE THINGS

THAT FIT TOGETHER SO PERFECTLY THAT IT APPEARS PREDE-
TERMINED. IT'S DREAMS OF FALLING INTO WARM WATER HOLE
WITH EXOTIC FISH CREATURE AND ENOUGH LIGHT TO SEE EV-
ERYTHING. It's finding HANDBILLS ABOUT SIN that are poems
in themselves. It's painting on walls in the suburbs. It's the
bridge in LONG ISLAND WITH 1958 AND 1980 on parallel
poles. IT'S FINDING OUT THE SPACE AGE BEGAN IN 1958. It's
STEVE PAXTON dancing in the sculpture garden at MOMA. It's
CARL ANDRE POEMS IN THE MOMA SUMMER SCULPTURE SHOW.
It's JONES BEACH ON SUNDAYS. It's MATISSE. IT'S MATISSE.
It's listening to old cassettes I made in winter and under-
standing them for the first time. A NOTION OF PROPHECY. IT'S
DOUGLAS DAVIS'S ARTICLE IN THE VILLAGE VOICE about post-
modern art. "POST-ART." It's pornographic pictures and black
feathers. It's GERMANY. It's JAPAN. It's hearing DOW JONES
AND THE INDUSTRIALS. It's loose joints and conversations.
IT'S THE SAME THING, THE SAME THING. It's understanding
painting. IT'S SOMEONE YELLING "LICK FAT BOYS." IT'S CON-
VERSATIONS ABOUT ALL ART BEING PRETENTIOUS. It's not go-
ing to look at ART in the galleries all summer. It's seeing
drawings by KEVIN CRAWFORD AND DREW B. STRAUB and
thinking about the relationship. IT'S THINKING ABOUT THE
RELATIONSHIP BETWEEN SEEMINGLY UNRELATED OBJECTS
AND EVENTS. It's an art "context." It's thinking about poetry
on as many different levels as I can. It's thinking about my-
self. It's companions and ratios and mathematical principles.
IT'S THE POETRY OF NUMBERS. Language, culture, time, spirit,
universe. IT'S THE PAST PRESENT FUTURE ALL TIME NO TIME
SAME THING. It's systems within systems that evoke systems.
ORDER-FORM-STRUCTURE-MATTER. It's seeing TRISHA BROWN
DANCE. IT'S ITALIAN FILMS FROM 1967. IT'S LAURIE ANDERSON
AT MUDD CLUB. It's NEW MUSIC, NEW YORK at the KITCHEN
for a week. IT'S CHARLIE MORROW'S PIECE FOR 60 CLARINETS
AT BATTERY PARK IN CELEBRATION OF THE FIRST DAY OF SUM-

MER AT SUNSET. It's the BRONX ZOO. Reading RIMBAUD'S LETTERS. Reading RIMBAUD'S ILLUMINATIONS ON THE SUBWAY AND IN A CAFE EATIN' CREMOLATA AND DRINKING PERRIER. IT'S FELLINI FILMS WITH TSENG KWONG CHI. It's finding things on the street. IT'S CONVERSATION WITH LYNN UMLAUF ABOUT THE NOW NOW NOW TAPES A.J. WEBER GALLERY SHOW. IT'S XEROXES PUT UP IN the West Village for Gay Pride weekend and hearing people that had seen them months later. IT'S THE NINTH CIRCLE AFTER THE GAY PRIDE MARCH TALKING ABOUT APATHY AND MILITANCY. It's wearing and distributing red-and-white stripes for one evening. IT'S READING AT CLUB 57 WHILE THIS WOMAN who I later found out was GLORIE TROPP is saying things like AHHH and DO IT and YEAH while I'm reading and it feels good. IT'S XEROXES at GRAND CENTRAL STATION IN A HURRY. It's the poetics of chance. IT'S GOING TO THE POETRY SECTION INSTEAD OF THE ART SECTION WHEN YOU GO INTO A BOOKSTORE. It's a panel about performance art with MEREDITH MONK, LAURIE ANDERSON, JULIE HEYWARD, CONNIE BECKLEY, AND ROSALEE GOLDBERG. IT'S GRAFFITI IN THE SUBWAY. It's riding the BUS FROM KUTZTOWN TO N.Y.C. WITH CONNIE BECKLEY. It's BRIAN WARREN'S NEW PIECES. It's reading BRIAN'S journal and feeling close to it. IT'S A SHORT POEM CALLED "ART BOY." It's feeling real good about being an artist. It's depression that can kill. It's telling other people that depression can be productive and talking to yourself. IT'S KOZO'S BIRTHDAY PARTY AND SPANISH AND JAPANESE AND HEBREW. It's "Running on Empty." It's delivering tropical plants in Manhattan. IT'S MANHATTAN IN THE SUMMER. It's reading NAKED LUNCH. IT'S DISEASE XEROXES. It's JOSEPH KOSUTH AT CASTELLI ON CONCEPT AND CONTEXT. IT'S JOAN JONAS'S "JUNIPER TREE." It's CONNIE BECKLEY'S INSTALLATION in the VIDEO ROOM AT MOMA. IT'S KERMIT'S NEW DRAWINGS. It's playing CROQUET in Kutztown. It's talking about epileptic fits in an art context. It's suicide. It's ART AS

SIN AS IF NO ART AS ART. It's MOHOLY-NAGY. It's JEAN COC-
TEAU WRITING ON "THE ORIGINAL SIN OF ART."

IT'S ANONYMOUS SEX. IT'S RE-READING DREW STRAUB'S "UNI-
VERSE" WHILE LISTENING TO THE "UNI-VERSE" cut-up tapes
we did in February or March IN AUGUST. IT'S READING BUR-
ROUGHS'S TALK ABOUT WORK WITH CUT-UPS ON TAPE IN AU-
GUST MONTHS AFTER WE HAD READ THE THIRD MIND AND
DID THE SAME THING. It's the most logical step. LOGICAL
DOESN'T MEAN RATIONAL. It's science-fiction films. It's read-
ing SARTRE'S SAINT GENET ALL SUMMER with much else in be-
tween. It's 40 postcards sent to KERMIT OSWALD 172 W. MAIN
ST. KUTZTOWN PA. 19530. It's not painting all summer except
maybe once or twice. IT'S UNDERSTANDING WHY I SHOULDN'T
TRY TO UNDERSTAND. IT'S "NEGATIVE CAPABILITY"—AS SAID
KEATS. DIANE DI PRIMA ON "LIGHT AND KEATS." It's wanting
to know more. It's an accumulation of information. IT'S AN
IDEA FOR TOTAL THEATRE. It's a new understanding. IT'S A
BEGINNING A SEED A GARDEN IT'S THE BIG CHUNK CALLED
POETRY.

> DECEMBER 21, 1817 (THE WINTER SOLSTICE)
> —JOHN KEATS
>
> The excellence of every art is its intensity,
> capable of making all disagreeables evapo-
> rate, from their being in close relationship
> with beauty and truth . . . several things dove-
> tailed in my mind, and at once it struck me
> what quality went to form a man of achieve-
> ment, especially in literature, and which
> Shakespeare possessed so enormously—I
> mean negative capability, that is, when a man
> is capable of being in uncertainties, myster-
> ies, doubts, without any irritable reaching

after fact and reason.—Coleridge, for instance, would not go by a fine isolated verisimilitude caught from the penetralium of mystery, from being incapable of remaining content with half knowledge. This pursued through volumes would perhaps take us no further than this, that with a great poet the sense of beauty overcomes every other consideration, or rather obliterates all consideration.

The word conveys the thing; it is the thing itself. Are we so far from poetry? May it be that poetry is only the reverse side of masturbation?

—Jean-Paul Sartre *(Saint Genet)*

But above all there's a sense-of-unity that surrounds the poem, a reality concept that acts as a cement, a unification of perspective linking

poet + man
man + world
world + image
image + word
word + music
music + dance
dance + dancer
dancer + man
man + world
etc.

All of which has been put in many different ways—by Cassirer notably as a feeling for "the solidarity of all life" leading

toward a "law of metamorphosis" in thought and word.

<div align="right">

—Jerome Rothenberg

(Technicians of the Sacred)

</div>

This is not to invoke the mouldy cliché of a marriage between East and West but rather the concept, held by Robert Duncan, of multiphasic modern man as he emerges into a global culture for the first time in history. Present-day aesthetics is an eclectic hybrid of the primitive and civilized, the old and new—a constantly widening conglomerate made up of scrappy bits of information ranging from quantum mechanics to shamanism or biology. And the forces behind its ever-changing patterns, which have caused the most drastic reorientation of Western art since its beginnings, are all the more elusive as they are unprecedented.

<div align="right">

—Ekbert Faas

(Towards a New American Poetics)

</div>

FEBRUARY 27, 1818—JOHN KEATS

I think poetry should surprise by a fine excess, and not by singularity; it should strike the reader as a wording of his own highest thoughts, and appear almost as a remembrance.

APRIL 8, 1818—JOHN KEATS

The innumerable compositions and decompositions which take place between the

intellect and its thousand materials before it
arrives at that trembling, delicate and snail-
horn perception of beauty.

Acrostics, Reading Horizontally

ART	SIN	BOY
AS	IF	NO
IF	NO	ART
LICK	FAT	BOYS

ANOTHER REVOLVING TRIANGLE
SYMBOLIZES INCESTUOUS NATURE
BEFORE OUR YEARNINGS

ARROGANT SIGN
INFINITE FALLING
NEVER OURS
INSIDE FEELING
NUMB OUTSIDE
ALCHEMY REVEALS TENSION

LOOKING INSIDE CALCULATE
 KARMA
FIND ANOTHER TRIANGLE
BEFORE OURS YIELDS
 SILENCE

SEPTEMBER 5, 1979
...

Read excerpts from *The Tao of
Painting and Chinese Calligraphy*
in Kutztown State Library.
 Getting restless.

Watch tape loop of *Video Clones*; seen in new poetic light. Thoughts about sequence and repetition.

Reading *The New Television/A Public Private Art*, by Davis and Simmons.

I don't talk much.

Easily inhibited.

SEPTEMBER 12, 1979

Making cut-ups/collages with information from three available sources:

1. Computer instructions for ELECTRONIC DIGITAL COMPUTER.

2. "Guide to Visual Aids and Teaching" (from Mother's college course).

3. Sister's work sheets from third grade dealing with WORD MEANING/CONTEXT, ETC.

Made a word computer data sheet with computer instructions and words cut out and pasted on data paper.

OCTOBER 1, 1979

> THINKING ABOUT BOXES
> WHAT DOES IT MEAN
> TO MAKE "GOOD" ART?
> MEANING IS A
> PRESUPPOSITION OF FUNCTION.
> WITTGENSTEIN.
> WHO CARES IF YOU DO
> OR DON'T. SOMEONE
> IS IN THE SUBWAY
> TALKING TO THEMSELF.
> TALKING ABOUT
> TALKING. TALKING
> ABOUT NOBODY

LISTENING. WHO CARES
IF YOU "MAKE" ART.
WHAT IS "MAKING"?
SEEING IS MAKING
ONLY IF SOMEONE
IS SEEING. THE PERSON
IN THE SUBWAY IS
SCREAMING, "NOBODY
IS LISTENING," BUT
EVERYONE IS LISTENING
AND SEEING AND
MAKING AND BEING.

DARK MOVIE HOUSE
SUCKING SOUNDS
PHOTOS TODAY IN TIMES SQ.
BEFORE AND AFTER.
SALIVA SHINES

BIG COCKS. LOOKING
AT PORNOGRAPHY ON
42ND ST. I RECOGNIZE
A GUY I MET ON
CHRISTOPHER STREET.
NICE COCK. SMILES.
ACTION COSTS MONEY
GLOSSY PHOTO MAKES
HIM SEEM REAL.

FASHION BOY SITS UP
STRAIGHT AND
DOESN'T SMILE.
I WANNA SUCK
YOUR COCK MOVIE MAN,
I WANNA

I WANNA HOLD YOUR
HAND, WALA!!
PRETTY EAST VILLAGE
BOY YOU LOOK LIKE A
POET I WANT TO
LICK YOUR FINGERS.
I WANT YOUR FINGERS IN MY MOUTH.

Imagining shadows
ignoring truth.
Blank stare with
matching glasses.
Didn't shave today
and don't care.
Dressing in costumes.
Color is distorted
and so is time. I've
never seen this
face before.

Sitting on TRAIN across
from hippies. I feel
sick. What did I
find out since then?
I'm thinking of memories
that fit a formula.
I saw this band a few
years ago.

I used to have a pigtail.
It was too late
when I even thought I
was a hippie.
These jerks are still confused
and it's four years later.

LET ME FUCK YOU LITTLE
HIPPIE BOY. LET ME
SIT HERE AND WRITE
THINGS ABOUT YOUR FAT
LITTLE COCK. IF YOU COULD
SNATCH AWAY MY
BOOK AND READ MY
WORDS YOU WOULD
(AND YOUR HIPPIE FRIENDS)
KICK IN MY FACE.
I'M SUCKING YOUR
COCKS LITTLE HIPPIES
IN MY MIND.

OCTOBER 3, 1979

FUCKING	FRIENDLY	FIRST
REALLY	RED	REAL
ENOUGH	ENERGY	ENLIGHTENMENT
DO	DOOR	DOES
ENDS	ENTER	ENOUGH
IMPLY	INSIDE	INJURY
NO	NAUTICAL	NEXT
HEART	HEAT	HOLY
ONLY	OPENS	OBJECT
REVEALS	REVOLVING	RETURNS
NOTHING	NERVES	NOTION
FEET	FRED	FORGETTING
ROLLING	READING	REALITY
ENDLESSLY	ENTIRE	ENVELOPE
DOWN	DIARY	DIRTY
INCIDENT	INITIALLY	INSIDE
NICE	NON-CHALANT	NO-ONE

```
HOT              HEAD            HEARS
OTHER            OF              OUR
RESISTANCE       RESEARCH        REPEATED
NURTURED         NAMED           NATURE
```

POPE NO RED CURTAINS
ONLY READING FORD BRONCO
T.V. LIGHT FRED'S FACE
ILLUMINATED WET LIPS
REFLECT RUM CAKE CONVERSATION
TIGHT LOVE FEELS WARM
OPEN MOUTH SCREAM POPE
LOVE EAT POPE CALLING
NO IDENTITY ESCAPES SEX
WALK WATER MILK CHRIST
PICTURES SAYING COME NOW
HOT REFLECTION JOHN'S FRIEND
HAIR WET CURLS SMILE HOT
FIRST ENLIGHTENMENT REVEALS
EMPTY GLASSES CALLING POPE
STOP ENOUGH SIGH TALKING
WET WARM MEMORY INSUFFICIENT
NEXT TIME QUESTION RETURNS
RECIPROCATE SALIVATE MASTURBATE

OCTOBER 4, 1979

Watched the 45-minute dance tape of Molissa Fenley and
Joan Frist—twice.
 Painting on St. Mark's Place
 Red on black
 20 color slides documentation

Suzanne Langer speaks of ritual as "the formalization of overt behavior in the presence of sacred objects."

> APPRECIATION OF ART IS A MORAL EREC-
> TION; OTHERWISE MERE DILETTANTISM. I
> BELIEVE SEXUALITY IS THE BASIS OF ALL
> FRIENDSHIP.
> —Jean Cocteau, *Writers at Work*
> (*Paris Review* Series)

> I KNOW I AM SOLID AND SOUND, TO ME
> THE CONVERGING OBJECTS OF THE UNIVERSE
> PERPETUALLY FLOW, ALL ARE WRITTEN TO ME,
> AND I MUST GET WHAT THAT WRITING MEANS.
> —Walt Whitman, "Leaves of Grass," I, 57

> YOU OBJECTS THAT CALL FROM DIFFU-
> SION MY MEANINGS AND GIVE THEM SHAPE.
> —W. Whitman, "Leaves of Grass," I, 178

> LOCATIONS AND TIMES—WHAT IS IT IN
> ME THAT MEETS THEM ALL, WHENEVER AND
> WHEREVER, AND MAKES ME AT HOME?
> FORMS, COLORS, DENSITIES, ODORS—
> WHAT IS IT IN ME THAT CORRESPONDS WITH
> THEM.
> —W. Whitman

> A VAST SIMILITUDE INTERLOCKS ALL, ALL
> SPHERES, GROWN, INGROWN, SMALL, LARGE,
> SUNS, MOONS, PLANETS,
> ALL SOULS, ALL LIVING BODIES THOUGH
> THEY BE EVER SO DIFFERENT

THIS VAST SIMILITUDE SPANS THEM, AND
ALWAYS HAS SPANN'D
 AND SHALL FOREVER SPAN THEM AND
COMPACTLY HOLD AND ENCLOSE THEM
 —Walt Whitman

33RD STREET SUBWAY STATION
 THIRTY-FOURTH STREET FLAG SHIRTS
 KITTY TRIES TO COMMIT SUICIDE
 SCREAMING COLORED WOMAN FEAR

OCTOBER 17, 1979
...

DRESSED ALL IN BLACK I RODE UP IN AN ELEVATOR FOUR
FLOORS WITH A BLACK MAN DRESSED IN ALL WHITE.

Wittgenstein:
The existence of an internal relation between
possible situations expresses itself in language
by means of an internal relation between the
propositions representing them. . . .

Even if the world is infinitely complex,
so that every fact consists of infinitely many
states of affairs and every state of affairs is
composed of infinitely many objects, there
would still have to be objects and states of
affairs. . . .

The information of the message is only
REDUCED by the addressee when he selects
a definitive interpretation. In the case of
aesthetic messages which require the simul-
taneous grasping of multiple senses, the in-
formational quality of the message remains
UNREDUCED.

Heraclitus:
The hidden harmony is better than the obvious.

It is what strikes me most in Van Gogh, the painter of painters, who, without going any further in what is called "painting," neither setting aside the tube, nor the brush, nor the framework, nor the motif, nor the canvas, nor the intrinsic beauty of the subject or the object, managed to impassion nature and objects to such a degree that the fabulous stories of Edgar Allan Poe, Herman Melville, Nathaniel Hawthorne, Gerard de Nerval, Achim Arnim or Hoffman say no more on the psychological and dramatic plane than these twopenny canvasses.

—Antonin Artaud

Recording spreads time over space; it is a mapping of time into space. It gives time the properties of space, in particular, reproducibility, permanence, reversibility, and divisibility. . . .

—Abraham Moles

The artistic deed is AUTONOMOUS, independent of its technique of construction. It may be accessible through its structures, but nothing *a priori* indicates that these are connected with the technique of construction.

—Abraham Moles,
Information Theory and Esthetic Perception

EVERY WAKING HOUR

WE WEAVE

WHETHER WE WILL

OR NO

EVERY TRIVIAL ACT

OR WORD

INTO THE WARP MUST GO

—From 9th St. school P.S. 122

OCTOBER 30, 1979

And some part of me thinks that this will make it better and it's frustration. And it's not knowing why or how. And it's boys everywhere, and it's boys everywhere. Now it means something else. It's talking about it to your friends all the time and they're bored. It's wanting all these guys, wanting them bad, but not really *wanting*. It's an ideal. It's something you know you can't have and that's why you want it. It's acting different every minute. It's looking and looking and erections without a cause, without a cause and without reciprocation. Reciprocate. Am I saying anything at all? It's getting to the point of not being able to work and not. And not. And I want you. It's ego. Ego. I need reciprocation. I always feel this, eventually. Is my mother still here. Grandma is dying and I'm crying 'cause I'm just 21 and I'm standing on 54th Street and I don't know why. I have no answers and no time to wait. I need it. I need. I need. Need answers. People look and turn away. I want to be rejected. I want—fuck it—fuck me. Fuck it. Fuck.

...

LOOKING BACK
 ROW BOY
PLAID EVERY HAIR
 PLACE SHIRT
EYES MISINTERPRET
 INTEREST
LONGING RECIPRO-
 CATE CALLING
NOSE AS SPECIFIC
 IMAGE FUN
EVERY BEING TIME
 DISTORTS
SMOKES PROFILE AS
 LURIE BOYS
NOSE AS MACHO
 SIGNIFIER TIMES
SEMIOTIC EXPAND
 VOCABULARY
BACKGROUND MUSIC
 CULTURE CHINA

DRAWING PENISES IN FRONT OF THE MUSEUM OF MODERN ART.

WHO OWNS WORDS MAKE DREW SAY
BLACK EYES GO DEEP PIERCE HARD
LOOKING WISHING MISINTERPRET
ALWAYS FANTASY WORLD TALKING
IMAGINE PERFECT HOT OCCASION
HE RETURNS GAZE HARD EYES NOW
I WANT I NEED I LONG
CLOSETS KEEP SUBURB BOYS HOME
VISIT MY JAPANESE ANY AGAIN
I WOULD TRY HARD WHAT NOW
LOVING BACK ROW BOY LOOKING
STABBED TO DEATH
BY BALL-POINT PEN

...

CRYING SCREAMING

ERECTION SLIDES DOWN

CASTRATION FANTASY

ARTAUD SAID HE SAW

HE SAW ALWAYS MINE

FACTUAL LOVE KILLS

STABBED TO DEATH

BY BALL-POINT PEN

BLACK LEATHER

ITALIAN DOMINATION

CALLING AFTER HE SAID

BLACK EYES HIT HARD

STILL WAITING IN LINES

ARTAUD SAID HE SAW

MONSTERS EATING FLESH

LICK OFTEN WARM MEAT

BLACK SHIRT RIPS OPEN

REVEAL MEAT RED EYES

ERECTION SLIDES DOWN

LATER NOW TALKING STILL

FRANKLIN FRED BEING NOW

HAVING DONE NO WRONG

EFFORT ACKNOWLEDGES IDEA

BLACK EYE MAKE UP TRYING

MEETING OTHER RETURN UNHARMED

RETURN FOCUS RETURN FULL

POLISH BREAKFAST CLARITY RINGING

FUN CHEEKS AS BEFORE

INFORMATION THEORY AND THEN

SORE LEGS HARD FLOOR

MISSING FRED'S SMALL ROOM

HALLOWEEN MEANS NOTHING

LAST PENIS YEAR T-SHIRT

RETURN TO SAME MEMORY

PROPHETIC POPE SCREAM STORIES

LYING SELF LOVES OTHER NOW
TRICK NOT NOW ACCOMPLISHED
REJECT THIS OVER AGAIN
I DO JOB ALWAYS HE TELLS
WISHING LOOKS WEREN'T WAITING

NOVEMBER [NO DATE], 1979

Writing in a book is also putting time in boxes—pages—the time in books is a different time than recorded time because you choose what speed to read it.

Time defines context.

We experience "art" as a result of many factors outside of the actual "art" itself.

Are all of the factors part of the "art experience" itself?

The "effect" of a work of art, possibly because of the limits of language, is rarely talked about as much as the formal qualities of the work itself. Although often, the effect is as *essential* to the experience of the work as its formal characteristics. It can then be argued that we are only in touch with the experience through the perception of those formal qualities (i.e., materiality—existence). However, the "art experience" is as dependent if not more dependent on context, concept, viewing situation, and the personal preconceptions and miscellaneous knowledge of the viewer's context, than one of those formal qualities.

Formalism is born of verbalization.

These thoughts occurred after seeing the Buddhist Chinese monumental statues and wall-painting directly outside of the entrance to Clyfford Still's paintings. On viewing these pieces and considering some of their formal qualities—size—relation to human scale—use of repetition to indicate number—use of intricate detail—craft—time in execution of art object—religious context—psychological effect of scale, number—

materiality (weight-roughness-solidity-power)—it seemed that I was having an experience (they were having an effect) because of these factors. And it was apparent that their intention in using these factors was to create an effect outside of the work itself. It is not merely decorative. It is not only aware of itself. (It was not created as a perfection of these formal qualities of the piece itself as much as it was as an attempt to cause an effect to form a situation of communication—a transformation of energy. This transformation is aware of context. Is dependent on context.)

Overheard several people say of Clyfford Still's paintings, "I hadn't seen enough of them to appreciate them—before this."

The effect of seeing a body of work—a piece of time—a lifetime of paintings—in relation to each other and in relation to themselves—is overwhelming.

The most incredible "experience" I have had recently. It causes great emotion to be stirred inside of me to be in contact with the lifetime of work of a powerful artist. While at the same time being overwhelmed and intellectually moved and filled with respect—having to listen to people denounce this work as meaningless, abstract, all the same thing, "You've seen one, you've seen them all"—to hear people walking through and trashing what seems to me quite an incredible feat. It fills me with disgust sometimes to the point of wanting to say something and usually laughing quietly or walking away. These paintings are 40 years old and some people can't even begin to deal with them, how in the hell can I hope to even consider these people while I try to make "art" in the present. And they are the majority.

The "art world" is very very small and very, very personal and for most people, in reality, no more than a personal philosophy in a physical manifestation.

There is shared interest, but it is small. There are some people here that make me smile. There are some people here

who are in touch with this shared idea about life that some people call art. I think art is a much bigger thing than some would like to admit. It is easier to ignore.

New York, which is supposedly the Art Center of the World at the present—even here there are small pockets of interest. Everyone is different and they all have different interests and to try to reach all of them is fatal. Clyfford Still knew about painting.

"To come into contact with a truly wonderful 'work of art' causes a tremendous revolution to occur in you."

—from *The Art Spirit*
(as remembered), R. Henri

Walking around looking at these paintings—my thoughts are clear—there are insights into various kinds of "viewing situations," ideas about the relationships between the viewer and the "work of art." Either they are viewing something that they feel they could not physically do themselves, or are seeing something they respect because of quality, time, value, historical value. Sometimes they resent being in contact with something that they could "theoretically" physically do themselves.

They do not want to be in contact with something, by virtue of an idea.

Some people refuse to acknowledge "effect"—or close themselves off from the beginning with preconceptions, misconceptions, explanations, prejudices, pseudo-understanding, false assumptions, etc.

An artist has an impossible ambition. It is a presupposition that he will fail.

To what extent can the boundaries of materiality, economy, political, social, historical, traditional language be extended—stretched, diffused, so as to attempt to include a wider interaction between artist and audience (public)? Should an attempt be made?

Do they want or need art?

They are in contact with "art ideas" whether they are aware of it or not, but can they become more aware? Can they be having or experiencing art without acknowledging it?

Does there have to be acknowledgement? Is there art if no one is seeing or receiving?

Art experience as opposed to daily life—if artists expand these boundaries—these ways of seeing (and they are) to include daily life—if artists see life—experience life as art—if the qualities called art become the same qualities of a special experience of daily life—are people who experience this special thing—are they having an art experience? Is it essential that they think of it in an "art context"?

Is this idea threatening to art as commodity?

Is television making us all more aware of aesthetic seeing—can we all see special things and are we all—artists?

There has always been a large void between an artist's intention and the actual effect of the materialization of that intention.

Advertising—commercial art seeks to close that gap—"effective" advertising.

To what extent are artists involved with that idea—can our alienation from the idea be mainly out of frustration?

Art History—the code of pathos—the dilemma of the dead artist's frame—is the public (and even the art public) so far behind that we lose sight and forget they exist and withdraw to make totally personal, self-referential art that is interesting to other artists only or "art sympathizers"?

Has the message of abstract art been unconsciously—or not—to "fuck the audience"—forget them and make art, vaguely hoping that they will be interested after?

What are the viewer relationships of the present?

I think they are pluralistic. I think they are vague and often ignored.

It's easy to fall into a trap of making things that are in the manner of previous "successful" endeavors—is it a trap?

The extent of change is a reflection of value?

Art as commodity.

However—what about the "focusing"? What about the things that are missed by eclectic methodologies?

What is the value of the constant focusing of Clyfford Still for an entire lifetime on one single medium and a limited vocabulary?

There are substantial arguments on both sides.

A retrospective always raises these questions—of change, growth, technique and value judgments.

There is always some consistency—even just the common factor of a single creator—presupposes continuity in a body of work.

Hope of adding to universal knowledge any idea that is influential. Time proceeds. Knowledge goes forward. Knowledge increases by the principle of accumulative thinking—all new information adds to and transforms previous knowledge.

Cumulative knowledge. To make something to present an idea that is influential—that someone takes in as an in-

fluential idea—that adds to all knowledge—the universal mind.

Thinking is cumulative.

A form of "art" that would be true to this idea of cumulative thinking would have to acknowledge some interest in time—exist in time—and think about the cumulative nature of time and transform time.

This can be approached through—fixed time—(painting, sculpture, photography), however, it seems recorded time (video tape, film, audio tape) would be an even more adequate medium to explore cumulative knowledge. Cumulative information.

All existence is cumulative.

The time in books is a different time because you can read the information at different speeds and the information is all present at the same time and it doesn't travel in time—you have to be the active perceiver instead of the passive receiver of information when you read books.

Ditto—paintings—sculpture (art objects).

Art performance—experience.

Video tapes—film—performances exist within a specific time—contain their own given "length of time"—existence—duration—

Cumulative growth—time—exist through change.

Movement—changing in time.

I came home and took all the things out of my pocket that I had picked up throughout the day and taped them onto a page of the *New York Times* that I found on my way home. There are several little "coincidences"—overlaps of information. Things that have distinct relationships although arbitrarily chosen.

And then I went to Club 57 to play reggae miniature golf.

"Criticism is the salvation of art."

—Joseph Laploca (in conversation)

> "Meaning—metaphor—memory."
>
> —Kermit Oswald (in conversation)

NOVEMBER 14, 1979
..

Pieces of the same thing at different times. At the same time that I'm talking at the same time I'm also talking to you at different times because I'm talking into these boxes these boxes keep time these boxes can take this time and make it a different time. Pieces of time in boxes. Putting things in boxes. Putting pieces of the same thing in different boxes. Pieces of the same thing at different times. It's the same thing.

NOVEMBER 17, 1979
..

LOOKING AT
JEAN (SAMO)'S
WINDOW AT
PATRICIA FIELD'S.

PAINTED BOXES
PAINTED CLOTHES

LOOKING AT PAINTINGS
HANGING ON A RACK

I like looking at paintings in a clothing store.
SAMO in Patricia Field's.
Wednesday the 14th after my performance at SVA for 12 hours, I went to Kiev to eat finally and eat with SAMO and he said he knew about the performance but wasn't there. He told me about the painting he had done that day. He bought a canvas at Utrecht's and paint and put all this paint on the canvas and let cars run over it and got the paint all over him-

self and then got on the subway and went to an appointment at Fiorucci and got paint on EVERYTHING on the way and at Fiorucci he got paint on the rug and couch and rich ladies' furs. He was asked to leave before his appointment.

NOVEMBER 20, 1979

Last night Kenny and I went to Times Square to do Polaroid photographs after seeing Barbara Buckner's video tape—*Pictures of the Lost*—at the Donnell Library. We watched this incredible black woman in a fluorescent orange poncho playing an electric organ. She was the best organ player I've heard in a long time. She would go through these incredible abstract chord changes. She was totally unaware of the preconceived structures of songs and the only way you could tell what she was playing was by listening to the words. She did the most far-out version of "Blue Suede Shoes" I ever heard. We were the only people watching except for two other men.

> "She sang the blues juxtaposed with space organ."
>
> —Jet (Kenny) Scharf

NOVEMBER 20, 1979 — BEUYS SHOW

Heard BEUYS at Cooper Union January 7
 Saw him the next day at 125 Delancey St.—Real Estate Show

> "Poverty means nothing to a man with a dream. Drawing is the probity of art."
>
> —from conversations with Charles
> Stanley while sitting for my
> portrait, January 1980

PENIS POEM
HE SAID TRAIN RUTGERS MEDIA ANSWER
SAMO. WINDOW LOOKING CONFRONTATION
FOLLOWING STREET LOOKING ALWAYS AFTER
FINALLY CATCHING
INTERPRET SEEING
WORDS BED FLOOR

This really happened . . . I met this boy 'cause we were late looking at SAMO's window at Patricia Field's—followed him to the East Village—went home—first time I ever came doing 69. Made love under blinking Christmas lights—Nova Convention poster in hallway—never seen again.

NOVEMBER 30, 1979

Words written as heard in Semiotics Class—continuously.

PHYSICS PURE POINT CAN'T COMBINE
EASIEST BLUE YELLOW YEAH EASIEST
TO SURE THING READILY IT SUPPOSE
RIGHT OR UP EXPERIMENT SUPPOSE
MARINE RIGHT NO SO SOMETHING HOW
MEAN INDIVIDUALLY EYES SUPPOSEDLY
COLORS EQUIPMENT EVERYBODY O.K.
IS PEOPLE KNOW O.K. LEARNED OTHER
SAID LEVEL HUH? DEGREES CONVERSATION
KNOW IS ABOUT DISCUSS SEE ABSTRACT
WARM OUT TAUGHT DIFFERENCE EYES
DOESN'T KNEW INSTANCE SNOW TELL
ICE IT IS UH FORMED UNDER COOLER
SLEET AM TAUGHT BEEN CHANGE
SNOW YOURSELF GUESS SOMEWHERE MUCH

FACT CODES TO COMMUNICATE DO
CONSISTENT ABOUT DIFFERENT POSSIBLE
THEM ASKING VERBALLY ORANGEY POINT
DOWN AWARE SEE POINTING LIGHTS
COLORS WARM COOL ART PAINTING SEE

Books/Articles Read/Consulted
William Burroughs Interview, *Paris Review: Writers at Work,* 3rd Series
"The Uses of Observation: A Study of Correspondential Vision in the Writings of Emerson, Thoreau and Whitman." Christopher Collins; 1971 (Mouton)
Information Theory and Esthetic Perception, by Abraham Moles, 1968
Cosmology—Charon
The Politics of Experience—R.D. Laing, 1967
Lolita—Nabokov
Artaud Anthology—Edited—Jack Hirschman, Second Edition, 1965
"A Vision," W.B. Yeats, 1937
"Performing Arts Journal/11" Vol. IV/No. 1 and 2, 1979
"I've Left: a Manifesto"—Bern Porter
Elements of Semiology, Roland Barthes, 1969
"Learning from Las Vegas"—[Robert] Venturi
Principles of Genetic Epistemology—Jean Piaget, 1972
Our Lady of the Flowers—Jean Genet
Ludwig Wittgenstein—*Tractatus Logico-Philosophicus*
"Joseph Beuys: His Life and Works"
Antonin Artaud: Poet Without Words—Naomi Greene
"Talking Poetics from Naropa Inst." Vols I & II
The Hidden Order of Art—Anton Ehrenzweig
"Meaning and Control"—D. O. Edge and J. Wolfe
Experience and Conceptual Activity—J. M. Burgers
Japanese Painting—Henry P. Bowie

Lady Chatterley's Lover—D. H. Lawrence
Dubliners—James Joyce
Finnegans Wake—James Joyce
Essaying Essays—Richard Kostalanetz
The Super Male—Alfred Jarry
Mythologies—R. Barthes
Ubu Roi—Alfred Jarry
The Banquet Years—[Roger] Shattuck

1979

Video Clones, video/dance performance with Molissa Fenley, New York City
Organized group shows at Club 57, New York City

1980

after the Baths in Semiotics class
Again it was the same and I feel just the same again. Waiting for
an answer. And you can say all you want to. I'm not saying any-
thing. And we sit and talk about Barthes' "Lover's Discourse."
And I experienced all these signs—condensed—last night and I guess
always again. And it's just the way you always knew it was. Noth-
ing has changed—it's still the same thing. But I'm tired—and feel
guilty about being tired of it. But it hurt like it hurts for everyone.
Distance and no more hope. O.K., give up—go home. He doesn't
want you—and it wasn't just that—the right moves never happened.
Uncomfortable pause and he gets up and walks away—but he was
the only hope—so go home and don't care—and especially don't
feel sorry for yourself—read Nietzsche, right? Rationalizations—I
mean I just didn't do the right thing at the right time, but I couldn't

control that at the time—so fast, I said. So he gets up and leaves and I've done it too—I've been on that side before. So why are you still talking. You've been in his shoes just one more rejection but this time it's not me who is feeling powerful. And it sounds like pure adolescent babble—silly—childish— and if I can't even overcome my own doubt—what can I overcome. This is not a little thing. It has been the only thing in my head since this happened—this thing has crushed me. A misunderstanding, he said. I am nauseous with chilled stunted exaltation, I said. Sometimes I'm really happy. When? he said. I can't remember if—I'm not sure he . . . We're not going to help you, he said. So go away again and say to your-self that maybe it's happening to you because for you it's more than rejection—for you it is something else too. I'm not just sad—I compensate with rationalization or others—They can do this to me and I can say it will help me—make me stronger, bigger. I already saw the sadness—tragedy at home. I can see inside of it and absorb it into myself so that it has become bigger than me inside me and it is only me. But it's not only me—it's always again still the same—the tragedy— the ultimate failure of the spirit. He said soul. I said I'm go-ing home. And how can this boy from the baths make me be in this place—and if he hadn't got up and walked away would you be better and didn't you cause it to happen—didn't you inflict the wound yourself? Sometimes I feel really stupid and sometimes I know I am—But you boy in the baths—you turned me inside out again and exposed myself—to myself— and I guess that's good again.

FIRST "REAL" GROUP SHOW IN NEW YORK CITY . . .
SALSA 'N' COLORS FEBRUARY 28–MARCH 9, 1980

I showed a large red-black on white painting 9' x 9' done January 15, 1979, in this group painting show called "Salsa

'n' Colors" at a Spanish school on the Lower East Side—107 Suffolk Street—in the gymnasium.

MARCH 18, 1980

These fucking beautiful boys drive me crazy. This guy in the subway sitting with his legs wide open in front of him—on purpose. Glancing at me and just enjoying being looked at. This guy in the cafeteria. Gorgeous. I just stand there and say "gorgeous" to myself over and over again. I find a reason to use the phone so I can stand there near him a little longer, just a little longer—pretty—pretty—pretty boys. And I just look and I know it's just as bad because I only look and I have an incredible imagination. I can have these boys, any of them, all of them, tonight alone in my little room in the dark—just my imagination—dark eyes, dark hair and gorgeous bodies, penetrating gaze. To quote from an essay by Jean Genet I read recently, "Eager thick penis rising from a bed of black curls." So writing it out. Writing it out of myself—stop thinking about it and take this energy into another form. This energy, sexual energy, may be the single strongest impulse I feel—more than art?(!)

APRIL 14, 1980

I missed Cosmology class. I completely forgot. I never thought about it the whole day till I saw Kenny and he said, "God is light."

APRIL 25, 1980: SEMIOTICS

The question of *whether* or *not* there *should be* any texts or grammar to raise moral issues or make us define our values, is itself a moral question.

Have the aspirations of the futurists and constructivists (the social upheaval of values of society by the introduction of abstract art) been realized?

• "People are afraid of being pop, but it's not easy to be simple."—Tony Shafrazi (in reference to B. Beckley's alteration of photograph in piece)

• saw Lethalithic show on Church St.

• idea about criticism taking "art" out of the realm of experience and turning it into a literary practice

• from idea that someone should be writing about Club 57 right now but not showing others because writing "about" becomes "input into"

• writing would/could become an influence on the Club and substantially alter it and its activities/participation, etc. as with media, journalism, etc.

• talking about something is changing or making that thing

• still respect for Kenny's paintings. They are rich in experience, but also still new enough to be interesting in realm of language, history, etc.

JULY 26, 1980–

After "Acts of Live Art III"
Finally understanding the conflict between the piece I presented and the generally "visual" domination of the other work. An

understanding of a totally "visually oriented" program with the exception of my "language-based" presentation.

Context (as it was) remains determinant of criticism comparison: immediate response.

Maybe the "language-based presentation" (re: calculable specific information) becomes part of other attention center (memory) recall: associations fixed: juxtapo (he said) and I remembered.

Reading Gide, Lautréamont, Solanis: information recurring of self as artwork. Diaries of Hugo Ball: pieces of. The life of the artist as a work of art itself. See: Greek understanding of. "Man thinks of himself as beautiful—however it is simply a rationalization to deal with miserableness of self." Mankind thought as source/bit maybe virus situation occurs: again. "Painting is a disease or a curse"—Frank Holliday. Valerie Solanis sees "man" as eternal mutation: deviation: aborted female. Male spirit seen as weak, in opposition, she said. They shot Andy Warhol, she said.

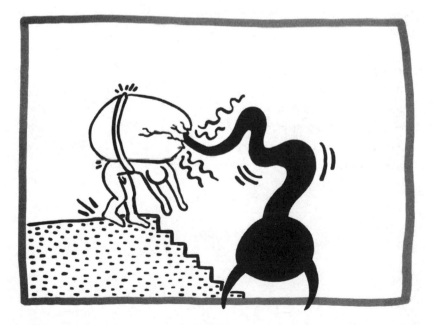

Special Projects
..

Began drawing on blank advertising panels in New York City subway stations

Group Exhibitions
..

Club 57 Invitational, New York City
Times Square Show, New York City
Studio Exhibition at P.S. 122, New York City
Events: Fashion Moda, The New Museum, New York City

1981

Solo Exhibitions

..

Westbeth Painters Space, New York City
P.S. 122, New York City
Club 57, New York City
Hal Bromm Gallery, New York City

Group Exhibitions

..

Drawing Show, The Mudd Club, New York City
New York/New Wave, P.S.1, Long Island City, New York
Lisson Gallery, London, U.K.
Brooke Alexander Gallery, New York City
Tony Shafrazi Gallery, New York City
Annina Nosei Gallery, New York City
Patrick Verelst Gallery, Antwerp, Belgium
Bard College, Annandale-on-Hudson, New York

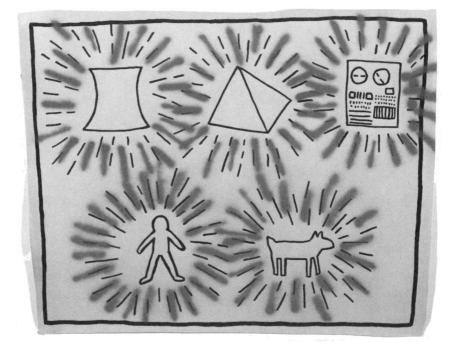

1982

Painting has a double advantage over the language of words. First, painting conjures objects with greater strength and comes much closer to them. Second, painting opens to the inner dance of the painter's mind a larger door to the outside.

—Jean Dubuffet
"Anticultural Positions"
December 20, 1951

Being born in 1958, the first generation of the Space Age, born into a world of television technology and instant gratification, a child of the atomic age. Raised in America during the sixties and learning about war from *Life* magazines on Vietnam. Watching riots on television in a warm living room comfortably safe in middle-class

white America. I don't believe in solutions. Things are beyond my control and beyond comprehension. I do not have dreams of changing the world. I do not have dreams of saving the world. However, I am in the world and I am a human being. In 1982, with telephones and radio, computers and airplanes, world news and video tape, satellites and automobiles, human beings are still frighteningly similar to human beings 2,000 years ago. I am scared to death.

I think I was born an artist. I think I have a responsibility to live up to that. I've spent my life up to this point trying to find out just what that responsibility is. I learned from studying other artists' lives and studying the world. Now I live in New York City, which I believe to be the center of the world. My contribution to the world is my ability to draw. I will draw as much as I can for as many people as I can for as long as I can. Drawing is still basically the same as it has been since prehistoric times. It brings together man and the world. It lives through magic.

MAY 4, 1982, IN BRUSSELS AIRPORT

..

It has been a long time since I have written anything down. A lot of things have happened. So many things that I have been unable to write them. I probably should be keeping a daily diary, however I don't seem to be able to ever start to write. So today is my [24th] birthday and I am sitting in an airport in Brussels waiting for a flight back to New York. The show in Rotterdam went fine and I also enjoyed Amsterdam. Drawing in the street with chalk in Amsterdam made me realize I can do it anywhere in the world (and with similar results). But, I miss New York and especially Juan [Dubose]. It's funny, but coming here made me even more glad to be American. Everyone here seems as if they would rather be in America, even if they don't know much about what it is really like.

In one year my art has taken me to Europe and propelled me into a kind of limelight. Everyone says it's kind of scary. I mean, the situation. Things tend to get over-hyped and then consumed and placed into a "safe place" (history). I do admit in some ways this does frighten me, but on the other hand: what is the alternative? Elvis must be Elvis. Looking at Willem de Kooning's ugly new paintings at the show at the Stedelijk frightens me. I would rather die than become that. However where I am now is feeling rather good. I mean in some ways it is the situation I always wanted or always dreamed of. I'm not sure where that dream came from, but it is hard to make it go away once it has started. I think the most important thing is keeping it all in perspective. Knowing that it is up to me what happens next. (And knowing when it is out of my hands.) The one thing (and in the end it was always the only thing) that I have control of is what comes out of me and into the world.

It is hard to control the thing once it has come out and entered the world. But only I can bring it to the world. The world doesn't want these things and doesn't need these things, but when they are here, they are here. Their importance all comes from what other people do with them. If these things are put into a situation they add something to it.

Everybody that does these things is adding to situations and adding to the world. Therein lies a kind of responsibility. That responsibility

is seen differently by different people who make things in the world. It depends on the "idea of the world" that the person has. Not everyone feels a responsibility to the world. I do not fool myself into thinking that these things I make can change the world or even make a big effect in the world.

People who make wars change things. People who use "control" make things happen in the world. That is not my interest at all. In fact, my "idea of the world" is very simple. My understanding of my place in the world is (I hope) humble and unassuming. I am filled with a certain kind of doubt about my role in the world. But that does not stop me from participating in the world. It only keeps me from expecting something from the world. It seems to me the only thing to do in the world is to "do" something. The "doing" is what the world is. I only do what I always have done when I make things. I don't know if I ever understood or will ever understand what this thing is or why I do it. But I know from other people who have always done it that it is a "real" thing to do and it seems to stay in the world after it is done. People who drew in caves thousands of years ago made things that are still in the world. The world gets bigger and bigger. People like Jesus Christ have added things to the world that also don't go away. That is an even bigger responsibility. The things that I make are a very small addition compared to this.

Today I am 24 years old. Twenty-four years is not a very long time, and then again it is enough time. I have added many things to the world. The world is this thing around me that I made for myself and I see for myself. The world will, however, go on without me being there to see it, it just won't be "my" world then. That is what interests me most about the situation that I am in now. I am making things in the world that won't go away when I do. If this "success" had not happened, then maybe the world would not know these things after I go away. But now I know, as I am making these things, that they are "real" things, maybe more "real" than

me, because they will stay here when I go. In the situation I am in now, I am a vehicle for these "things" I'm bringing into the world. I am not having things and making things and waiting for the world to have them. The world is waiting to have them. At 24, that is maybe a funny feeling. The things that I make are "in" the world as soon as I make them. That is also the situation I always dreamed of (I guess). So that

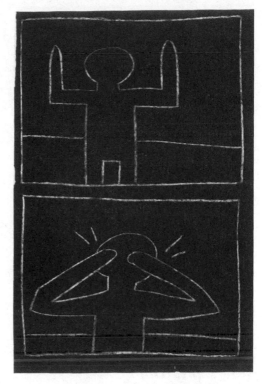

there is a kind of reason for making these things and the "things" in some sense become more important than me. The world is waiting for the things and I am the only one who can bring them these things. There is a kind of freedom in that. There is also a kind of hysteria in that, but it depends how you see the world. I only think that I want to be the one who makes the "things." I don't know what I want the world to be. But only I can make these "things." These things that are called the works of Keith Haring.

1982

Solo Exhibitions

Rotterdam Arts Council, Rotterdam, Holland
Tony Shafrazi Gallery, New York City, with LA II

Group Exhibitions

Still Modern After All These Years, Chrysler Museum, Norfolk, Virginia
Fast, Alexander Milliken Gallery, New York City
Young Americans, Tony Shafrazi Gallery, New York City
Larry Gagosian Gallery, Los Angeles, California
Blum Helman Gallery, New York City
New Painting 1: Americans, Middendorf Lane Gallery, Washington, D.C.
Art of the '80s, Westport Weston Arts Council, Westport, Connecticut
Wave Hill, Bronx, New York

Young Hoffman Gallery, Chicago, Illinois
The Agitated Figure, Hall Walls, Buffalo, New York
Holly Solomon Gallery, New York City
Painting & Sculpture Today, Indianapolis Museum of Art, Indianapolis, Indiana
Richard Hines Gallery, Seattle, Washington
The Pressure to Paint, Marlborough Gallery, New York City
Documenta 82, Kassel, Germany
The U.F.O. Show, Queens Museum, New York
Urban Kisses, Institute of Contemporary Art, London, U.K.
Beast: Animal Imagery in Recent Painting, P.S.I, Long Island City, New York

Special Projects

Spectacolor Billboard, Times Square, New York City, a 30-second animated drawing repeating every 20 minutes for one month
Installation, Paradise Garage, New York City
Print and distribute 20,000 free posters for June 12 anti-nuclear rally, Central Park, New York City
Paint fluorescent mural on cement handball court, Houston Street at Bowery, New York City

Books & Catalogues

Keith Haring. Text: Robert Pincus-Witten, Jeffrey Deitch, David Shapiro (Tony Shafrazi Gallery, New York)
Rotterdam Arts Council. Essay: Richard Flood
Marlborough Gallery. Essay: Diego Cortez
Appearances Press. *Drawings: Keith Haring*
Documenta 7

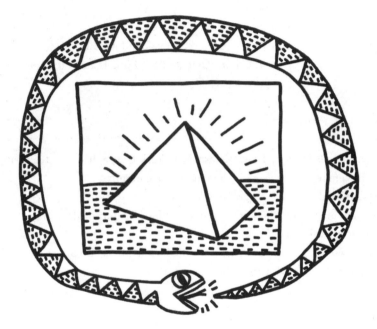

1983

—from catalogue "Tendencias en Nueva York," organized by Carmen Giminez. Palacio de Velazquez. Parque del Retiro, Madrid, Oct. 11–Dec. 1, 1983.

Painting is nothing new. People have been drawing since the Stone Age. In every culture people have attempted to depict their world as they see it and feel it. Images have been drawn, scratched, sprayed, carved, baked or painted in whatever materials were available to that culture at that particular time. Man-made images have always been important and necessary elements in this ritual we call "life." They have adorned our shelters, tools, clothing, monuments, vessels, bodies, tem-

ples and the land itself. Different cultures have attributed to them greater or lesser value and designated to them different degrees of meaning and purpose. But they are always there in one form or another. It is part of mankind's way of reaffirming and celebrating its existence.

In the last 100 years we have seen the invention of telecommunications, radio, automobiles, television, air and space travel, computers, genetic science, satellites, lasers, and on and on. In short, our experience of life has been drastically altered. The role of the image maker cannot be seen as the same as it was 100 years ago, or even 10 years ago. The rate of change is accelerating at an increasingly rapid speed and the artist has to change with it. Contemporary artists cannot ignore the existence of media and technology and at the same time cannot abandon ritual and popular culture. The image maker may be more important now than at any other time in the history of man because he possesses qualities that are uniquely human. The human imagination cannot be programmed by a computer. Our imagination is our greatest hope for survival.

1983

Solo Exhibitions

Fun Gallery, New York City, with LA II
Galerie Watari, Tokyo, Japan, with LA II
Lucio Amelio Gallery, Naples, Italy
Gallery 121, Antwerp, Belgium
Matrix 75, Wadsworth Atheneum, Hartford, Connecticut
Robert Fraser Gallery, London, U.K., with LA II
Tony Shafrazi Gallery, New York City

Group Exhibitions

Morton G. Neumann Family Collection, Kalamazoo Institute of Arts,
 Kalamazoo, Michigan

New York Painting Today, Carnegie-Mellon University, Pittsburgh, Pennsylvania

Biennial 1983, Whitney Museum of American Art, New York City

The Comic Art Show, Whitney Museum of American Art, Downtown Branch, New York City

Back to the U.S.A., Kunstmuseum, Lucerne, Switzerland

Tendencias en Nueva York, Palacio Velazques, Madrid, Spain

Bienal de São Paulo, Brazil

Terrae Motus, Institute of Contemporary Art, Boston, Massachusetts

Post-Graffiti Artists, Sidney Janis Gallery, New York City

Currents, Institute of Contemporary Art, Philadelphia, Pennsylvania

Pittsburgh Center for the Arts, Pittsburgh, Pennsylvania, with LA II

Special Projects

Artist-in-residence, Montreux Jazz Festival, Switzerland

Fabric design for Vivienne Westwood, London, U.K.

Computer graphics album cover for *New York City Peech Boys*

Paint Fiorucci, Milan, Italy, with LA II

Paint choreographer Bill T. Jones, London, U.K., photographed by Tweng Kwong Chi

Paint murals, Marquette University, Milwaukee, Wisconsin

Paint building in Tokyo, Japan, with LA II

Paint mural on Avenue D, New York City

Books & Catalogues

Champions. Essays: Tony Shafrazi

Tendencias en Nueva York

Back to the U.S.A. Text: Klaus Honnef (Rheinisches Landesmuseum, Bonn, und Rheinland-Verlag)

1984

This drawing I first did in Milano. It was something I had been thinking about for a while. The reconciliation of the head and the stomach. Pure intellect without feelings is impotent and even potentially dangerous (i.e., the computer in the hands of those who wish to control). Ex-

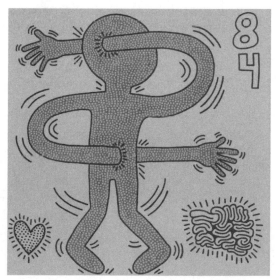

pressionism (stomach) without intellect is pointless and usually boring. The problem facing modern man now (the reconciliation of intellect and feelings/brain and heart/rational and irrational/mind and spirit/etc. etc.) is compounded by the increasing power of technology and its misuse by those in power who wish only to control. The mentality of people who are motivated by profits at the expense of human needs is perfect for the computer. Computers are completely rational. They save time and money, they can keep records of every transaction (telephone, bank, etc.). Money is the opposite of magic. Art is magic. The worlds of art and money are constantly intermingling. To survive this mixture the magic in art has to be applied in new ways. Magic must always triumph.

"Keith Haring in Milano"

I spent three weeks in Italy in June of 1984. During that time I produced all of the works exhibited as well as an installation at the Venice Biennale. I am accustomed to working in this way; to visit a country and produce art on location utilizing the materials and resources available in that country. I am particularly fond of Italy. In the last three years I have been all over the world. I have worked in Japan, Australia, Brazil, and much of Europe. When you are visiting a country to work, instead of as a tourist, you experience it in a richer, more authentic way. This was particularly true in Milano. During the three weeks I spent working on this show I made many friends. In restaurants, paint shops, carpentry shops, pizza shops, clubs, and of course the gallery. Even though I spoke very little Italian, I found it easy to communicate. The combination of the people, the pasta, and the easy going romantic lifestyle made it a perfect place to work.

I began by visiting a workshop on the outskirts of Milano where they produce terra-cotta pieces. I chose several vases of different sizes and shapes and began the next day to systematically sand, wash, and then embellish the surface

with marking ink. The largest of these was big enough for me to stand inside of. There were several small vases which I was attracted to because of their similarity to the shape of nuclear cooling towers. The confrontation between the history of vase painting and the contemporary approach of drawing with marker and the mixture of contemporary and ancient symbols produces an ironic mixture of opposites. This irony is even more apparent in the plaster sculptures I did with L.A. 2. L.A. 2 is short for Little Angel Two, a graffiti-writer from the Lower East Side in New York City. I have been collaborating with him on sculptures, paintings, and installations since 1982. His "signature" is a typically New York version of what I feel is as close as the Western World has gotten to a stylized form of writing similar to Eastern calligraphy. His particular "tag" or signature stood out from the rest of the graffiti writers whose works I saw every day on the streets of New York City. We began combining our two styles to create an overall surface of intermingling lines. All of the work we have done is about "surface" and usually covers and transforms an object it is applied to. Our first visit to Milano in 1983 was to spray-paint the entire Fiorucci store. We painted it in 13 hours.

Salvatore [Ala.] flew Angel to Milano from New York specifically to paint these plaster sculptures. We bought the sculptures in Torino, painted them Day-Glo, and then L.A. and I covered them with our "tags." I only wish Michelangelo could see them, but then again maybe he will. While Angel was here we also collaborated on a few vases and one large totem.

The totems and other wood wall pieces were done in Pedano's wood shop. It is great to travel to another city in the world and work with local craftsmen. The quality and speed of the workmanship was incredible. I went to Pedano's shop and drew directly on large sheets of wood. They then cut out the shapes and secured them in bases. I used a tool I had

brought with me from New York and carved my drawings into the wood. These drawings, as always, are done directly without any pre-drawings or plans. The tool is similar to a drill except that it cuts a line instead of drilling. It requires two hands and a considerable amount of control to push it through the wood. One of the things that I am continually interested in is the amount of different ways of making marks and the varieties of experience to produce the same consistent line (i.e., carving, painting, drawing). Each requires different amounts of time, concentration, and effort, but the result remains amazingly consistent. My recent use of animation and computers pushes this idea one step further.

The paintings, which made up the main body of the show, were my release. These paintings were some of my first works with acrylic paint on a stretched muslin. I chose to begin painting with acrylic because of the wide range of color I had been ignoring in my previous works on vinyl. I think I also just wanted to prove that I could paint, or do anything, if I wanted to. I chose muslin because the surface was smoother and more delicate than canvas. I had my friend, Daniela, bring Day-Glo acrylics with her from New York because it was impossible to find them in Italy. I had fun doing these paintings. One of them was done on stage during a live TV show called "Mister Fantasy," where I was awarded an "Oscar" along with David Byrne and others.

Many times when I am working in another city I am inspired by the culture and environment of that city. In Milano I discovered many new ideas and images that went directly into the work. I stayed in the gallery until late every night painting until my hands hurt from holding the brush, and then I went to Plastic to unwind. Plastic is my favorite club in Europe. Nicola [Guiducci] plays music that made me feel like I was in New York.

Working in the gallery was really great because I was always supplied with enough food and assistance to work at

my own frantic pace. I have fond memories of Salvatore going out at 2:00 in the morning to find me cold Coca-Colas, and the man from Pink Panther Pizza bringing me endless amounts of my favorite Milanese pizza with plenty of garlic.

Another great thing about the show was the opening. The Day-Glo poster, which was also plastered all over Milano and Venice, was given out for free to the hundreds of people who attended. There was an incredible cake which was an exact reproduction of the exhibition postcard. Lots of people came, lots of fun young people, fashion people, and art lovers, and even the mayor of Milano.

I suppose people reading this expect me to write about my work and try to explain what it is I am trying to say, but I really prefer if the work speaks for itself. I try to make images that are universally "readable" and self-explanatory. The person who is looking for a simple answer to their questions will probably be disappointed. An artist is a spokesman for a society at any given point in history. His language is determined by his perception of the world we all live in. He is a medium between "what is" and "what could be." If an artist is really honest to himself and his culture he lets the culture speak through him and imposes his own ego as little as possible. If there is no mystery there is only propaganda. People always ask me: "Where do you get all these ideas?" I say, I'm not sure, I only know that I'm living now in the 20th century and I absorb information at an increasingly rapid rate. We all do. Information is coming from all kinds of sources, new sources every day. Technology is moving faster, perhaps, than we can keep up with. I digest information from these sources, channel it through my own imagination, and put it back out into the world. I am continually trying to find new ways to bring these things into the world and to expand the definition of what an "artist" is.

I dedicated this show to Francesca Alinovi. Francesca was the first person from Italy who I met in New York. I met

her in 1979 when she was curating a video exhibition to travel through Italy. In 1980 she tried to organize a show for a museum in Florence with Diego Cortez. Repeatedly she was turned down for the budget. Diego eventually organized a similar show in New York City called "New York, New Wave," which was the first official show to showcase the new New York scene. I met Francesca repeatedly in New York and did several interviews with her. She was one of the only critics who I ever met who grasped the whole sense of what was happening in New York. She traveled frequently by herself to the Bronx and made friends with graffiti writers there. She was the first person to take Ann Magnuson and Kenny Scharf, Club 57 pioneers in performance art, to Europe. I remember the best interview I've ever done in my life was with Francesca. The conversation had gone into the world of the machine and technology and how the machine had changed our perception of the world, etc., and after looking down at the tape recorder (machine) we realized it had stopped and refused to record our entire conversation. We did one other interview after that, but it never replaced that first one. I miss Francesca, but I especially missed her in Italy, because I know she would have been with me at my show. So, the book and show are dedicated to her memory.

OCTOBER 30, 1984

I think the greatest feature of a lot of the images is that they're not completely explainable and they can have different meanings for different people. That's something that man seems to have less and less patience for, but in earlier civilizations symbols were much more versatile.

A lot of times the images are simply born out of the need to do something different. Sometimes they come from consciously wanting to get some idea across. But often it just comes out of my imagination without trying to make it mean

anything specific. The challenge is to be in a state of mind which allows spontaneity and chance while still maintaining a level of awareness which allows you to shape and control the image. Every drawing is a performance and a ritual.

Modern man is consuming information at an increasingly rapid rate. A modern artist has to produce images quickly and efficiently enough to keep up with our changing world. However, the elements of chance, and magic, and spirit cannot be sacrificed in this quest.

The freedom of the artist is symbolic of the human spirit in all mankind.

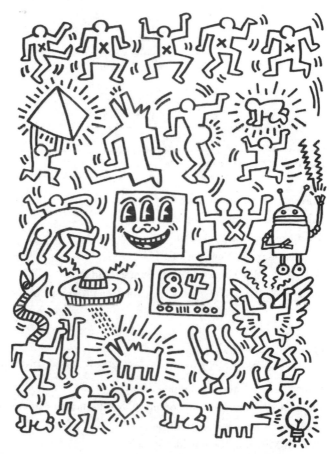

1984

Solo Exhibitions
...

University Museum of Iowa City, Iowa
Paul Maenz Gallery, Cologne, Germany
Salvatore Ala Gallery, Milan, Italy, with LA II
Paradise Garage, New York City
Galerie Corinne Hummel, Basel, Switzerland
Semaphore East, New York City, with Tseng Kwong Chi

Group Exhibitions
...

Robert Fraser Gallery, London, U.K.
Biennial III—The Human Condition, San Francisco Museum of Modern
 Art, San Francisco, California
Aldrich Museum, Ridgefield, Connecticut

Via New York, Montreal Museum of Contemporary Art, Montreal, Canada
New Gallery of Contemporary Art, Cleveland, Ohio
Arte di Frontiera, Galeria dí Arte Moderna, Bologna, Italy
Aperto 84, Venice Biennale, Venice, Italy
Content, Hirshhorn Museum, Washington, D.C.
Disarming Images: Art for Nuclear Disarmament—show traveled through-
 out United States
Tony Shafrazi Gallery, New York City
Musée d'Art Moderne de la Ville de Paris, Paris, France
New Attitudes: Paris/New York, Pittsburgh Center for the Arts, Pittsburgh,
 Pennsylvania

Special Projects

Paint mural at National Gallery of Victoria, Melbourne, Australia
Paint mural at Collingwood Technical School, Melbourne, Australia
Paint mural at Gallery of New South Wales, Sydney, Australia
Artist-in-residence, Ernest Horn Elementary School, Iowa City, Iowa
The Kutztown Connection, performances to benefit the New Arts Program,
 Kutztown, Pennsylvania
Children's Festaville, artist-in-residence and mural, Walker Art Center, Min-
 neapolis, Minnesota
Artist-in-residence, poster and sticker design, Le Mans, France
Paint candy store murals, Avenue D, New York City
Anti-Litterpig Campaign: Create logo for New York City Department of
 Sanitation
On-site painting, Museum of Modern Art, Rio de Janeiro, Brazil
Paint fishermen's houses, Ilheus, Brazil
Paint mural, Children's Village, Dobbs Ferry, New York
Body-paint Grace Jones, New York City, photographed by Robert
 Mapplethorpe
Create 60-second animated commercial for *Big,* a store in Zurich, Switzerland
Design set for *Secret Pastures,* Brooklyn Academy of Music, New York,
 choreographed by Bill T. Jones and Arnie Zane

Paint mural for Asphalt Green Park, New York City
Create First Day Cover and limited edition lithograph to accompany United
 Nations' stamp issue of 15 November commemorating 1985 as *International Youth Year*

Books & Catalogues

Pittsburgh Center for the Arts. Text: Fidel Marquez; photographs: Tseng
 Kwong Chi
The Human Condition. Text: Henry Hopkins (San Francisco Museum
 of Modern Art). Miranda McClintic (Smithsonian Institution,
 Washington, D.C.)
Primitivism. Editor: William Rubin (The Museum of Modern Art,
 New York)
New Art. Editors: Phyllis Freeman, Eric Himmel, Edith Pavese, Anne
 Yarowsky (Harry N. Abrams, New York)
Untitled 84. Introduction: Robert Pincus-Witten; text and photos: Roland
 Hagenberg (Pelham Press, New York)
Hip-Hop. Text: Steven Hager (St. Martin's Press, New York)
Art in Transit. Introduction: Henry Geldzahler; text: Keith Haring;
 photographs: Tseng Kwong Chi (Harmony Books, New York)
Art at Work: The Chase Manhattan Collection. Text: various authors
 (E.P. Dutton, New York)

1985

Solo Exhibitions

Schellmann & Kluser, Munich, Germany
Tony Shafrazi Gallery, New York City
Leo Castelli Gallery, New York City
Museum of Contemporary Art, Bordeaux, France

Group Exhibitions

New York 85, ARCA, Marseille, France
Of the Street, Aspen Art Museum, Aspen, Colorado
Rain Dance, 292 Lafayette Street, New York City
The Subway Show, Lehman College, Bronx, New York
La Biennale de Paris, Grand Palais, Paris, France

Homo Decorans, Louisiana Museum, Humlebaek, Denmark
Les Piliers de la Coupole, Galerie Beau Lezard, Paris, France

Special Projects

Organize and curate *Rain Dance,* a benefit party and exhibition for the U.S.
 Committee for UNICEF's *African Emergency Relief Fund*
Design set for *Sweet Saturday Night,* Brooklyn Academy of Music,
 New York
Paint set for *The Marriage of Heaven and Hell,* choreographed by Roland
 Petit, for the Ballet National de Marseille, France
Create cover illustration and centerfold for *Scholastic News,* reaching an
 audience of three million American schoolchildren, grades one
 through six
Collaborative poster with Brooke Shields and Richard Avedon
Create 25' × 32' backdrop for permanent installation at *The Palladium,*
 New York City
Create mural and distribute free T-shirts and balloons for *Keith Haring Day*
 at Children's Village, Dobbs Ferry, New York
Host painting workshop and distribute free coloring books at the first
 Children's World Fair celebrating *International Youth Year,* Asphalt
 Green Park, New York City
Print and distribute 20,000 Free South Africa posters
Create painting at *Live Aid,* July 13, J.F.K. Stadium, Philadelphia,
 Pennsylvania, to be auctioned, with proceeds donated to *African
 Famine Relief*
Paint mural on handball court, P.S. 97, New York City
Body-paint Grace Jones for performance at Paradise Garage, New
 York City
Paint St. Patrick's Daycare Center, San Francisco, California
Design four watches for Swatch Watch U.S.A.
Children's drawing workshop, Museum of Contemporary Art, Bordeaux,
 France

Books & Catalogues

...

Beyond the Canvas. Introduction: Leo Castelli; text and photos: Gian
 Franco Gorgoni (Rizzoli International Publications, New York)
America. Text and photos: Andy Warhol (Harper & Row Publishers,
 New York)
Notes from the Pop Underground. Editor: Peter Belsito (The Last Gasp of
 San Francisco, Berkeley, California)
Keith Haring: Peintures, Sculptures et Dessins. Text: Jean-Louis Froment,
 Brion Gysin, Sylvie Couderc (Musée d'Art Contemporain de Bordeaux,
 France)
New York 85. Text: Roger Pailhas, Jean-Louis Marcos, Marcellin Pleynet
 (ARCA Centre d'Art Contemporain, Marseille, France)

1986

I think public sculpture should aggressively alter our perception of the environment in a positive way. People love to interact with sculptures by climbing, sitting, touching and moving. For me, the most effective public sculpture would function as visual and physical entertainment. I think public art (unless there is a specific political or ideological message) should make people feel comfortable, and brighten their environment. These sculptures were designed to be played on . . . a kind of "adult-scale" playground.

JUNE 25, 1986 — NEW YORK CITY

The best reason to paint is that there is no reason to paint.

I'd like to pretend that I've never seen anything, never read anything, never heard anything . . . and then make something.

Every time I make something I think about the people who are going to see it and every time I see something I think about the person who made it.

Nothing is important . . . so, everything is important.

JULY 7, 1986: MONTREUX

It has been such a long time since I last tried to write down anything about what has happened (is happening) in my life.

It has been moving so quickly that the only record is airplane tickets and articles in magazines from the various trips and exhibitions. Someday I suppose these will constitute my biography.

It is only now that I realize the importance of a biography. I mean I always have realized that I enjoy to read (and have learned many things from) the biographies of artists whom I admire. It is probably my main source of education. In the beginning of my "career" (what an awful word) I was misled by a teacher who thought the things I was writing to be pretentious and self-important. Years later, when I read those things I wrote in 1978, it didn't seem so pretentious, for almost everything I wrote about "wanting to do," I actually did in the four or five years that followed.

Now I regret that I didn't continue to write constantly. Especially in the years from 1980 to 1985 when so many things happened that changed my life, and things happened so quickly that it became one big blur. When dissected and put in a logical order, the "rise to success," as it is sarcastically called, is not as astonishing or "overnight" as it may appear.

The "social responsibility" that I find in my work is found in the LINE itself. The acceptance of my LINE is responsible for my acceptance as a public figure. The connection to "primitive" (I hate that word) culture is the key to understanding how and why my art became completely acceptable and quite natural in an age that finds itself technologically and

ideologically very far removed from these so-called "primitive" cultures. "Art," after all, is something that is at the very basis of human existence. The need to separate ourselves and connect ourselves to our environment (world) is a primary need of all human beings.

Art becomes the way we define our existence as human beings. This has a perverse air to it, I admit. The very idea that we are so different from other beings (animals) and things (rocks, trees, air, water) is, I think, a great misconception, but if understood is not necessarily evil. We know that "humans" determine the future of this planet. We have the power to destroy and create. We, after all is said and done, are the perpetrators of the destruction of the Earth we inhabit. No matter how slowly this destruction is occurring, no matter how "natural" this de-composition is, we are the harborers of this change.

We are not completely evil, however. There is a kind of excuse we conjure up for our destruction. We are human and we "understand" beauty. Jean Dubuffet delivered a speech at the Art Institute of Chicago that clearly explains the misconception of beauty embraced by the Western Culture. This speech, which I discovered in 1977 in Pittsburgh, I have read and re-read, and it is one of my favorite things written by another artist. This text and Robert Henri's *The Art Spirit* are the literary references of my philosophy.

I've read many other things and many informative texts (i.e., Nole's "Information Theory" and Eco's "Semiotics," etc.) but few have had such a simple, profound effect as these works by Dubuffet and Henri. Both were written decades before me, but each is relevant to contemporary art and, I presume, will be relevant forever.

Some things don't change. Everything goes in circles and repetition is a law of nature. People are the same (or similar) all over the world. Religion is a response to existence that is common to all cultures and all peoples everywhere. People

aspire to "believe" in something. People need this "belief" to explain and justify their existence. The different facets (or faces) of religion are different only because people are committed to the idea of "different" cultures and different "nationalistic values." The common denominator is always the same. Whether voodoo or Buddhism it all comes down to the same thing, really.

The same is true of art and culture, obviously. There is a common denominator that runs through all time, all peoples.

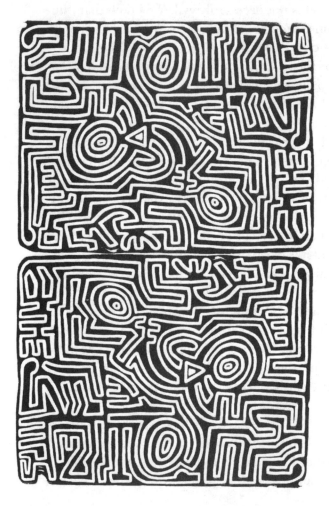

I keep thinking that the main reason I am writing is fear of death. I think I finally realize the importance of being alive. When I was watching the 4th of July fireworks the other night and saw my friend Martin [Burgoyne], I saw death. He says he has been tested and cleared of having AIDS, but when I looked at him I saw death.

Life is so fragile. It is a very fine line between life and death. I realize I am walking this line. Living in New York City and also flying on airplanes so much, I face the possibility of death every day.

And when I die there is nobody to take my place. There is nobody working now who is even vaguely similar to my style or attitude or principles. I mean that seriously. I suppose that is true of a lot of people (or everyone) because everyone is an individual and everyone is important in that they cannot be replaced. But, right now, there is nobody in the world who can be put into a group with me and called a movement.

My movement consists of only one person. There are several people whose work has similarities to certain aspects or features of what I am doing, but nobody has all of them.

Even Andy Warhol, who I am often compared to, is in fact a very, very different kind of artist.

Andy has been a big influence as an example of both what to be and what not to be. I have learned a lot of things from Andy about how to deal with people and how to deal with "the public" and the public's "image" of me.

Nothing is ever taught as a lesson, but by watching (observing) and quietly taking note. I have spent a lot of time with Andy watching and listening. Many of the lessons I have learned my whole life have been about what I don't want to do or be.

I don't really know exactly what I want to be, but I know what I don't want to be.

I think part of the reason I feel I have a "responsibility" as a public figure is that I know that there are always people watching . . . people that look up to you in a kind of way, especially young people. I would love to be a teacher because I love children and I think that not enough people respect children or understand how important they are. I have done many projects with children of all ages. My fondest memories are of these experiences. When I was 21 I spent a summer teaching "Art" at a day-care center in Brooklyn. It was the most fulfilling summer of my life. There is nothing that makes me happier than making a child smile. The reason that the "baby" has become my logo or signature is that it is the purest and most positive experience of human existence.

Children are the bearers of life in its simplest and most joyous form. Children are color-blind and still free of all the complications, greed, and hatred that will slowly be instilled in them through life.

I will never forget some of the adults who touched my life through my childhood. Sometimes very brief encounters have made an impact that is very lasting and very real. If it is possible for me to have that kind of effect on any children, I think that would be the most important and useful thing I could do.

Touching people's lives in a positive way is as close as I can get to an idea of religion.

Belief in one's self is only a mirror of belief in other people and every person.

I would love to do a book one day with photos of me all over the world with different children. Many pictures like this exist from every place I have visited. I always have had contact with children on some level during every exhibition in every country.

This is one of the things that I am thinking when I say there are aspects of my life and art that are not duplicated by any other artist that I know of.

I have letters from children all over the world that testify to this connection. I don't know if it is my funny face or my simple nature that provokes laughter and sympathy between me and them. But we share something that to me is very important to understand the reason for living and meaning of "life," if there is any "meaning" to life at all.

Children know something that most people have forgotten. Children possess a fascination with their everyday existence that is very special and would be very helpful to adults if they could learn to understand and respect it.

I am now 28 years old on the outside and nearly 12 years old on the inside. I always want to stay 12 years old on the inside.

I think it is very important to be in love with life. I have met people who are in their 70s and 80s who love life so much that, behind their aged bodies, the numbers disappear. Life is very fragile and always elusive. As soon as we think we "understand," there is another mystery. I don't understand anything. That is, I think, the key to understand everything.

People keep asking me how "success" has changed me. I always say that success has changed people's responses and behavior toward me and that change has affected me, but it has not really changed me. I feel the same on the inside now as I did ten years ago. I was as happy then as I am now.

Happiness cannot be measured in accomplishments or material gain. Happiness is on the inside. Success has done much more to affect me in a negative way than a positive way, however, I will not submit to this. I am as satisfied as I was before. I still have many shortcomings and many victories. I think nobody can be happy all the time. It is very strange to me that people expect "success" to equal happiness, even after they have seen all their media stars suffer and die and hurt themselves.

Money doesn't mean anything. I think money is the hardest thing for me to deal with. It is much easier to live with no

money than to live with money. Money breeds guilt (if you have any conscience at all). And if you don't have any conscience, then money breeds evil. Money itself is not evil, in fact it can actually be very effective for "good" if it is used properly and not taken seriously.

You have to be objective about money to use it fairly. It doesn't make you any better or any more useful than any other person. Even if you use your money to help people . . . that doesn't make you better than somebody who has no money but is sympathetic and genuinely loving to fellow humans.

Usually the people who are the most generous are people who have the least to give. I learned this first-hand as a newspaper carrier when I was 12 years old. The biggest tips came from the poorest people. I was surprised by this, but I learned it as a lesson. People on the streets of New York who give money to beggars are often people who have very little themselves. They don't expect anything in return. It is quite natural. Charity for the sake of making one feel better about oneself is not really charity.

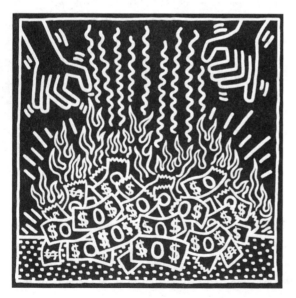

Anonymous gifts are the most honest and admirable.

I am certainly very far from perfect, and I don't want to sound like a saint. Everyone has shortcomings. Everyone has a side of them that is selfish and everyone has the potential to be evil.

Good and Evil are very hard to explain or understand.

I'm sure that evil exists, but it is hard to isolate. Good and evil are intertwined and impossible to separate. They are not completely opposites and in fact are often one and the same.

I'm reading Timothy Leary's autobiography, *Flashbacks*, which he gave me on a recent visit to Los Angeles.

A few weeks ago I had dinner with Timmy in New York and we talked about computers, drawings, etc. I might be doing some drawings for a new computer program he is developing.

He was commenting on how my drawings were perfect for translation into computers because the drawing line was already very close to the idea of "pixels" (the dots, or squares, that comprise a computer-generated image). I have already, I explained, used computers in Tokyo in 1983 and even earlier on a video-text machine at NYU in 1980. My main problem with the computer is the restriction of the image, in that it is always trapped inside this box (on a screen) and, except in the printing, is very limited in its scale.

I was, however, interested in the tactile experience of drawing, which is very different on a computer. Time-lapse (and/or spatial displacement) occurs when a "mouse" is used to draw. This displacement of image and action creates a new problem to be solved by the "drawer." The drawer then has the added ability to take the image and manipulate its color, size, and placement. The image becomes a workable entity restricted only by the limitations of the computer program, programmer, and the screen of the monitor itself.

There are endless possibilities to be investigated in this area. Maybe Timmy will be able to convince me to return to this investigation.

I know that it is true that I possess (because of the deductive, composite nature of my line) the ability to use computers very effectively. This line, which is both archaic and univer-

sal and futuristic (with its computer capacities), is a very "real" line.

It is, as Brion Gysin wrote, a line closer to a carved line than a drawn line.

I want to write to several of my friends (writers, scholars, etc.) and ask each to write a paragraph about this "line" I utilize. I think it would be interesting to hear Bill Burroughs, Brion Gysin, Tim Leary, Allen Ginsberg, Pierre Alechinsky, Robert Farris Thompson, etc., speak of this line.

It is a privilege to have met these people and have had the opportunity to talk with them. Especially since each had important influences on my work and now have expressed interest in this work. I, in turn, wish to acknowledge their contribution and try to understand my contribution as well.

JULY 15 OR 16 (I CAN'T TELL), 1986: DELHI, INDIA

I am sitting on an airplane in Delhi, on my way to Tokyo. There is one more stop in Hong Kong. I left the airport in Milano this morning. I went there via train through the Swiss Alps and spent the night there. There was a press conference to announce the unveiling of the "Statue of Liberty" painting I did in New York City with 1,000 high-school kids in June which will hang on the "Castle" in the center of Milano. This press conference was a little unsettling because of the way the presentation was made to explain and solicit "sponsorship" for the City Kids Coalition. This was all out of my hands, since I can't speak Italian and I'm not directly involved with the business aspect of this project. However, it becomes a reflection on me, so I was a bit uneasy.

The business aspect of sponsorship for projects of this kind—that are to benefit, ultimately, City Kids or other worthy causes—can be misconstrued and appear exploitative. It is a difficult area: I am involved because of my interest in the project and the people who will benefit from it, not to help promote

the financial support-
ers (in this case Burger
King or Benetton). But
the decision to partici-
pate or not is weighed
against the exploitative
side effects and in this
case, ultimately, I think
it is worth it to have
the project exist and to
have had the experi-
ence of a positive inter-
action with and lasting
effect on these 1,000
students and the peo-
ple who will see the

painting. Even though there is a risk of being manipulated or
exploited by the commercial sponsors. I realize I will receive
criticism but, again, I think the project itself was much too
important to worry about a little criticism.

As in all things: Time will clarify the events that are pres-
ently unclear.

This same issue comes up in any critical consideration of
my work and work ethic in general. I am sure that in time
mine will be understood to have been a very clear, selective,
hopefully intelligent, politically sound, humanistic and imag-
inative approach to the "role" of Contemporary Artists.

The press conference was also a good excuse to see a lot
of friends in Milano who I haven't seen in a while. Daniela
Morera, Nally Bellati, Lisa Ponte of Domus, etc.

And Nicola Guiducci, who kept me out till 4:30 in the
morning drinking champagne and doing coke.

Then I left for Roma. In the airport there I was changing
my prepaid economy-class ticket to first-class when I noticed
the lady in front of me had a Grace Jones photo in her note-

book. I was tempted to ask her about it and then I saw she had Grace's passport. So I got to see Grace for 15 crazy minutes in the airport, she on her way to New York City for the premiere of "Vamp" (the movie I painted her for a strip-tease scene in) and I on my way to Tokyo. The series of events and accidents that led up to the "coinciden-tal" meeting reassures me that I am still in tune with the universe and traveling the right path.

My belief in "chance" and destiny has led me right so far, and whenever things like this remarkable "coincidence" happen, I'm reassured that I'm still on target.

I want to take a break now to write a letter to Timothy Leary. I just finished reading his autobiography somewhere over northern India at 600 miles per hour. It has changed my life . . . again.

Delhi, India
July 15 or 16, 1986

Timothy—
I'm writing to you on an airplane refueling in Delhi en route to Tokyo. I just finished reading *Flashbacks* in the air over northern India traveling at 600 MPH at an altitude of 29,000 feet. Rather appropriate, no?

Funny, but I began reading it in Montreux, Switzerland, which, now that I've read it, is also appropriate. I had no idea of the complexity and length of your story. It changed my life. I mean, I was born in 1958, so while I was growing up I was only aware of the events of the early Sixties through a strange mixture of sources filtered through the protective guard of my parents. I got most of my information through television, *Life* magazine pictorial essays and some associations with enlightened relatives. I was very absorbed and interested, however, and I think affected at a time when my personality and ideology were in their most "affectable" or impressionable stages.

Quite honestly, I have never before read anything you have written, but had a kind of "blind respect" from the bits and pieces of things I knew about you.

I was very overwhelmed by the book and felt compelled to make contact. I can't wait to have a long conversation with you without the distraction of the "party" settings we have met in so far.

It is too much to go into now in a letter, but I have a lot of things I want to share with you about my personal development and self-discovery that were happening while you were making history.

All of a sudden (now) some things became clear to me in a way that was similar to my introduction to the work of William Burroughs and Brion Gysin in 1978. I mean, that things that existed in my head as ideas I thought to be my own were given form by

seeing their embodiment in the life and work of someone else.

It is hard to believe I only discovered Burroughs, Ginsberg, etc., in 1978. I "accidentally" stumbled across the Nova Convention at the Entermedia Theatre in N.Y.C. and the effect was astounding to me.

Like my "accidental" meeting with Andy Warhol and Pierre Alechinsky's work and N.Y.C. graffiti and Grace Jones and you.

To name a few.

I sent you, yesterday, from Montreux, two drawings I did in my hotel there. I wanted to send them to you because they were important to me and after being absorbed in *Flashbacks* I felt compelled to give them to you. I don't know how much about my work you know. I'm also sending a catalogue from my exhibition at the Stedelijk Museum (Amsterdam), which you probably haven't seen.

The drawing of Grace at Paradise Garage is my first drawing of Grace. I have drawn "on" Grace but never drawn her. The drawing is from a photo you will see in the Stedelijk catalogue that was taken during her performance at Paradise Garage (which is where I met you—while I discussed with Grace the preparations for the performance). I don't know if you know how important the "Paradise Garage" is, at least for me and the tribe of people who have shared many a collective spiritual experience there. The "Garage" also changed or affected my life incredibly through various "re-imprinting" experiences and transformations.

I "discovered" the Garage by divine "accident," of course, like I "discovered" the Grateful Dead in 1975.

There is too much to explain to put in writing: my first LSD experience at 15 and consequent trips in the fields surrounding the small town where I grew up in Pennsylvania. The drawing I did during the first trip became the seed for *all* of the work that followed and that now has developed into an entire "aesthetic" view of the world (and system of working).

The effect that the re-programming had on my life at 16–17–18, which made me find new friends, leave Kutztown, see "God" and find myself (with complete confidence) inside myself and believe in this idea of "chance," change and destiny.

While I was in the airport this morning in Roma I was changing my ticket from economy to first class and because of "complications" was at a special ticketing counter when I noticed the lady aside of me had Grace Jones' passport in front of her.

Grace was in Rome for a week taking a break from recording, and was about to catch a plane to New York for the premiere of "Vamp." We spent 15 crazy minutes waiting together for our planes, her to NY, me to Tokyo.

This incredible "coincidence" made me aware that I was, again, in tune with the universe and whatever "destiny" collides people's lives together was still at work and I am still "on target."

It is with deepest admiration that I write to you, and feel with conviction that our meeting was another of these "coincidences" that will bear great fruit.

I am now more excited and enthusiastic about finding a way to work together on a computer program or at very least sharing some time "exchanging" and "exploding" some ideas together.

Thank you, and I look forward to seeing you and Barbara and Zack (and your horny dog) at my first convenience. (If not sooner.)

Love,
Keith

JULY 26, 1986

I am sitting at the airport in Milano waiting for Juan [Rivera] to arrive from New York (Juan No. 2).

I arrived back in Milano two days ago after the Tokyo trip.

When I arrived in Tokyo I learned that Brion Gysin had died. I hope that he is safe. I sent a drawing from Tokyo that I had made to be buried with his body at the cremation ceremony last week. I found out yesterday that the person the drawing had been sent to had a mental breakdown. So who knows what happened to the drawing.

I remember Brion telling me, more than once, about how frightened he was about death for the simple reason that he pondered the possibility of having to repay for all the things he had done, said, written and painted in his life. What if God is, after all, a woman—a very angry woman?

I'm sure he's fine. I think a lot of people learned a lot of things from Brion. Unfortunately much of his importance has gone unnoticed or at least unacknowledged. I feel lucky

to have met him and enjoyed a few years of his long life. He is a legend.

Brion's writings and especially his paintings have helped me understand myself and my work in a very important way. He was difficult to keep up with. A kind of saint from the underworld (or other-world)?

He understood my work (and life) in a way that only he could, because he lived it. His paintings give my paintings historical precedent.

He has been called the "grandfather of graffiti" because of his "writing paintings." Crossing the gap between East and West, he turned calligraphy into a kind of surrealist writing. From his expulsion from the Surrealist group by André Breton (for being gay) to his years spent in Morocco and Paris he has been an "outsider." Usually written out of history instead of in.

Brion sometimes complained of this sort of conspiracy of un-acknowledgement, but I think inside it was the source of a kind of private personal satisfaction. Being popular, he knew, has its drawbacks. In a way, his purity and "otherness" was preserved and almost exalted by being "the outsider." As usual, time will tell: He and his contributions will be respected for generations to come.

It seemed to me that Brion had done . . . everything (been everywhere) and somehow come out on top, but not knowing which end the top was on.

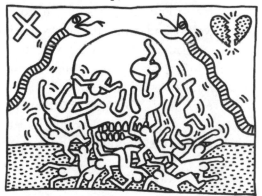

I will miss Brion, but I hope he lives on, in a way, through me and through the things I learned from him. If I could accomplish a portion of things he has, I would be happy.

The Watch Story

I forgot to write down the Timothy Leary watch story (or stories).

Timmy got a watch as a present from his wife, Barbara, before he had met me. Consequently, during a trip to L.A., I visited their house, after a timid invitation by Barbara. I say timid because she said she had something she wanted me to see, but was hoping I wouldn't be mad. I was curious. It turned out she had painted their dining room table *à la* [sic] Swatch with my figures running around the top of the table. I was flattered and surprised, not angry.

Sometimes this kind of transformation is the most interesting thing for me to see. Like the "break-dancer" graffiti I saw in Milano yesterday that is in the manner of Haring. I love seeing my drawings re-drawn by admirers and making the images become part of the universally available IMAGE BANK. It makes them become an undeniable "fact."

The Second Watch Story

Timmy tells this great story about a recent confrontation with some campus police at an over-filled lecture hall in a conservative university. The police wanted him to stop his lecture because the over-capacity crowd was a "fire hazard." When these students rejected the idea of ending the lecture, tension started building. Timmy had to talk to the police to try to find another solution, to find a way to continue the lecture and defuse the confrontation.

Timmy was having a heated argument with the "captain" of the campus police when the policeman stopped in mid-sentence. He'd noticed Timmy's Keith Haring watch and exclaimed, "Oh, that's a great watch." Timmy explains this as the "power" the watch had to catch the attention and change the mood of "even" this angry cop.

1986

Solo Exhibitions

Dag Hammarskjöld Plaza Sculpture Garden, New York City
Stedelijk Museum, Amsterdam, Holland
Art in the Park, Whitney Museum of American Art, Stamford, Connecticut
Galerie Daniel Templon, Paris, France

Group Exhibitions

Life in the Big City: Contemporary Artistic Responses to the Urban Experience, Rhode Island School of Design, Providence
An American Renaissance: Painting and Sculpture Since 1940, Fort Lauderdale Museum of Art, Fort Lauderdale, Florida
Spectrum: The Generic Figure, The Corcoran Gallery of Art, Washington, D.C.

Masterworks on Paper, Galerie Barbara Farber, Amsterdam, Holland

American Art of the Eighties, Phoenix Art Museum, Phoenix, Arizona

Sacred Images in Secular Art, Whitney Museum of American Art, New York City

Surrealismo, Barbara Braathen Gallery, New York City

Gabrielle Bryars Gallery, New York City

Linda Ferris Gallery, Seattle, Washington

Vienna Biennial, Vienna, Austria

Havana Biennial, Havana, Cuba

Contemporary Arts Center, New Orleans, Louisiana

Television's Impact on Contemporary Art, Queens Museum, New York

Thomas Cohn Gallery, Rio de Janeiro, Brazil

The First Decade, Freedman Gallery, Philadelphia, Pennsylvania

Contemporary Screens: Function, Decoration, Sculpture, and Metaphor, The Art Museum Association of America, San Francisco, California

What It Is, Tony Shafrazi Gallery, New York City

Special Projects

Paint set on MTV during guest appearance of Duran Duran, New York City

Paint permanent murals at Mount Sinai pediatrics ward, New York City

Collaborate with Brion Gysin on *Fault Lines*

Collaborate with Jenny Holzer on billboards for Vienna Festival 86, Vienna, Austria

Body-paint Grace Jones for feature film *Vamp,* Los Angeles, California

Paint 90′ × 90′ outdoor mural, Amsterdam, Holland

Children's drawing workshop, Stedelijk Museum, Amsterdam, Holland

Open Pop Shop, retail store, 292 Lafayette Street, New York City

Create background art for Run DMC/ADIDAS tour poster

Design set for *The Legend of Lily Overstreet,* Limbo Theatre, New York City

Drawing workshop, Children's Museum of Manhattan, New York City

Collaborate with 1,000 New York City youths on 6-story *CityKids Speak on Liberty* banner, dedicated on July 2 for Statue of Liberty centennial celebration

Create mural for Club DV8, San Francisco, California

Paint *Crack is Wack* murals, New York City

Paint permanent murals at Woodhull Hospital, Brooklyn, New York

Collaborate with Grace Jones on *I'm Not Perfect* video, Paris, France, and New York City

Paint mural at Jouets & Cie toy store, Paris, France

Paint 300' mural on Berlin Wall, West Germany

Collaborate on outdoor mural with Phoenix, Arizona, schoolchildren, Washington and Adams Streets, Phoenix, Arizona

Books & Catalogues

An American Renaissance: Painting and Sculpture Since 1940. Text: various authors (Abbeville Press, New York)

Keith Haring: Paintings, Drawings and a Vellum. Text: Jeffrey Deitch (Stedelijk Museum, Amsterdam, Holland)

Art After Midnight: The East Village Scene. Text: Steven Hager (St. Martin's Press, New York)

Input/Output. Editors: Time-Life Books (Time-Life Books, Alexandria, Virginia)

What It Is. Editor: Wilfried Dickhoff (Tony Shafrazi Gallery, New York)

Art in Transit (Japanese Edition). Introduction: Henry Geldzahler; text: Keith Haring; photographs: Tseng Kwong Chi (Kawade Shobo Shinsha, Tokyo, Japan)

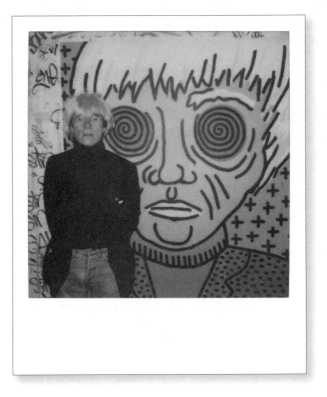

1987

Sitting outside in shorts on a porch painted yellow and blue with blue tables and chairs with lots of flies trying to make myself start to write.

I've been to Brazil for three weeks already and haven't written anything yet. I read *Neuromancer* by William Gibson and *The Autobiography of Malcolm X* and *Extermination* by Bill Burroughs and re-read Brion Gysin's *The Last Museum*. I painted a few paintings on the walls of Kenny's house on the beach outside of Ilheus.

And then I found out Andy Warhol had died. Since then it has been hard to think of anything else. This sort of changes my schedule.

I'll return to New York on March 16 and go right away to Europe. To Belgium to check out the place I'm supposed to have a

show in June in Knokke and then to Germany to work on sculptures in a steel factory outside of Düsseldorf (I'm supposed to be making the maquettes now) and then to Munich to put the finishing touches on the Carousel for Luna Luna, the artists' amusement park. Then return to N.Y. in time for Andy's memorial on April 1. Then I get to stay in N.Y. and paint a painting for Mr. Chow's new restaurant in Kyoto and finish the sets/costumes for the dance piece with Jennifer Muller and Yoko Ono. After the opening night of that piece, April 21, I leave for Europe. Again.

[I'm going] for a group show at Beaubourg in Paris and to do a mural at a children's hospital there and to work on the sculptures in Germany and then to Tokyo to judge a sculpture competition for Parco. Supposedly designing street signs for some new streets in Tokyo, also.

Then back to Europe or America till June 1, when I have to be on TV in Brussels or Antwerp and open a show in Antwerp on June 4. June 5, Luna Luna opens. Then stay in Europe for opening of Knokke show and sculpture project

and maybe to do a mural in a building in Düsseldorf.

That is it up till July and for now that is all that is planned.

This gives me sufficient time to stay busy and keep my mind and body occupied—and keep my mind off of what is disappearing around me. After Bobby Breslau died in January, I had to start to deal with a new sit-

uation of aloneness. Bobby was always a kind of guiding (aesthetic) spirit to help keep me on the right path for the last few years. His opinion was highly regarded and I respected his taste and judgment. Ultimately it was my decision, always, but his strong opinion helped sway those decisions. There cannot be another Party of Life without Bobby, although we (Bobby, Julia Gruen and I) had already decided we wouldn't do one this year. It changes things in a funny way. It's kind of like a bird getting thrown out of the nest. The last few years especially have been important and challenging times to make the right choices and chart the right path. Bobby and Andy were instrumental in helping shape that path.

Bobby was a saint that was sent as a messenger and protector, like Jiminy Cricket to Pinocchio. He knew everybody and introduced me to other key people in my life, like Grace Jones and Larry Levan. It wasn't so much Bobby's introduction, but his support and endorsement that won for me the immediate respect of the people he introduced me to. He had been living in N.Y. his whole life and had been on the "scene" since the Sixties. Everyone that knew Bobby respected his opinion. He had worked with Stephen Burroughs at the height of his career in the Seventies. And then in the early 1980s he met me and adopted the role as my guide and protector. Bobby was the perfect screen to throw ideas against. His reaction, whether positive or negative, whether followed or contested, was always a very concrete reaction and very strong opinion. Although we sometimes disagreed about things, the very fact that we did disagree helped me to clarify my confidence in my opinions or decisions.

He never judged me, but often disciplined me and would not hesitate to tell me if something was in bad taste or bad manners. He would never lie to me whether he had been advised to or not. I remember on occasion Bobby sitting beside me at my desk and dialing a number and handing me the

phone, before I had a chance to protest or think twice, so that I would have to speak to the person on the other line whether I liked it or not, and was forced to "thank them" or "deal with it" or "tell them what you think," like I knew I should have in the first place.

He pushed with a strong but gentle arm, and a sharp but tactful tongue. And when he liked something he was never subtle in showing his praise. The ultimate sign of approval was the little "dances," as Benny Soto called them, when he would enter the studio, see a painting, and jump up and down and clap his hands. "Way to go, kid." Or "You did it again, kid." Always encouragement and support.

And not only for me. Bobby helped many with his insight, advice, opinions, and encouragement and support. From models to designers, to artists to dancers to performers, musicians, photographers, business people, and just plain friends.

He was quick to suggest available opportunities and options and offer confidence for any projects you were considering. He made this his role in life and never complained. At the same time he was an extraordinary artist and craftsman himself. The framed letter from Diana Vreeland hanging in his apartment was a testimony to this. She said, "You are to leather what Cellini was to gold." His leather work was incredible in design and execution. The leather "baby" he made for me was later a prototype for the "inflatable baby" we made in Hong Kong. It was incredible to arrive home to my new apartment on Sixth Avenue in December and find the new set of "Bobby Pillows" he had made to match my leather couch. It was the last thing he made for me, and they are really beautiful.

Bobby was also the guiding light behind the Pop Shop. He respected my limited interest in "making money" and understood, as I do, the aesthetic reasons for the Pop Shop's existence. The Pop Shop is an extended "performance" and even

though Bobby tried to make it "make money," he never pushed me and never questioned my own personal goals and reasons for doing the Shop. Although our opinions differed, we understood each other and respected each other.

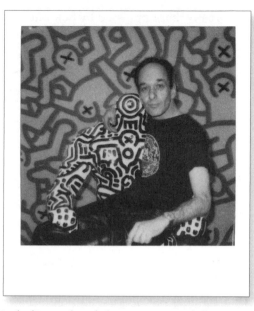

I remember one of the last meetings Bobby and Julia and I had before Bobby went into the hospital. We were discussing the "career-minded" goals of the manager of the Pop Shop, and his misunderstanding of my personal goals for the Pop Shop. Bobby explained that he "always had a good feeling" about my incentive for starting the Shop and "understood" why I wasn't so interested in making money. Very few people understand why someone would want to open a shop and not make money. I don't think Bobby had worked for anyone like that before, but he respected my attitude and went along with it. He let me know he thought I "knew what I was doing."

Bobby had an artist's sensibility and sensitivity. He was also my eyes and ears. He was always the first to find me in the *New York Times* and the *Post*. He was always clipping articles of interest and bringing me tapes to listen to. He could "sense" talent. One time a few years ago we went to a party at the Limelight for one of the Jacksons. There was a young singer who we had never heard before who performed. He kept telling me how great he thought she was. I wasn't

really that impressed by her, but he was really adamant about it. Well, he was right, as usual. She was Whitney Houston.

Losing Bobby meant a new responsibility to not only go forward without his assurances, but also to try to fill the gap he left by continuing to give support to other people that need it.

The last thing in the world I expected to hear after I left for Brazil was that Andy died.

Andy was the complement to Bobby's support. He was the other assurance that what I was doing was on the right track. I mean, it's not as if there aren't any more people that support me and give me confidence, it's just that Bobby and Andy were probably the main two.

Andy's life and work made my work possible. Andy set the precedent for the possibility for my art to exist. He was the first *real* public artist in a holistic sense and his art and life changed the concept we have of "art and life" in the 20th century. He was the first *real* "modern artist."

Andy was probably the only *real* Pop artist. One thing that I was most impressed by in a recent show at the Dia Foundation of the "Disaster" series was a paragraph in an accompanying pamphlet about the paintings. It was a quote from Lawrence Alloway about Pop Art, saying how in the beginning of Pop there was a breakdown and fusion of life and art (a celebration of popular culture) that was first embraced by Pop artists. Then little by little the painters withdrew from this area and took their ideas back into the form and arena of the art "establishment." This, it said, is the point where Andy separated from the rest of the group and remained true to the original ideas of Pop Art.

Andy remained a Pop artist. He reinvented the idea of the life of the artist being Art itself. He challenged the whole notion of the "sacred" definition of Art. He blurred the boundaries between art and life so much that they were practically indistinguishable.

He addressed the phenomena of the camera and recorded image in a way that Duchamp only hinted at. He challenged the whole commodity-oriented direction of the Art world by beating them at their own game. He became a teacher for a generation of artists now, and in the future, who grew up on Pop, who watched television since they were born, who

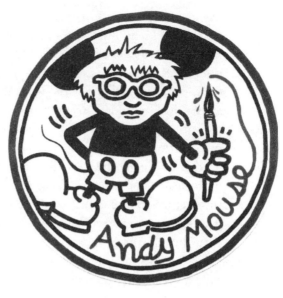

"understand" digital knowledge. I honestly think he was the most important artist since Picasso, whether people like it or not, and a lot of them don't. The museum and auction worlds didn't know how to deal with him. The "value" of his work was not equivalent to the "market value" of his works. Conceptually, he was certainly much more important than Johns or Lichtenstein, but his prices never equalled theirs because he didn't play "the game" by the rules.

I was continually getting compared to Andy, but I don't know if it was for the right reasons. For me, it was an honor to be compared to him even though I feel we are very different and our contributions are different.

But I will always acknowledge my debt to him. The biggest honor was the support and endorsement he bestowed upon me. By mere association he showed his support. When we began to trade works we traded value for value, but quickly as we became friends we began to trade work for work (one for one instead of disproportionate amounts). I learned a lot of things from Andy in the five years we were

friends. He prepared me for the "success" that happened to me while I knew him, and taught me the "responsibility" of that success. He taught mostly by example, but would often offer ideas and suggestions, sometimes humorous and sometimes serious. During the last few years he was one of the few artists that I could really talk to about some of the things I was attempting to do. Also, he was one of the only artists whose studio would inspire me to work more and work harder. Ironically, he was the one who convinced me to be more health-conscious and aware of my body. When I was at the Factory and he could do more push-ups than me, I knew it was time to start working out. He was always interested in everything I was doing and was totally plugged in to everything that was happening around him. He didn't, however, only take; he gave as much as or more than he took. He was the personification of New York.

It is hard to imagine what N.Y. will be like without Andy. How will anybody know where to go or what is "cool"?

Selfishly, I feel like I will lose more than most. I lost a friend, a teacher, and the biggest supporter in the real Art World.

Like Bobby, Andy was the reassurance I looked forward to for the difficult course I am charting. He set the precedent for my venture into the commercial world and the popular culture. He is the validation for a kind of "seriousness" or "realness" that is balanced on the tightrope I am walking between "high" and "low" art. His support made me oblivious to the critic cultures waiting for a wrong move and anxiously anticipated fall. His understanding was more valued than any art critic's. Most critics only write to defend their own ideas and previous statements, anyway.

Andy practically convinced me to open the Pop Shop when I started to get cold feet. He always added his support to a new idea or venture. He further showed his support for

the Pop Shop by creating a T-shirt for it and plugging it at any opportunity.

He got jobs for me, he directed collectors to me and continually traded works.

I feel like I have a responsibility to try to continue the things that he inspired and encouraged. There isn't anyone else who can pay homage the way that I can. At least,

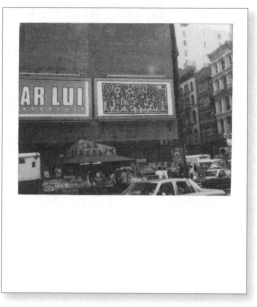

nobody I know of now. There have to be new artists coming up somewhere, but right now there is nobody. It is not an easy venture and it will be even more difficult without Andy or Bobby, but it is worth whatever risk is involved and it is an honorable undertaking, whether it is understood now or not.

In time everything will become clearer. I hate sounding pretentious or egotistical, except that I really never thought anyone understood how to build on Andy's achievements, except Andy, and maybe me. Not only in a formal way, but conceptually and with the same holistic approach and attitude. His visual vocabulary and technical means and especially the actual "look" of his art (his line, his "graphic" sense) determined and made possible the wide range of applications and complexity of his "art" and its integration into the popular culture. His graphic quality in painting preceded and predetermined the possibility of using the silkscreen process. Conceptually the photos, films and photo

silk-screens inevitably addressed the commercial world and the mass media. He gave a philosophy to the modern value system of images. The "value" of "pictures" and images.

All of the philosophy of "fame and success" and all of the portraits and films and talk of "machine art" and "business as art" and all of the personification of what became known as Pop Art was born of his honest evolution of his early graphic sensibility. The work naturally "happened," and the things that followed were inevitable.

This is where I think I share the most with Andy. I think the work I am doing and the direction my life and career have taken was completely determined by my graphic sensibility (my drawing style) and a careful evaluation and understanding of what that is and what it possesses within itself that determines its evolution. It's about understanding not only the works, but the world we live in and the times we live in and being a kind of mirror of that. I think it happens really naturally and inevitably if you are honest with yourself and your times.

That is the reason I have the Pop Shop and why I can do a video for Grace Jones and why I can use computers, design sculpture parks, vodka ads, and make paintings without it contradicting itself. The line determines the work. The philosophy and attitude of the early work (i.e., the subway drawings, public murals, graphic contribution) determined the public-ness of the work. Popular culture ingests it whether I like it or not.

But of course I liked it, because that was the whole intention of the art: to affect and enter the culture by understanding it and reflecting it; to contribute to and broaden the concept of art and the artist as much as possible. Artists help us understand ourselves and our times through pictures, parables, and actions. Andy understood that better than anybody. His life was his art and his art was his life. They were practically indistinguishable.

Andy understood the idea of "modern" art, really "modern." He lived a totally "modern" life. I think he reinvented "modern" art.

Andy had an incredible sense of timing. One thing I learned from going to a lot of parties and "social" events with Andy was that he always arrived at the right time. He'd always arrive when the party was in full swing, but before the peak. In fact, his entry would often be the height of the party and the signal that the party had actually "started." His exits were equally well timed. I would often catch him slipping out without saying goodbye. It was, of course, too difficult to try to say goodbye to *everyone*, so he'd just leave when nobody would notice and then people would slowly realize and start saying, "Andy's gone, when did he leave?" He didn't want his exit to signal the "end" of the party, so he quietly slipped out when we least suspected it . . . mysteriously and with style. He left like he had left hundreds of parties . . . unnoticed leaving, but instantly missed; his absence both bewildering and unexpected. The party goes on, but something will be different. Andy is gone and I miss him already.

MARCH 28, 1987:

On a plane from Düsseldorf to New York City
A continuing contemplation brings me to the conclusion that all of this problem of "the surface" of painting stems from an inability to paint or to create an image of adequate strength. Even old painters were not obsessed with this problem of the surface. They are, in fact, quite thin. The illusion is created with color, perspective, space, composition, etc.

The current preoccupation with the surface, I think, stems from the painter's inability to deal with the painting as an image itself.

Andy Warhol is a perfect example of the minimum requirement to create an image of timeless and monumental quality.

All of the unnecessary application of wax, straw, towels, broken plates, chairs, utensils and wood constructions, which serve to "build up" the surface, is merely an excuse for not knowing what to paint!

Most "modern" painting is lost in formal investigation, which better serves a pursuit of "science of materials" than a true pursuit of images and intervention, and art.

Any "real" intervention in the culture is beyond the limitations of materials and "formal elements."

Material should be at the service of the painter, not a prerequisite to the painting itself.

Broken plates, straw, wax, and wooden constructions are only an excuse, and do not constitute an evolution of ideas. It is quite easy to "invent" new areas of discussion of "the surface" through artificial means. It is only a diversion from the real import of the thing itself.

Art is, after all, about the image we have before us, the lasting impact and effect that image has on us, not only the ego of the artist whose obsession with himself prevents him from seeing the larger picture.

Julian Schnabel is not a genius. He's probably not even a great painter. I'm sure that he is interesting today in a limited capacity and he is very interesting for collectors and dealers, but in the long run, his contribution is slight. Joseph Beuys has already explored most of the territory of the ambiguous figurative abstraction that Julian Schnabel pretends to have invented.

Certainly his paintings can sometimes allude to "new inventions of nature" or things we have never seen before (new forms, etc.). However, what is this? Is this new, or even interesting?

His own conviction of his "importance" makes him even more difficult to digest. His obnoxious insistence on his importance disgusts me to the point of nausea. If he again

attempts to make one of his self-referential speeches at Andy's memorial on Wednesday, I promise I will do my best to end his speech as quickly as possible. Andy hated his speeches and would *never* have wanted him to speak at his memorial.

Speaking of memorials . . .

After "accidentally" running into George Condo in Munich (I went there for Niki de Saint-Phalle's show, but mostly to meet Jean Tinguely at his opening). The funniest thing was the big fat German ladies standing in front of Niki's sculptures looking exactly like the big fat sculptures! Jean was fun as usual! Very fast and very fun. He brought masks to the boring lunch and turned the atmosphere around immediately!

Jean has made, finally, a sculpture for me in trade for a painting I did in Lausanne in 1983 or '84. It was a two-sided painting I did as a "performance" in the museum during a show of "New Art" from America.

Anyway, George Condo's show was quite incredible and very *George*! He's still my favorite painter, with, of course, Jean-Michel Basquiat, still the *M* of art . . .

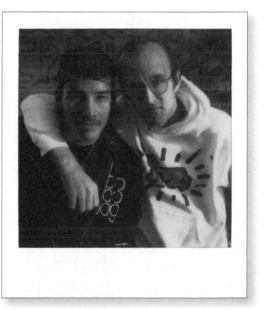

Anyway, the reason I started to write this (about memorials) was that in the supplement to George's catalogue, there was an interview I read in the airplane from Munich

to Düsseldorf. At first I was quite depressed because I was sure that I was not an intellectual after reading George's interview. However, a few days of thought made the difference between our pursuits much clearer. And there is a *big difference*. We share some things, but much is different.

Anyway, there is one question George is asked about *life* and *art* and which is more important, and George said *art* is more important because it is immortal. This struck a very deep note inside me. For I am quite aware of the chance that I have or will have AIDS.

The odds are very great and, in fact, the symptoms already exist. My friends are dropping like flies and I know in my heart that it is only *divine intervention* that has kept me alive this long. I don't know if I have five months or five years, but I know my days are numbered.

This is why my activities and projects are so important now. *To do as much as possible as quickly as possible.* I'm sure that what will live on after I die is important enough to make sacrifices of my personal luxury and leisure time now. *Work is all I have and art is more important than life.*

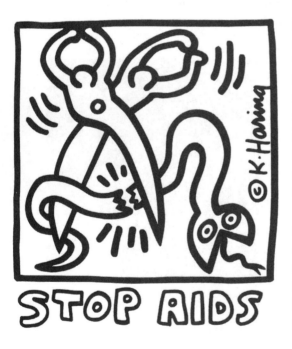

STOP AIDS

Look at Andy. All of a sudden he is gone. All I have to remember and keep him alive is all of the *things* he left. Everything, *every* memory becomes in-

valuable, timeless. *But the "things" will survive me, the memories will die with me.*

I'm not really scared of AIDS. Not for myself. I'm scared of having to watch more people die in front of me. Watching Martin Burgoyne or Bobby die was pure agony. I refuse to die like that. If the time comes, I think suicide is much more dignified and much easier on friends and loved ones. Nobody deserves to watch this kind of *slow death*.

I always knew, since I was young, that I would die young. But I thought it would be *fast* (an accident, not a disease). In fact, a man-made disease like AIDS. Time will tell, but I am not scared. I live every day as if it were the last. *I love life.* I love babies and children and some people, most people—well, maybe not *most*, but a lot of people!

I've been very lucky so far; luckier than many. I don't take it for granted, I assure you. I appreciate everything that has happened, especially the *gift of life* I was given that has created a silent bond between me and children. Children can sense this "thing" in me. Almost all children have a special sense of this "thing" in other people. *They know.* Some special people also know these things. Most of my friends are this kind of person. Juan Rivera is this kind of person. That is why I love him, I'm sure. I've always been attracted to these special people. It is this quality that separates me from other artists. Maybe you don't understand this now, but you will. I am different.

Many artists have this understanding of the world that separates them from it, but only some of them are truly special in a way that they can touch other people's lives and pass through them. I'm sure when I die, I won't really die, because I live in many people.

Spirits travel without limits. Andy is in me now. I knew before he died that he would never really die. He lives inside many people. He understood all of these things.

Most people never give him credit for this. He has an outward image of a manipulator, a "user" of people. In fact, the opposite is true—people used him and he let himself be used. He wanted to make things better for everyone else. He helped a lot of people to see themselves. He was not transparent, but maybe a mirror. Nobody can be responsible for other people's lives. Everyone ultimately charts their own course.

You can only help and encourage people to live for themselves. The most evil people are the people who pretend to have the answers. The fundamentalist Christians, all dogmatic "control religions," are evil. The original ideas are good. But they are so convoluted and changed that only a skeleton of good intentions is left. . . .

Most of the evil in the world is done in the name of good (religion, false prophets, bullshit artists, politicians, *businessmen*).

The whole concept of "business" is evil.

Most white men are evil. The white man has always used religion as the tool to fulfill his greed and power-hungry aggression.

Business is only another name for control. Control of mind, body and spirit. Control is evil.

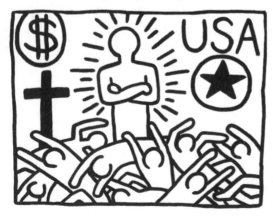

All stories of white men's "expansion" and "colonization" and "domination" are filled with horrific details of the abuse of power and the misuse of people.

I'm sure inside I'm not white. There is no way to stop them, however. I'm sure it is our destiny to

fail. The end is inevitable. So who cares if these pigs kill me with their evil disease, they've killed before and will continue to kill until they suck themselves into their own evil grave and rot and stink and explode themselves into oblivion.

I'm glad I'm different. I'm proud to be gay. I'm proud to have friends and lovers of every color. I am ashamed of my forefathers. I am *not* like them.

Today I read in the *New York Times* that all of the officers who killed Michael Stewart were *again* dismissed of charges.

Continually dismissed, but in their minds they will never forget. They know they killed him. They will never forget his screams, his face, his blood. They must live with that forever.

I hope in their next life they are tortured like they tor-

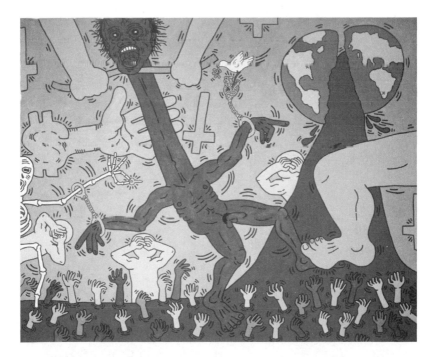

tured him. They should be birds captured early in life, put in cages, purchased by a fat, smelly, ugly lady who keeps them in a small dirty cage up near the ceiling while all day she cooks bloody sausages and the blood spatters their cage and the frying fat burns their matted feathers and they can never escape the horrible fumes of her burnt meat. One day the cage will fall to the ground and a big fat ugly cat will kick them about, play with them like a toy, and slowly *kill* them and leave their remains to be accidentally stepped on by the big fat pig lady who can't see her own feet because of her huge sagging tits.

An eye for an eye . . .

I'm not afraid of anything I'd ever done.

Not ashamed of anything.

MAY 11, 1987: TOKYO

The first parts of this are being rewritten from notes taken since the beginning of the trip. This is the first time I've had time to write.

APRIL 22

Leave New York City at 7:30 PM for Paris. Came to airport in limo with Adolfo Arena. Smoking pot all the way to the airport.

Traveling with Juan and Kwong. Take two Valiums and sleep almost all the way to Paris.

APRIL 23

Arrive in the morning. Took a taxi into Paris to drop off the Beaubourg canvas (to be painted) and some luggage. Called George Condo at Vendôme Hotel. Also Hôpital Necker wanted a meeting so we rushed over and had a meeting with

the people there. There were several painting experts(?), and we met the hospital directors.

Hôpital seemed a bit apprehensive about what I would paint. They had only seen some books/catalogues and were a little worried. I drew a quick sketch and explained why I didn't work from "exact" plans or sketches. They seemed a bit more "assured." Chose paint colors. Then went back to meet Juan and Kwong and caught taxi to airport for 3:00 PM flight to Düsselfdort.

Arrive in Düsseldorf at 4:00 PM. Picked up by Hans Mayer. Go to gallery and then immediately to factory in Essen at 5:00 PM. We see the cut-outs of maquette of "Red Dog for Landois." Looks O.K.

APRIL 24–11:00 AM

. .

Meeting with Hans and executive from Mercedes-Benz at Mercedes plant in Düsseldorf. Discuss possibility of Mercedes painting my sculptures. Tour the plant. Pretty incredible.

Two PM return to factory in Essen to attempt to construct maquette. Seemed impossible at first. Ancient roller (portable) borrowed to attempt to roll the steel. Discouraging after having worked at Lippincott.

Eventually we get some satisfactory results good enough

at least to indicate the exact radius, position, etc., of final maquettes.

Return to Düsseldorf for meeting with Helge Achenbach to discuss mural at new headquarters of BBD&O (huge advertising agency, I'm told) and meet one of the presidents of BBD&O. Looks O.K.

Then (surprise), dinner with the man Helge Achenbach is trying to get me to do carpet with. Sneaky surprise, but unavoidable. I told him I would only do it if Sol Lewitt will do it, since they say Sam Francis and David Hockney have already agreed and they say Sol will do it. I don't believe it for a minute, so I agree to do it only if Sol does. I'm sure he won't.

But if he does it, I will.

Had told Hans of the mural the evening before and he expressed concern (justifiably) over Achenbach. Hans thinks Tony Shafrazi should be involved. I don't really think so since Tony sometimes has a way of fucking up projects like this by over-complicating them, but to appease Hans I called Tony and suggested he have a meeting with Achenbach and share in the percentage. So of course *everyone* is making money off this and I am doing the work . . . again.

APRIL 25

Call Julian Schnabel at hotel (he's in same hotel) and arrange to see him at his show. He's installing a show at the museum. It looked good.

Buy a postcard of my mural from New York City I hadn't seen before and sign copies of books in bookstore after I am recognized.

Drive to Netherlands to see museum with Hans. Possible place to show the big sculptures. Great sculpture gardens. Huge. Great Dubuffet, Oldenberg and lots of Lipchitz. Incredible Van Gogh collections all hanging salon-style, side

by side, packed together because main building was getting repainted or under construction. Funny situation. It made them all look like cheap imitations because of how they were hung, Manet and Renoir and Mondrians all mixed up, side by side and only inches apart. Funny how important "space" is . . .

When their "importance" is reduced and they're forced to compete with each other they are not so "grand" anymore. Only the great ones withstand this test. Great lesson in art history and reality.

Drive back to Düsseldorf at 110 mph in Hans' convertible BMW just in time to change and shower to go to dinner at Krupp's house.

Nice, "cute" mansion. Very formal couscous buffet. We are the only ones not wearing ties. Nice people, lousy food. "Chit-chat" and discuss possibility of Krupp doing assembly of other sculptures since original factory only seems capable of "cutting," not assembling and bending. Was this a prearranged "accidental coincidence"? Hans is very clever. Like Andy, many dinner parties were also "meetings in disguise." No wasted time! Makes sense to me . . .

Did some drawings for guests, including the inevitable "this is for my 16-year-old brother" drawing.

If I could only meet all these 16-year-old sons, brothers, nephews I'm always drawing for . . .

SUNDAY, APRIL 26

Went with Hans to Kunstsammlung in Düsseldorf to see *incredible* collection. Warhols for days! Twombly, Rauschenberg, Beuys . . . Andy gets so much more respect in Europe. Nobody has a Warhol collection in a museum like this in America. Small museum, great light.

Hans has great stories of times spent with Andy in

Germany. Anybody who Andy spent this much time with and was still selling paintings to and doing favors for must be O.K.

I am becoming more respectful of Hans and wondering why Tinguely warned me about him?

But there's always two sides to every story. I should know about two-sided stories!

Went to see Hans's new house being reconstructed. He has an idea for me to do a huge sculpture for this amazing circular piece of land in the middle of his property. Looks incredible. I am intrigued and honored.

Return to hotel and pack for return to Paris. Kwong Chi has been running in the park and is convinced he has found the "cruising part" because of discarded rubbers and trampled bushes. Good for him . . .

Read yet *another* AIDS article in *Herald Tribune*. Article about homophobia increase on American college campuses. Violence, etc.

Very frightening, but very predictable.

In fact, very much according to "plan," I'm sure.

3:00 PM—Fly to Paris

Check in La Louisiane. Dinner with Juan and Kwong in Brasserie.

MONDAY, APRIL 27
..

Go to Hôpital Necker to check paint, buy brushes, etc. Seems to be in order. Go to Beaubourg to explain how to hang my canvas and inquire about photo of mural being included in exhibition. Inquire about Beaubourg video crew shooting mural painting. Three women assure me they will do this. Of course, consequently, they never appear again. Dinner with Condo and Mabe and Kwong and Juan.

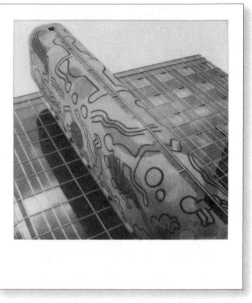

10:00 AM—Arrive at Necker ready to paint.

11:30: Paint arrives. Begin to paint. I told Juan I didn't think I needed him as I struggle alone till 4:00 PM. Kwong is sleeping. Beginning is very difficult. Immediately realize *brushing* all of background color is ridiculously impossible. I break for lunch and go buy rollers myself. Hospital staff doesn't understand English and don't understand what I'm saying. Kwong Chi arrives after frantic secretaries call hotel. I am working inside a box held from a crane by a steel cable. Building is eight stories high.

Instructions for moving are signaled to man operating crane. Tricky at first but maneuverable. When Juan arrives it becomes much easier because we both paint at same time. I outline, he rolls.

Finish at 8:00 PM. Two colors, two coats each.

Dinner with Roger Nellens and wife and gorgeous son at Otto Hahn's house. Talk business entire dinner. Discuss all aspects of Knokke exhibition.

Juan points out later in hotel that Nellens' order of business is a little strange:

1. T-shirts
2. Pop Shop merchandise

3. Posters—invitations
4. Exhibition
5. Possible mural

I agree, he has it backwards.

8:00 AM–8:30 PM: Paint mural. Meet Julia at lunchtime. Buy more brushes. Much faster with Juan there all day. Fourth color is now on, two coats each. Arms, hands hurt and blistered from brushes and rollers.

10:00 PM: Dinner at La Coupole for opening of Jim Rosenquist's show. Sit across from Jim. He has great stories of sign-painting days when he was working in New York City in the Sixties. Incredible stories. It makes my mural sound small. Talking about 40-foot O's . . . Julia is here and fun. Meet Swedish dealer interested in showing me who shows Rauschenberg, Rosenquist, etc. Meet Belgian lady who has gallery Brussels. Makes me promise I'll visit her . . .

Mural rained out—thank God! Feel too sore to paint anyway. This means it's impossible to finish mural *and* do Beaubourg painting before Japan. So I'll do Beaubourg painting when I return.

I go to Beaubourg to explain this. In the meantime, they have canvas hanging already. It's hanging backwards (seams facing out). It is impossible to find anyone in this museum. It's so big nobody knows what is going on. Very frustrating. Now they say they might not be doing the bag they asked me to design either.

Went to Templon to see Jim Rosenquist's show. Nice

drawings. I'm not sure what I think of the paintings. Went to see Bruno Schmidt's show and met Kwong Chi there.

Was having an argument (silly) with Juan earlier in the room because I said he was "stupid" because he was watering the flowers in the room with the shower hose. So he wanted to stay in the room. But I ran into him on the street outside of the gallery. Everything is O.K.

Go to see Hervé Di Rosa's show. Disappointed, but I wasn't expecting much. I'm sure it's possible to know the difference between good and bad painting. Not much of interest anywhere right now. Basquiat and Condo are the only ones I think are really good.

Had lunch at (my favorite) restaurant near Beaubourg. Probably my favorite because I know what to order on the menu and the waitresses aren't *so* rude. Met Julia at hotel to go over list for my birthday dinner. Kwong is out researching restaurants to find a suitable "background atmosphere."

5:00 PM: Interview with Otto Hahn for *Beaux-Arts* magazine in hotel.

Interrupted by George Condo's phone call inviting me and Juan to dinner at Claude Picasso's house.

Interview went O.K. Forever trying to explain the same things. It seems people always "understand" after asking the right questions. Each interview helps me understand more about what I think myself.

Dinner at Claude and Sydney Picasso's house was interesting—fun. They had KH magnets on their refrigerator. It must be incredible to eat, sleep, watch TV, etc., around these paintings.

I guess the family always gets the best work. Lots of pieces I've never seen before. Picasso seems endless. Amazing how many things one can produce if you live long enough. I mean, I've barely created ten years of serious work. Imagine 50 years. The progress and evolution is remarkable. I would love to live to be 50 years old. Imagine . . . hardly seems possible.

Not for me . . .

9:00 AM—Fly to Munich with Kwong and Juan.

We meet people from Luna Luna at airport and drive to hotel (Holiday Inn) in Augsburg and then lunch outside with tulips and beer, watching busboys with tight pants and cute little butts.

Then immediately to work on the carousel. It was about a half hour's drive from Augsburg to a little town in the country. Reminds me of Kutztown area. It turned out the guy who was working on the carousel (Peter Petz) makes them for a living and sends them all over the world. He also designs other amusement park rides and paints and restores old ones. The house and surroundings were incredible. Like a place I always dreamed of when I was a kid. Twelve-foot-tall King Kongs, monsters, pieces of carousels, statues, etc., etc. The family turned out to be really nice.

The carousel was great, except for a few "unknown" char-

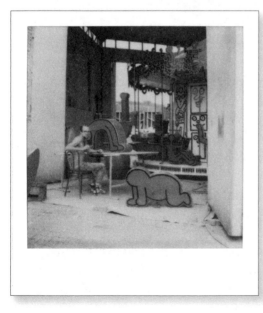

acters I never drew and a change in my design of the top panel that they said they "found in my book." The carousel people say Andrew Heller (Luna Luna) told them to change it and Heller says they did it themselves. Eiwther is possible. I didn't use the "mouth" character, and I ignored their idea of adding a snake to my pattern, by doing abstract lines instead.

They added lines through stomachs because they said they saw a drawing like that in my book. (So what?)

Anyway, besides this, everything there went great. I painted the inside part of the carousel with cartoon characters and did the top border with abstract lines.

We finished painting at around eight and ate a meal outside prepared by Peter Petz's girlfriend—nieces, ex-sister-in-law and nephews. It was really beautiful. It's moments like this that I'm really glad to be doing what I do. The setting was amazing, surreal and peaceful and the "family" sort of adopted us. "We decided we love you," which is pretty amazing for the first day you meet somebody. It's amazing to be working with people who really respect you and go way out of their way to make you as comfortable as possible. A contrast from Paris!

Later we drove into Augsburg and went to the carnival there, where Peter had painted a lot of the rides, etc. It was incredibly beautiful and clean and well kept. (Like Coney Island is supposed to look.) Kwong Chi was great in the Fun House—screaming hysterically, becoming the main attraction.

For me and Juan the main attraction was all the American Army boys. Seems there's a huge base nearby so there were lots of humpy black boys. A taste of New York City! We rode the bumper cars and bumped a few hairless muscular brown bodies.

Fireworks for May 1st! Great display—very impressive.

Then return to Holiday Inn (the most depressingly American hotel we've stayed in so far) and called Tony. He's still worried because the Art World gossip hotline still says I have AIDS. He said Christo's wife heard it and asked if it was true. People are really too much. They have to talk about something. I'm tired of having to explain to Tony how I'm taking care of myself. If anything causes me tension and stress it's him, not staying up late or working hard. I live for work.

Return to finish painting carousel. Today I outlined all the characters and chose their placement on the carousel.

Final choices of lights, colors, etc. Lots of pictures with the "family" and friends.

9:00 PM: Drive to Munich.

Kwong has his "guide," so he has chosen several bars and discos that are listed as "mixed and young crowd." Hardly true. Either straight or full of German queens. Yecch! We got turned away from NY-NY because the queen at the front door didn't like my sneakers. What a joke. NY-NY— she's obviously never been there.

More tacky bars and finally home in a taxi with Kwong trying the last chance—the driver. *No luck.*

We have to go to sleep to leave for the airport early because the Pope is coming to Munich tomorrow and "could affect the traffic," according to the man at the front desk.

12:30: Missed the Pope. No traffic. Fly to Paris and arrive at 2:00 or so.

3:00 PM. I go with Kwong Chi to Le Train Bleu to decorate the cake for my birthday dinner there.

The assistant pastry chef turns out to be extremely cute and shy in a very adorable sort of way. Rosy cheeks and tight pants. Nineteen or 20 years old. We smoked hash before we went (a mistake), but the whole thing turned out to be much more fun than I imagined.

Kwong Chi blew his big chance, I thought. If I was alone in Paris I'd definitely have picked up this one! Or at least tried . . .

Return to hotel and take a nap, a bath and dress for dinner.

The restaurant is inside the train station, but it is apparently a very old, very famous restaurant. Lots of rococo glitz. Very French!

Guests included:

Juan Rivera
Julia Gruen
Tseng Kwong Chi
George Condo and Mabe
Louis Jammes
François Boisrond
Rémy Blanchard
Jim and Mimi Rosenquist
James Brown
Donald Baechler
Mr. and Mrs. Daniel Templon
Andrée Putman and friends
Bruno Schmidt
Chuck Nanney
Joe Glasco
. . . and others

Nice dinner with great toast by Jim Rosenquist. Something like:

There once was an artist named Haring, whose line was never wearing and also daring and also intent on sharing. (For exact transcription, see Kwong Chi.)

After went to Condo's with Julia, Kwong, Roberto (George's assistant), Joe Glasco and then Donald showed up complaining about needing more coke and being obnoxious. We went home to try to sleep.

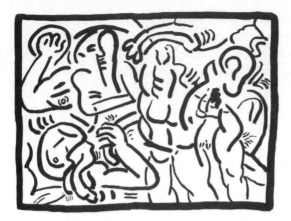

My real birthday. Stayed in bed till 2:00 PM and then got up and went to the Matisse show. Depressing in a funny kind of way. Too many drawings of tits and ass. I'd think he'd get bored. The drawings of just heads or of more "situations" were more interesting. Also, all of the more abstracted simple ones and of course the paper cut-outs are all great. Still something left me with an empty feeling. Walked around a little, but it's cold and rainy. I'm worried about finishing the Necker mural. If it doesn't stop raining I don't know when I'll do it. It's also very cold and very windy.

Went back to hotel and read a lot of Joe Orton's diary. Fell asleep.

MAY 5, 1987

9:00 AM: Wake up to finish mural. It's not raining, but cloudy and still windy and cold. I convince myself, though, that it's not as cold as yesterday and less windy.

I go to hospital and the crane has not arrived yet.

Very nervous.

11:30: Crane arrives and I begin to paint the black lines. Juan helps to balance and direct the crane since it is very windy. Wearing gloves and hooded sweatshirt, but it's too hard to paint wearing a glove. After a while I don't feel the cold.

Jim Rosenquist visits.

Some press (not much) visits.

Otto Hahn's wife visits.

I finish at 9:00 PM. Looks great, but it's always hard to see anything immediately after finishing. Feels good, though.

Eat dinner with Dan Friedman, Kwong and Juan.

Call New York and talk to Tony about painting at auction. It only went for $12,500. It should have been more like $17,000–$20,000 or more. I told Tony I wanted to buy it myself if it went under $15,000. But Julia was over here and we didn't coordinate in time to have somebody buy it. Not a disaster, but disappointing.

MAY 6, 1987

Woken up by telephone calls. Swiss company wants me to design cigarette pack and maybe pick name also.

I doubt it, but ask for proposal in New York City. My collection of "propositions ignored" is one of my favorite files.

Have lunch with Julia and Juan. Julia returns to New York today. Depressing conversation about changing gallery situations. Always the same problems with money. I don't trust Vrej Baghoomian at all now, either. Bad stories from James Brown about Vrej's financial games. Always the same story. Getting money that is owed to me is like

they are doing me a favor. They've got it backwards. I may have to take drastic action and finally start working on my own.

Call Tony. Talk about sculpture being made for Children's Hospital in Long Island. Should be installed in July. Vrej has left the gallery.

6:30: Return to hospital for the "reception" of my mural. In the meantime, someone has spray-painted slogans on the bottom of the concrete where the mural is painted. Lately there is a strike by medical students in Paris. I was not told the complete story why they are protesting, but I had heard a lot about it. The Minister of Health, M or Mme Balzac, is scheduled to show up for the reception of the mural and some press was expected. So, I assume they wanted to take advantage of this opportunity to get attention. I don't want to be involved in the politics of this situation, however, I don't mind the graffiti, since it is several feet below where my mural begins and will probably be removed. The politics are "outside" of my politics for this painting. I painted it for the enjoyment of the sick children in this hospital, now and in the future. Inevitably the mural will outlive the complications of the moment. I don't think art is always "outside" of politics, but in this case my mural certainly has no bearing on supporting the politics of either side. Its only politics are in support of a creative input into the healing process and an attempt at changing a previously dull, boring building and giving it life. Nobody could argue that that is condoning the politics of the government's policies to medical students.

The press attendance was almost nonexistent. Maybe one or two photographers. Hospital employees had repainted the graffiti before M or Mme Balzac arrived. This repainting would have made great press (for me and the med students) and a great photo. Kwong Chi was feeling ill and didn't make it to the reception, either. So the only photos of this are my Polaroids.

The Minister of Health showed up and was very nice. But the whole thing was very official and very boring except for the fact that all of these med student protesters sort of took over the reception and used it as their own forum. George Condo came and convinced me to leave, and I did.

So Juan, George and I went to George's house, watched *The Shining* (my favorite horror movie) on video and then did coke and painted. Joe Glasco came and also painted. So George, Joe, Roberto and I were all painting at the same time in the same room. Weird, but interesting. I made three small paintings.

2:00 AM: Return to hotel.

MAY 7, 1987

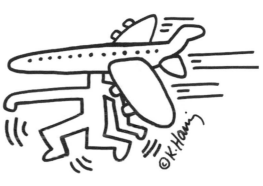

12:30: Leave hotel for airport.

2:30: JAL flight to Tokyo via London and Anchorage. Both times we had to get off the plane. Boring. There was a disgusting man sitting across from us who kept making obnoxious spitting, hocking noises and swallowing his slime for the entire 18-hour flight to Tokyo.

I finished reading Orton diaries and read James Baldwin's *Giovanni's Room*. I have to read more James Baldwin because I'm supposed to meet him to do a project with him in the south of France in a couple of weeks.

SATURDAY, MAY 9 — TOKYO

11:30 AM: Meeting with Parco judges about the judging procedure for Nippon Object Competition and discussion of designs (drawings) for street signs for Parco and contract writing.

Then we go shopping in Shibuya. Sign autographs in store and start a chain reaction. Finally leave store because we're causing too much congestion.

4:00: Meeting with art critic about judging competition, etc.

6:00: Go to Shinjuku to see neon signs and play Pachinko. Tokyo is truly amazing. It's like one big amusement park. Video screens everywhere and neon like you cannot imagine. Juan has never seen anything like this before and is bugging out. Packed with people. We eat in a very funky Taiwanese restaurant under a bridge. "Very *Bladerunner*." I sign chopsticks for everyone at table.

9:00: Juan and I take a taxi to meet Tina Chow at her hotel and then go to her friend's house for a macrobiotic dinner. Her mother and sister Bonnie are there. Also a director, a Japanese TV star, a designer and a few interesting people. I can't remember all these Japanese names. I can't remember names, period. I have a feeling the reason we are eating macrobiotic is that our host looks like he has AIDS. I know that look well, unfortunately. Really great dinner, nice house, nice people. Tina's mother is really cool and really beautiful.

TUESDAY, MAY 12, 1987

Take train to Tama City to see new Cultural Center (incredible building) and meet with city officials of Tama City. Discuss the project I will do in September or October with children in Tama City. Creating two murals that will be donated to the city and placed in children's hospital, sport center, library, etc., and also the project of helping children create paintings on little clay bells that will be put on a wooden "tree" designed by me for a kind of "peace ceremony." All details of money, etc., will be worked out by Seiko [Uyeda]. Had to remove shoes to enter this huge municipal building since it will not be opened until October 30 and they don't

want to dirty its "virgin" floors. I could imagine if they continue this when the building is public, the thousands of pairs of shoes lined up outside. They said, though, that after Oct. 30 people can walk in with shoes.

1:00 PM: Return to Aoyama to meet Kaz Kuzui and to meet other man who is giving us space for Pop Shop. Great space and great idea. In Tokyo real estate is so expensive that to rent a space is almost impossible. When companies buy a piece of land to build on it takes two–three years to get the necessary permits, etc. So since this space is unused the people sometimes use it temporarily and pay a rent to the big company that owns the land. So Pop Shop will go up in a temporary building on a temporary location for a temporary time. Perfect. The whole concept is perfectly in keeping with my aesthetic.

THURSDAY, MAY 14

Twelve-hour flight to Paris. Watch *Jumping Jack Flash* with Whoopi Goldberg. Take Valiums and sleep. They also showed *Crocodile Dundee*. Both movies have my T-shirts in them.

Stewardess recognizes me and asks for autographs on plates.

Arrive in Paris 5:30 PM Paris time.

Call Julia and Tony.

Pierre Keller calls, wants to come to Paris to discuss some project.

Go to dinner with Juan and run into curator from Beaubourg and talk about show. Lucio Amelio is staying in the hotel with Joseph Beuys's wife, Eva, and her two kids. They are installing a piece at Beaubourg.

FRIDAY, MAY 15, 1987

10:00 AM: To Beaubourg to arrange painting. Quick meeting with person about the plastic bags I designed for the show. I

agree to take 500 bags as my payment, since they will not be selling them.

Buy paint, brushes and plastic containers, which total $1,000. Paint in Paris is ridiculous!

2:00: Return to museum to hang the canvas tarp. After giving up on the museum crew, I hang it myself.

Meet Eva Beuys and Lucio.

Back to hotel and then walk to George's house to meet them and go to Claude Picasso's house for his birthday. Adolfo calls with phone number of Run DMC/Beastie Boys manager to arrange tickets for Tuesday.

SATURDAY, MAY 16

8:30: Another call from Switzerland about cigarette-pack design. I say no for last time.

9:15: Meet Pierre Keller in the hotel and go to Beaubourg together. Sit in café and discuss project for Lucky Strike posters. I tell him my price. He gives me the other photo he took of me and Andy in my studio when we did the Montreux poster. Also has a transparency of the sculpture Jean Tinguely made for me for our trade. It's incredible.

10:00: Arrange paints, plastic, ladder, etc., and begin to paint around 11:00 A.M. A lot of people all day long. Immediately the ladies working in the concession around the corner from my painting complain about the music. I explain I have permission and have no intention of lowering it (it wasn't loud) or, as she suggested, "playing something French." All day long different people came to complain and then other people would explain to them that it was O.K. At one point this "very French *lady*" tried to explain to me that I was giving her a headache. I suggested aspirin or take the day off because if I couldn't play the music I wasn't going to paint. The more they complained, the more obnoxious music I played until finally I played the Beastie Boys and they

brought the head of security with two guards. We had a confrontation and naturally I won, since my painting was ultimately more important than a few distraught employees' bullshit complaints.

The Japan Air Lines stewardesses showed up and were surprised (an understatement) to see me. Lots and lots of gorgeous boys. Autographs all day long and giving out buttons. Finish painting around 7:30 and do a video interview and more photos. More autographs. Clean up and take paint (still have 80% of the paint I bought) to hotel and call Leor about Beastie Boys tickets. He's here with E.K.

Dinner with Pierre and Juan and then coffee with Lucio and François Boisrond. Go to Attention (gay disco) with Juan and meet this boy (Paolo) who looks really tough till he opens his mouth. He takes us to Kit Kat (downstairs at the Palace). I see Peter Kea, Jean-Claude (who says Boy George is in Paris) and this guy who I met with Lucio, a black opera singer. He's incredible and it's his birthday. I see an amazing fake shirt and sign a few shirts on hot boys. Then this big black guy comes over and kisses Juan on the ear and says, "Later." So I kept picking on Juan, saying, "Why don't you leave with him?" So, he starts to leave and I follow him and we have an argument and leave the club. Consequently, the guy we came with and were presumably leaving with was not amused and went home. We made up eventually and went home and made love furiously.

SUNDAY, MAY 17

Call from Nellens. They're coming to Beaubourg opening. Call from Swiss magazine about the body paint job. Call from Vienna asking me to come there to be in this movie.

2:00 PM: Meeting with guys from Belgian TV about the show I'll be on in June. Long talk about a lot of things. A lot about Andy—I really miss him sometimes. We're supposed

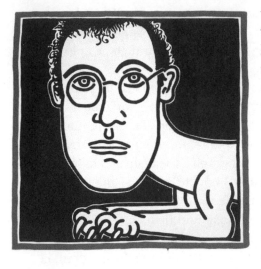

to go see Boy George with Jean-Claude. But I find out Jean is going to interview him and I don't want to go for that. I tell them to call late if they want, but they don't.

Then I find a phone number in my pocket— Paul. I think this is the guy we met last night, so I call to invite him to the hotel. He sounds different on the phone, but he says he just woke up and assures me he is Paul and was at Kit Kat last night with us. So at 4:00 there is a knock at the door and it is the black soprano who [it] turns out is also named Paul, and had given me his number last night to give to Lucio.

Very funny. We all go to Le Palace for tea dance. We see the other Paul and it doesn't look interesting anymore. Cute boys, but boring.

We go to dinner at Condo's house and watch *The Shining* again. That's the third time I've watched it with George.

MONDAY, MAY 18

..

Pierre called to confirm Lucky Strike poster job. Meet Leor and E.K. at their hotel and go to lunch near Beaubourg. Rain. Rain. Leor gave me an All Access badge for the concert tomorrow, but I have to get the rest from him later.

Check in at Beaubourg to finish details. Call Hans Mayer in Düsseldorf to see when we return to work on sculpture. At Beaubourg we ran into this cute kid I drew on at the Palace the other night who was with Jean-Claude. He meets us at

our hotel and in the meantime Frederick Dayan and Jean-Claude call to invite us to go see Rita Mitsouko at La Cigale. The kid leaves his scooter at the hotel and we all go to see Rita Mitsoutko. Good show, very French! All go to the Palace and drink and dance until 3:00 AM. Kid comes to hotel to get his bike, but says he has to sleep at home. Very French!

TUESDAY, MAY 19

10:00 AM: Meet Nellens and Monique Perlstein at hotel to go to opening. Buy fake Free South Africa shirt near Beaubourg. Show is strange. I see Jenny Holzer and talk and see Daniel Buren and talk. That was the most interesting thing at the show. I think I like Daniel Buren's work more all the time. Each new variation gives a kind of credibility to the validity of the investigation. Very clear, very clean, no lies. Most of show is full of a lot of lies. Pretentious lies. If this is a true survey (and it's not) of the last 10 years, it's pretty depressing! I'm glad my piece is downstairs and outside of the exhibition. The catalogue is huge and weighs a ton, but it is all in French, so I don't know if my representation in it is good or bad. Pop Shop is included in the historical chronology, though, which seems good. Finally things begin to be taken seriously, which is the first step toward being understood.

We go to lunch with Nellens and Monique Perlstein. Monique has the card from my show of drawings in Antwerp and it is beautiful. Nellens are jealous. I hope this Knokke show is not going to be a disaster. We talk *again* about T-shirts, etc.

Return to hotel and call Tony. John Carmen calls Tony, so we have a conference call and then John gets Grace on the phone so we have a four-way conference! Happy Birthday Grace. Maybe she's still coming to Belgium.

6:00 PM: To Beaubourg to meet George and Mabe. I run into Louis Jammes and he suggests we do another portrait.

George, Mabe, Juan and I walk to the Grand Rex for Beastie Boys and Run DMC. Get our tickets at the door and get seats inside. I go backstage to look for E.K., who is nowhere to be found. Talk to DMC and Beasties. Cold at first, but eventually people are cooler. Thought I heard someone referring to me as Keith Gay. It's O.K. with me since it didn't sound like an insult, actually. Everyone signs my jacket. Talk about New York and Tokyo, etc.

Beastie Boys about to go on, "Lower the Flag and Play Rocky." I return to my seat. Great show. A lot of audience abuse. Eventually after Run DMC, the crowd in front got out of hand and somebody (from the band?) threw mace. Mild chaos, which spills out into street and police break up the mob. Fun for Paris! Nobody seriously hurt. We go eat around the corner and then go to Palace for the "dinner." Actually everybody from Beasties and Run are there and is O.K. party. Food fight started by E.K.

Stay a while longer to talk to French cock-teasers and return to hotel.

WEDNESDAY, MAY 20

Picked up by a taxi to deliver us to the Cartier Foundation. I assume this has something to do with what Daniel Templon was saying the other day about moving the sculpture. We arrived and were surprised to find out that this was the home of one of my favorite sculptures, *Long-Term Parking* by Arman. So, already the place was O.K. with me.

Had a great lunch with the director of the foundation, Marie-Claude Beaud, who turned out to be a good friend of Jean-Louis Froment and equally lovable. We found several ideal locations for my sculpture. Daniel said they are considering buying, but she said they'd rather commission a piece specifically for the site.

Had a nice conversation about the "Eastern" (i.e., Japanese, Chinese calligraphy) aspect of my work, the approach, method, attitude, etc. I think people see my work completely clearly after they realize the connection to (what seems obvious to me) a larger philosophic and aesthetic tradition. I think my ability to explain this is definitely developing more coherently, the more I write and the more I answer questions (i.e., interviews, lectures). I think I always sensed it and understood it intuitively, but it is difficult to explain.

Took a taxi back to hotel and made and received phone calls. Several calls to work on Swiss magazine-cover project. Find a model, call Azzedine for suggestions, call Iman, call Zurich. Call Hans in Düsseldorf to check on sculpture. George Mulder called to explain delay in James Baldwin project. Baldwin's in the hospital, hope he's O.K. If he can't do project, I suggest we use Bill Burroughs. George says, "Who's William Burroughs?" Call Debbie Arman in Monte Carlo. Call Kermit to talk about his problem/my problem of

him having to move, having another baby, etc. Meaning he has to sell some art, maybe, and we have to find new storage space. No big problem. We'll find money for him somehow. Also talk about production of models for Düsseldorf sculpture. Call from London. ICA wants me to come to do children's workshop in July. Probably.

Then I judge the drawings sent to me from New York for the "Spectra" contest for Mattel Toys. One hundred thirty-three drawings by children (6 to 12): their concept of what a teenager from outer space would look like. This was a fun task. Some great drawings. Some hysterically funny. I picked (of course) the ones with the craziest imagination. There is hope out there in the future generations.

Went to dinner with Lucio Amelio and his boyfriend at a Vietnamese restaurant near the hotel. We invite his boyfriend to our room, unsuccessfully. He has a cold, he explains.

THURSDAY

Take Polaroids of Beaubourg painting. Also, suggest they should put a little barrier in front of it, since it has already been soiled from people leaning or passing against it. Look everywhere in exhibition to find photo of Necker mural. I can't find it.

Took a taxi to get my portrait done by Louis Jammes. Passed a truck unloading Warhol paintings. Louis Jammes portrait session was in studio of Robert Combas, who, I've always had the impression, can't stand me. I don't care about him one way or the other. I just don't care. After the photo this other guy arrived (sort of cute) and immediately they had to close the curtains to do drugs. How boring. I can't believe they're gonna do H in front of me as if they're proud of it. I mean, I hardly know these people. The (sort of) cute guy is bragging about how well he speaks English and explains how he stays in New York with a "*faggot*" who works for the French em-

bassy. He says, "He was the only man I ever slept with that *didn't* touch me." He sounds so surprised. I wanted to ask him what about all the other men who slept with him that *did* touch him? They weren't *faggots*, so that was fine, I presume.

Louis walks me to the Métro station and I take a train back to the hotel to meet Juan.

Went to James Brown opening at Galerie Maeght-Lelong. Interesting show. Not what I expected (that's good, right?) but some great paintings. Not so sure, though. Need another time to look.

Lots of people there. More art dealers than artists. Definitely is "money art." It even "looks" expensive. I think that's my market problem, my paintings don't "look" expensive.

FRIDAY, MAY 22

11:00 AM: Quick meeting with woman who called and wanted to talk about Brion Gysin and the problem of not letting him disappear. Also, all the works that were inherited by Bill Burroughs have to be sheltered by a foundation to avoid ridiculous French taxation. I want to help however possible. Have got to have an exhibition of *Fault Lines*, so we can start to accumulate monies toward a foundation. Brion Gysin and William Burroughs have had incredible influence on me and provided a lot of inspiration. Brion, after becoming my friend, became a kind of teacher (like Andy). I learned innumerable things from our conversations, but I think equally

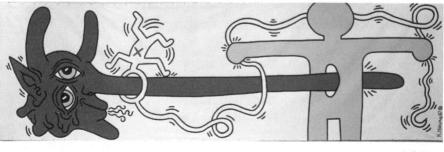

as much from his "works." It's important that his work be available to future generations of artists. Their work gave me a structure from which to build and within which to understand what I had already done. When I discovered their work in 1979 it was a major revelation, filling in all the missing pieces. I was, I suppose, already working in that direction without understanding what I was doing. For the first few weeks their influence came through their "works" only, but after I met them (and especially Brion), a give-and-take of information began that helped me to understand the intellectual side of what I was doing.

Also, it was my first real contact with "the brotherhood" of artists that has existed through the ages. They initiated me, in a way, into this "brotherhood" by sharing with me some of the secrets and intimacies of their lives as young, gay artists. There is a very real historical line that can be traced all the way back. Brion knew all about this. He spoke of it very eloquently and, although thoroughly more intelligent than me, never talked down to me, but talked to me as if I were also a part of this. Through his confidence in me and his assurance and analogies to my historical counterparts, I began to accept the fact that I am part of this, whether history will accept it or not. Many, like Brion, have been written out of history by an uninformed, barbarically (fake intellectual) conservative, homophobic public. It is up to the people who knew Brion and understood his importance to try to fight against his disappearance.

Anyway, this woman talked with me about Brion and also told me she thought it was important that I keep working because I understood how to "compose" a picture. The key was in her use of the word "composition," and I think I know what she means. This is, in a way, what Brion was talking about in the introduction he wrote for my catalogue in Bordeaux. Beaubourg painting is titled (for Brion Gysin) "Untitled" because he could see it from his window.

Drive to Cartier Foundation and see Ferrari exhibition, again. Mainly came back because Jean-Louis Froment was supposed to be coming up from Bordeaux, but he never showed up. Also saw Yves Morisi, the newscaster whose jacket I drew on for French TV during a live transmission from the Paris Biennale in 1985. Also, ran into Claude and Sydney Picasso and got a ride with them back to Paris. Had lunch together at Café Trocadéro.

Back to hotel and drop off bags at Condo's house. Ate dinner at restaurant in Bastille with George, Mabe, Juan and Joe Glasco. Great new paintings at George's. Makes me want to paint like this, but I keep thinking I have to resist the temptation. There is really a line of logic and consistency in what I am doing and, however frustrating at times, must be pursued. I'm sure if I repainted over and over I could make paintings like this, but that's something else. A lot of people could do that, but not a lot of people can do it the other way.

SATURDAY, MAY 23

Woke up. Did autographs on towels for the girls in the hotel who've been answering my phone for the last two weeks. Taxi to airport. Fly to Nice on a plane headed for Johannesburg. Picked up by Yves and Debbie Arman at the airport and drive to Monte Carlo. See apartment, take a walk on the beach and talk to Alberto Vençago, the photographer, who has flown down from Zurich to shoot the cover with suncream painting for Swiss magazine tomorrow. He wants to shoot early (7:30), so we go to bed to get some sleep.

SUNDAY, MAY 24

Wake up to paint at 7:00 AM. Photographer and model arrive at 7:30. First impression was not good. I thought they were getting a black girl, instead it's an Amazonian farm girl from

Utah. She looks better without clothes. I "paint" her with five colored sun-block creams with my fingers. This is the first time I've ever painted a body with my fingers. Too bad it wasn't a boy. Alberto takes lots of photos in the apartment. Yves and Juan also clicking away.

Then we go outside. The reaction from people is great. Lots of fat German tourists running after us to get pictures.

We make a "monoprint" by putting a white sheet on the grass and L'Ren lying on top of it. This was, in fact, her idea. In the middle of the print the Monaco police arrive and ask us to stop. We finish the print and return to Yves' apartment with the police.

Police leave after a while.

MONDAY, MAY 25

Write a little, take a long walk on the beach, swim with Debbie. Watch 14-year-old boys playing soccer on beach. Call Hans Mayer: now I don't have to be in Düsseldorf till Monday. Begin to make (try to make) reservations to leave Nice Monday.

TUESDAY, MAY 26

Drive to Nice with Yves to go shopping, etc. Visit Arman's studio in Vence. Book reservation on train and plane to get to Düsseldorf by Monday night. Buy Styrofoam for seat covers for apartment. The man at the Styrofoam place let me use the saw to cut out some extra shapes. Small crowd of people watching. Return to Monte Carlo.

Call Julia, Tony, etc. Tony still obsessed by AIDS rumors. I think I'm in *more* danger driving with Yves. I think it's really disgusting that people have nothing better to do than wait for the next victim, like vultures. Maybe they're concerned. I

don't know, in a way I've gotten over it. I really don't care anymore. Life and death are inevitable. I think I've had a great life and every day is a surprise. I'm happy to be alive today.

Called New York to talk to Juan and found out, by accident, that Adolfo was planning a party in my studio. Called Adolfo to tell him he is *not* having a party and he can hand in his keys till I return. Also, trouble brewing at Pop Shop. I think it's definitely time to make some changes. Belgian TV calls to confirm arrival Tuesday.

Paint the Baby Room for Madison, Yves and Debbie's forthcoming baby, my goddaughter. Also paint the crib and high chair. More calls from Julia about New York situa-tion. It's pretty depressing that I can't leave New York without things falling apart. Julia is the only one I can count on. I really have to start to plan a new course, new strategy (i.e., Tony, Pop Shop, Studio, etc.). I'm more sure about what to do all the time. Took a long walk to beach and sat and watched the sun go down.

Go to beach. Not unlike *Death in Venice*. Sitting on a towel near group of boys. Very content just watching. Wrestling, smoking, grabbing their cocks. Very sweet.

Call Jean Tinguely at The Hermitage, but he has checked out already. Dinner with Yves and Debbie and then go to Drag Queen Bar in Nice. Sort of boring, but interesting in the way that most provincial gay bars are interesting.

Yves and Debbie have a brunch to watch the Grand Prix. We are on roof watching and Yves is downstairs and runs into Grace Jones and Nicolo. We all watch race from roof and Grace comes upstairs. Race is pretty boring. Most interesting thing is when the maid drops a whole tray of champagne glasses. We go to Café de Paris with Grace after the race and run into Patrick's (Bulgari) brother. We all go to Mexican restaurant near Nice and then to Jimmyz (boring disco in Monte Carlo). Crowd is very old, very bourgeois and very boring. Grace runs into (Princess) Stephanie. We get re-introduced, but she doesn't remember me. But why would she? We only hung out one night at the Palladium two years ago doing coke and dodging Rick James. Juan and me split a half hit of Ecstasy Grace got from someone. She and Nicolo do one also. Return to apartment with Yves. Grace and Nicolo and me and Juan spent night in same bed, mostly watching each other. If we would have done more X anything might have happened.

6:30 AM: Wake up and do four drawings for Gallery 121. Get a ride to the airport in Brussels.

9:30: Flight to Hamburg (on tiny plane). On the plane we see a copy of *Stern* with pictures of Luna Luna. Also, buy a copy of *Actuel* with Pee Wee Herman on the cover.

Arrive in Hamburg and go to press conference—full of people. Kenny Scharf is at press conference. Gianfranco Gorgoni is here to take pictures for *Life*. We go to Luna Luna and get photographed and interviewed a lot. It rained almost the whole time. Luna Luna looks even better than I expected. Very professionally done. I also ran into a guy from *Schweizer Illustrierte* who says the cover with the girl from Monte Carlo is out. He leaves a copy for me at the hotel. We go to the hotel and have a sauna and swim. Magazine looks great. Kenny has a package from New York with new shirts, etc. Looks great. Call New York and talk to Julia. Back to Luna Luna to see it at night and then to an Italian restaurant with Gianfranco, Kenny, Juan, a lady writing for *Life*, and a girl Gianfranco fancies who wants to do a radio interview with me. After dinner, she interviews me.

WEDNESDAY, JUNE 10

Drive to Münster to install Red Dog sculpture. We meet truck, at a truck stop along the highway, that is carrying the Red Dog. It is still white, painted only with primer. With Klaus Richter and Juan and only one crane we manage to install it ourselves. Pretty amazing considering it is solid steel and weighs a few tons. It looks really cool. It seems a little small even though it is 15 feet at the nose. Amazing there is no rain in Münster today. Usually it rains.

Drive back to Düsseldorf and show Hans the Polaroids. Hans is leaving for New York to try to sell a Bacon painting. He'll fly the Concorde and return Friday morning for the opening of his Lichtenstein show. Talk to Tony on the phone about the Warhol trade. He wants me to give him three drawings if I give Hans seven drawings for the Warhol. Seems ri-

diculous to me. The only reason I am involving him at all is because Hans suggested it and I have to respect his wishes. I'll give Tony two and Hans eight, that seems more fair.

We go to hotel and I take a bath. Juan is watching TV—"The Night of 100 Stars" from Radio City. It makes me miss New York. I'd rather not be reminded of it. Funny, though, I miss it less now than I ever did before on one of these long trips, and this is the longest I've ever been away. We got out for a walk and visit the hustler bar and the train station and finally end up in the Gay Shop, an overstocked magazine shop with every *Wonderboy* ever printed. It's amazing, the quality of sex shops in Germany. Somehow, all of this has gotten sort of nostalgic, though, I mean, there really can't be any more anonymous sex or street "cruising" in the "original" sense of the word. Everything has changed quite dramatically. We haven't had sex with anyone on this entire trip. I'm kind of proud of that in a funny way. Not even the safest sex. I only miss it sometimes. But I've always enjoyed fantasy almost as much as reality. Masturbation will never go out of style.

THURSDAY, JUNE 11

Return to Münster to supervise painting of Red Dog. We arrive in the rain and it is already half painted. We do some of the "grass replacement" around the sculpture and go to the Landesmuseum to look for Kasper König. The painters assure us they will paint the rest whenever it stops raining. However, in Münster one never knows when that will be. At the museum we don't find Kasper, but see Matt Mullican and Daniel Buren. It's always nice to see Daniel. Everyone else around this project seems a little cold. The guide (not catalogue) for the Sculpture Project is a bit disappointing. The explanation for my sculpture is not very explanatory and almost apologetic. I don't honestly believe they really want me in this show. I think it threatens them in a weird way. Every-

one is always on the defensive.

We return to Düsseldorf and I arrange to use the gallery to do the drawings for Hans. I buy some gouache and ink and set up an area near the window to work. The gallery is empty, ready for the installation of the Lichtenstein show.

I do 11 drawings.

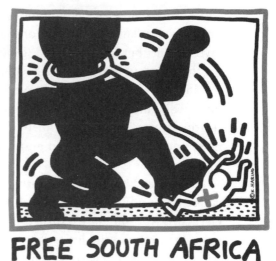

FREE SOUTH AFRICA

The girls working in the gallery invite some friends and one girl's sister makes a video. A kid from the street passing by recognizes me and comes in to watch for almost the entire time. He's a skateboarder and graffiti writer. After I finish I do small drawings for everyone that is there, with ink on cardboard. Everyone is happily amazed and they invite me to have dinner at a Japanese restaurant. Great dinner, really nice people. Afterward we buy some hash and go to Manuela's apartment to smoke. She has a great fake Haring her friend made for her and a Free South Africa poster on her wall and a Warhol poster. They told me a great story about how they rented a street billboard space a few weeks ago for 100 DM ($50) and put my Free South Africa poster on it. I think that was really great. She said, "You have people working for you all over the world," as if it was a matter of fact. And I guess it is.

FRIDAY, JUNE 12

Go to gallery at 9:00 AM to sign the drawings from last night, which look even better now, as is usually the case. I let Klaus

choose a drawing for helping me with the engineering, production, installation, etc., etc., of the Red Dog. He chose my favorite one, but I'm glad. I go to buy the paint and brushes for the BBD&O mural with Achenbach's assistant.

In the middle of Düsseldorf we saw a duck cross the road (at a red light, and between the lines of the crosswalk) in a relatively busy intersection all by himself. He was crossing from one side of a bridge to another at a small creek. Very funny.

The stretchers for the painting were late to arrive so I walked around, visited Hans, and went to see *Fantasia* (in German). At 5:00 PM I returned to BBD&O with Juan and helped them hang the huge (11′ × 25′) canvas on the walls. After some difficulty with warping, etc., it looked fine. At 6:30 I started a kind of loose black "outline" painting of "media, communication, etc." with several sort of cynical jokes hidden inside it.

In two hours I finished, to applause, and left so the paint could dry overnight. We went to the gallery to see the Lichtenstein show of "perfect" paintings and then went to dinner with Hans and his wife and friends.

SATURDAY, JUNE 13

Woke up at 8:00. Walk over to BBD&O to finish the painting. I decide to fill in the color fast and drippy instead of carefully. Sometimes painting around the preceding drips and leaving a lot of white space. I never did it like this before and it looks great. Very American, sort of hints of Stella scribbles and Frankenthaler drips and Warhol brushwork. Everyone seems pleased. I finish about 2:30 and go to gallery to leave leftover paint for Klaus. Tony has arrived, but is not in hotel. We talk on phone. I arrange to meet Tony to go to cocktail party this lady is having for a group of people on an art tour from the Guggenheim. Mostly boring New York people,

some nice people like Joe Hellman and Joyce Schwartz and some people I never met. Everyone is polite, but I'm always suspicious.

We had a meeting with a man who wants to commission a project for his building outside Düsseldorf. Tony was sort of over-enthusiastic and took over the conversation. I think he would really rather be an artist than a dealer. It was a little annoying, although I know he means well. The project sounds interesting, though.

We take a taxi to see the mural and meet Achenbach and people from BBD&O to have dinner. Tony freaked out over the painting and says it is the best I ever did. Maybe it is. I always think the last thing I do is always the best, but that would indicate a progression of constant improvement. I think that is thoroughly possible. I think every time I draw I learn something new and at the same time draw upon everything I've already learned before. That would explain why each one would be better or at least more informed than the last. Maybe, though, that's why people like old work, because it isn't over-informed and too articulate.

MONDAY, JUNE 15
···

9:00 AM: Flight to Geneva via Zurich. I hate flying at this time because it is full of boring businessmen. I detest businessmen.

We are picked up at the airport by Pierre Keller and (surprise) François Boisrond. He has a show in Lausanne. We check into hotel (Beau Rivage) and eat by the pool. Hotel is beautiful and is probably *really* beautiful when it's not raining since it is on Lake Geneva. We eat and then have a sauna (private) which turns out to be a great place to fuck. Pierre (as usual) arrives promptly at 4:00 PM for our scheduled meeting. I get photographed looking at François' Lucky Strike posters and then I am released until our scheduled de-

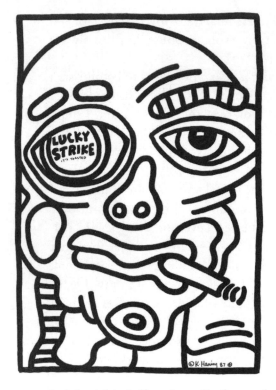

parture to François' opening where we are to meet Jean Tinguely. We go to opening and I buy two small pencil drawings. There is a really cute kid hanging around me who, of course, turns out to be the son of the owner of the gallery.

Tinguely arrives very late, which makes Pierre very nervous, but he doesn't get reprimanded by Pierre. Jean arrives with his new girlfriend and Jeffrey (the guy I met with Niki de St. Phalle in Munich). Jeffrey is really fun and really smart and sort of flamboyant in a very sophisticated way. We all go to dinner at the hotel. Pierre has, of course, arranged eating very carefully, but I am a guest of honor so I sit across from Jean and François and aside of Pierre and Jeffrey. Francis (the son of the gallery owner) is sitting all the way at the end of the table, but he continually catches my glance and acknowledges it with a smile or raised eyebrow. Dinner is interesting except my stomach is hurting really badly. We end dinner by autographing the nametags and menus. Francis gets a beautiful drawing from me and he wants me to send him some T-shirts and, of course, I will. I go upstairs to bed and try to sleep. In the middle of the night my stomach is hurting so badly that I have very little actual sleep.

I wake up with my stomach still hurting. I am scheduled to be picked up at 7:45 and taken to the bank, then to school (Gymnase du Bugnon) to meet Pierre. The bank is closed so I cannot deposit my money yet. I have dollars from the mural in Düsseldorf. We get to school at 8:30. I begin immediately to do the ink drawings for the Lucky Strike posters. Each poster must contain the logo (drawn) of Lucky Strike. I do nine drawings with variations of different ideas. They actually came out pretty cool—considering how miserable I was feeling when I started. The final drawing (No. 10) was a skeleton smoking a cigarette, which I gave to the school to be hung in Pierre's classroom. The man from Lucky Strike was not amused, but I could care less. I had a quick meeting with him about the posters and, with the assistance of the students, chose four. Then, I picked the colors and made a drawing to explain the color specs and talked about payment. Also, I designed a button for the school. The students (some of them gorgeous) were pretty interesting and very interested.

Due to complications we arrived back 15 minutes after we were supposed to have left for Basel.

Pierre was practically foaming at the mouth because we had upset his schedule. He moped all the way.

We arrive in Basel and go to the art fair opening. Meet Tony at Hans's booth, which is the most impressive. Big installation of Andy's *Last Supper* paintings, including my portrait of Jesus. It almost brought tears to my eyes. Andy looks better and better. I see some other great Warhols at Kluser's stand.

Hans has two of my new(er) paintings and also two of the new drawings hanging on the outside of the booth between James Brown and Jean-Michel. They look really great there.

Templon has one of my paintings on the outside of the booth also.

I am very well represented, considering the best thing is to have as little as possible on view, at the most respected places, in the best company.

I also visit Lucio Amelio, still trying to convince him to do another show in Napoli. He has to get over his Salvatore Ala hang-up. I really love Lucio.

WEDNESDAY, JUNE 17

Wake up really early (5:30) and taxi to airport. Fly to Brussels. At 1:00 PM we get picked up and go buy paint and brushes with Emy Tob.

2:30: Begin painting mural on wall in cafeteria [at Museum of Contemporary Art in Antwerp]. Press opening for museum is ending, but some photographers arrange to return. The wall is very smooth and some of the paint is difficult. I have to get pigment and ink to add to the black paint for a more dense line. I finish mural in five hours. The lady working in the restaurant is amusing, but seems genuinely thrilled by the new addition to her cafeteria. She keeps offering me sodas and beer and food. I take lots of Polaroids and go to hotel to take a bath.

We get picked up by Monique at 10:00 PM to go to dinner at Emy's house. Really nice dinner and great house with great collection of art. Have a nice talk with her son who just returned from school in London. Talking about media's influence on our society and culture, the differences between America and Europe, the future, etc., etc. Nice to have an interesting conversation that is challenging for a change. Talk about Alechinsky, because they have a few of his paintings, and Japan and calligraphy and me. Nice evening and home to sleep.

Wake up, pack and get driven to Knokke. We see the place I'm going to use as a studio—an old tea-room called the Penguin. It is right aside the Casino, on the ocean with windows toward the street—perfect. The paint they have ordered is the same brand I tried to use yesterday on the mural and didn't like, so we find another place (in Holland) to buy paint. Send telex to Tony about proposed paint project contract.

The man working in the house is stringing up a wild boar that Roger Nellens shot the night before—the biggest one he ever shot. They are skinning it while we eat lunch. It is really like a country house here and kind of timeless in a way. They grow a lot of food in their garden and the kitchen is the center of attention. The helpers are always busy cleaning, or making waffles. There is a huge juicer (restaurant size) that always has a huge basket of oranges beside it because Roger likes fresh orange juice.

There are so many birds here it is amazing. I am sitting outside on a table made by Niki de St. Phalle, which has two huge sculpture people sitting at it also. I am sitting across from the Dragon house, where we are living. It is really surrealistic. Writing quietly, listening to birds and looking at this dragon.

Wake up. Fresh orange juice. Tea and rolls with fresh strawberry jelly and eggs from the chickens in the backyard.

Make ten gouache drawings on handmade paper. Fun to do since it is quite systematic, but still an adventure. Lay down colors one by one working on all ten at once and then one by one "finish" them by adding Chinese ink.

Eat lunch.

5:00 PM: Drive to Antwerp to go to opening of the

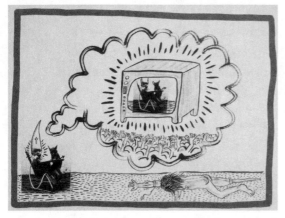

museum where I did the mural. It is opening with a Gordon Matta Clark retrospective. Meet several more people who say they have my pieces. Also, run into Jason (the kid I met when I was on Belgian TV), who has the copies I'd asked for of his baby picture. I take enough for ten drawings. I am thinking of using them for collages.

We return to Knokke and eat at the Casino. I call Tony and we argue about my telex to him. He is really adamant about his commission.

Tereza Scharf calls from London and says they'll come here after Hamburg.

11:00 PM: Begin "The Story of Jason," a series of nine drawings with Jason's baby pictures. This is one of the greatest "groups" of drawings I've done in a long time. It turned into a kind of story about good/evil and Christ/anti-Christ, etc. It works like the old series of drawings that all refer to each other, but without any obvious order, specifically. Very much like the cut-ups, referring to many things at once at the same time and different times.

2:00 AM, go to sleep.

SATURDAY, JUNE 20

12:00 NOON: To casino to begin big mural. Wall is about 14′ × 50′. I do drawing with black acrylic of detailed "gambling scene." Big brush and pretty quickly. Very Dubuffet, or something, with a little hint of Stuart Davis. I finish at 3:30 PM to applause.

Return to Dragon and sign last night's drawings. Write in diary and eat lunch. Begin more ink drawings. Monique Perlstein comes for dinner. Finish 11 drawings, including one of a dream from last night about me getting caught by my grandmother in her basement with two boys. Also do a portrait of Grace (from Casino program cover) and a self-portrait.

SUNDAY, JUNE 21

Wake up at noon. People are arriving for lunch. Some collectors, the guy who made the canvas for the Casino mural, some critics, etc. Everyone is in the Dragon looking at my drawings. I already feel like this is my apartment and feel trespassed upon. Sign drawings and have some trouble with the dried ink smearing. Lunch for 20: wild boar.

Go to Casino to finish mural with everyone from lunch. Fill in color inside all the black shapes—one color at a time. Very "Cobra" brushwork and very drippy. Finish around 9:30 with back hurting and smelling bad. Return to house to eat and call Condo in Paris and Claude and Sydney Picasso to invite them to come to Belgium Sunday. Also, I wanted to call home since I haven't talked to them for a while so I did and my sister Karen told me Grandma died. They had just found out.

It was really strange since I had just made the drawing of the dream with her the night before. I talked to my sisters, Karen and Kristen, for a long time.

Funny, but having dealt with death up close it is not so hard to deal with it when it happens to someone who has had such a long life. I know she is in a better place, and she was lucky to have had a relatively long and peaceful life and lived to see her great-grandchildren.

MONDAY, JUNE 22

Wake up at 10:00 and go to Casino to see exhibition space and organize studio. Begin to paint Xavier Nellens's wind-surfing sail and then his surfboard. The surfboard is Styrofoam and will be coated with hard plastic. Seems like a really cool way to make paintings. I want to try it. Call Alex Hernandez to confirm his arrival Saturday. Telex Julia. *Esquire* magazine of Germany wants to do a big story on me for their first issue. Paint in Penguin studio all day. David Neirings visits, also Viken Arslanian visits. Funny that my two biggest fans in the world both live in Belgium.

TUESDAY, JUNE 23

Wake up at 8:00 and write in diary. At 9:00 AM drive to Holland to buy brushes and then to the Penguin to start with black lines. Finish underside of surfboard. I paint all day. While I'm painting there's a huge fire in the hotel near the Casino. I continue painting. At the end of the day Leopold, the mayor, comes by and I later find out he bought the painting I was working on. Strange painting . . . oil paint drawing—half abstract, but I am happy he likes it. It is sad to make all these things and then just sell them. I want to keep everything for myself. By the end of the day I finish six or seven paintings. At the end of the day, Monique cooks and brings food to the Penguin.

WEDNESDAY, JUNE 24

Paint all day. Finish all the paintings. Otto Hahn arrives and likes them. A lot of people coming by to watch now. I work, uninterrupted, all day. At 10:00 PM we all go to the house for dinner. Nice dinner, except I got stoned after I finished painting so I am a bit spaced-out. I don't talk much during dinner.

Also, during the day the doctor from Antwerp has visited and told me all blood, X-rays, etc., were normal. So I was O.K. till the phone rang and it was a "lady" from *New York Newsday* asking me to comment on the rumor that I have AIDS. I can't believe this could have gotten so out of hand just from being out of New York for two months! I was nervous because I was tired from painting and stoned and I didn't want to sound unsure of myself. I assured her I was fine and also assured her it was obnoxious of her to ask me in the first place. She kept persisting till I finally told her I had given her more than enough of my time and resumed my dinner. It put me in a weird mood, though. It seems strange coming at a time when I am working harder than ever before and doing some of the best work of my life, especially after feeling great after having had some doubts myself. People are too anxious. They can't even wait till you're sick! It doesn't make me very anxious to return to New York!

THURSDAY, JUNE 25
..

9:00 AM: Tony arrives from New York. We go to Casino to begin to hang the large paintings. Everything goes very quickly. We return to the house for a lunch for the press—mostly local, but also an AP man. I spend extra time with him because it is important that people in the U.S. know what I've been doing for three months in Europe . . . not dying. Jason arrives from Antwerp by train. Everyone goes to the Casino to finish press questions. Also to Penguin to see the new paintings and sign some kid's pants. He said, "I want a little man with a willy," so I drew him a big willy.

Return to Dragon and write this and begin drawings. It's a strange feeling to make this many things and hardly have time to really see them. I had a feeling while I was doing the big mural in the Casino that maybe I would make this my last show. I sometimes get really sick of the selling part. I

would love to just make things and let them accumulate and pile up. I like to make them, but I don't like to sell them. All the time I spend thinking of how much they should cost and what percentage I get and which ones I should keep and how many I should do, etc., etc., seems really counterproductive and anti-art. The reason I make art and the reason I became an artist was not for this.

It's really satisfying to make the things and really fulfilling to see people's response to them, but the rest is difficult. I tried, as much as I could, to take a new position, a different attitude about selling things, by doing things in public and by doing commercial things that go against the ideas of the "commodity-hype" art market. However, even these things are co-opted and seen by some as mere advertising for my salable artworks. I fear there is no way out of this trap. Once you begin to sell things (anything) you are guilty of participating in the game. However, if you refuse to sell anything you are a non-entity. My decision to come to New York and be a "public" artist was spurred by my desire to communicate and contribute to culture and eventually history. Once I decided to be "visible" instead of merely entertaining myself (masturbating) with my paintings then I entered the game. I always believed that if I maintained (and I have) my original motivation and integrity, then I could avoid being a victim and play by my own rules.

I have tried as much as I could to prove over and over that I was interested in a very sincere portrait and have tried to expose the system and politics of the art world by breaking as many rules as possible while at the same time building a stronger and stronger position as an artist in the world. Sometimes I have been successful, but overall I'm not sure if people really get the point, and in a way it's like running on an electric treadmill.

It is impossible to separate the activity and the result. The act of creation itself is very clear and pure. But this cre-

ation immediately results in a "thing" that has a "value" that must be reckoned with. Even the subway drawings, which were quite obviously about the "act," not the "thing," are now turning up, having been "rescued" from destruction by would-be collectors. Possibly only the murals on cement walls that cannot be removed and the computer drawings, which can be rearranged at will, are free from these considerations. The problem is I actually enjoy making "things," and I have always loved owning "things" and seeing "things" from other places and times. It is not a new problem, but there are new factors involved. The issues have become more complicated and history has defined the "value" of certain things in different ways: the value of something according to how much it has affected change and influenced the world, and the value of things in terms of monetary value. Also, the sense of time and the shortness of the moment.

I hope that I will make some advances to break open this game. Maybe the way to do it is to not sell anything else. Or maybe it is to continue the same way, carefully decid-ing which things to do and which things not to do, doing more and more "public" art and selling less and less of my work. (However, it will only create a bigger problem after my lifetime—to decide ownership and distri-bution—if I just stock-pile everything.)

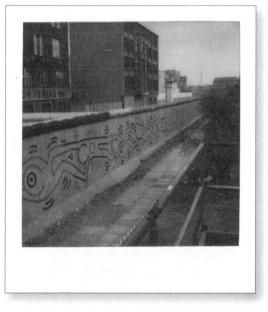

The only time I am happy is when I am working. If I work, I produce "things." But

I don't want to watch these "things" treated like stocks and bonds. I don't want the things I have already made to interfere with what I will make. I don't want what I have made to dictate what I should or should not make or how much I should work. I wish I could make things all the time and never have to think about what happens to them afterward; I just want to "make" them.

After writing this I proceeded to do ten gouache-and-ink drawings and then eleven ink drawings on Japanese paper. Being a little frustrated and tired, but forcing myself to continue drawing, produced some interesting results in the last ten drawings. I was using a Japanese brush on Japanese paper and I began to do abstract drawing/writings that looked like Japanese calligraphy. I switched brushes and procedures for each drawing and the resulting eleven drawings were unpredictably interesting as a group. Very Brion Bysin, very Japanese, a bit Condo and very close to my original sumi brushwork from the Seventies. Finish, tired and exhausted, and watch bits of *Reanimator*.

FRIDAY, JUNE 26
...

Wake up and go to the Casino to hang the show. Carry all the paintings from the Penguin after photographing and signing them. We need two Polaroids each: for Tony and for insurance. We re-confirm our request for five Prince tickets for Monday night. The man from the record company assures me it should be no problem. Finish arranging paintings. Return to doctor to check sinuses; he says they are less swollen. After all paintings are in place and all drawings hung, we go over a list of works for labels and pricing. Long discussion with Tony about the pieces, etc. This is very difficult but, I suppose, very important.

I go to the Penguin to paint three vases: one for Monique Perlstein and two for Monique Nellens, hoping to restore my

faith in art by painting instead of pricing. I decide I want to finish alone and ride the bicycle home, so Juan and Jason take a ride to the house with someone else. I finish and have a wank and ride solemnly to the beach. I drive for a few miles, around the sand dunes. I keep thinking about Martin Burgoyne for some reason, except it's not sad anymore; it's something else now.

Somewhere, herein, lies the importance of being an artist. Artists help the world go forward, and at the same time make the transition smoother and more comprehensible. Often it is difficult to isolate the actual effect of artists on the physical world of "reality": their effect is so much a part that it is part of the interpretation or experience of "reality" itself. We see as we have been taught "to see" and we experience as we have "been shown" to experience. Each new creation becomes part of the interpretation/definition of the "thing" that will come next; at the same time becoming a kind of summation of everything that has preceded it. This constant state of flux is recorded in time by events and within events by the "things" that populate, define and compose these events. Since he creates them, these "things" are the responsibility of the artist. They must be constructed with care and consideration (aesthetics) since it is these "things" alone that will bring "meaning" and "value" to events and consequently our lives. By artists, I don't mean only painters and sculptors and musicians, writers, dramatists, dancers, etc., etc., but *all* forms of artists within the labor force: carpenters, plumbers, draftsmen, cooks, florists, bricklayers, etc., etc. Every decision is, after all, an aesthetic decision when you are changing, arranging, creating, destroying, or imagining "things."

So-called "primitive" cultures understood the importance of this concept being applied to every aspect of their lives. This helped to create a very rich, meaningful existence in total harmony with the physical "reality" of the world.

Contemporary man, with his blind faith in science and progress, hopelessly confused by the politics of money and greed and abuse of power, deluded by what appears to be his "control" of "the situation," etc., etc., believes in his "superiority" over his environment and other animals. He has lost touch with his own sense of purpose or meaning. Most religions are so hypocritically outdated, and suited to fit the particular problems of earlier times, that they have no power to provide liberation and freedom, and no power to give "meaning" beyond an empty metaphor or moral code. This lack of meaning lies more in the "things" themselves than the ideas and thoughts we use to describe and explain these "things." These "things" are part of a cyclical pattern, since they are used to explain other "things," and they are the results of ideas that manipulate other "things" and they are the source of and the result of thoughts and ideas. They are both subject and object. That is why it is so difficult and so important for artists to interfere with (and enhance) this ongoing cycle of meaning and metaphor, subject and object. The only way that this cycle becomes enriched, and hence more fruitful and meaningful, is through the insertion of aesthetic manipulation.

As new "things" are created, the thoughts and ideas that will become the "interpretation" and "response" to these new "things" will also be the source of new thoughts and ideas and newer "things." Time marches on . . .

I'm sure this is not all airtight, but the basic idea is right. Art is important, and important artists (respected ideas) are important because their ideas and creations are widely discussed and dispersed. The responsibility that carries with it is, for me, mind-boggling. I feel it is my duty to spend the rest of my life trying to understand what the role of an artist should be, to be situated so that I am in total harmony with myself and the world. My other responsibility is to make these discoveries known, to the best of my ability, through my work, (i.e., the "things" I create).

I sign the edition of prints. Alex arrives at 8:05 in Brussels. Juan goes to pick him up at the airport. I have an interview for TV at the Penguin while I am painting Monique's shirt, pants, coat, hat, etc., for tomorrow. I finish hanging the rest of the show and eat lunch. Another talk with Tony to go over prices and how much I want in case they do a package deal. It is very hard to determine. We agree on everything one by one, and he assures me I will be given an itemized list of works and amounts I will receive. Several of the pieces are already sold and more collectors are arriving. I take another long bike ride to the beach. When I come back Pierre has arrived with François Boisrond. He has the proofs and contract from Lucky Strike. Everything looks great except, of course, they don't want to use the one with the lady (pseudo-Picasso) smoking a cigarette because it is "too strong."

I want to look at the show quietly, with no people. I get the key and go inside. After 20 minutes, this kid (Baptiste Lignel) comes in who looks like a cuter, younger version of me, or maybe a cross between me and Tweety Bird. Anyway, he's real shy but eventually explains he is the son of a collector from Paris and they had come all the way for my show. We talked a while. He had very strong opinions about which work he preferred and why. He was very adamant that I should continue the bold, simple style, and spend less time on the "newer," more intricate style. He said, "You're the only one who can do this, so you should keep doing it. Other people can paint the other way, but nobody can paint like this." We also discussed my visibility in France and the unavailability of my things (Pop Shop) in Paris. After talking a while I jokingly told him I should hire him to be my manager. Now that I think of it, a 13-year-old manager may not be a bad idea. He was really bright and we had a great conversation.

Wake up. People are already arriving. Jean Tinguely with Jeffrey Deitch and Jean's girlfriend with dog. Marie Françoise from Daniel Templon arrives and says Daniel is on his way. Later he arrives with his wife and baby. The Dragon is full of kids and people grabbing their free T-shirts from the boxes. We had a problem with the ink on the first batch of T-shirts, so we got them for cost and are giving them away. As always, this got out of hand and we had to put the remaining ones away. People came from everywhere. A lot of friends I have met during the past two months in Europe came for lunch. The friends from Hans Mayer gallery and Hans himself. Hans was just in New York City yesterday and came to Knokke today—crazy! The two girlfriends we met in Düsseldorf drove all the way, also. Jan Erik and his friends from Amsterdam. Helena with her new husband, from Amsterdam. Patricia (tattoo) and a friend from Amsterdam. Plus, everyone in Belgium who I've met in the last month. It was like a wedding party. There was a huge tent set up on the lawn (in case of rain) and tables set around the lawn; several waiters and cooks; three-course meal with cold salmon and then hot ham and spinach and potatoes and then homemade mousse and homemade sorbet and ice cream.

There were lots of kids playing everywhere; kids on the trampoline, kids drawing in the Dragon. The lunch went from 1:00 to 5:00. The weather was incredible. It was the warmest, sunniest day I had seen since my trip to Belgium. It was almost too warm! It seemed like the official beginning of summer. Everyone was in good spirits and mingling with each other. Klaus Richter brought me a little painting that is really beautiful. Everyone was wearing the T-shirts and having a great time. By the time it was time to go to the Casino I was already exhausted. At the Casino we had to first stand in front of the big mural while people made speeches in Flemish

and French and then in English (the mayor). Then Roger made a nice little speech in English and ended by saying, "Let the music begin," at which time Rita Mitsouko started blaring through the sound system. Nobody was allowed to enter the exhibition yet. Everyone had to wait till I officially opened the show by walking into the ex-

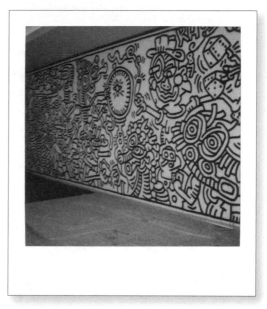

hibit with the mayor and a glass of beer.

It was pretty amazing; I never did this before. It was a great "opening." There was a mad rush of people into the exhibition space, but mostly toward me. Everyone that had heard about my "signing" in Antwerp had returned with more things. Since I have, now, a reputation for signing things, people expect me to do it. This can become a bit of a problem. I don't mind doing it when I choose to do it, but when I feel forced to do it, I lose my patience very quickly. Many people really become quite rude if you explain you'd rather talk to your guests and not sign their shirt(s). There were a lot of people who had traveled quite a long way to see me, and I really wanted to talk to them. I was very annoyed after a while and simply refused to sign any more things. The problem is, there is always an exception: the person you really *have* to sign for (a friend, a patron, a child, etc.) and as soon as you sign this one exception, all the others come running.

I woke late and had tea and breakfast. I had promised an interview with German *Esquire* magazine since they had come all the way for the opening. The interviewer was quite interesting and intelligent, so it was a very easy and engaging interview. When people are understanding everything you're talking about and inspiring deeper conversations, I can talk for hours. We had a nice long talk, but had to end because we were running out of tape. Besides which the man was here to discuss the "video shorts" project. We talked a little and exchanged addresses and numbers, and I decided I need to think about it more before I make any decisions to begin.

I walk back to the house and run into Niki de St. Phalle, who has come for my show. She doesn't like opening galas, but wanted to see the exhibit and also see people living in her Dragon. Nobody has really lived there for the entire time it's been here—15 years. She liked the show and is interested in trading something sometime. I would love to visit her houses in Italy. I call London to find out the name of our hotel for tomorrow. We have to leave early to drive to Antwerp to get the tickets at the door for the Prince concert. We drive to Antwerp and get the tickets and passes, which are actually just souvenirs, since you can't go backstage with them.

Prince was incredible. I was really impressed. It was a big change since I saw him at the Palladium in 1981 or '82. The whole show (lights, sets, costumes, etc.) was really tight, really sexy, and really good. A lot of people in the audience recognized me, since I've been in the papers and TV here lately, and asked for autographs.

Wake up late. Meet with Tony quickly about final money arrangements. Arrange a flight to London at 5:00. Clean up the Dragon, which looks and feels like we've been living in it for a year. We take the car to drive to Brussels and leave it at the airport till we return from London. It seems London is "chock-a-block" full of tourists for Wimbledon, etc., so we're stuck in this 42nd Street fleabag hotel. We see a theatre that is showing *Prick Up Your Ears*, the movie about Joe Orton and Kenneth Halliwell. Since I've read Orton's diaries, I've been dying to see the movie, and what better place than London!

So, we go see the movie and it's really great—hilarious and tragic at the same time (exactly the same time).

After the movie we ask two queens in the theatre about gay discos and I ask if Heaven is still open. They tell us where Heaven is. We go out and walk around a little and eat at a gross steak house. Disgusting food. Very English. We take a taxi to Heaven. It is almost the same as I remember it, big and gay. We hang out, sort of bored, until me and Alex notice these two guys cruising Juan. They're sort of cute in an old sort of way. Muscular, but a bit tired. After seeing how dismal the rest of the scene is, we decide to talk to them. They suggest a tour of London. We drive around a little and smoke some hash. It turns out they are strippers, which accounts for their physique, and we become a little more interested.

After we finally suggest a striptease at our hotel, they quickly agree that it is a good idea. So we all go to our fleabag hotel, push the double beds together, and have safe sex until the sun comes up (one hour later). We ask them to leave so we can sleep, since they said they couldn't stay, and the cuter one gives us an 8″ × 10″ glossy of himself from his audition book.

Sort of amusing for London and even more amusing considering this is the only sex we've had on this trip so far, besides with ourselves, of course.

SAFE SEX!

© K. Haring 87

Check out of hotel and go to the ICA. See the show, "Comic Icono-clasm." Lots of interesting pieces in the show, but something is missing. Maybe it has something to do with the exhibition space itself: it just doesn't work. The idea of the show is great, but it is muddled by too many inferior pieces. If it were more selective I think the strength of the idea would be more clear. The show makes the idea look a bit trivial.

We eat lunch and prepare the room for the workshop. Apparently they are only expecting about 20 kids—hardly worth a trip to London. But it turns out O.K. Nice kids and a few groupies. I do a quick interview for the ICA video. We catch a plane back to Brussels at 7:00.

SUNDAY, JULY 5

Wake up late. Lots of people around the house. Spend the early afternoon drawing. I did seven drawings I owe Roger: a kind of series about butterflies, cocoons, and birth. Then I did four vases. Three for Monique and one for Emy. I used ink instead of acryllic, but I think if I cover it with something it should be O.K. It is great using ink on terra-cotta because it soaks it up really fast and makes a line like on paper. I do some more drawings, including one for Bo and one for the widow of Hergé, the guy who drew Tin-Tin. I did a drawing for her of Tin-Tin on a dolphin, with red polka dots.

I return to the Surf Club to paint the background of the wall I volunteered to do. They have "containers" on the beach for storing equipment. The side of one container is approximately 8' × 25' and it is perfect for painting. Xavier scraped and sanded it and I rolled on a white primer. After hanging out awhile we return to the house for dinner.

MONDAY, JULY 6

Sign some posters for all the people who work in the house. Head toward Surf Club to start wall. Lots of gorgeous surfers hanging out waiting for wind. I begin mural and immediately attract a crowd. By the time I finish, to applause, there are 50–60 people watching. The sun is really hot and I wear sunblock and a hat. The audience is incredible. This is really summer: surfers at the beach. I only miss Avenue D a little bit. There are even Spanish-looking people here. One particularly cute kid says he is Dominican. I take lots of Polaroids of surfers and do autographs on shirts, shorts, helmets, etc., etc. Then I go with Harry-Michel on another catamaran ride, this time I take the helm. Not as much wind, but fun to be in control of the boat. We return to the beach and dismantle the sails and put away the boat. More photos.

They organized a barbecue on the beach. Really great. Sun sets at 11:00 PM. Lots more people want stuff drawn on them. Dominican kid is back again, still wearing little shorts. He can't stop smiling and I can't stop "rapping." Really fun barbecue. Huge bottle of champagne for me. Really nice guys. Bruce Weber would love it here.

TUESDAY, JULY 7

Make ten gouache-and-ink drawings. All the drawings at the Casino are sold, so I'm making some more before I leave to refuel the supply. I also am talked into doing two small

paintings. I am a little tired of working, but somehow when I force myself I get interesting results, so it's hard not to be curious about it. Even if I'm tired of working I can work, so why not? Really, what else is there, after all? The wife of Roger's assistant has come to photograph me working on these two paintings and brought with her two really cute twin boys about seven years old. So somehow, with them watching me paint, both the paintings turned out to be about two's, or twins. Should be interesting pictures. Since I have already promised it, I paint the huge vase that Tinguely did the "holder" for in the backyard. I use a big brush and it goes pretty quickly.

WEDNESDAY, JULY 8

A lot of kids come by to visit and say goodbye and get shirts signed. I don't know why I attract so many cute boys, but it keeps the scenery interesting. I do my final group of ink drawings. More kids come by with skateboards to sign. Play on the trampoline in the backyard. Eat another fabulous lunch by Roger. I do a big three-eyed face painting on the refrigerator for Roger with oil paint, and go with him to buy a sack for the stuff I've picked up. I drive to the Surf Club for goodbyes, promising to return next summer.

At the house eat another concoction by Roger—banana

duck. Also fresh calamari caught this afternoon, the best I've ever eaten. *Life* magazine calls to say the Luna Luna article is delayed, and to ask some more questions. I go to visit the exhibition at the Casino one last time. Funny how sometimes I lose all faith and everything looks like shit to me. Luckily this doesn't last long, or maybe it's good it happens 'cause it pushes me further. I hope I'm never satisfied. You always have to strive for improvement.

THURSDAY, JULY 9

Wake up and finish packing. Have a last fresh-squeezed orange-juice Nellens breakfast and load the car. We drive to Paris with Roger and Monique to visit Niki. So we have lunch in Niki's backyard. We tour the house and studio. It's full of her and Jean's stuff. We talk about a lot of things and she gives me a lot of books, including the AIDS book she did. She also wants to design rubbers and I tell her I'll investigate the possibilities in America and Japan since she's had no luck in Europe. I also get the name of a doctor who is a big AIDS specialist in America. I want to investigate experimental treatment for those with positive diagnosis who do not have actual AIDS yet.

I feel more optimistic after being in Europe and I think it might be a good idea to live longer. I think I could have a great future and be very productive. Niki takes us to the forest near her house to see the "head" Jean and others have been working on for 15 years. It's really incredible—huge and actually has movable parts. It's better than Disneyland. You can walk inside of it and climb stairs all through it. It has a theatre and an apartment inside. I've seen pictures of it and have wanted to see it since Lüggenbühl's son told me about it while we were working together at the Paris Biennale in '85. She also takes us to see Jean's house where she used to live also. It is a really old (medieval) castle with sheep running around outside. We return to Niki's house and meet

Marcel Duchamp's step-daughter-in-law, who is also Matisse's granddaughter.

SATURDAY, JULY 11

Taxi to airport. Concorde to New York.

SUNDAY, SEPTEMBER 13, 1987

We're boarding Flight 002 leaving Kansas City for La Guardia Airport. We just left William Burroughs's friend's house outside of Lawrence, Kansas, where we were shooting guns. It's the first time I ever shot a handgun.

We arrived here Friday afternoon after traveling back to New York City by bus on Friday morning from Kutztown. I had my preview of the first exhibition I've ever had in my home town, Kutztown, Pennsylvania, on Thursday night. We hung the show, a small painting retrospective, 1981–87, at James Carroll's studio on Main Street.

The opening was a pretty funny thing. There was a phenomenal amount of people. I autographed posters for about two and a half hours non-stop. There was a constant line of people for the entire opening, many college students, mostly female. My grandma and Mandy came and some uncles, aunts and cousins. Some school friends, grown-up with kids. Some town people and old teachers from elementary and high school. My one cousin came with an adorable friend I didn't even have time to shake hands with. There were reporters from the *Reading Eagle*, *Morning Call* and the local paper, the *Patriot*. A group of barefoot surf-looking cute kids brought me a Gumby (six-foot) to autograph. I quickly gave him a huge, mounted penis. My mother liked that.

There was also a bunch of really cute little kids who wanted drawings and autographs. All in all it was really fun and more hectic than I expected.

The following morning
we took a Bieber bus at
7:00 AM to New York City,
took a subway to the stu-
dio, and caught a taxi to La
Guardia.

We arrived in Kansas
City and were picked up at
the airport at 3:30. After a
short tour of Kansas City
we headed to Lawrence. The
first person I saw as we
arrived was Matt Dillon.
He's in Lawrence shooting a
movie. We heard local "Matt
Dillon stories" for the next
two days while we were here.
Mostly about his seduction
of local teenage girls (true or
false), who cares?

Talking to Matt in the
corner and Jim Carroll, who
was on our flight, and Anne
Waldman. A car turns the
corner and someone yells,
"Hey, Keith!" It's Allen Gins-
berg arriving for the open-
ing of his photo exhibit down
the street. We go to the show,
kiss Allen, he walks me
through the show. Some pho-
tographers and video crews,
including a German photog-
rapher from *Stern* who I
know from Area. Start meet-

ing local college students. Turns out Lawrence is the home of University of Kansas. It's a pretty hip campus. Lots of art boys hanging around. Someone in the gallery asks me to do a chalk drawing on the front sidewalk. I oblige, doing a drawing for Allen. Allen writes an adjoining haiku to go with the drawing.

"Taking pictures of the sky
Naked on the sidewalk
The flasher rises in Kansas."
—Allen Ginsberg, Sept. 11, 1987

Immediately after the photographers finished snapping, the gallery ladies were already running around talking about "preserving" it. The next morning I found it polyurethaned. It washed away part of the chalk, but was still visible.

This was my first collaboration with Allen.

Me and Juan get a ride with some college art boys to the hotel to smoke pot and see if Timmy Leary and Barbara have arrived yet. They haven't. We smoke. Timmy calls, he came without Barbara. We agree to meet later for a drink.

We go with the kids to see Lucifer, an abandoned frat house covered with local graffiti. Scary place. Abandoned after a fire several years ago. We go to the reading late, after being at their house for some beer. They had a Free South Africa poster hanging in their kitchen. We see Jim Carroll read and leave again. Run into John Giorno. Back to hotel later to see Timmy in bar.

Next day we plan to go in search of skateboard hangout. After breakfast there is not enough time before Timmy's lecture. I see a girl with my T-shirt on street and offer to autograph it, but she doesn't believe it's me. Timmy's lecture is preceded by Jello Biafra from the Dead Kennedys, who has just been cleared in an obscenity case in L.A. over a poster by Geiger (the artist who designed *Alien*) that depicted various

cocks and asses. Unbelievable story. The poster, inserted in the record, was nothing compared to some of the images I have created. The stories about the search, etc., are pretty scary. I wonder if there is any possibility of me being singled out.

He read a lot of provocative material and was really impressive. Timmy's rambling lecture about everything from drugs to computers was slightly tired by comparison, but great. He offered some interesting ideas, and introduced me to the audience as the "future of American art." I was wearing the "AIDS is Political-Biological Germ Warfare" shirt. Some woman came up to me afterward to discuss her findings (top secret) about the probable cover-up. She was a little too paranoid (can you blame her?) to tell me much, 'cause she didn't know me, but we talked for about a half hour. Then I went with Juan and two college kids to find the skateboard ramp. We finally found it and I spray-painted some stuff on it. Unfortunately the ramp is in bad shape and will probably need to be refinished soon. I wonder where the painted boards will turn up.

We get to Liberty Hall in time for the 9:00 PM reading. John Giorno is great as usual. Anne Waldman was really good, too. William was William (always a treat), and Allen read "Howl" and sang two fun songs. This is the first time I've seen a group like this since the Nova Convention in 1979. Nova Convention changed my life. I got the feeling that this event was happening at an equally powerful and important time—not only in my life, but in history. The weekend was full of "historical moments." Conversations with Allen and Anne at the hotel party afterward were invigorating.

Sitting in a hall in the hotel with Tim, Allen, several art boys and college students, some naked except for towels, running to the pool, it looked like a college dormitory party. Powerful moment. Met a guy from Detroit who had come with Jack Kerouac's wife who told me an interesting story

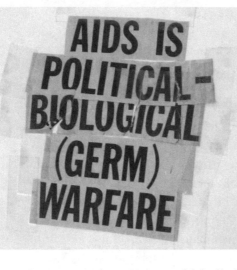

about an art history class lecture comparing me to Gustav Klimt. Another kid from Berlin had heard a "serious" lecture about me two weeks earlier in Berlin.

Gave out some of the AIDS shirts to Jello and the others. There was a 15-year-old cockteaser who was rapping to everyone but making out with a 50-year-old bull dyke. This kid has serious problems. We moved the remaining party to our room about 4:30. Mostly college kids, confused art boys, etc. We (me and Juan) went to sleep at 6:00 AM.

Woke at 12:00 and went to William's house. We talked about the paintings and drawings he's working on. Shooting boards with paint cans on them and pictures. Some pretty interesting ones. Funny how the gunshots look so much like Brion's drawings. Smoked a joint with William to aid in "seeing stuff in the paintings." More people arrived. Matt Dillon, Jim Carroll, Terry Toye and Patricia, who drove down from Iowa. Most of us drive out to William's friend's house to shoot guns. I shot a handgun. Sort of fun, I guess, but too boring to shoot at targets. Talked to William about the Amazon, talked to John about AIDS, said goodbyes all around and off to the airport.

Last night during William's reading he mentioned the AIDS paper about germ warfare. He had a copy of the same poster I took the caption off of for my shirt.

As usual, there was a lot of this "cosmic coincidence" around this weekend. Things just sort of fell in place without

any effort. The "magic" is very real. Someone was discussing healing in the car today and said something about the only healing that will help the AIDS virus is "magic," holistic medicine, visualization, psycho-medicine, etc. I hope my generation will be able to carry on the "magic" that this previous generation has excavated and gently tried to teach us. They have liberated a part of us that is too important to be dismissed and passed over. As the gems of our era (founding fathers) disappear, like Brion and Andy, etc., it becomes increasingly important to keep the fires burning and use their knowledge and experience to prepare the present and forthcoming generations for the world they are about to inherit.

For that reason and a thousand more this weekend was a very important stepping stone in my life. I'm happy I'm here.

OCTOBER 2, 1987

I'm on a train leaving Zurich. When I arrived yesterday I slept a while and then went to the Trickfilmladen studio to start working on the animation. We had to start developing characters. The six one-minute spots are designed to teach children about home safety. It's the first time I'm using my "cartoon" characters for an animated film. It's funny to see these characters, most of which I invented when I was ten or eleven years old, turn into "real things." It's nice to be back in the house of Rolf Baechler where I did my first real animation three years ago for the store here called BIG. This time I'm sort of the art director and designer instead of having to do all the drawings.

Rolf and Yunia's kids are all real happy to see me. It's been three years and they've grown. Actually, that's not true. I met them three years ago the first time, but I saw them last year in Montreux when I was at the jazz festival. They can't stop climbing all over me and giggling a lot. Their father is

always trying to get them to calm down and act normal, but they can't help it. Especially Serafina, the little girl, who giggles even if you touch her with one finger! I'm sort of an honorary member of the family. Again, they told me the story of how the kids cried for three days after I left them three years ago. I seem to be adopting these little families all over the world.

Speaking of families: I'm sitting in an empty train car so I'm playing my radio real loud. I've got a tape on that Junior made me called *Paradise Lost*. It still hasn't sunk in that the Paradise Garage has closed forever. Every time I hear a song that is a "Garage song," I get real emotional. I can't explain exactly why, but something about just knowing it was there was a comfort, especially when I was out of New York City. There was always something to look forward to immediately upon my return. In fact, I often scheduled my trips around the Garage, leaving on Sundays and returning before or on Saturdays. It was really a kind of family. A tribe. Maybe I should open a club, but I really don't want to deal with that headache. This is the worst heartache I ever felt. It's like losing a lover when everything was going just fine. It's like when Andy and Bobby died. Maybe Paradise Garage has moved to heaven . . . so Bobby can go there now. That would be nice.

The last night was pretty incredible but not as sad as I thought it would be. People were sort of numb. It's just so weird knowing that you're not going to see a lot of these people again. There were a lot of people I only used to see there, a lot of them I never even spoke to the whole five years I went there, but I feel like I "know" them 'cause I shared something with them. Grace came for a little while, but didn't stay long. Larry Levan played all night and all the next day till after midnight. I had to leave at midnight because I had work to do Monday morning to prepare for this trip to Europe.

The last couple of weeks have been really hectic. The mural in Philadelphia with City Kids, and then a trip to Kansas

to see Bill Burroughs, to Detroit for an installation at Cranbrook Academy of Art.

Cranbrook was pretty cool. I did probably my best painting to date! The room had 16-foot-high ceilings and the walls were 35 feet long. I did a fast Gysinesque color "calligraffiti" background with big Chinese brushes and then the next day painted with Japanese brushes with black (ink/paint mix) with different size lines and brushes. Each brush I used was nailed to the wall at the end of a line. The big Chinese brushes looked so cool after using them that it seemed like a good idea. I went there with no materials and decided what to do after seeing the space. So I bought all these brushes with Cranbrook money that weren't very expensive and weren't very reusable after the abusive painting of the color, so it seemed like a good idea and also, since this was a temporary installation, it was a chance to experiment. I'm obsessed with brushes, so somehow to sacrifice them to the painting was a kind of homage to the brushes themselves. The whole thing was a kind of sacrifice anyway. The room will be repainted in one month.

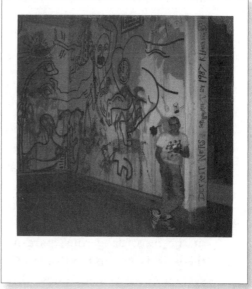

I took Kwong along to take pictures. Photography has become such an important part of my work since so much of it is temporary. It is, after all, the phenomena of photography and video that have made the international phenomenon of Keith Haring possible. How else would everyone in the world have plugged into my information?

Most information about art is conveyed through pictures now. Sometimes that's deceptive, but in my case it is the means *and* the end. Of course, the effect of scale is lost in photo depiction, but almost all of the other information is transferable.

My lecture at Cranbrook was probably the best I've ever done. The auditorium was packed. A lot of people there, in fact most of them, were not Cranbrook art students. Many people came from Detroit and a lot of kids from the private middle schools at Cranbrook. Somehow the words just flowed and I was pretty articulate. I'm anxious to hear a tape of the talk. Mobs of people afterward for autographs. My patience was even longer than usual.

Some girl brought a poster for me to sign which she said she got at the Tate in London. It's really funny to me how all these museums sell poster and postcard reproductions of my art, but refuse to exhibit, collect or even acknowledge it within the museum. I bet they didn't sell Peter Max in art museum bookshops ever. They want to play with me, but they don't have the balls to stand up and support me now. Wait, everyone says, just wait and be patient. I should be glad, I suppose, that I am still outside of their acceptance. It gives me a kind of freedom and gives me something to work against. Does this mean I'm still avant-garde? Ha-ha, just kidding. I can't believe that some people are so shallow as to worry about whether one person, like Saatchi, collects me or not. How can one person be an important determiner of what is good or not? In fact, if someone is trying to use their power or collecting to impose their taste and standardize the taste of the entire culture, then I think they are the most suspicious suspects of all. It's all banking and investment bullshit at that level. Saatchi might as well be a bank. The art market is one of the most dangerous, parasitic, corrupt organizations in the world, next to the Roman Catholic church or the justice system in the United States. How naive of me to even think

that art was an island of "purity" in this vast chaos of business and "reality." The only time it remains pure is when you are doing it at a real public level without monetary compensation or when you do it totally for yourself in seclusion. Even now, when I draw in public, the autograph-seekers are sometimes motivated by the hope that my signature will be "worth" something instead of simply because they like it or admire it. It is, however, impossible to go backwards. I'm in this thing now and I've got to deal with it. I think I'm doing a good job of it so far.

I wish I could keep a diary in New York City; it seems I am so busy in New York, and there is so much going on that I never have time to think about it, let alone write it down.

Re-reading this last page I have to add the possibility of purity during the moments of working with children. When I do drawings with or for children, there is a level of sincerity that seems honest and pure. Admittedly, even some children keep their autographs because they are told "they might be worth something later." But most of them keep them because they love them.

OCTOBER 3, 1987

I'm back on the train. What a fucking day! Twenty-four hours seemed like a week. Pierre picked me up at the train [in Lausanne] and we went directly to lunch with Mrs. Rivolta of the gallery and her 16-year-old, Francis.

This was the same fancy little restaurant that mistook Jean Tinguely for the repairman of the lift when he arrived in his coveralls. I was wearing my "safe sex" sweatshirt prominently displaying the cartoon "Willie." Needless to say, heads turned.

Pierre had with him 50 samples of the "condom button-boxes" that I'm producing in Switzerland for the Pop Shop in New York. They look great. After lunch we quickly visited

Dolce Vita, the nightclub that has utilized my "wine label design" for stickers, T-shirts, etc. I helped myself to two packs of stickers and requested T-shirts sent to New York immediately. We had another quite small glass of Swiss white wine. By now I was already buzzed from the wine at lunch. Now a quick trip to Gymnase du Bugnon, the high school where Pierre teaches, which is splitting at the seams full of beautiful boys. Pierre, never wanting to waste an opportunity to work (three cheers for Pierre!), has arranged a photo shoot with a quite famous photographer who is shooting "personality portraits" on chairs for a chair company. Very chic. He has, so far, done Godard, Issey Miyake, etc. I am to be paid 5,000 Swiss francs for a 10-minute sitting and the photo will appear in only distinguished magazines all over the world (i.e., *Domus, New York Times Magazine, Der Spiegel*, etc.). The shooting goes great.

Rémy Fabricant, the guy who worked for the advertising agency that invited me to do the first animation in Zurich three years ago, is here with his girlfriend. Apparently he works for a new ad agency that is doing the chair campaign. There is an amusing confrontation between Pierre and Rémy. It seems they both have taken responsibility for knowing me well enough to persuade me to do the shooting. Pierre, of course, wins triumphantly and is quite pleased, not unlike a spoiled child. I love Pierre, but he can be a bit much, sometimes. However, he is often correct in his attacks.

Now it seems the time is getting close for the opening. We go to the hotel to check in. Pierre has got me a room at the Beau Rivage Palace, one of the most beautiful hotels I've ever stayed in. I have two telexes waiting for me as I check in. One from Julia explaining everything that is happening now in New York. Another is from Eunice Kennedy Shriver, who is chairperson of the *Special Olympics*, thanking me for the cover I did for their Christmas record, currently being released, and asking permission to use the image for their Christmas

card. Why not? Sure, Eunice, go ahead! I call Julia and have her confirm this by phone to Mrs. Shriver. Everything seems O.K. in New York.

We go to the opening. The show looks nice. It's a small gallery and everything fits just perfectly. There are several young people, mostly Pierre's students, waiting for me. The crowd increases, but never becomes overwhelming. I do drawings on shirts, pants, shoes, etc., for about two hours. Many people buy prints. The gallery has made a nice announcement card that I sign also. For some reason Switzerland produces some of the most beautiful boys in the universe. I draw on babies, purses, pants legs, erect nipples under T-shirts, and supple asses. People are buying prints and having them removed from the frame for me to dedicate. Near the end of the opening I do a quick taped interview about my collaborations with dancers (i.e., sets, etc.) for a ballet critic.

Now we are scurried off to dinner at a great little country-style restaurant in a little village near Grandvaux where I've eaten twice before. They have reserved the whole restaurant and we eat fondue. I am at a table with Mr. and Mrs. Bonnier, who have a gallery in Geneva. We have very "serious" art conversations. Somehow I always feel as if I am trying to "convert" people over to my side. Am I a "missionary"? I'm certainly on a "mission"!

(This man just sat down near me and keeps looking at me like I took his seat. He apparently had his suitcase on the rack of the seat. Sorry, Mary! If his suitcase had been on the seat, I wouldn't have sat there. I had no idea whose luggage was on the rack, there were a lot of people sitting around already. He can stare all he wants, I'm certainly not going to move so he can sit underneath his luggage. If he was an old lady, maybe. But for a Swiss yuppie . . . sorry!)

After dinner I do drawings for all the cooks and waiters, who appear to be all in the same family. They present me with three great bottles of Swiss wine. This small restaurant

is supposed to be quite famous for its extensive wine selection. Also, Pierre's friend, Philippe, gives me a bottle of Armagnac from 1958. He is a young collector, very tall and thin and cute with a big nose like my father. He already has ten pieces of mine (drawings and prints). Actually, he has already given me a bottle of 1958 Armagnac a few years before, which I still haven't opened. I'm waiting for the proper birthday. Oh, I forgot—at the gallery they had special wine made for the opening with a label the same as the invitation card. They are sending me a case of this, from which I'll take four bottles now. So now I have eight to carry.

We go to Pierre's house for a quick visit, after defacing a local political poster by adding noses and ears to turn the faces into pigs.

Once I start, it's hard to stop.

After Pierre's we go to Dolce Vita. It's sort of punk-disco, playing a mix of new-wave, rap, heavy metal, etc. To me everyone looks like they're on heroin. If I lived in Switzerland maybe I'd understand why.

After standing around bored for about an hour, a *very* black girl befriends me and asks to be photographed with me. After this people start asking me to draw on things. A sort of young punkish boy wants me to draw on his tit. He is slim with a nice hairless chest and this seems like an adequate surface to embellish. Periodically pinching his already-erect nipples, to his delight, I draw a man whose head is his nipple. We are photographed. I continue to drink beers. A real cute "nerd-look" asks for a design on his shirt. I oblige. Now the black girl, who tells me she is from Boston and lives in Paris and Lausanne, says her friend wants a drawing on her tit, too. I've never done this before, except on Grace, so I say why not? She pulls up her shirt, revealing a really beautiful small breast that could excite even me. I draw a similar figure as I had on the boy, except that the figure's head is bigger since her nipples are bigger. We pose for photographs.

A man is introduced to me who runs the local radio station. Everyone decides we should go on the radio, now, at 3:00 AM. They grab champagne, the cute nerd, Pierre, the club owners and head for the radio station. Somehow Brion Gysin's name comes up talking about people who've been in Lausanne. Also, Timothy Leary lived here for a while. I'm delighted to meet someone who knows of and appreciates Brion. I'm feeling more comfortable now.

I pick out some records: Rita Mitsouko, Grace Jones, LL Cool J, Michael Jackson, and Tom Tom Club. We do a sort of interview with Pierre, who is rather smashed at this point, translating as much as possible. I talk about my respect for Michael's attempts to take creation in his own hands and invent a non-black, non-white, non-male, non-female creature by utilizing plastic surgery and modern technology. He's totally Walt-Disneyed out! An interesting phenomenon at the least. A little scary, maybe, but nonetheless remarkable, and I think somehow a healthier example than Rambo or Ronald Reagan. He's denied the finality of God's creation and taken it into his own hands, while all the time parading around in front of American pop culture. I think it would be much cooler if he would go all the way and get his ears pointed or add a tail or something, but give him time!

I'm getting tired and we end the broadcast. It's 4:30 AM now. The nerd takes me to the hotel. We have a heavy discussion about life, death and the Pope, and he goes home before I can even muster up any attempt at making a pass at him. I'm not really that interested. I call Juan in New York and talk a little while. I miss him most at night.

Next morning wake up to a call from some lady in London working for *House & Garden*. She says she's supposed to be doing an update or something. Not this morning . . .

Pierre picks me up. He has a hangover. I sign some of the small Lucky Strike prints we will edition. I dedicate a print for Philippe (the young collector) and rush to catch the 12:37

train to Zurich. The train is arriving as we get there. It is full of surprisingly boring looking Army boys. Now I've got to get to Zurich and get to work. It's very tempting to take the train to Milano instead. Wouldn't that be fun! But, I forgot, I'm here to work, not have fun!

Got to Zurich, ate another apple in the station, took taxi to hotel and called Rolf. I took a quick visit to Bruno Bischof-berger Gallery to see Francesco's show. I had seen the paintings in his studio in New York, but they look even better in a sterile atmosphere like this. I left Bruno a bottle of wine with my label and a note. I still feel a little sad not being in his gallery, since he shows almost all of my favorite artists. I really should be in his gallery. It's stupid that it was just a premature decision to avoid Bruno in 1982 when he wanted to show me. I took Tony's advice and said no. Now Bruno won't show me because I denied him in the beginning, or something. But paranoia always makes me think he just doesn't think I'm good enough. I really shouldn't worry about things like this, but it's hard not to. I know that in the end it will not be any of these little things that will determine the importance of anything.

OCTOBER 4, 1987

The last two days have really been an experience. It's kind of like taking a crash course in animation. Franz and Rolf are great and I'm really learning a lot. Somehow it all comes pretty natural. My hands hurt from so much drawing. Basically I've just been developing the three characters and the dog, drawing them in different positions and with different expressions so that Rolf and Franz will have adequate material to animate with. It's really cool 'cause it's exactly the way all the Disney stuff and other cartoons were done. Somehow I've always wanted to do this, and now I have a chance to do

it with a kind of authority and sense of purpose because I have done so many other things first. If I had been an animator first, I don't think I would have the same relationship to it as I do now. Now it's like one more thing to prove to myself I can do. I think it really gives my drawing "sense" a whole other dimension and this aspect is coming at the right time in my development. It's sort of going back inside to take a closer look at certain aspects of what I already did intuitively. Everything happens for a reason. And I'm sure everything always happens at the right time and in the right place.

It's really a joy to work here, too. Every day I eat with the family and today we went to the park with the kids for about two hours to fly kites. Taking turns carrying the kids on my shoulders, holding hands, balancing on a fence, and generally having a good time playing. I really love this family. I think it's important to be able to have these experiences. It's the one thing that makes everything else worth all the trouble and heartache. Like, a couple of days before I left New York, I visited Nina and Chiara Clemente and was drawing pictures with them on their walls. It's probably one of the most memorable moments in my life. Whatever else I am, I'm sure I, at least, have been a good companion to a lot of children and maybe have touched their lives in a way that will be passed on through time, and taught them a kind of simple lesson of sharing and caring. Sometimes I really wish I could have my own children, but maybe this is a much more important role to play in many more lives than just one. Somehow I think this is the reason I'm still alive. Speaking of being alive, I really miss Andy sometimes. People are always bringing up the subject of his absence. I wonder if people will miss me like that? What a selfish thought! Do artists only make art to assure their immortality? In search of immortality: maybe that's it . . .

I have to stop writing. My finger hurts so bad! The dent in my finger is really big. I've had this since I was a kid, but when I draw a lot it gets really deep.

I'm going to go back to reading Kurt Vonnegut's new book, *Bluebeard*, and go to sleep.

OCTOBER 6, 1987

It was a bit sad leaving last night. We worked all day to finish the "character sheets" and do some tests with the color backgrounds I suggested. Everything looks great. Rolf did a 15-second test of the little B-boy (chilly willy inspired) who really looks a lot like BIPO. We plan to name him BIPO in the English version of the films. I did some chalk drawings with Sonya and Serafina at midday which was really fun. After dinner with the family it was time to say goodbye to the kids, who were a little upset because I assured them I'd return soon after Christmas to do more work on the animation. Serafina was telling a great impromptu story inspired by the

salad at dinner. She explained it was a flying salad that would carry them and their house to New York so that we could all live together. I told her I would look for her in her flying salad bowl tomorrow from the window of the plane. I certainly will.

I did a drawing for Franz and Rolf and Xeroxed all of my drawings so I could

take the originals with me. They gave me a copy of the preliminary test films. We hugged and said goodbye. They promised they will send me the little Smurf and Smurfette ice-cream containers that I had emptied earlier.

I arrived at the airport, checked in and got on the plane to Brussels. When I got my luggage and left the customs area I found Jean Tinguely waiting for me. He had been on the same flight from Zurich, had a first-class ticket for me, and had just missed me getting on the plane. The people on the plane couldn't tell him whether I was on or not, so he waited to find me afterwards. We drove together to Knokke in a car Roger had sent. It was a great ride. We talked about: what we both have been working on, Japan, skateboard ramps, graffiti in New York, his ticket for driving 150 mph, painting race cars, painting airplanes, Niki de St. Phalle's painted airplane, Paris, collaborating on drawings to be editioned by Pierre Keller, the Guggenheim, fountains, not working, working, Roger's cooking, calligraphy, the Beaubourg, Pontus Hulten, Galerie Beyeler, Bruno Bischofberger, money, the restaurant he did in Kyoto, flower arranging, his next trip to New York, etc., etc., etc., and ended up doing drawings in the back seat for the rest of the way to Knokke. He always says amazing things to me, and is really supportive. He assured me that he could convince Pontus Hulten to get me permission to see the "sunken lobby" of the Beaubourg, which I tried to initiate a few years ago to no avail. He's so cool, he understands how I understand calligraphy, and he gives me a lot of credit for things others don't notice. He really makes me feel at home. We did some cool drawings together, mostly me adding to drawings he had done earlier, but we decided next time to start from scratch and be more equal in our efforts. Our drawing habits complement each other nicely.

I woke early after strange dreams. Something about biker gang murders, my sisters, Kermit, Juan, moving or cleaning apartments, leaving a ladder in the street in front of the church, a pizza shop, looking at a U.S. map inside the Rhode insurance agency, firing a houseboy, etc., etc., all taking place in Kutztown or a combination of Kutztown and New York. The moon was almost full last night and sleeping inside the Dragon at the Nellens' house was really strange. It was almost as bright as daylight outside and the light was pouring through all the round holes in the windows. Sleeping alone, I awoke a few times during the night to piss and look out the windows. Sleeping in Niki's dragon is a lot like a dream anyway. I remember this summer having strange dreams also. I wonder how much effect this could have had on the work I was doing in Knokke and my unconscious self?

I just boarded the plane to Nice. It's funny to me how many different ways my name gets spelled on boarding passes, but this is the best. I've seen Harding, Harving, etc., but this one says Harinck. Looks/sounds like a combination of Inc. and ink; I like that.

This morning I drove with Monique to Brussels and met Pierre Staeck and went to the school where he is the director. He is a big fan and supporter of my work. I first met him when he interviewed me at Daniel Templon Gallery in Paris last year. He lectures about me and has written articles about me. He says he wants to write a longer, serious piece about me sometime soon. His school is small, but concentrated. It is called something like the Center for Graphic Research, and teaches video, drawing, painting, advertising, and is the most famous in Belgium for cartooning. There are only about 180 students. He has arranged an impromptu slide lecture at 9:00 AM. I arrive, put in my slides and do a quick talk, stopping after every sentence for a translation.

I seemed to do well, but it is always difficult to tell when you are using a translator. It is very hard to explain subtle points. One question may have benefited from the need to simplify: I was asked if it is different to do a painting in the street, and in a museum. Does the painting suffer when it changes contexts? I answered simply that of course it changes, just as any painting is perceived differently in a museum or a public place. My work does not necessarily suffer more just because it's associated with the street. A change of context changes *any* painting equally, but the work remains the same!

Another point was made by a teacher who likened my use of color blocks with black lines on top to Léger's. He asked if it bothers me that in fact we use an almost identical "system." I said that for a viewer to associate me with Léger could only be a compliment, because my process for arriving at this result is quite different from Léger's. I acknowledge my debt to him, as to all previous artists I have learned from (including Picasso, Warhol, Matisse, etc). The point is that though I may have borrowed or stolen (if you wish) his technique of color with black lines overlaid (also used by Miró), I've made it my own by using it in my own way.

I do not, as Léger, work out the color/line relationship with pencil and work and rework it until it is satisfactory. I do not use it on a canvas as a kind of investigation of formal relationships. Léger already did that, so I don't need to. I use this technique to cover large areas, usually on murals, sometimes on canvas (and now animation), as a tool or vehicle for my work. I paint spontaneously the color shapes and then directly apply the black lines, also spontaneously, in relation to the color shapes (and often inspired by them). This becomes a process (full of chance), which is a tool to use as I wish to produce an effective result.

It has, I suppose, a calculated effect, since I know it will work. The task is for me to use this effect in a way that is both challenging to me and successfully balanced and evo-

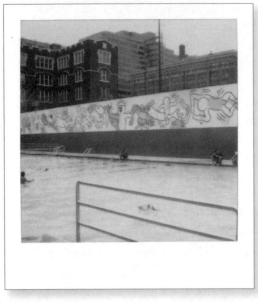

cative to the viewer. The skill of drawing and balance is the key, not the technique. The paintings do not only bear a resemblance to Léger, of course, but also evoke comparisons to African, American Indian, Aztec and other traditional forms, but not by imitation, but because of the quality of drawing. The images drawn on top of the color blocks are quite different than Léger and have more in common, I think, with the art and images from the other cultures I just mentioned. At the same time that they are associated with these so-called "primitive" cultures by their use of linear, two-dimensional, and even decorative elements, the information being conveyed is completely contemporary and in most cases would not or could not have existed before. They are informed by technology, popular culture and the Information Age. They explore the "effect" of these new realities on the human condition and experience of the "self."

Also the way in which they are executed and the places they are executed is quite different from Léger. I think he would be quite happy to see these paintings "accepted" by the public he desperately tried to reach during his lifetime. Because of his interest in Socialism and politics, he sought to place his paintings in public places of work and was quite disappointed when the "workers" in the factory rejected his offerings. This is not the case with me. Most of these paintings are put in public places (i.e., schools, hospitals, swim-

ming pools, parks, etc.) and quite rarely do any of them receive a negative reaction. In fact, I have found the public quite anxious to accept and appreciate my work, while the bourgeois and the "critical art world" is much less receptive and feel themselves to be "above" such work.

As Pierre Staeck pointed out to me, the popular culture and the artists of Léger's time were so far separated that the artists could not accept him. Now, after 50 years of cartoons, television, advertising, Pop Art, video music and films, the gap has been shortened so much that an artist like Keith Haring is possible. The "official" culture and the "popular" culture are often intermingled and sometimes even identical. The artist no longer needs to remain outside of the public. This doesn't sound to me like a new idea. Remember Andy Warhol? The Information Age and the camera have blurred the boundaries between high and low art. If Léger were alive today, wouldn't he want to draw with a computer? Wouldn't he be quite happy to be able to see his images televised to the "masses" he dreamed of working for? Yes, of course, now people can go to a museum and appreciate a Léger painting. Probably many more accept it immediately, but that is another thing! In time everything becomes palatable. Picasso no longer looks as shocking as he did originally. He has been safely categorized as an "artistic genius," whose pictures have been proven to be "important" and even "classic" by the tremendous prices they fetch. The market has proven them a sound *investment*! People wear dresses covered with prints similar to Léger and Picasso, and have for the last 25 years. How could you expect them to still find it vulgar and radical as it was 50 or 60 years ago?

But we're not talking about things that are accepted *later*, we're talking about *now*. The length of time it takes for something to go through the process of consumption and acceptance and imitation has been getting shorter and shorter and shorter. Even Pop Art took at least ten years to be assimilated into the culture. But not now! My works appeared on

T-shirts and clothes in every continent of the world *before* I had even made *one* real KH T-shirt. Before I had even *one* museum exhibition. Before I was dead. Before it was even considered or proven to have any "monetary investment value." *This is the new phenomenon.* This is art of an Information Age that is moving so quickly that it may soon go beyond catching up and actually surpass itself, so that the popular culture dictates the actions of artists and makes an elitist separatist culture obsolete. This is a very frightening idea to the people who wish to keep their positions in the safety of the "art world" and remain separate and special. I am sure that there is someone who will use my example as a starting point and go beyond what I have done, so much so that I will one day look as "old" and as "classic" as Léger. And I'm sure that one day an artist will be asked, "Doesn't it bother you that you have used a technique similar to that of Keith Haring to achieve your effect?" And I'm sure he (or she) will be as ready to answer as I was!

I arrived in Nice and met Yves and Debbie.

OCTOBER 8, 1987

Yesterday when I arrived at Yves and Debbie's, the first thing I see is a beautiful Tunisian girl of about 17 years wearing a little maid's outfit complete with stockings and high heels. Now I know I'm in the right place. The baby, my goddaughter, is incredibly adorable. Madison looks like a little baby lamb that hasn't grown any fur yet. She's really cool. They have a cute German girl who is the temporary "nanny." Yves has another name for it, something in French, which he explains means "a beautiful young girl who takes care of the children." He's too much! Anyway, the house looks great and it's a relief to finally be in a kind of paradise atmosphere with no appointments or obligations.

We had dinner with Grace last night. She's here to find an apartment in Paris, since she plans to be in Europe a lot this year. She and Debbie went swimming in the ocean the night before, so she caught a bad cold and doesn't stop whining. I'm convinced she will not feel better till everyone feels worse than her, as she is constantly moaning and complaining, "Why me?"

Anyway, it was nice to see her. She came for dinner, and Marisa Del Re and an assistant from her gallery. They were working on a sculpture show at the Casino, where a huge Lichtenstein is installed in front with the Calder and the Appel. The installation/placement is horrible, but the piece is fantastic. I can't imagine what sculpture *could* survive the same placement in front of the Casino. It is so kitsch and overdone that only a really tacky bronze fountain could compete with it. We talked about art a bit. Marisa said she liked my sculpture in Münster. Can you imagine that in front of the Casino? Preferably jammed in between all of the existing sculpture, I'm sure! Yuck! Kind of like a yard sale at a museum!

Grace had to be escorted (driven) home the entire two blocks by Yves and me and of course she insisted we come in and was practically begging for a massage. But against Yves' better judgment, we decided to leave. Not before she insisted on showing us the suppositories Patrick bought her for her cold: Ahh, the full moon . . .

I walked around more, went to look at the Lichtenstein sculpture up close. It's really incredible. Must be aluminum. It's really thick. It is three brush strokes blown up to huge size and painted accordingly. Incredible job. It's probably 30 feet high. Really cool and really Pop. I wonder what Claes Oldenburg thinks of it . . .

I'm looking at it with the full moon behind, and I walk around it for a long time.

I finally got back in the house. It is 7:00 AM. The door downstairs apparently gets locked at 5:00. I arrived back at 5:15 and couldn't get in. Nobody answered the phone till now. What a wonderful morning. Now the sun is so bright I can't go to sleep. Everyone took Valiums after dinner, so nobody heard the phone. Spent all day doing nothing. Bought art supplies, visited Grace, ate Tunisian food. Hung out for a while with a Moroccan waiter. Everything amounted to nothing, but I suppose that is the joy of Monte Carlo . . . doing nothing.

They found my baggage in New York. It should arrive today. Also my pieces at auction went for very good prices. (More on this when I throw away this pen, go to sleep, and wake up and continue writing.)

I find it kind of absurd that I am so aware of these things now, but I've come to learn the importance of knowing what's going on in this area. Since my pieces are put into the auction market I have to deal with the situation, whether I like it or not. To just ignore it only makes it more of a "situation." I still have not bought anything back myself, but I've begun to follow the auctions to at least find out if things have been sold and for how much. Especially since there are people out there who could try to affect my market by making it appear as if there was a general move to dump my stuff on the market, creating a kind of "stock market crash" where everyone follows. If people want to hurt my "market," they can even create a false impression by overestimating the value of something so that when it doesn't reach the estimate at auction it will appear as if they are losing value. This is what I was afraid of in this auction. There were several pieces—two wood reliefs and four drawings—which had much higher estimates than those for similar pieces in the last auction. So if they went low, it could look like they are not wanted any-

more. The weird thing is that this affects the desire for my new work, so to ensure a market for the work I am doing now and the work I want to do in the future, I have to make sure that the older work is still in demand. What a strange cycle!

The other weird thing is that the work I did earlier is already in competition with the work I am doing now. I am 29, and I've been showing works internationally on the "gallery circuit" (i.e., art market) since around 1982. My things started appearing in auctions around 1984 and since then have been in many auctions. Unfortunately, many of the people who were buying my work originally in 1982 or '83 were merely buying it as an investment. They could care less whether they liked it so long as it would make them money. I thought many of these people were assholes in the beginning, and naively sold them works that may not have been of great quality. They are now reselling all of these things and making much more money than I made originally.

This whole system sucks dick, but it is almost impossible to avoid. What young artist would not be seduced by the chance to sell work at the first opportunity? Also because the initial sales are instrumental in creating an interest in the work and creating an audience. Also, of course, I wanted to sell pictures instead of deliver house plants. So it is a vicious cycle. (1) You are singled out in the "group" critically by art critics and/or the public. (2) This creates an interest in your works in the public and among art dealers and galleries. (3) They realize that this means they can sell the work, so they offer you exhibitions. (4) People buy the work, which enables you to work more, buy bigger/better materials and work space, and support yourself without doing un-art-related work. (5) This also means your fellow artists no longer see you as part of the "group" since now you make money, so your entire social situation changes around you. (6) You now are immediately thrust into the art "market" since peo-

ple begin to buy the work. (7) Many people buy the work because it is still very inexpensive since you are still relatively unknown and your prices are fixed accordingly. (8) The more work you sell, the more demand there is by word-of-mouth by the people who are "collecting" it. Many people begin to think of you as a risky investment, but an investment none-theless. Since the work is still inexpensive they can afford this small risk. (9) You produce even more works since you now have more time, money and a new audience and, of course, more offers for exhibitions because of the growing interest and the new "market" for this new "rising" artist. (10) As the demand increases the prices begin to go up. (11) Because you are being collected and exhibited more critics and jour-nalists begin to write about the work. The "hype" of the art world begins to escalate. (12) Everyone feeds off this, includ-ing you. (13) Eventually the works begin to appear at auc-tion, since the prices have risen substantially and some of these "investors" are eager to "cash in" now before a possi-ble loss begins to set in. (14) These people who were "specu-lative" collectors probably don't believe in the value of the work in the first place and are eager to dump these things and make their next "risky investment" on some new "art-ist" they feel might be able to make them a few bucks. (15) Now the works at auction are in competition with the works you are still producing and a balance must be sustained. (16) The artist now must regulate his production to assure his ability to sustain this "balance."

This is a "general" scenario. My specific case is a little different because of the added "situations" I have brought to the system that have confused and challenged the system it-self. The addition of my "popular success" and my immer-sion in the popular culture and also the special projects that have been a fundamental part of my growth and life in the art world are now factors in my position in the art market. Most of these have affected my market strength in a negative

way, similar to the way that what Andy did negatively affected his relationship to the market. So far I have sustained my strength without any artificial means. But it has been an uphill struggle, since my supporters are outnumbered by those who wish this pest would go away. But, like Andy, I will haunt their little world forever whether they like it or not.

This overall "situation" explains why I am interested in the auctions now. I cannot simply hope it will all go away if I ignore it. It won't. And in this auction my standing was very good. All of the pieces seemed to be overestimated, which could have been bad if they'd failed to get the prices suggested in the catalogue. But the pieces went for even more than the top estimate, some drawings bringing up to $5,500. This is good considering that the same drawing in a gallery would cost $3,000 tops. The only piece that went for less than estimated was a piece by LA ROCK. It was listed in the catalogue as being by Keith H and LA ROCK, but there were no lines of mine on it. It even said in the catalogue that it was signed by LA and not by KH and LA. This drawing went for $1,500. That's still O.K.

OCTOBER 11, 1987

I haven't had a chance to write since the early morning entry on October 9. The rest of that day turned out to be pretty eventful. After I stopped writing, Debbie and I went to pick up Jan at the train station—he came from Amsterdam to spend the weekend. We returned to the house and went with Yves and Debbie to Nice. First we went to visit Ben [Vautier], who has a house outside of Nice. It's pretty cool; covered (on the front and one side) with paintings and objects, sort of like a sloppier, more European, older Kenny Scharf. Inside was even better, full of postcards on all the walls and pieces by him and others. He had a small Macintosh computer he

was learning to use. He said he read the newspapers every day and had copies of *Le Monde* stacked all over the place to prove it. Everything seemed to be in boxes and files. He kept referring to it as his "archives." He gave me some stickers and a poster that I drew on and gave back to him. Then he gave me a print that said simply, "no More Art—Ben," and he wrote all over it. We stayed a while looking at everything and hearing stories. It was somehow very French. We drank some wine, ate some chicken wings and talked.

We left for Nice where we had an appointment at Galerie Ferrero, the gallery I had visited with Yves the day before which shows mostly only the work of Arman, but also Cesar and Ben, and had lots of odd antiques and prints from Picasso, Miró, Braque, etc. It is sort of a mish-mash of everything, but seemed to have a sensibility running through the whole mess. They had an incredible machine I had never seen before that could make photo prints instantly—similar to a Xerox machine, but doing very accurate reproductions on photo paper. Yves had an idea for me to paint my hand and make a small edition of prints of it. It sounded fun, so why not? There were two things I wanted very much to trade for. One was a Picasso etching of the artist and his model where the artist was fucking the model while still holding his brush and palette. The other was a stuffed alligator head ashtray holder that had a glass dome with two small crabs inside the glass. It was very strange and hard to resist.

So with a small Japanese brush and China ink I did a very detailed drawing on my left hand and printed photographically an edition of ten prints. Three APs and two PPs. I traded the nine prints and one PP for the Picasso and the alligator ashtray. I gave Yves a PP. It turned out really cool.

The ink was very durable and I kept it on my hand. We drove back to Monte Carlo and ate dinner and did photos with my hand and nude with Debbie, also nude, and Bea (the German girl) also nude. Jan took Polaroids. We took Ecstasy.

The more the X kicked in the stronger the photos got until finally Yves was photographing me wearing only my leather jacket and lace panties and Adidas making out with Bea— wearing only black stockings, high heels and a garter belt.

OCTOBER 12, 1987

I just finished reading Kurt Vonnegut's new novel, *Bluebeard*. I think we're flying over Russia. The flight to Tokyo from London makes one stop, in Moscow. I'm a little scared.

The layover in Moscow was interesting. You couldn't see much from the air or in the airport. Pretty dismal and cold. They had a first-class lounge where they served me ice cream and tea. There were lots of magazines lying around but not many in English. The whole place was very "propaganda-looking"—things about Strategic Defense Initiative and lots of pictures of Russia, but all in a style that was very uncontemporary. It seemed like all the stereotypical ideas I had of the USSR. I considered making a "tag" in the toilet, but the ceilings had open slats which made me think there might be a hidden camera. We were happy to re-board the plane.

OCTOBER 13, 1987: TOKYO

I was greeted at the door of the plane by a woman who was there to escort me through customs and make sure I was O.K. I was impressed. Someone on the plane must have alerted her that I was arriving and they considered me important enough to escort. That's Japan for you . . . I asked her if she was also the one who got to greet Michael Jackson a few weeks ago and she said she was. Now I'm really impressed.

I spent all afternoon walking around, mostly buying fake KH T-shirts. They had the best ones, so far, at Hysteric Glamour. Blow-ups of Club DV8 shirts with Pop Shop wall photos printed all over the sleeves. Pretty weird! My favorite of the

ones I bought is a good second-generation KH rip-off. There were a lot with just the Pop Shop logo. We haven't even done that yet, but it's a good idea.

OCTOBER 14, 1987

Went to a new French restaurant that had just opened three days before. It was really cool inside. Sort of anthropomorphic bio high-tech. Got introduced to everyone. A cute girl who's a new singing celeb in Japan came to meet us at the restaurant. She's a big fan and exactly the kind of gorgeous Japanese girl I always thought I'd marry. Too bad I have absolutely no more interest in girls. We all went together to this other club that was designed by the guy who did *Bladerunner*. People had described it like the Palladium, but it's way beyond that! Like the inside of a spaceship.

I got home around 2:30 AM and called Juan. He says he won't come to Tokyo unless he gets a wedding band. Of course, he proceeds to tell me about how he can't help being "attacked" by everyone in New York who wants to sleep with him. (What a terrible problem.) He's convinced if he has a commitment from me he won't be enticed to fuck around anymore. I'm not so sure. In reality I am not fucking around like he imagines I am. People do not throw themselves at me 24-7. I look, but so what? Nothing ever happens. I'm sure for him it's different since he is a walking sex object. I'm real confused. I think I want to be independent sometimes, but if he would call me and say he was leaving for good and really do it, I think I would freak out.

I've never been good at this. I've never really understood love or had a relationship that went smoothly. I always seem to seek rejection and the more I am loved, the more I don't want to accept it because I *want* to be hurt. I like to pity myself or something. Maybe it's time for me to get married. I'm not sure I can live without Juan when it really comes down

to it. I am really sicken-
ingly jealous yet at the
same time excited by
the idea that he's a sex
object. The whole thing
was too much like des-
tiny. And you know you
can't fuck with destiny.
So, he's coming to Ja-
pan in two days and by
the time we leave on
October 30, I've got to

either make a commitment or say goodbye forever. This is
not the kind of thing that can be decided over the telephone.

THURSDAY, OCTOBER 15, 1987

Met Seiko at 8:30 AM and went to Tama City to meet my
"staff" of volunteers and to see the trees I designed and the
panels we'll do the murals on. The trees were only made
about six feet high, but still look O.K. They didn't have the
right kind of brushes, but everything is getting worked out.
The bells are small metal bells instead of the ceramic bells we
originally intended. Considering all the changes and the rain
(they say a typhoon is coming) everything still has the poten-
tial to go great.

TOKYO —

I went to Tokyu Department Store to buy brushes for tomor-
row. This store has everything you can imagine—including a
Montreux Jazz Festival poster of mine from 1983. Also I
went to Parco to see Bruce Weber's show on Rio de Janeiro.
Most of the photos were the same as in the book, but a few
hadn't been published. A picture of Eriksen (the kick-boxer)

coming out of the water with a perfect outline of his cock. What a perfect human specimen. My "Eriksen" should be arriving any minute. Juan's plane was supposed to land at 4:15, but it could take him a couple of hours to get here with the rush-hour traffic. Also saw Francesco Clemente's book *India*, which is really beautiful. Also Michael McKenzie's book about art in New York in the Eighties. I browsed it; some good stuff, a lot of shit. Cutrone cover and full of Kostabi bullshit. One major misquote I saw immediately: There's a picture of the Houston Street mural, defaced, that says, "Unlike KH's mural, which was commissioned, all of the others which ended up on top of Haring's just seemed to appear there." What bullshit. The real story concerning that mural is much more complicated. How dare he credit Tom Otterness with initiating that wall after we shoveled and hauled 20 or more bags of garbage from in front of it just to paint it the first time. We were never commissioned. I paid for the paint the first time, for all the subsequent repairs to it, for the second time when I applied a coat of silver paint to wipe out the defaced mess, and for all the paint for the graffiti collaboration by seven other artists that I initiated after. Get your story straight!

Juan is here, no more writing . . .

SATURDAY, OCTOBER 17, 1987

On the train to Tama. I was discussing with Seiko how much the fundamental difference between people here and in the West had so much to do with religion. Everyone here is born a Buddhist, whether they are actively practicing or not. The basic attitude toward the world and the concept of "self" is very different than the Western idea, most of which is a result of Christianity. Somehow I think Buddhism instills a basic premise of "peace" with the world and the self and a kind of

respect for the individual as well as the "whole." The basic general attitude of people here has a kind of intensity uncommon to me. The attention paid to details and aesthetic sensibility is an "understood" (unquestioned) fact. People do not think that "art" is a separate concept or pursuit in the same way as in the West. There is an unwritten understanding of respect and coexistence.

It is certainly not utopia here; problems exist at every level. There are many moral dilemmas and confrontations between tradition and behavior "standards" and "moral codes." All I'm saying is that the underlying attitudes and aesthetic sensibilities seem to permeate every situation. The sense of "order" is not a thing that has to be "forced," but something that is within everyone and everything. Standards are not imposed, but felt and unspoken. It is a "pleasure" to work here and a "pleasure" to follow rules because it seems to be something you do by your own choice, not only because you are told. It is a much more complicated situation than can be "explained" by these simple observations, but I think I have an idea of what lies within the complicated system.

We took the train to Shibuya and Juan and I went toward the hotel. We ran into some people I knew from New York. This guy that does a sort of drag show of a dead Marilyn Monroe. They told us about a cool bar. We ate and went to meet them there. It was the gay part of Shinjuku, but not a gay bar—sort of a "mixed" crowd and a great DJ. They had a Pop Shop poster at the entrance. It was fun because I was into it and was getting off on drawing strange and erotic things. We stayed till I got tired of signing things and left. We went to a gay bookstore and bought a magazine. There were some gross American tourists wandering around, one of whom was leering at Juan: "Hey, beautiful, can I get in your pants?" Give me a break.

It's really amazing to work here, be here. It's not like this for me anywhere else in the world. Even after working my ass off in New York for nine years, I don't get the kind of respect or appreciation I get here from making even the smallest gesture of kindness. Here everything you do is appreciated, it seems. There is some connection I have to this place, and this culture, that is really hard to explain. Some kind of feeling as if I'm from here or something. Maybe I've been here before. Kwong Chi always says I used to be a Navajo Indian woman in my past life, but I think I might have been a Japanese painter.

The last two days have been so busy I haven't had time to write. Major four-hour meetings on Monday and Tuesday with the Pop Shop staff of Tokyo. Going over all products to be made here and deciding what to send from New York. The most difficult thing is deciding what *not* to do, since there are so many possibilities. Everything seems to be going O.K. I met a manufacturer of eyeglasses that might be interested in having me design for them. They make great quality merchandise and they were very excited about working with me. We still have to talk about money, of course.

Somebody stole a Picasso painting today from a gallery on the Ginza. He killed the gallery owner to steal it and got away. Pretty incredible!

Today I went to a huge printing company to see what they could do. It was unbelievably big and capable of making anything I can imagine. Tattoos, pop-ups, holograms, vinyl bags, flip books . . . anything. It's really exciting to see the quality they are capable of. I can't wait to start.

I got up and went shopping for art supplies to work on my drawings Saturday. Kaz suggested I call Fran in New York to try to get a better understanding of what she was trying to explain. I did and it made more sense, although she agreed with several of my complaints. We went to the suburbs to see the place where we're getting the containers that will house the shop. We redesigned the way we will construct the containers and decided on placement of windows, doors, etc. It's all starting to seem very real now. Juan thinks people should have to remove their shoes before entering. At first I thought this was too much, but maybe it's cool. I've got to think about it more. After we left the container place we drove back to Tokyo to see the place we can rent for our "disco" party for the opening of the shop. I want a place that will hold 2,500 people, but it seems that in Tokyo that is completely unheard of.

Then we went to Roppongi to have dinner with the queen who owns a whole building full of restaurants and discos. We had met him before when I was here with Parco. He owns a tacky laser disco. When we entered, one of the waiters was wearing a badge with my drawing and the disco's logo. He immediately disappeared before we could question him and mys-

teriously the badge had disappeared when he returned. Kaz and I immediately got more suspicious and finally tracked down the manager just as the owner was arriving. The owner said he gave them permission to print it as long as they didn't sell them. He says they only printed 50–100 of them. How dumb does he think I am? Who gave *her* permission?

The rest of the opening was rather comical and purposeless, with dinner in a funny Chinese restaurant in his building. The food was good but full of MSG.

He wants me to paint a disco he's building in Hawaii. Don't count on it, Mary.

The funny thing is, he's a total queen, but he always has a doggy white girl with him. Really tacky and really Tokyo Pop.

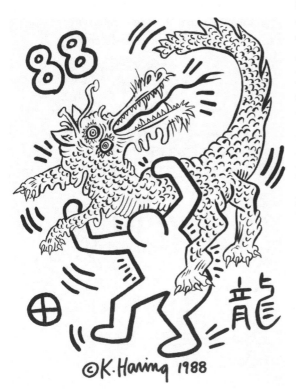

©K.Haring 1988

SATURDAY, OCTOBER 24

Got up and went to Tokyu Hands department store to buy paper, then went to Sato's office in Shinjuku to work on designs for Pop Shop. It was pouring rain, a perfect day to work. I spent seven or eight hours working on designs for phone cards, the new Pop Shop bag, stickers, shirt labels, and a sweatsuit design. Very tedious work to go over all the lines with a fine pen and white-out so that the lines would be

perfect. The lines drawn with marker must be cleaned up, but the lines painted with brush, which I'll do tomorrow, I leave untouched so you can see the brush lines.

SUNDAY, OCTOBER 25

Went back to the studio to work on the designs for Pop Shop Tokyo. I did some dragon drawings for a New Year's card and a poster-style calendar. We had an incredible dinner with Eiko at an Italian restaurant. We talked about everything from her proposed collaboration with Grace Jones to fascism in art to the abuse of artists by Japanese corporations. She's working on set design for a Philip Glass opera and a Broadway play (*M. Butterfly*). We had a very intense conversation about art and my relationship to Japanese culture. It was one of the most provocative and inspirational conversations I've had in a long time. We seemed to hit it off right away and it was very easy to talk together. She brought up a lot of interesting points about Japanese people's idea and understanding of "art" as a concept.

MONDAY, OCTOBER 26, 1987

Got up at 8:30 and went to the studio to work on ink drawings for shirt designs. I did a New Year's shirt with dragon-skin sleeves (scales) and some patterns to use to make printed (all-over) long-sleeve shirts. They came out pretty cool. The only thing I'm afraid of is that there have been so many all-over pattern imitation shirts that I hope mine is going to look better than (or at least as good as) the fakes.

I started to do the color specifications for the artworks I've done the last two days, but before I knew it, it was 3:30 and time to taxi back to the hotel to meet Seiko.

Seiko arrived and told me the address and we left for the

lecture in a taxi. We arrived at the American Center and I met the interpreters and put my slides in the carousels.

The talk went sort of weird. Everyone was *very* quiet and *very* serious. It took a while for people to ask questions, but after a while people warmed up and the questions got better. A little bit of doubt, though. Maybe I'm overestimating how much people here understand my art. One question raised was, do I think that since people in Japan have seen very little of my actual works, except from magazines and books, will they understand me opening a shop here—except as a fad or a trend?

I don't know. My answer was, "Since I've waited five years to do commercial work here, people have had long enough to find out about me and most of them have a pretty good idea about the different kinds of work I've done." I hope this is true. We will see. It's too late to have second thoughts.

Afterward there were a few autographs and then I said goodbye to everyone. A lot of the volunteers who helped at Tama City came. Some brought photos they took of me during the days at Tama as presents.

I went to dinner with Seiko and the staff who organized the Tama project. One of the interesting discussions was of the original concept for the project at Tama City. Their original proposal was to do a land art piece using mirrors held by *all* of Tama's residents between six and eighteen years old. Viewed from the air the image of my "crawling child" would be seen, photographed by plane and also by satellite. They had calculated the size that would be needed for it to be visible by satellite and everything! The image formed by sunlight reflecting off the mirrors would be photographed and "give the children of Tama City a sense of their place and participation in the Island of Japan and as residents of the Earth." The "extended concept" was to do photographs by satellite like this all over the world. They said the NASA satellite they

had researched was timed to pass over major cities in the world at 9:00 in the morning. Imagine my crawling baby . . . created by light from the sun in mirrors held by children in several different cities all over the world: Moscow, Paris, Tokyo, Shanghai, New Delhi, New York, Los Angeles, etc. My baby would actually crawl around the entire globe. Sounds like a great project . . . can you imagine the organization? Anything is possible. Or, is it?

Taxi back to the hotel in the rain. Now I've got to call Julia in New York and go to sleep so I can get up early tomorrow.

TUESDAY, OCTOBER 27
..

I got up at 8:30 again this morning to go to the studio to finish all the color specifications for the things I designed here. Finished just in time to rush to the train station with Juan, Sato, Kaz and the man from the Nagoya ceramics manufacturer, to catch the bullet train to Nagoya, a two-hour ride. Most of the ride I spent reading *Time* magazine. The cover story was about life in the Soviet Union. I'm not sure how anxious I am to go there, now. Maybe they don't need to have an "outsider" come and make them feel more like "outsiders" themselves. After reading the article I have a different image of the real situation of being a Soviet citizen or a Soviet artist. Maybe me going there would only make their limited means seem even more limited to them. (A kind of tease, And nobody likes a cock-teaser!)

We got to the ceramic manufacturer's studio around six o'clock. We were supposed to take two hours to choose the shapes of rice bowls I wanted to do and paint some samples. I ended up taking about four hours, but I painted four small rice bowls and two large ones (with kids). Some I did with figurative patterns that made the rice bowls look more African or Indian than Japanese, and some I did with real simple

fish paintings. The more I painted, the more I learned how to control the glaze pigment on the clay surface, the more "into it" I got, the less I wanted to leave. We left just in time to reach the local train station (the train left 30 seconds after we ran through the doors). Now we have just enough time to get to the Nagoya station, where we can catch the last train to Kyoto at 11:00 PM.

I really love to work. I swear it is one of the things that makes me most happy and it seems to have a similar effect on everyone who is around me while I work. Now Juan and Kaz and Sato and I are all joking and talking and really sort of "weird."

I would love to be able to spend a month or two in a small town in Italy or Spain just working on ceramics, painting them and building things with them.

WEDNESDAY, OCTOBER 28: KYOTO

Since we were in the neighborhood, we went to try to find Mr. Chow's, where my painting is hanging. It turned out to be right aside of "Tinguely," the restaurant/café Jean did all of the light sculptures and tables and chairs for. I first went inside Tinguely and took pictures and bought a catalogue. It was really cool, but much more chic than I expected; maybe *too* chic. After we were politely "let out," I walked back toward Mr. Chow's, down the hall. It was closed. Why it was closed on a Wednesday night I don't know.

Back to the hotel.

We showered and Juan went out to buy socks. (We didn't have any clean ones and we were going to dinner in a geisha house and, of course, we'd have to remove our shoes.)

This was the highlight of the trip to Kyoto. The geisha house was really cool. It is difficult for people (even Japanese) to get a chance to visit a geisha house. It's kind of like a Jewish country club, I guess. Very exclusive. But Kaz knows

some of the women who run the house, and one of them arranged our dinner.

Today we left Kyoto at 9:00 AM and took a train to Osaka. We visited the company that makes eyeglasses and sporting helmets (ski, cycle, motocross). They are very interested in doing glasses with me and it seems like they are capable of doing great stuff. We met the president and he was impressed and gave his seal of approval. Now we have to negotiate exact details and terms. They are also interested in skateboards and motorcycle gear and outfits. It was a productive meeting and seems very promising. It is still very unclear exactly what I will do and how much they are willing to pay. The whole thing could theoretically go down the drain when we begin to negotiate.

We went to lunch with people from the company and ate shabu shabu.

Next we went to see National's showroom in Osaka. It was really boring and we mostly just played with their "toys." I don't actually like Panasonic radios and probably wouldn't buy one myself. I want to go very slow on this one. Since they approached me first we are talking to them, but I would rather be talking to Sony. Sony didn't come to me, though, so we have to open the shop first and see what happens.

So now it's back to New York. I have so much work waiting for me I can't believe it. I've got about a month before I return to Tokyo in December to open the shop. I've got to do some more work on the animation for Switzerland, reorganize the studio and my new storage space, go over a lot of stuff with Tony (especially about Hans Mayer's sculpture project), do more design work for Tokyo (the fans and the kimono print), hang the art in my house, work on the print project for Marty Blinder, the print project with Bill

Burroughs, organize the show of my collaborations with Brion Gysin, which is opening at Tony's gallery December 15, etc., etc., etc.

Does it ever stop?

I hope not.

NOVEMBER 4, 1987

Back in New York. But had to write this down. It's almost a full moon.

Today Claude and Sydney and Jasmine Picasso stopped in to visit.

Tina Chow called to say hello.

Called George Condo about Julian Schnabel's opening at the Whitney tomorrow.

I bought a piece of mine at auction for $10,000.

Stephen Sprouse fashion show is tomorrow, but I can't even bring a date.

Allen Ginsberg called to invite me to be his date to a dinner at the American Academy of Arts & Letters but I can't go because I already promised to go see my friend Molissa Fenley dance at Dia Foundation.

Yves and Debbie Arman are in New York and tried to buy my piece at auction, but stopped at $8,000.

Grace Jones invited me to dinner.

Larry Levan stopped in to see me.

What a day! Is this New York on a full moon in 1987, or what?

NOVEMBER 13, 1987

I am on a flight from Frankfurt to New York about to land. I came to Düsseldorf with Tony yesterday to go to the Cologne Art Fair and to see the sculpture that has been made out of cor-ten steel from my maquette. This was the first one

blown up to this scale (8 feet) and the next one will be about 25 feet. The sculpture looked great. Hans also had one of my new paintings at his booth. By coincidence it was directly across from a Penck painting at the adjacent booth. I blew him away. I love hanging aside of Penck, it makes the difference so obvious. Anyway, we flew to Germany at last minute's notice. (Tony called me about 1:00 and the car had to pick me up to go to the airport at 3:30. But, since this was really important, I decided to go.) The trip there went very smoothly and we spent all day Wednesday at the fair in Cologne, seeing the other small maquettes at Hans's warehouse, going to see the Ludwig museum (a disappointment) and seeing lots of art world people and generally being the center of attention. I ran into lots of people from New York and Belgium and Paris, etc. Keith Sonnier is the only artist I ran into.

The real reason I wanted to write this down is because of the amazing things that happened on Tuesday before the impromptu trip to Germany. I went to see Bill T. Jones and Arnie's company dance at a performance for children at Manhattan Community College. It was at 10:00 in the morning. I woke up at 9:00 and took the train downtown. When I entered the auditorium, eating an apple, I went to the front row to a vacant row of seats. After a few minutes a class of students came and the teacher told me I had to move. I got up and looked around for another seat near the front. Suddenly a teacher was asking me, "Are you Keith Haring?" I said yes, and she said she had a seat available here in the middle of her group of students. They were all junior-high-school age. The only available seat happened to be between her and a beautiful Puerto Rican boy with a black-and-blue eye. I sat down and the teacher explained, "He was the one who recognized you." All the kids started asking for autographs on their programs. I talked to the kid. After a while he started describing the "last time" he saw me, "painting Carmine pool." I suddenly realized that he was the "mystery boy" who I hadn't

met (because I was too busy painting) but who I had watched from afar the whole day. I have a Polaroid Kwong took of him that I have stared at many times. I even used it as a source for a painting I did that's in the studio right now. I always thought I'd never get a chance to meet him or even see him again. He said he's from the Lower East Side and has known "of me" for a long time but never met me. What an incredible coincidence. A gift from God. Things like this make me think destiny outweighs chance very often. He agreed to come to visit me after school. But a few hours later I ended up on a plane to Germany.

Second coincidence: At the airport (ten minutes before the plane was scheduled to leave) I went to buy batteries. At the gift shop I ran into this kid who I had stared at across the room during a dinner with Grace Jones at her restaurant a week ago. We never met at the restaurant, but now he came up to talk. He was on his way to Germany, also. Except he was going to Frankfurt and me to Düsseldorf. In minutes, we had exchanged numbers and said hellos and goodbyes. Coincidence(?). What kind of day is this?

1987

Solo Exhibitions

...

Tony Shafrazi Gallery, New York City
Galerie Kaj Forsblom, Helsinki, Finland
Gallery 121, Antwerp, Belgium
Casino Knokke, Knokke, Belgium
Kutztown New Arts Program, Kutztown, Pennsylvania
Galerie Rivolta, Lausanne, Switzerland

Group Exhibitions

...

Focus on the Image: Selections from the Rivendell Collection, Phoenix Art
 Museum, Phoenix, Arizona
L'Époque, La Mode, La Morale, La Passion, Centre Georges Pompidou,
 Paris, France

Borrowed Embellishments, Kansas City Art Institute, Kansas City, Missouri
Sculpture Project in Münster, Westfalisches Landesmuseum, Münster,
 Germany
Avant-Garde in the Eighties, Los Angeles County Museum of Art, Los
 Angeles, California
Kunst aus den achtziger Jahren, A II Art Forum Thomas, Munich, Germany
Comic Iconoclasm, Institute of Contemporary Art, London, U.K.
Leo Castelli and His Artists, Cultural Center of Contemporary Art,
 Polanco, Mexico
Computers and Art, Everson Museum of Art, Syracuse, New York

Special Projects

Lecture at Yale University, New Haven, Connecticut
Drawing workshop and lecture, Whitney Museum of American Art,
 Stamford, Connecticut
Drawing workshop with finalists from WNET/13 Students' Art Festival,
 New York City
Set design and costume concept for *Interrupted River,* choreography by
 Jennifer Muller, music by Yoko Ono, Joyce Theatre, New York City
Paint permanent outdoor mural at Necker Children's Hospital, Paris, France
Design carousel for Luna Luna, a traveling amusement park and art
 museum
Judge Nippon Object Competition, and design street signs for Parco, Tokyo,
 Japan
Body-paint model for cover of *Schweizer Illustrierte,* Monte Carlo, Monaco
Paint permanent mural at Casino Knokke, Knokke, Belgium
Participated in Art Against AIDS, New York City
Paint mural at Museum of Contemporary Art, Antwerp, Belgium
Paint mural for Channel Surf Club, Knokke, Belgium
Paint mural at Team BBD&O European Headquarters, Düsseldorf,
 Germany
Children's drawing workshop at Institute of Contemporary Art, London, U.K.
Paint mural at Carmine Street public swimming pool, New York City

Collaborative mural with Philadelphia CityKids, Pennsylvania

Paint permanent mural, Boys Club of New York, 135 Pitt Street, New
York City

Permanent murals and sculpture commission, Schneider Children's Hospital,
New Hyde Park, New York

Artist-in-residence and mural installation, Cranbrook Academy of Art
Museum, Bloomfield Hills, Michigan

Drawing workshop, Brookside School, Bloomfield Hills, Michigan

Collaborate on two murals and painting workshops with 500 children,
Tama City, Japan; paintings donated to permanent collection of
Tama City

Design album cover, posters, and limited edition silkscreen for A&M Re-
cords' *A Very Special Christmas,* proceeds donated to Special Olympics
(platinum album, cassette, and compact disc)

Books & Catalogues

..

Avant-Garde in the Eighties. Text: Howard N. Fox (Los Angeles County
Museum of Art, Los Angeles, California)

Kunst aus den achtziger Jahren. Text: Sabine Fehlemann, Raimund Thomas
(A II Art Forum Thomas, Munich, Germany)

Comic Iconoclasm. Text: various authors (Institute of Contemporary Art,
London, U.K.)

*L'Époque, La Mode, La Morale, La Passion: Aspects de l'Art
d'Aujourd'hui, 1977–1987.* (Centre Georges Pompidou, Paris, France)

Digital Visions: Computers and Art. Text: Cynthia Goodman (Harry N.
Abrams, New York)

Skulptur Projekte in Münster 1987. Text: Klaus Bussman, Kasper König
(Dumont Buchverlag, Cologne, Germany)

Luna Luna. Essay: Hilde Spiel (Wilhelm Heyne Verlag, Munich, Germany)

1988

I just left the Frank Stella retrospective (his second) at MOMA.

A few observations:

The big square geometrical paintings (about 12 feet square) look more "pop" than anything else.

They look like stereotype "modern" paintings.

Pure modern, abstract painting, but more than that they seem to be a summation of this kind of flat, color-field, abstract, geometrical painting.

Almost a joke about this kind of painting . . . The viewer is overwhelmed and consumed by the scale alone.

Colors geometrically, mathematically chosen. A kind of "making fun" of the painting process.

The space in these paintings is completely flat, but available to "move" inside of . . . it beckons. Optical illusion (science) makes

the painting move and the space penetrates the surface and the wall it hangs on.

It seems more of a concrete, conceptually sound comment on "itself" than even Jasper Johns.

A painting of a painting.

A modern joke.

Literary joke?

And now the constructions.

I can't help wondering what is going through his mind.

I can't help doubting.

Wondering if this is a joke, too.

Making fun of the surface of all paintings. Making fun of the way paintings rest on the wall. Making fun of the status of painting in 1987.

The choice of color combinations seems deliberately "bad."

Almost seems as if he had a need to be "bad" to be "new." The schlocky paint job and horrible color combinations seem to be an attempt to surpass the Abstract Expressionists again.

Proving he can do it.

Proving it doesn't matter how meaningless the marks look and how haphazard the choice of colors is.

Proving that at this point, for him, his task is more conceptual than tactile. He puts all the "right" elements together with all the "wrong" parts and succeeds because of scale and the strength of the market and his "ugliness."

His "ugliness" assures his "newness." If it appears ugly now, we think perhaps it is only too "new" and will grow beautiful in time. He knows there is no more "risk" for him, so he tries to create "risk."

This is truly scribbling. Compared to Tobey, Pollock, Warhol, de Kooning, everyone, everyone . . . it looks "bad." Wrong colors. Uninspired gestures. You can see the difference immediately. He's not dumb. This had to be intentional!

But what does that mean? Glitter paint and muddy, child-ish art-school color combinations . . . on purpose.

Technically well-produced. Expensive-looking production. Large scale, expensive materials.

Particularly unskillful scribbles. Makes Dubuffet's late work look elegant and masterful.

So, why? To prove a point? To reiterate the joke? Making fun of the art world that worships him?

A well-planned practical joke? Actually "practical" joke is perfect.

It is "practical" in that it follows all the right rules and breaks all the right rules. The choices are wise and pre-planned.

Maybe even something profound.

But it is infuriating for assholes like Robert Hughes to say things about how Stella was the only artist capable of translating the "graffiti-like" use of garish colors and gestures into a successful art work. That is so tacky. Stella is making a "mess" on purpose and still getting credit for using things (ideas) that this critic doesn't understand. He uses Stella to dismiss all the possible "quality" of an entire "stereotyped" misunderstanding. If this is what Stella got from what Hughes calls "graffiti," then "graffiti" really is bullshit.

They've both missed the point completely. Stella is making jokes about quality. Quality of seeing, quality of life, money, money, money . . .

He's playing games with the art world and making practical jokes about the art market. I don't think he thinks his things have anything to do with "graffiti," and if he does, he's a fool.

Robert Hughes (Robert Who Cares) is another story and not worth thinking about for too long.

Many of the constructions are really beautiful. I enjoy looking at them. I just can't figure out why. Obviously scale

and form and "space" are intricately "worked out" with great results, but why the "bad" paint job?

Will these colors look as good in ten years as Pollock's do now? Did Pollock's colors look this bad when they were new?

I guess I'm just too obsessed with lines and color and have too much respect for what I've seen and done to just throw it all away to look at this shit. I refuse to be forced to believe that this is "quality" and I am not.

I love paintings too much, love color too much, love seeing too much, love feeling too much, love art too much, love too much . . .

I can't help thinking he's laughing while he does these. He's making fun of everybody. Especially me.

I'll grant him that he knows about constructions and shapes and space and the surface. And I can't deny that the overall "look" of the thing is still very "right" and fits in perfectly in the scheme of things, especially in the market-generated concept of history. "All the right moves!"

But this doesn't cancel out all the things he dabbles in and makes jokes about. His misuse of overall pattern and colorization does *not* mean that he did it the "right" way and others' use is only "halfway." Painting like this can be successful and interesting. It doesn't have to be "bad" and "ugly" to be "new." There are several pieces that seem to "make fun" of my patterned surfaces. The museum world, some critics, and a blind faith in the "market-directed" art world would like to believe Robert Hughes and dismiss others' investigations to make a clear, simple "reading" of art history. Yes, this is Frank Stella's second retrospective at MOMA. They have not even shown one of my pieces yet. In their eyes I don't exist.

To add insult to injury, upstairs in the "collection" they have Barbara Kruger, Robin Winters, Mark Inerst, Judy Pfaff, Eric Fischl, etc., etc.

I wonder how many people visit MOMA looking for their Keith Haring.

Well, a New York museum with only one Warhol hanging can't be expected to be too informative.

At the end of the exhibit, with the works from 1987, Stella comes so far off the wall that it looks like a sculpture leaning against the wall. Some are attached at only one small point. They are completely three-dimensional, with cones and geodesic "balls." It seems a continuation of the perfect "joke" about modern "painting," about "painting" in general, and the "surface" and materials and the function of "painting space."

Looking at a 1987 piece, owned by the Stedelijk, I am wondering if the museum world will ever embrace me like this, or if I will disappear with my generation.

A man walks up to me and says, "Keith, in my opinion it is you, in the early 1980s, who gave him the freedom to do this."

Unfortunately, of course, this man doesn't work at the museum.

POP SHOP OPENING TRIP
WEDNESDAY, JANUARY 20, 1988

Wake up late, pack, stop at Dr. Goldberg's for a blood test and rush to the airport. Smoke a joint on the way, knowing it's the last one for three weeks. We buy rings (silver and turquoise) at an airport shop that sells American Indian stuff. Are these wedding rings? Airplane ride is uneventful. We have seats on the upper deck. Three Valiums to help make the 14-hour flight go quickly. On the plane I picked up a copy of *Der Spiegel* to browse through and found a full-page picture of me in a chair, that I had "posed" for in Switzerland in October. It is a kind of advertisement for an expensive furniture maker. The stewardess saw the picture I had ripped

out and tried to find me another copy of the magazine on the plane, but couldn't.

We woke up at 8:00 AM to find a postcard under our door from two "Japan boys," who said they are staying at the hotel and want to meet us. We called them and invited them to our room, hoping for the best, but of course they were not cute. But still very nice. I signed their cards and explained we had to eat breakfast and go to "work." They were thrilled and went away quite happy after a few photographs.

10:00 AM: We met Pop Shop people to take us to buy lanterns, a lucky cat, and an outdoor sign box for the Shop. First they took us to see the "containers" that will house the Pop Shop. They looked as I imagined them, except still very "raw," and were in the process of being "finished." Hard to believe they'll be ready in two more days. We found great lanterns and a nice sign box to paint in the wholesale kitchen-supply neighborhood similar to the Bowery in New York. Kwong Chi had fun looking at all the display plastic food and stuff.

The meeting with Sato at four o'clock was exciting and frustrating at the same time. A lot of the merchandise is really great, but miscommunication caused a lot of small problems. Kwong and Juan return with a copy of the magazine that Kwong has been taking "dinner" pictures for that had three pages of my Paris birthday dinner at Le Train Bleu. Juan also brought an issue of *Popeye* with one of my jackets in it from New York Pop Shop, listed at $600. Also the staff showed me about six magazines with "advance press" mentions and photos for Tokyo Pop Shop. It looked pretty good. The most disturbing thing was problems with plans for the Pop Shop party next Tuesday. Junior's name is not even on the invitation, and the cost of the party is 3,500 yen. The club will

hold only 500 people, they say. I'm allowed 50 comp invitations. Much of the confusion is due to the last-minute change of location for the party, since the disaster at Turia (the original party location) last week.

SATURDAY, JANUARY 23

Woke up and read Julia's fax. Tony has finally gotten paid by Hans Mayer for the paintings he bought three months ago at a big discount. The amount of payment doesn't sound right to me, but I'll have to wait to return to New York to check it out. The gallery shit is just as much of a pain in the ass as the Shop is. Sometimes I'd rather not deal with the "art market" at all and just do my own work. There isn't much difference between the people I have to deal with in the art market and in the commercial world. Once the artwork becomes a "product" or a "commodity," the compromising position is basically the same in both worlds. Some "artists" think they are "above" this situation because they are "pure" and outside of the "commercialization" of pop culture, because they don't do advertising or create products specifically for a mass market. But they sell things in galleries and have "dealers" who manipulate them and their work the same way. In fact, I think it is even more deceptive to pretend you are outside of this system instead of admitting it and actually participating in it in a "real" way. There is no more "purity" in the art world than on Madison Avenue. In fact, it is even more corrupt. The Big Lie.

SUNDAY, JANUARY 24

Wake up and go to buy a brush at Tokyu Hands and look at chalk. Trying to find a big piece (or pieces) to draw with on the street in Harajuku for photos for *Friday* magazine. I could only find regular size chalks, so I bought an entire box. We

had to meet the photographers from *Friday* at 1:00 at the container. I painted the first coat on the red circle and then we all headed toward Harajuku. Underneath an overpass for pedestrians I did several chalk drawings using the existing street markings as a starting point. I added bodies to "rectangular" white markings on the street and added bodies to paint boxes indicating parking positions. Almost immediately a huge crowd gathered. A policeman tried to make us stop, calling my drawings "vulgar." I found this amusing, considering I was drawing skateboarders and a large "mother and child" image, etc. After the photographer explained and persuaded him, he left us alone. We got great pictures and I handed out buttons and did autographs. When we left to head up to the main part of Harajuku, where the dancers are concentrated, a crowd of kids followed us for autographs. Kind of a procession, like the Pied Piper . . .

I returned to the hotel and showered quickly and met Kwong and his friend Yoshi to go to the movies. We went to see Ann Magnuson in *Jimmy Reardon* with River Phoenix. It was cool to be watching Ann in a movie in a theatre in Tokyo. It wasn't a very good movie, but it had some funny parts and River Phoenix is pretty hot. After the movie we went to eat at a fun restaurant that only served one thing, and then went home to the hotel.

Woke up at 8:30 to the sound of a brass marching band playing in the street outside the hotel. I've heard this sound in the morning before in this hotel, but have never heard an explanation of why or what it is. We fell back asleep and woke up at 9:45 to a phone call from Tacey asking me if I could come to the container [the Tokyo Pop Shop was constructed out of two shipping containers joined in an "L" formation] and meet about fixing the floor. I thought I had already explained my feelings about this, but I wanted to make sure, so I agreed to meet there at 10:30.

I was getting a little nervous about the progress of the container and let out my frustrations on Kaz. He assured me we'd try to resolve the problems. After meeting and stressing the importance of the deadline, people started to take it more seriously. I went to the hotel to get my paint to work on the sign for the gate and the red circle. Juan had agreed to go to the airport to meet the people coming from New York. I worked on the gate sign on top of the roof of the container and then started the red circle. It seemed that Kaz and my lecture in the morning were effective since now things seemed to be getting done very quickly. The carpenters arrived and put in the new floor, the stones for the yard arrived, the gate went up, etc., etc. Finally it looks like this thing is really going to happen.

Kwong Chi arrived as I was finishing the red circle. He said he had been to the pool and he had good stories of showers and hairless bodies. I'm looking forward to going swimming tomorrow. We walked home through Harajuku. We found several funny fake T-shirts in one shop there. One particularly funny one had a copy of my baby sort of running that said underneath it, "Run Away Children." Others had copies of drawings and unintelligible phrases. I got back to

the hotel, and then the phone rang. The New York crew had arrived.

Everyone walked through Shibuya and looked at the neon signs. We're quite a group, all together: Junior short, white and sort of comical and always snapping at everyone and everything (yes, Miss Girl); Adolfo [Arena] looking mulatto and like an adorable teddy bear; Jessica [Gines] pretty, and very New York Puerto Rican; Brian [McIntyre], who everyone thinks is Eddie Murphy; Kwong Chi, who everyone thinks is Japanese but is actually not very Japanese-looking at all to me; Juan, forever handsome with a chameleon face that adapts to every place we go, making him look Brazilian, Moroccan, or in this case part Japanese; and me (no comment).

Everyone tired so we head back to the hotel. First a quick stop at Mister Donut, where there is a *Big River* theme this month and the whole place is covered with Tom Sawyer decor, some of it cartoon and some realistic. On the bags there is a pastel drawing of Tom Sawyer on a raft with Harry Belafonte. (I swear to God, it's his face.)

TUESDAY, JANUARY 26
...

Wake up to the band sounds again. Today we discovered the source: There is a school behind the hotel and at 8:30 every morning, it is the marching band rehearsal. They're really good. I called the CBS correspondent who is covering the Shop opening for CBS Morning News and went over our shooting schedule.

WEDNESDAY, JANUARY 27
...

I got to the container around 3:30 and started covering the floors with the paper and then began to paint the walls and ceiling. They had gotten a gas blower-heater to dry the paint.

The fumes of the gas were making me nauseous and the work was not going as fast as I expected. Taka, the Pop Shop "cute boy" employee, was assisting me in cleaning up my drips of paint on the floor. By the time Juan, Jessica [Gines], Brian [McIntyre] and Adolfo [Arena] arrived I was starting to feel sick and had diarrhea and didn't want to finish. Juan didn't appreciate Taka, and Brian immediately started to put the move on Taka. I decided I'd stop painting instead of finishing the whole inside tonight. CBS had already shot footage and now another crew from a show called *11 PM* wanted to shoot. I forced myself to paint some more for the TV crew, and then finished for the night. Sato and Taka gave me shiatsu to try to relieve the pain in my neck and shoulder from painting the ceiling.

THURSDAY, JANUARY 28

Wake up early and go to the Shop to resume painting. I feel much better today, and painting goes O.K. We don't use the dryer because of the fumes. The staff begins to work in the display cases and I begin the floor. Brian, Jessica and Juan visit. Adolfo doesn't. I'm getting more annoyed about this and keep asking what's wrong. It seems Junior and Adolfo are complaining about being here and not having a good time. I'm trying to concentrate on painting, but am getting concerned about the situation. By the time I take a break from doing the floor and go outside with Juan, Jessica and Brian, I'm feeling exhausted but also exhilarated by progress on the Shop. I make a comment to Juan about how amazing it is how much has gotten done in so little time, and his only reply is to criticize the staff for "cutting corners" and to point out some small details that aren't resolved. I blow up and say, "Fuck you, I don't want to hear that now." I'm really pissed-off because I've been working my ass off and he only has criticism instead of encouragement. I go across the street alone,

telling myself I've had it and don't want to be around some-one like this anymore. I reconsider his idea of a "divorce." It sounds like a good idea. I try to block this out and continue working, but when he returns to the Shop with food I ignore him. Brian stays, and Jessica and Juan leave.

I finish painting about four hours later at 1:00 AM, to-tally exhausted. I was putting the floor paint on very thick so it would be more durable. Kaz, Kwong, Brian, Julia and I go to a small restaurant to eat and I return to the hotel totally beat at 2:30 AM. Juan is asleep and I avoid him in bed be-cause I'm still mad about his "attitude" earlier.

FRIDAY, JANUARY 29

Wake up at 6:45 to do the installation shots with Kwong Chi. I call Adolfo to make sure he'll at least be at the press conference at 12:30, and tell him to bring Junior and Jessica. Kwong and Brian are already at the Shop and call to alert me that the floor is still wet. I am on my way. When I arrive they are outside the container. We turn on the gas heater-blower and try to dry the paint. Most of the floor is O.K. but parts are tacky. The Formica counter and poster display counter are really wet. We start taking photos on the dry side. The dryer seems to be working, but everyone is nervous because the Shop must be ready to open in four hours and no display of products has been done yet. We continue making installa-tion photos, although the electricity keeps shutting off. The staff arrives around 8:30, and begins working in the stock-room and outside. At 10 o'clock we finish our photos and begin "display." It is rather hectic since I want to oversee and design all the displays. Everyone is working well under pres-sure, however. New York crew arrives with seemingly less at-titude, although they're not much help, either. Press begins to arrive, including an AP photographer.

At 7:00 I finish, exhausted, and return to the hotel.

I go immediately to Adolfo's room to discuss all the "attitude" and complaints I keep hearing second-hand. He denies everything, of course, except that Junior feels he came too early. I am really pissed. Who asked Junior to come so early? I suggested a ten-day trip because I thought they'd like it, not to do *me* any favor. I wish they had never come at this point, and assure him they can both leave whenever they want. I'm too tired to go through the whole thing with Junior right away and we're expected to meet for dinner soon. I go to our room.

But dinner is disastrous. We go to a nice Italian restaurant near Harajuku. By this point everyone is already taking sides and being defensive. It is split between those who want to be in Japan and those who don't, with some exceptions on both sides. People are already tired of each other, in particular Junior and Brian and Julia and Junior and Adolfo, and everyone is tired of Jessica's mouth. Kwong and Julia are at one end of the table with Brian, Kaz and Fran, and I'm in the middle. Juan is stuck in between and suffers from my frustration with the inability to cope. He doesn't want to be on either side, but changes seats to be away from the "intellectual" end of the table. This comment along with Brian's stupid mistake of eating Juan's food just because the waiter put it in front of him by accident, and several snide comments from Junior about Juan and me not having sex (which I am furious to find is common knowledge at this end of the table) and Jessica's obnoxious dinner manners and loud mouth all add up to a horrible meal. I'm beginning to freak out realizing there is almost a full week to go and no pleasant end in sight.

After dinner, while still at the table, Julia lets me know more of her feelings and assures me not to worry, although of course I am worrying. We finally leave. By this point I am angry with Juan again because of the dinner conversation. Three days without sex and it is a major issue. I'm bored again and angry and confused and feel betrayed.

We walk home and on the way Juan finds a stuffed donkey toy in the trash and wants to bring it with us. I'm fed up and don't want it in my (our) room. By the time we reach the hotel it is worse. We all go to Adolfo's room and watch this stupid TV show that did a story about the Shop. The coverage is pretty dumb, a sleazy game-show type atmosphere with show girls. After the show Juan and I go to the room. My stomach hurts (probably from nerves) and I'm pissed about the dinner conversation. I'm determined, now, to make our non-sex an issue, by continuing to avoid contact with Juan. We go to sleep almost immediately.

SATURDAY, JANUARY 30

8:30: I wake up hearing Juan in the shower and fumbling around his clothes, and assume he is getting up to take a walk or give me a scare by disappearing all day. I pretend to be asleep and let him leave, subconsciously wishing he'd leave for good. At 10:00 I get up and shower and shave and head to the Shop for what is supposed to be the big "opening day" to the public. When I arrive, there is no one there, no lines, no waiting fans, nobody. CBS News is there again to film the anticipated crowds. Obviously the advance publicity never reached the right people. Last night's TV show was not exactly what I'd call good publicity. The four photo shoots we did last weekend for *Friday* magazine (a popular weekly) were bumped by a chief editor for "political" reasons. Apparently people were not aware of the fact that I'd be at the Shop all day on the opening, so all the autograph-seekers and fans I've been encountering everywhere I go weren't aware of the "opening."

People trickle in. I do a short TV interview and then go to the NY diner for breakfast. Feeling guilty, I call the hotel to find Juan and leave a message for him to come to the Shop. Kwong and Julia arrive, looking distressed, and talk to

Kaz, trying to avoid me. I ask what's wrong and they explain Juan is on a plane to New York. I wasn't really expecting him to actually leave. I'm sort of shaking and trying to act "normal," but have lost my composure. I take a Valium I'd brought, anticipating a hectic day of signing, and try to rationalize. Adolfo, Junior and Jessica arrive. Adolfo brings me a bottle of Absolut. They obviously all know. Junior, Adolfo and Brian are persuaded to go on a tour to the Imperial Palace. Jessica stays and comforts me while I try to be pleasant and smile and sign autographs. The attendance is constant, but sparse.

Jessica and I go to the hotel to call JAL to see if he really got on the plane. They say he boarded a flight to Chicago and is going to transfer to San Juan. I assume he's going to stay with Paul in Puerto Rico. He didn't take anything—keys, money, etc. I have to return to the Shop and try to preoccupy my mind. I have meetings and sign autographs. At around 7:00 the Cover Girls visit and hang out for a while. We do some photos and I tell them I'll probably see them next week in New York at the reopening of Studio 54, where they are performing. Meeting with the ceramics guy who's working on the rice bowls. To hotel with Junior, Jessica, Brian and Adolfo on the subway—drinking Absolut. We hang out in the room and I call JAL to try to leave an emergency message in Chicago for Juan when he is changing planes. They say they will try. We all go to eat in Shinjuku (except Junior) and go to Boogie Boy afterward, where we all get smashed. Julia is especially drunk and being fun, dancing. We taxi home around 3:00 in the morning.

SUNDAY, JANUARY 31

I have to be awake for an 11:00 AM interview at the Shop. I am preoccupied with Juan and find it difficult to be "cute." Return to hotel—there is no message from Juan, but he prob-

ably never looked at the message board in Chicago. Eat lunch with Jessica and then go to my room to write.

At 4:30 in the morning Juan calls. He's at Nicky's house. He says he's sorry, but needed time away and says I need to decide what I want. This is true. He says I should spend time alone in New York when I return. I am most concerned about his well-being and tell him to get the house keys. He says he'll wait for me to get home, and we both tell each other we love each other. We talk for an hour. I feel better knowing he's O.K., but I really have to decide what's the best thing for me to do. Rationally I think it will never work out perfectly, but on the other hand, I still really love him. I need some time to think, I guess.

FRIDAY, JULY 22, 1988

Leave New York at 9:00 for airport after having been up all night, almost, and packing last minute as usual. Alain was visiting from Paris, so I went to dinner with him and then to Studio 54, but we didn't get in (too full), so we went to the World. Stayed a while and went home. Last night everyone came to the studio to visit. Seems like I'm going away for a long time—but it's only a week.

I just finished reading Jean Dubuffet's *Asphyxiating Culture* (a recent translation). It sort of rambles and repeats itself, but the message is clear as a bell and is frighteningly true. The entire concept of culture is fabricated by an elitist, power/money conspiracy tied to the Catholic Church, ruling parties, and the "powers-that-be" in general. The very concept of an Official Culture that is recorded, explained and supported by the wealthy and powerful is no more than another way to insure their control and dominance.

The museums and "history" books are full of "objective observations" that present themselves as *fact*. But the "culture" has been invented. It is what they say it is. Naturally,

whatever they choose to ignore or exclude from "their history" is somehow forgotten and left out of their "culture." Periodically, token homage may be paid, but only after it has been whitewashed and "explained" through their concepts and "cultural evaluations."

In short, art is still being manipulated by and for the wealthy, educated white minority. Any others who happen to succeed are merely curiosities.

Nothing has changed, it is only more subtle. Artists pretend to be independent. Artists are, of course, allowed little liberties and even encouraged to be "subversive" and "political"; this only makes the control less obvious while in actuality it is strengthened.

But all of this is nothing new. It wasn't new when Dubuffet wrote about it and it wasn't new when Jesus spoke of it. But Dubuffet and Jesus couldn't escape it, either. That's why, I suppose, I feel hopeless and confused. It is a never-ending cycle. The condition of being a human being in 1988 is bad enough, but the gift of being an artist is equally hopeless.

I mean, what can I accomplish, really? The situation I find myself in is not very promising. We are being controlled. The roots of this control are so deep that they are completely disguised and part of everything: language, "culture," geography, religion, the economy, technology, history, education, everything, everything.

So what? I can see it, a lot of people can see it. But, take South Africa for example: How can it be possible that apartheid still exists? Dr. King was speaking against it 20 years ago. The world knows it's wrong: journalists, protests, books, songs, movies—no matter how many oppose it, it exists now in 1988 and it is as strong as ever.

AIDS, crack, military escalations, elections, fundamentalists: it's too big and it's too late.

The art world is just a small model or metaphor of the Big Control. All you can do is these little things to feed the

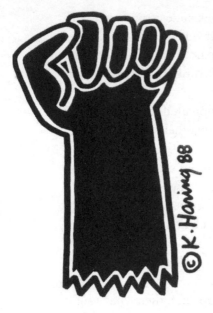

situation. Try to expose it and try to make things a little more bearable. Go to Hiroshima, paint P.S. 97, do an AIDS book cover for teens, try to go to the USSR, paint what you see and feel. But *shit is going to go down.* The world goes on and on, but things are changing faster and faster.

And here I am. I mean, picture this: Picture the Earth from a distance as this big ball. I was on one side yesterday and in a few hours I'll be on the other side. A trip that would have taken months (or years) a few hundred years ago.

We go forward, we have the means, but we're still in the same situation. And we still fightin'.

By any means necessary.

By any means necessary.

By any means necessary.

JULY 24, 1988

I go to dinner to talk with Fran and Kaz about the future of the Pop Shop. It seems it can't go on at the level it is and still make money. The money Toko invested has to be paid back so that they can be permanently cut off. Toko has been "faking" their management the whole time and pocketing money, trying to recoup their investment. It's not a pretty picture. We're trying to settle on the balance we owe them without prosecuting them.

To start over we need money. Money to produce goods and money to maintain the Shop. Sales are declining or are stabilized at a low level. All the fakes may have something to

do with this, but I don't think that's it. Kaz wants to move the Shop to Hokkaido (in Sapporo) as a kind of franchise and then open a permanent shop in Tokyo. There are several possibilities to pursue.

All of this is depressing and unnerving. Can I handle a more complex situation in Japan? I know it's the only way I can make money and really penetrate the culture at the same time. I think of all the options and consider giving up.

MONDAY, JULY 25

Couldn't sleep very well. Woke up around seven o'clock and lay here thinking about Pop Shop dilemma. To insure a future here I may have to do the Shop in a more Japanese way, which means to sell things in more than one place, like everyone else. I don't think I can get people to go out of their way to come to the Shop, especially if there are fake things everywhere else. I am worried that maybe people are tired of the things because they have seen them so much because of all the imitations. And unless a bigger company is involved it will be very costly and time-consuming to pursue all the fakes. I suppose I have to decide if I want to be involved or not—or find a way to be less involved, but still have the work be present. Maybe I just have to hire someone in New York who will act more like an agent or manager for the "things." I seem to have distanced myself more and more from the mass-produced K. Haring, and I am certainly more interested in inventing than distributing.

I went to Tatsuno (the lawyer) with Kaz and had a short meeting. We are going to the police department tomorrow to officially file an accusation and complaint against Indio, the company we want to prosecute as an "example" to everyone else. We have samples and photos from their catalogue of things of mine they copied from the inside cover of *Art in Transit*. It is a pretty clean case. Hopefully the police will do

something this week so it can be presented to the press this week while I'm here.

After the meeting I walked around, saw a show of Andy's prints (where I was besieged by all the gallery workers) and "shopped." There are so many fakes now it's hard to believe. It is hard to find a store that *doesn't* have some fake KH things or KH-inspired things. I've stopped collecting them, unless they are particularly amusing.

It is interesting to see the way the images have become generic in a way. They don't really signify KH, but something that seems much more of the collective consciousness or "universal" culture. Sometimes they are only barely recognizable as my drawings. This is interesting to a degree, but when it gets to the point where they are overshadowing my own things then it becomes more of a problem. This puts me in a strange, but interesting, position in Tokyo. I'm not quite sure how to resolve it, and I'm trying to figure it out as I go.

After walking around, eating pizza at the restaurant across from the hotel, and more walking, I faxed Julia and decided to stay in and read instead of going "out" to Shinjuku to the bars. I read the first chapter of *Cities on a Hill*, which is about gay politics and gay liberation in the Castro area of San Francisco (pre-AIDS and post-AIDS). It was pretty compelling reading and, as an objective view, made some things clearer to me than they have been. The amazing transformation of gay life from the early Seventies through the Eighties is exactly the same story of what I went through in New York. It is a kind of report on my generation and the preceding one for those of us who have chosen to live our lives in the open and not hide in the closet. In many ways it made me proud and in some ways very sympathetic. It's not an easy time to be alive, and maybe an even more difficult time to die.

Woke up and went shopping in Harajuku and Shibuya. Coughing a lot and not feeling so great. It's hard not to worry or speculate about being "sick," and this coughing doesn't help, especially after reading about AIDS until three in the morning last night. Walked around, visited Pop Shop (which was empty) and was sort of depressed and discouraged. Saw lots more fakes or versions of my art on all kinds of things. It has become such a part of the visual culture of Japan and been assimilated so much that it has completely lost any association with me, but rather appears to have been here all the time and is now akin to "the English characters of the alphabet."

Met Kaz and Tatsuno to go to the police station in Shibuya to officially file an accusation against Indio. It seemed to go well and they may take action before I leave Tokyo. We cannot alert the press or do any kind of action for the media until the police have made their move.

After the meeting we returned to the office and Fran and I went to eat something. We discussed her next movie and talked about sex and gender roles in Japan, trying to figure out why people do what they do or act the way they do. Because there is no moral code as laid down in the Bible here, the sexual rules seem more a part of traditional male/female definition and not so much "morality."

A guy from Swiss Air told me a story of a recent dinner he was at with many important art dealers where he asked the Saatchis, "Do you work with Keith Haring?" There was total silence at the table, and he was later told he shouldn't have brought up the subject. How was he to know?

We had a long discussion trying to figure out Japanese understanding of American culture, particularly me. Through trying to answer their questions about my situation in the

past and present in Japan, I came to explain how I felt I was losing my naive confidence in the Japanese understanding of (or capacity for understanding) my work. I had always felt that the things people responded to in my work were tied to their own traditions of the "sign" and the gesture and the concept of the "spirit of the line" that is so evident in sumi painting and calligraphy. I thought people here were more receptive to my work than Westerners because they understood it and felt it more clearly and deeply. The proliferation of all the imitations has taken away some of my confidence. The things that are copied are usually redrawn and therefore the whole "power" of the line is lost. This is very distressing to me since I believe the very essence of my work rests in this concept of the "gesture" and the "spirit of the line" to express individuality. The only thing that remains is the concept or the "cuteness" and the fashionable hype. I really wanted to believe that people here loved the work for the right reasons and that they were even more in touch with it than Europeans and Americans because they "felt" it and "read" it in this way. I still believe that this is the case, but only to the minority. The majority of people only know about my work from all the things they see on clothes and in magazines.

This is not a bad thing, necessarily, but it is a fact. I mean, I am a new phenomenon that is neither "good" nor "bad" or "right" or "wrong." It just is what it is.

My challenge now is to deal with this situation and try to go forward by continuing to work and define my position and my art. I believe that in time all things will become clear.

WEDNESDAY, JULY 27, 1988

Fran and Kaz and I had an emotional dinner/meeting at the Korean restaurant. We decided to continue working on Pop Shop, but agreed we all have to expand to deal with it. I also

explained to Kaz that I would relinquish much more responsibility to him as my agent in Japan if I thought he was prepared to handle it. Keith Haring is a full-time job. He has to hire someone to work for him to work for me. Up until now he hasn't really seemed like he could devote enough time to it to justify giving him a contract with a percentage and the power to find and negotiate work for me. I feel he's capable of it (theoretically and aesthetically) but he needs to have someone to do all the running around under his direction. I would like to work with him if we can work this out. I also stressed to them the importance of acting on this as soon as possible since, realistically, things could change very quickly since I may be sick. I want to have everything in place so if I do pass away, things will continue without me. I want my contribution to be an ongoing and a living contribution, with or without me.

THURSDAY, JULY 28, 1988

Woke up and went to the lobby to meet Fukuda and his wife. We drove to the airport and took a plane (one and a half hours) to Hiroshima, where we were met by a TV crew and photographer who followed our exit from the airport and arrival at the hotel. We checked in and met the other people who were going to be our hosts. They had already been researching the possibilities of doing a mural and had several sites to show me.

We all went to visit the Peace Museum & Memorial, which is a vivid documentation of the horrors of Hiroshima. It is impossible to imagine the magnitude of the bombing until you personally experience this museum. I was followed by the photographer, which was uncomfortable, but not even that could minimize the shock of what I was looking at. There were many families with children in the museum at the same time. I had, of course, read about and seen some photos

of Hiroshima, but I never felt it like this. It is incredible that this destruction was caused by a bomb that was made in 1945, and that the level of sophistication and number of nuclear warheads has increased since then. Who could ever want this to happen again? To anyone? The frightening thing is that people debate and discuss the arms race as if they were playing with toys. All of these men should have to come here, not to a bargaining table in some safe European country.

There was one photo of a pile of human skulls that was beyond reality. Pictures of radioactivity's aftereffects were nothing short of science-fiction horror. Descriptions of black raindrops, photos of melted faces, etc., etc.

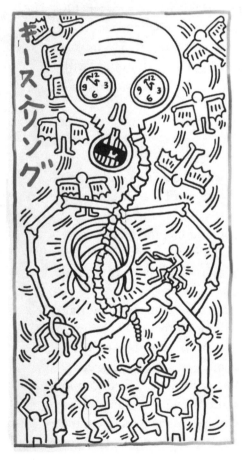

Strangely, what struck me most were two photos of Jimmy Carter's visit to the Peace Museum in 1984. In both pictures Amy (approximately 17 years old at the time) is at his side. The look on her face says it all. It is maybe the archetypal expression of any intelligent, sensitive American teenager upon realizing for the first time the profound reality of our fragile situation. In one picture all you can see is one eye and part of her head, since she is standing behind her father. The terror in her eye is so real and so sincere that it riveted me to tears.

After leaving here we walked through the park in

silence. It was not necessary to speak, for everyone understood. We visited some monuments in the Peace Park and the Dome, which is a building left standing (partially) after the bombing as a reminder of the vast destruction.

Across the river from the Dome is the school where I want to paint. Its proximity to the park and its perfect exterior wall that faces the park makes this the obvious choice. Upon seeing it and realizing its importance I try to explain to them that a mosaic-like mural would be more appropriate and more permanent. Everyone agrees. We walk around the school and then go to a meeting at the mayor's office to explain my proposal. The men we met with there were very resistant and cited every excuse imaginable (including the effect of a mural on the educational process) why I shouldn't do it there. They suggested, however, that the perfect location would be in the new contemporary art museum, which was near completion. They had already arranged a meeting with one of the museum directors. They didn't understand why I was more interested in putting my art in a more real-life situation, and cited all the usual reasons.

Anyway, it was not the city's permission I needed for the school project, and I was interested in seeing the musuem also. We met the director and he agreed to give us a tour tomorrow and show us the walls they've already considered. Then we went to see an immediately available site at the YMCA. But doing a piece there, we decided, would dampen the museum's interest and minimize the city's interest. So we went and had dinner (Japanese soul food) at a very funky place and visited the "gallery" of one of our hosts—which turned out to be a frame shop. While there I met his 76-year-old mother (a survivor of Hiroshima), who was my big fan. I did a big drawing for her, much to her delight. When we left the shop she came downstairs for final bows and goodbyes, and as we walked down the street (quite a long way) she remained standing, watching. As I turned the corner I looked

to see if she was still there, even though I knew she would be. One final bow. Moments like this make me fall in love with this country: the subtleties and nuances of daily life and values that Western people aren't even conscious of anymore. There is a kind of poetry to all life here and every action seems symbolic.

I wrote a fax to New York and began reading the chapter on Jerry Falwell's church in *Cities on a Hill*. I slept and had strange dreams.

SUNDAY, JULY 31

Wake up at 12:00. Go to buy more luggage for all the stuff I bought here. Kaz and Fran come to pick me up and take me by taxi to the bus station, where I check in and head to the airport. Now I'm on the plane back to New York. Hard to believe this all happened in a week.

NOTES:

A few weeks ago I was invited to Bob Rauschenberg's studio for a reception to receive representatives of USSR's artists' union (the governing organization of all artist activities). I felt honored to even be invited, considering the only other artists were Roy Lichtenstein, Christo, Laurie Anderson and some others. I met the representatives from Russia and we talked about my possible work there. I explained I have been trying to get something organized there, but have not had much luck. Information packages and letters had gone through the U.N. and Yoko Ono, but I had gotten no response. They assured me that they were the only ones who could help me. A man I met there who runs a project in Florida that does multiples with American artists like Lichtenstein, Johns, Rauschenberg, etc., told me he was the one working on Bob's exhibition in Moscow and he would personally deliver a package of info for me.

I chatted with Roy Lichtenstein for a long time and made

arrangements to visit his new studio the following week. When I visited him we traded some prints.

I'm only writing this now because for me it was significant that I was invited and that I'm accepted and treated as an equal by these artists, while much of the art world (at least critics, dealers and museum people) treat me as a curiosity easily ignored. It is times like this that I regain the confidence that is continually being drained by the ignorance of the art magazines, and criticism that pretends I don't even exist. The acceptance by these artists, who I respect, and who I feel my work fits in historically with, is much more important to me than any critics, museum directors or art dealers. Anyway, I just wanted to write this down so I'd remember it later.

MONDAY, AUGUST 22

..

Concorde to Paris
To Hotel George V
To studio to see George Condo
Stay up till 3:00 or 4:00 AM
Return to hotel

TUESDAY, AUGUST 23

..

Sleep till 4:30 PM
To Beaubourg (closed)
To Condo studio
To Dave (Chinois)—nice meal
To Hotel Lotti (Condo's room)
To our hotel

WEDNESDAY, AUGUST 24

..

To airport via La Défense to see Big Arch
3:00 PM: Arrive Düsseldorf

Hans meets us at airport
To gallery—add words to T-shirt and poster design
To new gallery—hang show and place sculptures
Eat at fish restaurant
To hotel and out to bookstore and bar

THURSDAY, AUGUST 25

With Vera to buy paper and ink
To gallery to make drawings
Dennis Hopper, Katherine, Tony and his friend, Barbara
 come to gallery
Do about 11 drawings
Give some to Vera, Hans, Klaus, Stephanie, Dennis
Jan and girlfriend on way home from Budapest—visit
 me at gallery
8:00: Return to hotel—dinner with Dennis, Tony,
 Hans, etc.
11:30 PM: Out with Juan to bordello. Boring. And then
 bar. Boring.

FRIDAY, AUGUST 26

Buy paint
To gallery to paint on walls
Photographs
Paint and watch guys build base for huge sculpture
Hang out at show
To hotel
Walk to gallery for opening of Dennis Hopper's photos
 at Hans's gallery
TV—paparazzi
Many friends from Europe arriving
Alain hitchhikes from Paris. (I met him at the Biennale
 in '85 in Paris.)

Yves arrives from Monte Carlo

Jason, Vik, and Emy's son drive from Belgium

David (from Belgium) comes with woman from
 Antwerp gallery

Monique and Emy from Antwerp

Pat Steir and friend come from Amsterdam

Jorg Schellman from Munich

We all go to see my show at other gallery since it
 doesn't open until tomorrow and some must drive
 home tonight

To Hans's house for incredible huge outdoor dinner for
 250–300 people

3:30 AM: To hotel

SATURDAY, AUGUST 27

Lunch with Dennis, Tony, Hans

To museum in München with same

Return to hotel

Drive to my opening with Yves and Juan

Full of people, sign posters for three hours (T-shirts,
 pants, etc.)

Graffiti kids hang out

Big dinner at fish restaurant

To hotel with Yves, girls and two graffiti boys

Hang out at hotel—boring

SUNDAY, AUGUST 28

Check out and drive with Yves—get lost near Bonn

Smoke, smoke

See Bavarian castles

Drive through to Lausanne

10:00 PM: Arrive Lausanne

Check in Beau Rivage

Fondue with Pierre Keller
Cruise park

MONDAY, AUGUST 29

To bank
To school with Pierre
Sign Lucky Strike prints
NOON: Leave for Geneva
Lunch with Galerie Pierre Huber
Leave for France
Problem Juan's visa—return to Geneva to consulate
 and get visa
To France—through Mont Blanc tunnel—through
 Italy
10:00 PM: Arrive Monte Carlo
See Madison, Debbie, Salawa

TUESDAY, AUGUST 30

Lunch with Princess Caroline's secretary at house
To beach—ride hot-dog (inflatable raft pulled by
 high-speed boat); spot Italian boy
6:00: To Roussillon to see Yves' mother, sister
Eat, champagne—stars—quiet—think

WEDNESDAY, AUGUST 31

Get up early
Write Jean-Michel article for *Vogue*
Lunch
1:00 PM Return to Monaco
2:00 Meeting with Guido Pastor about studio space.
 Wants to give me free studio in new building. Discuss
 mural projects.

4:00 Return to house.
To beach—ride hot-dog with Yves, Debbie and Juan—
 see boy again.
Edit and rewrite Jean-Michel piece
9:00 Try to fax New York (no way)
Eat Mexican food at Villefranche
Sleep

THURSDAY, SEPTEMBER I

9:00 Wake up—fax article
Do 14 gouaches
3:00 To beach—talk to Italian boy—ride tubes pulled
 by boat with him. Talk till 6:00.
6:30 Return home
Calls to NYC, Knokke
Juan cooks—eat—sleep
Good sex with Juan

FRIDAY, SEPTEMBER 2

11:00 Paint mannequin for Yves and Debbie
2:00 Buy Polaroid and go to beach
Ride tubes with Massimo and take Polaroids—walk
 him to his hotel—niente
7:00 Calls to NYC
9:00 PM dinner at house with Princess Caroline,
 Roberto Rossellini, Guido Pastor, etc.
Helmut and June Newton cancel because they arrive
 late from Rome
Discuss possible set design for Monaco Ballet with
 Caroline
Talk about studio with Guido
Collaborations from Bruno—he asks me to write in
 catalogue

Nice dinner, lots of champagne
T-shirts to Caroline

Fly to Düsseldorf
Stephanie picks us up
To gallery—take Polaroids
To lunch
To house
To Klaus Richter's opening (group show)
Drive to Cologne to party at Hoffman's house
DJ from London, weird performances
Stay till 2:00 AM
Return to Mayer's house
Talk—sleep

NOON: Breakfast and drive to Knokke with Klaus
Richter
3:30 Arrive Knokke
See Xavier, Monique and Roger
Monique Perlstein and Emy arrive. Discuss ceramic
project
Jan from Kreon comes with sample of light fixture—
discuss continuation of project
Sign posters—give away shirts
To beach club. Club has changed and owner won't
release the container I painted.
Return to house. Pierre Staeck arrives.
Dinner
To casino with Vik and Jason and Juan and Roger to
see Botero show
To Dragon to sleep

Paint three paintings: one to trade with Otto Hahn for
 Lichtenstein drawing, one for Xavier, one to trade for
 Buddha painting
Draw on Jacques' bike
Draw on jacket for Christophe
Lunch
Drive to Paris with Xavier and Roger
Dinner at Otto Hahn's house with family
To hotel—Condo calls
To George's hotel
To our hotel to sleep

TUESDAY, SEPTEMBER 6

To airport to Concorde
See Toukie Smith and Bob De Niro
Concorde to NYC

1988

Solo Exhibitions

Michael Kohn Gallery, Los Angeles, California
Hans Mayer Gallery, Düsseldorf, Germany
Tony Shafrazi Gallery, New York City
Hokin Gallery, Bay Harbor Islands, Florida

Group Exhibitions

Committed to Print, The Museum of Modern Art, New York City
Hokin Gallery, Bay Harbor Islands, Florida
Penson Gallery, New York City (collaboration with Gian Franco Gorgoni)
Bernice Steinbaum Gallery, New York City
Leo Castelli Gallery, New York City

Gran Pavese: The Flag Project, Museum van Hedendaagse Kunst, Antwerp,
 Belgium
Ideas from Individual Impressions and Marks, Lehigh University Art
 Gallery, Bethlehem, Pennsylvania

Special Projects

Open Pop Shop Tokyo, retail store, Tokyo, Japan
Design sets and costumes for *Body and Soul,* Munich, Germany
Artist-in-residence, Toledo Museum of Art, Toledo, Ohio
Create poster and do public service announcement for Literacy Campaign,
 sponsored by Fox Channel 5 and New York Public Library Associations
Easter at the White House: paint 8′ × 16′ mural erected on White House
 lawn, and donated to the Children's Hospital, National Medical Center,
 Washington, D.C.
Lecture and drawing workshops, High Museum of Art, Atlanta, Georgia
Permanent mural, Grady Hospital pediatrics emergency room, Atlanta, Georgia
New York City Ballet 40th Anniversary/American Music Festival: Create
 image for use as poster, program cover, stage projection, and T-shirt
Create First Day Cover and limited edition lithograph to accompany United
 Nations' stamp issue commemorating 1988 as International Volunteer Year
Paint *Don't Believe the Hype* mural, Houston Street at FDR Drive, New
 York City

Books & Catalogues

Keith Haring 1988. Introduction: Martin Blinder; essay: Dan Cameron
 (Martin Lawrence Limited Editions, Van Nuys, California)
Collaborations: Andy Warhol, Jean-Michel Basquiat. Introduction: Keith
 Haring (Mayor Rowan Gallery, London, U.K.)
The Dog in Art from Rococo to Post-Modernism. Robert Rosenblum
 (Harry N. Abrams, New York)

1989

Leave New York after losing my Amex card for the first time in my life. Pick up another card at airport and board the Concorde unabashed.

Flight is smooth and fast. Ahh, technology. At customs we are searched (bags), but much to his dismay he finds nothing.

The hotel is O.K. Close to Champs-Élysées and the Eiffel Tower. We eat, call Lysa [Cooper], and prepare to head to Bains Douches. In the lobby waiting for the address from the concierge we run into Hubert (the owner of the Bains Douches) and he drives us to the club. Outside we ran into the black opera singer Andy introduced me to (Paul Étienne). He says Lucio Amelio is in town also. The club is packed and I immediately remember what I hate about Paris. Or, rather, one of the things I hate about Paris. In crowds people push and step on you and nobody even acknowl-

edges it. After NYC it's hard to get used to this. The club is too full. We find Lysa and her friends and hang out, but it's too hard to deal with this crowd. Gil [Vazquez] is tired and I'm ready to go, too. We return to the hotel and talk for hours. Seems like it's really hard for everyone else to deal with our friendship and everyone seems to keep interfering. It all seems really simple to me. All I know is he makes me feel happier and smarter than anyone I ever met in my life. It sort of brings a lot of things to the surface that are lurking just below. We can talk for hours. We are still up at 6:00 AM so we eat breakfast and try to sleep.

SATURDAY, FEBRUARY 11

Baptiste [Lignel] calls. We arrange to meet at Beaubourg at 5:00. We arrive "almost" on time. With Baptiste, a friend, and his mother we go quickly to Hervé Di Rosa's store at Galerie Beaubourg. It's a sort of Paris Pop Shop *à la* Di Rosa. They have some of the stuff from my shop. We go next door to the gallery and run into Hans Mayer. Surprise. We talk, agree to meet later, and head to the museum. Immediately we run into Hans's wife, Stephanie, and her brother, sister-in-law and mother, etc., etc. As I'm talking to them, Dino (friend from Zurich) comes up. It's one after another and pretty amazing.

At the museum: Jean Tinguely's show is remarkable. Unfortunately, Gil and I haven't eaten and are famished through the entire show. It's really incredible, though. A lot of new pieces made in 1988. It's great to see this work since he was close to death a year and a half ago. It's incredible what he has accomplished since then. Also great to see people's reaction/participation to/with these pieces. Children are compelled to touch them and gaze in wonderment. It's totally enchanting and accessible on many levels. Full of metaphors for everything from Life and Death to industrialization and

its effect on the human condition. There were a couple of really frightening pieces. There was one made in '88 that was really like some weird court of the devil with a kind of vision of this evil being overseen by a horned beast (bull skull). It had a moving metal "wing" and "court jesters" sitting in front on either side that looked like evil little sci-fi creatures.

There is this sort of naturalistic fantastical mysterious feeling of not knowing (or caring) from whence it came, but believing it is real. So real that it originated in your own dreams. It is of another place and time. To see only this piece in another context (outside of a museum or gallery) could evoke terror and displace even the "coolest" observer. Amid all the other works, which are sometimes overwhelming, it is difficult to separate feelings and reactions. It is a totally aggressive exhibition. The viewer is *forced* into submission. This is a rare instance. Most exhibitions only achieve this with an active permission granted by the viewer. You can "let" yourself be seduced. This work forces you (however politely) to see it, feel it, become it. Children's reactions to it make its impact quite clear. I was watching faces of people looking as much as I watched the works. It's a wonderful lesson. In some ways I always strive for this, but only occasionally achieve it. It is the ultimate reaffirmation.

There was a piece from 1967 called "Requiem for a Dead Leaf" that is a huge machine (a series of pulleys, wheels, belts) that is entirely black, intricately constructed, and serves the sole purpose of causing movement of a white piece of metal with a dead leaf (maybe cast) attached to it. The whole complicated mechanism exists for this one small movement. This piece really freaked me out because it is the closest manifestation I have ever seen to the "dream" I have had continually since I was a small child, often accompanied by a high fever or appearing in times of despair. I haven't had it for a while now, but remember the feeling of isolation that accompanied it and of often going into this state of "leaving my

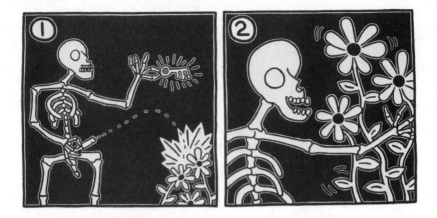

body" during some intense moments. Last night, for instance, talking to Gil, lying in darkness, I start drifting off and the room gets bigger and bigger and I feel as if I'm far, far away. The dream used to begin with (as best I can put it into words) a kind of obsession with this huge, powerful, ominous *machine*. Very dark, loud, metal (heavy, overpowering metal) and constantly moving, turning. I always am aware of the motion of the machine and its power and then something strange happens . . . it produces or picks a flower (I think a daisy). I think sometimes it hands it to a small child (me?). But the overwhelming impression is of this huge thing existing for this small gesture. I don't know what it means. I've never tried to figure it out. I just accept it. I never tried to paint it because my ability to explain it or imagine it falls short of the clarity I see in the dream. This sculpture is the first time I've seen anything that immediately brought me back to this dream. Incredible.

After the show we ate sandwiches and took the subway back to the hotel. As we entered Shirley MacLaine was leaving. Too cool!

Hans didn't call. I call Lysa and agree to meet for dinner. The hotel operator wants an autograph. Ha Ha Ha.

Went to dinner with Lysa, Joanne and their friends. They

were 45 minutes late, but we ran into Ara's sister and brother at the restaurant so I talked with them while we waited.

Then on to a club. House music? The DJ is wearing a KH shirt from CAPC Musée in Bordeaux. We take mushrooms. Hang out—dance—meet the DJ, who is a major fan. Funny how all over the world I seem to have this connection to DJs. Something about rhythm?

We leave this club. One of their friends has a BMW bike and I ride with him. I love riding on the back of motorcycles, especially when they're being driven by a big handsome French man. We go to Le Palace and hang out. Male model wearing a KH shirt. Big, beautiful and stupid. "He's all in the Kool-Aid and doesn't know the flavor." Meet more people. Tripping nicely. Downstairs is another club—after-hours. We hang out there. Turns out Jean-Yves (Grace Jones's friend from La Vie en Rose) is running this club. Big surprise. Dancing, having fun. Some asshole (6'5" and with glasses) is bothering the girls. I went to get a drink and came back to find Gil has just punched him in the face. The guy is bleeding. He's real stupid and keeps asking for more until they finally throw him out. Gil is real cool about the whole thing.

We leave with the girls and go buy bread and pastries. Me and Gil take a taxi to the Eiffel Tower and walk around the park still feeling a little of the residue from the mushrooms and just sort of getting off on the whole evening. It's incredibly beautiful, cloudy sky, people walking dogs and jogging. Watch some swans and ducks and take a taxi back to the hotel to look for Shirley MacLaine. Instead we have breakfast in the room and fall asleep. It's too fucking perfect.

SUNDAY, FEBRUARY 12

Woke up at 5:00 and went to Claude Picasso's house. We went over our plans for Spain and looked at a map and discussed the exact itinerary. Went to meet Jean and Baptiste for

dinner. At dinner Baptiste proposed that I rent his apartment in the Olympic Towers—$15,000 a month. Sounds ridiculous, but I don't know, it could be quite funny. After dinner, he drove us to meet Lysa and the girls and we went to a tacky gay bar called Boy for tea dance. It was full, but somehow depressing. I just can't handle these queens sometimes. Gil and I left and came back to the hotel to sleep. We have to fly tomorrow.

MONDAY, FEBRUARY 13, 1989
..

Fly to Madrid. Taxi to hotel. The meter was going a-mile-a-minute. I think it was fixed. We've taken longer rides since then for one-third the price. Oh well . . .

Christopher Makos is in the lobby and we find out where the Matisse and the Magritte shows are. We arrange to meet for dinner. The Matisse show was great—some rarely seen paintings from a collection in the USSR. Some great paintings he did in Morocco.

We go to the hotel and meet Christopher for dinner. Unfortunately he's traveling with Mark Kostabi, one of the few people I truly dislike. "Nauseating" is to put it politely. I knew Kostabi was going to be here, but I didn't want to have to see him. I successfully avoided talking to him and walking next to him and sitting anywhere near him, but it is impossible to avoid his constant haunting stare. That is really the reason I couldn't stand him in the first place. Even before he tried to be an artist, he was always this "face" in the crowd at openings and events in New York. He'd just stand near you and stare at you. He used to do it to a lot of people. It gives me the creeps. And even now that he thinks he's a "famous artist," he still does it. I can't stand it and worse yet he's a terrible artist. Yeccch! Anyway . . . we also ate with the designer Moschino from Milano and some other friends of Christopher. We decided to go to a club afterward and it was

a disaster—horribly pretentious with bad music. We asked some American girls there for other possibilities and they gave us two more names, but they didn't seem too hopeful considering it was Monday night. The first one we tried was closed and had a few people outside, but nobody knew where else to go. The other place was supposed to open at 5:00 AM. We decided to go home to sleep and get up early.

TUESDAY, FEBRUARY 14: VALENTINE'S DAY

Ha Ha—early? We got up around 4:00 and did our (soon to become a daily habit) push-ups, sit-ups and leg lifts. I'm actually starting to show a little muscle. We got to the Prado by 6:00 and had enough time to get totally blown away. I immediately went to see the Hieronymus Bosch painting *Garden of Earthly Delights*. I have a book with reproductions of the details of the entire painting, and I look at it periodically, but it is incredible how intense it is to be seeing the real thing. It just opens up your senses in a way that is remarkable. Later, discussing this painting and the other we saw there I was explaining to Gil that I was amazed by the sense of hyper-reality in these paintings. It's hard to imagine (since we live in the age of the photographic image) what it was like to see and think like this in the 1500s. Before the camera replaced our idea of reality with a tangible frozen-moment of realtime that we now consider reality—before that—this is all there was. Paintings. Now people have this concept of reality as a "fact." A rational, tangible thing that can be recorded—proven—calculated. The "reality" in these paintings is an imagined or highly aestheticized reality—almost hyper-reality. The reason has something to do with the amount of time encapsulated in this stagnant image. (Condensed-time.) Each face is made of many faces. The distortions (anatomical and conceptual) of the bodies and the use of light make these things have their own reality in a way that a photographic

image never can. If we ever find a way to give these aesthetic qualities to photographically recorded images (photos, film, video) after they've been recorded or during the process of recording them, and find a way of manipulating the rational, scientific "reality," maybe we will achieve something similar to these paintings. It has to be done with some kind of computer that rearranges "reality" and imposes its own sense of aesthetics into what is actually being physically "seen." This will likely be possible sooner than we think. For now, we have totally lost this sense of hyper-reality and are lost in what we are convinced is "real."

We left the museum and went to see ARCO (the Art Fair), which happens to be in Madrid now. It is totally boring and has the exact opposite effect on me of the Prado.

We return to hotel, eat (bad food) and meet Christophe again to go to some party for a Spanish pop star, Bose. It is full of paparazzi, none of whom recognize me, of course, and lots of boring people. Gil and I leave for the club we tried last night that was closed. Tonight it's open, but totally empty. The bartender says it's too early. We give up and return to the hotel. Ah well, Valentine's Day. I'm happy, but I can't explain why. I'm constantly reminded of "reality" by taking my AZT and Zovirax every four hours, but somehow the time in between seems totally magical. I have a really good time with Gil. We seem to be able to make the best out of even the worst situation. I'm writing now, watching him do his exercises, listening to an old Juan Dubose tape, and feeling very content. I still find it hard to believe that Juan Dubose is really dead. I kept thinking about it . . . seeing the funeral and remembering. I suppose I'll always remember these things along with all the good stuff I can remember. The one thing he left forever was his spirit through the music. Even in these tapes of other people's music, somehow his presence is there. It's strange. I remember Valentine's Day one year when we wore matching white suits (running suits) and sneakers and

stuff for this party that Deb Parker had. We used to be really into that . . . matching clothes. It really was great for a while. Nothing ever seemed to stay the same, though. Everything changes. Always. Right now I'm not sure if I understand anything anymore.

WEDNESDAY, FEBRUARY 15

Yves has disappeared. He was supposed to be driving to Madrid to be at the last day of ARCO, which was yesterday, and now it is Wednesday and he hasn't arrived yet. Debbie called to see if he was here. I was worried yesterday, but I didn't want to call her in case he was messing around with somebody. Now it's a little weird, though. We'll see . . . I hope he's O.K.

We got up early (relatively). I went to get my tickets for Barcelona at the Iberia office downstairs and there was a big demonstration going on outside the office. After, we had breakfast and took a taxi to see the Magritte show. It was pretty incredible. There were several paintings I had never seen before. Funny how after a while the shock of his imagination wears off and it seems almost like a "formula." The way he substitutes things, omits the expected, and inserts the unexpected, becomes a kind of predictable process. His painting style remains interesting throughout, though, and often is even more interesting than the subject he is painting.

After this we went to the park where I had been in the exhibition in 1983 or '84. The building that had had the exhibition was now having an Artschwager show. We walked around the park, took photos, and talked. As we were getting ready to leave we ran into François Benichou. He's the guy who had published some lithos in Paris with me in 1985 and took me to meet Pierre Alechinsky. I hadn't seen him in almost three years. Strange coincidence. We talked, agreed to do another project together when I'm in Paris in a few weeks,

and then I had to leave because we had a car arranged to meet us at the hotel at 2:30. On the way to the hotel we stopped and saw *Guernica*. It's always intense. Somehow, now, seeing it behind all this glass makes me despise Tony's act of vandalism even more. (Kill lies all?) The drawings that are hanging with it are incredible.

We met the driver and went to visit Escorial, the place Claude Picasso told us to go see. It's about an hour outside of Madrid. It was fucking amazing. Built by King Philip, it has two palaces within it and a monastery and library (the second-largest, after the Vatican's). We toured the entire thing. There were tombs inside with the remains of kings and queens.

Debbie just called. Yves is dead. He had an accident in Spain on the way to ARCO. I can't believe it.

I am writing this now, two days later in Nice. We immediately got a plane on Thursday morning to Nice via Barcelona. The whole thing is like a bad dream. I mean, I left New York to try to have a vacation from the omnipresent "reality" of death and my continuous struggle to avoid it by working constantly. Then, a week before I was to leave for Europe Juan Dubose dies, and I have to help arrange all the details of the funeral, contact friends, and spend time with his family. Finally, I leave for Europe determined to have a wonderful and relaxed time . . . and now this. Yves was probably one of my closest friends. I am the godfather of his child. He was the most enthusiastic supporter of my work and one of the few people that I think really believed in me 100%. There is nothing I can say or do to change anything. I feel empty and helpless—especially now, faced with the task of consoling Debra. I'm supposed to be her best friend, besides Yves. I'm supposed to be the man she loved most besides Yves because I am the most similar to Yves in her eyes. I don't know if I can live up to this expectation. I don't know how strong I really am. It's not as if any of this was really unexpected. I've

driven with Yves on many occasions when I thought my life was in danger. I've prayed to myself many times while he drove that it wouldn't happen while I was in the car.

Yves is dead. Nothing can change that now. I was petrified to come to this apartment. In Madrid, the night before I left for Nice, I tried to go out to dinner to avoid thinking about it. It worked temporarily, but by the time I was finished with dinner I was really about to fall apart. We had dinner with François Benichou, a famous fur designer, and a collector who bought my giant vase from the exhibit in Madrid in '83 or '84. I tried to be polite and attentive but it kept becoming clearer and clearer in my head. After dinner they wanted to go to this club but I just couldn't do it and Gil agreed we should leave. In the taxi I started crying silently and when we arrived at the hotel I sent Gil upstairs and walked to the Prado and broke down. Somehow it was horribly appropriate to be mourning Yves in front of the Prado. While I was walking (or pacing) in front of the Prado I found a black high heel. Again it was horribly poetic. I had to go back to the hotel and face it and face myself. I called Juan to tell him, but could hardly get the words out. I finally made myself go to sleep. Gil is as much help as he can be.

In the morning we flew here to Monte Carlo. You can't imagine the feeling of arriving in the Nice airport without Yves to meet me or arriving in the Emilie Palace and seeing the faces of the people at the front desk. Debra is not handling it very well. But, how can she?

I've run out of clever things to say and I can only try my best to be of some comfort. There are a lot of people coming and going from the house all day. The phone never stops ringing.

My tooth was hurting so I had Roberto Rossellini (who has been here a lot because he lives in the building and is a good friend of Yves and Debbie) call his dentist and arrange an appointment. He took me to the office and they saw me

very quickly. They gave me a standard form to fill out that was all in French. The receptionist translated some of it, but not all. He examined me wearing a mask and rubber gloves (which is now standard procedure), but during the examination he discovered the KS spots on the roof of my mouth and asked me what it was and I told him. He became very indignant that I had not informed him I had AIDS. I reminded him he was wearing a mask and rubber gloves and that I hadn't been fully explained [sic] about the questionnaire. He didn't really care. He was pretty ignorant considering he was supposed to be the best dentist in Monte Carlo. I left with the advice that there was nothing he could do for my tooth since he saw no decay. He said if it gets worse I'll need root canal. I hope this doesn't happen.

I left feeling completely helpless and rejected, a feeling that seems to come very easy to me. I was watching a huge flock of birds in the sky near the Casino swooping down and through each other. I got shit on twice. Seems like there's a lot of that going around.

I'm trying as hard as I can to make some sense out of all this madness. My life, my misguided love, my friends, suffering, pain, and little bursts of sanity. It's got to get better, I think, but it only seems to get worse. How long can it go on? And who am I to question it? It's not even a question of understanding anymore, but accepting. I accept my fate, I accept my life. I accept my shortcomings, I accept the struggle. I accept my inability to understand. I accept what I will never become and what I will never have. I accept death and I accept life. I have no profound realizations—it is blind acceptance and some kind of faith. I am becoming numb to all of this, which is in a way even more frightening. Nothing even surprises or shocks me anymore. I am becoming very hard on the outside and even softer on the inside. I have to get through this. All of this and my own life, too.

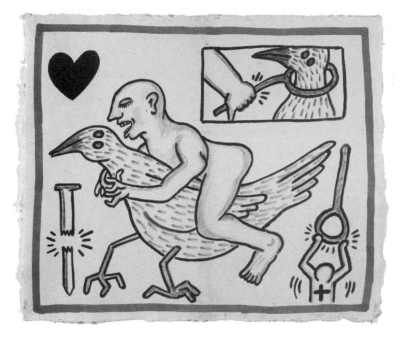

SATURDAY, FEBRUARY 18

Debbie's parents arrived today. Grace Jones and her son Paolo came last night and slept over. Paolo slept between me and Gil—except not exactly in the middle. I had about two feet of bed to lie in except I was so tired I slept anyway. Some strange dreams. Yves' mother and sister are back from Spain where they saw the body and did the formalities for transportation of Yves to Vence. He'll be there tonight. They want me to paint an angel on the coffin. Of course I'll do it—for Yves. Also, Debbie wants me to speak at the service. This scares me, because I'm not good at things like this, but I really have no choice. It's amazing how resilient I seem to have become. It's like I gotta be strong for everyone. But inside, I'm all alone. I was reading Yves' book last night, which he had just published and given me a copy in New York, but

now many of the passages take on a whole new meaning. A few of them are really horribly prophetic.

> Even when you die if it's early in the morning,
> the birds are singing.

and

> Success, success, successful romance
> Younger, younger you become
> The love, the love in your life
> Will give you life until you die.

and

> Creativity, biological or otherwise, is my only
> link with a relative mortality.

The whole book takes on a new meaning now. I suppose death has that effect. It sort of forces you to sum things up and make the final appraisal. I'm starting to feel a little lost in my situation with Gil. I really need some kind of support right now and I'm not sure he is capable of giving it to me. He tries, but as usual, this relationship is mostly dominated by me. Even though we are not really lovers, there is definitely a kind of relationship that follows the same pattern. It was inevitable that the magic would start to wear off and things would start to become more realistic. I'm not sure what will happen when I draw the curtains and look at what is really there. I'm completely blinded with infatuation and determined to create something out of nothing. Sometimes I think it is just my own insecurity that creates the problems or illusions of paranoia that cause the tension.

I wish I was not so determined to feel secure about everything. I want everything to be comfortable and in reality

nothing ever is. Eventually you begin to make sacrifices and ignore the things you don't want to see. I'm not sure that the whole thing is not just an illusion in my imagination. Everyone is, I suppose, the center of their own world and therefore its creator. I don't feel very profound or even very talented sometimes. And I find it very hard to look in the mirror without being reminded that my days are numbered. The bump on my head sometimes looks bigger and sometimes looks like it's going away, but it's always there. Last night Paolo was doing a drawing of me and, of course, included a big spot in the middle of my forehead.

Gil tries to ignore it and pretend not to think of it, but I can tell sometimes, like when I take my medicine, that it is freaking him out as much as me. I'm scared. And I'm not sure what role I expect him to play. I've gone ahead and put him into the whole situation and wrote him into the will and stuff 'cause I think I'm sort of teaching him (or trying to) to understand how I feel about everything so he can be my voice in the future. But how do I know if he even wants this responsibility? I remember how much it freaked me out when Brion wrote a will right in front of me leaving me all his stuff. He immediately sensed my inability to cope with it and eventually rewrote another will before he died some months later. I can see the same thing happening with Julia and I'm afraid I'm starting to see it in Gil. I don't want to be a burden to anyone, but I really think I have to have people who I love and trust deciding these things. Especially after seeing the mess that Yves left, with no will, tax problems, debts, unmarried officially to Debra, no money in the bank and a young daughter. At least Madison has his name on her birth certificate.

The whole concept of preparing is uncomfortable, but it is better faced ahead of time, so that I share in the headache instead of passing it all on to "whoever." I just signed a new will two days before I left for this trip. It is what I feel

is best right now. It may change anytime. I really want to try to teach Gil who and what I am. I wish I thought he really was secure about having this responsibility. I don't know what more he can do to show me he does. He seems genuinely interested. He seems to be absorbing most of what I'm saying and he seems to be the right person to tell these things to. Except I can't help wondering if it is mostly my own projection of what I *think* he is and what I *think* he thinks. How can I know? I don't want to be pitied and I don't know how to be loved. I only know how to love. All I can do is hope I'm doing the right thing. I love Juan a lot. I realize it even more at times like this. He's the only person I really called to talk to about Yves. I just can't spend all my time with him when it starts to feel like I'm talking to a wall. Maybe I created the wall. It's always what you make of it that determines a situation/relationship. At least I'm convinced he really loves me in spite of everything. In spite of my inability to show him love and patience to understand him—he still loves me. I think I just had to have someone else to talk to and to bring all these things to the surface. Gil is playing that role and becoming a good friend. I think I can teach him something during the time I have left and maybe I can learn some things myself. Just the fact that he makes me question all these things and realize certain things must mean that it is worthwhile and the right thing to do. I think he is

teaching me who I am and showing me to myself. What I see in that reflection is *my* problem.

WEDNESDAY, FEBRUARY 22

I'm on a plane to Barcelona/via Madrid. Yves is buried. I stayed in Monte Carlo as long as I could, but I really have to get back to my trip. Debra is going to leave for New York any day to take care of the stuff in the apartment. Leaving last night was one of the hardest things about this whole thing. I sang Madison to sleep, which was one of the most beautiful moments I've had in a long time. She is so precious. The feeling of holding a baby and rocking and singing them to sleep is one of the most satisfying feelings I have ever felt. I'll never know the pleasure of having this experience with my own child, but the times I've done it with Zena and Madison or my little sister, Kristen, are deeply embedded in my memory. To make Madison sleep, I had to sing verses of "Amazing Grace," but adapting the words and changing

each verse as I went. I found it almost effortless to find words that would rhyme and fit the rhythm of the song. I sang to her about life, her father, the love he and I share for her, taking care of her mother, etc., etc.

Two days ago we buried Yves. Well, not buried, really. Here they put people in a kind of mausoleum. (Family "plots" that

can hold four or five stacked on top of each other.) The only coffin inside before was Yves' grandmother. His grandfather, who is 91, was there to watch Yves go into the chamber. It's funny, 'cause his grandfather had always joked that he didn't want Yves to be buried with him in the family plot because Yves was so "agitate" and "funny" and he didn't think he'd have any peace with Yves near him. Now, quite probably, Yves will be right in between his grandmother and grandfather.

There was a simple service in a chapel (no longer used as a chapel) that was all painted white inside and lit like a gallery with track lights. Several people got up and spoke about Yves. Most of them only spoke in French, however, and I was compelled to say something in English. It came to me much easier than I expected. I simply spoke from my heart. It's true I loved Yves from the first day I met him. He taught me a lot about life and how to enjoy it and "accept" it. The night before, I had painted the coffin. It was the first request his mother had when I arrived in Monte Carlo. Everyone was sure it is what he would have wanted. Painting the coffin was an incredible (to say the least) experience. It was effortless, also, pouring out of my heart and hands. I painted with silver enamel on the shiny black Spanish coffin. Originally I intended to do just the angel, which he had adopted as his "sign," but found it necessary to complete the whole thing.

At the bottom was a mother and child. And then I wanted to write FOREVER + EVER, but because the R didn't fit, it turned into this: FOR EVE R AND EVER

I think Yves would have liked this the best. It was totally "accidental" but definitely a powerfully "directed" accident. He loved these sort of word-plays and twists of fate. This was an intense experience. I'm totally without any more emotions. I've been totally emptied. Cleansed. I have to start over and figure stuff out again for myself. But I have to con-

tinue, have to keep on keepin' on. Have to be strong. This is not the last trial and tribulation I will have to endure and it's not the first. Each time makes me a little bit tougher, a little smarter and a little bit more gentle. Life is a challenge worth taking. I wouldn't expect it to be any other way. The pain defines the pleasure. The wonderful thing is that it goes on and we adapt. Somehow there is always this human capacity for adaptability. As long as I can, I want to be a good person and be a good friend. I learn more about how to do that every day. I want people to be able to say about me what I said about Yves—that every day he lived to the fullest and his life (our life) was and always will be complete. I'm content every day. I do what I can, I accept what I can't. I'm as happy as I can be and as compassionate and loving as I think I can be.

FRIDAY, FEBRUARY 24, 1989

Barcelona is a lot more easygoing than Madrid and seems to have a much more active street life. We went to an Acid House club the first night we were here. Maurillo, a guy I know from Plastico in Milano, told us where it was. It's incredible to me that all over the world people are listening to the same music and sharing this sort of "world culture." Yesterday we went to see the cathedral that Gaudí was in the process of building when he got hit by a train. We climbed the stairs to the top of the highest tower. It's pretty incredible and hard to imagine how it must have been received at the time it was being built. It still seems sort of out of place with the architecture that was around it and that has been done since. His use of intuition instead of strict pre-planned architectural drawings in building is still unheard of. Someone told me that there is a group of people who are trying to finish the construction of the building. This seems ridiculous since he left no exact architectural plans for the completion. His whole concept of "how to build" was important to

the production itself. It's kind of like trying to finish an unfinished painting after a painter's death.

Last night we went to an opening of "new" Spanish artists that had been traveling from Germany. It was pretty boring. The only interesting thing was it really made me think about how little I have to do with what most people consider to be the basic concept of "painting." I think somehow I start from a completely different premise. I don't know how to explain it exactly, but it has something to do with the reason for making a thing and the ritual of the process of making. Somehow so much of this stuff looks completely pointless and lost in some kind of search without an end. I feel like each thing I do has a logical conclusion and the entire process of arriving at that conclusion *is* the art itself. There is never a question of changing something or rearranging things. Some would say that is my biggest fault, but I think it may be my biggest asset. Most art is about striving to "become" or "attain." I don't think it's about that necessarily. I think it is interesting to see the result of someone's "struggle," but it is also interesting to struggle with the results from someone's pure expression. I believe the process of "making" is a complete thing in itself. We went to the Miró Foundation today and I noticed in one of the paintings that he had painted out one of the lines with white. It looked wrong to change it somehow, when the thing itself is supposed to be an expres-

sion of the subconscious. A lot of the paintings utilize drips and splashes. I think the painting would have been as good (or better) with the line left in. But who am I to say?

I met Syndria downstairs and went to get the paint, batteries for the radio, brushes, etc., and got to the wall at exactly 12:00. The wall had been prepared (cleaned) and people were waiting. I started almost immediately. There was already press arriving, mostly photographers and one TV crew. The red paint (acrylic) went on really easily because the wall was really smooth.

The painting went really easily. I had a rough idea of what to paint and it all worked out pretty well. The neighborhood kids were all over as usual and acting pretty much the same as kids anywhere (trying to get as many buttons as possible). A lot of media showed up—all three TV stations— two local and one national. A person from ARS was making a tape for me. Lots of photographers from newspapers and magazines. Even Spanish *Vogue* was there. Montsey was pretty well connected to drum up this much press in only two days. (We really only decided to do this on Saturday morning.)

One of the proprietors of a local whorehouse was protesting that this mural will only hurt the neighborhood because people will think there are a lot of drugs there and the police will close the bars. That's ridiculous, however, because everyone already knows how bad the situation is in the Barrio, and the mural is only an attempt to reach out to the people who actually live there and are affected by it every day. The message was one of education so that people will be more careful and conscious of AIDS and hopefully avoid it. The mural only had the word SIDA at one place to make the message absolutely clear and at the other end it said in Spanish, "TOGETHER WE CAN STOP AIDS." The painting took about five hours, as I predicted. The wall had a strange slant to it, which made it awkward to paint on, but one of my favorite things about painting murals is the amount of adapt-

ability (physically) you must put up with to accomplish the task. I found positions that were new to me to balance and keep the consistency required. Some of the best photos of this painting are of the body language and posture.

There was one kid about ten years old, David, who adopted me. He stayed close by the whole time and kept the other kids from bothering me. At the end, he kept insisting on being in all the photos with me and helped me clean up. The day after the mural, when I returned to photograph it, David had left a present of a pencil-holder and a pencil with one of the neighbors to give to me. He was in school and had wanted to give it to me if I came back when he wasn't there. That was probably the highlight of the whole two days.

Tuesday was the last day. Now that the media knew I was in Barcelona, the phone didn't stop ringing with requests for interviews, TV appearances, and stuff.

I kept telling people I was leaving and didn't really have time. We went to the Picasso museum. It was pretty incredible. We also went back and photographed the finished mural. There were a bunch of people who had heard about it on TV taking photos and looking at it.

We left for London the next morning. It was sunny and warm when we left Barcelona and cloudy and cold in London. Oooh, I love this country!

George Condo is staying in the same hotel. We visit him immediately. He had some weird thing happen in his room the night before and had broken two mirrors and Anna got a bad cut on her head. This hotel is full of antiques, so the mirrors are supposedly worth a lot of money. Also, they let the bathtub overflow and owe money for water damage to the room below. We hang out in his room for a while and then go downstairs to order food. The room is really like a little apartment with a kitchen and stuff. There are fresh lilies in two rooms so the place smells great all the time.

We hang out, work out, and then meet Denise (who we met in Monte Carlo) to go to dinner at a trendy little restaurant in the neighborhood. Sean Connery is there. We had a nice little dinner and came back to the hotel to crash. Jason and Liz Flynn have arrived and left a curious message I didn't understand.

Wake up and eat breakfast and talk to Roberto Castellani on the phone about Pisa project.

Jason and Liz and Liz's sister come to meet us and show us (sight-seeing) around London. We go to all the obvious places. Jason is hysterically taking photos of everything and acting like a typical American tourist. We walk around a long time. Liz's sister has a two-year-old boy who is a real troublemaker and great fun. We eat awful spaghetti and return to the hotel.

FRIDAY, MARCH 3, 1989

Woke up late. Went to see Condo's show at Waddington. It's really amazing. I truly enjoy seeing things that knock me off my feet like this. It is totally inspirational and makes you want to go home and work immediately. Curiously, Gil had almost identical reactions to some of the works. He instinctively liked certain works, which later George told me were also *his* favorites.

There was a little painting called *Madonna and Child* with the most mysterious light emanating from it. At a distance it appeared carefully constructed, but under closer observation was completely loose and intuitive. The genius of it is its ability to mask reality and induce the viewer to fill in all the gaps. The viewer finds himself constructing a "pretty" picture in his head from a chaos of seemingly unrelated shapes and colors. It is almost comical; but the joke is not on George. You want to laugh out loud sometimes. Some drawings are downright ridiculous, but somehow they be-

come transformed by all of our "knowledge" and precon-
ceived ideas and *remembrances* of "art" and we invent a new
thing in our own heads that combines our expectations with
what is before us. He walks a very thin, but very impor-
tant, line.

Leaving the show I said to Gil how it makes sense that
"these are the paintings of a man who could break mirrors in
his hotel room and flood the bathtub causing extensive water
damage" without even noticing it.

The large painting at the entrance (which is also the cover
of the catalogue) is remarkable. It combines dozens of al-
ready great drawings into a college of drawing and painting
that truly exceeds the sum of its parts. The thing that always
intrigues me about George's things is how they grow on you
and keep changing. When you see them months later, you re-
member things you saw the first time and seek them out, but
also you are overwhelmed by new things you hadn't noticed
the first time. They really have a life of their own.

SATURDAY, MARCH 4

Wake up at 2:30 and smoke a joint. I go to the Leonardo
da Vinci show myself, 'cause everyone else is going record-
shopping. The exhibition was even more magical than I imag-
ined it would be. After the mastery of technique was achieved
he had an entire universe to explore, pick apart, and explain.
His imagination always kept him ahead of himself. His com-
ments on painting and nature and science and their interrela-
tion make his position quite clear. The simple, logical truths
he reveals seem timeless and profound. His universe was one
of total harmony and compatibility, with man drawing all his
knowledge and power from nature and creating in the same
way that nature creates. Everything had an explanation or a
relationship that could be logically deduced. Yet with this ra-

tional approach to "reality," he constantly interjected the irrational and the imaginative.

There were four drawings at four separate parts of the exhibit from the "Deluge" series he did in 1515. They were explained on the placard to be "his last significant artistic expressions" and the "reason for them was unknown." They all seem to show the effects of a large, overwhelming force of nature—a village at the center of a storm or an almost abstract cloud of billowing currents and crosscurrents. They look frighteningly similar to what has been described as the scene of a nuclear explosion. These drawings, although difficult to pick apart and therefore ignored by most of the lines of viewers, are dense and complicated, almost abstract, dark, prophetic drawings. There was never a storm that could have looked like this at his time, but now there certainly could. I kept going from Deluge drawing to drawing and studying and comparing them.

The other amazing thing in the exhibition was the computer video actualizations of some of his ideas. It made them clear in a way that he would have been envious of. I overheard a man say, "Imagine what he would have done with a computer." Indeed . . .

After leaving, completely light-headed and floating aimlessly, I walked around a while, watched hordes of skateboarders hanging out under the museum, which had all different kinds of ramps, banked walls, and stairs that looked as if they had been designed specifically for their use. I walked along the Thames toward Big Ben. The sun was just going down and the sky was turning all kinds of colors. Subtle, but beautiful. It was a really great special time to be alone and wander around the exhibition and walk along the Thames afterward at sunset. Sometimes I forget how much I enjoy being alone. It was the first truly enchanting experience I've ever had in England.

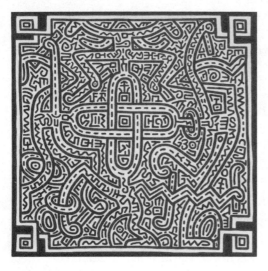

We fly to Casablanca and
change planes and land in
Marrakech at 12:30. No
change places are open.
We find a taxi and go to
La Mamounia.

The hotel is incredible,
or at least it looks like it
used to be. It has been to-
tally redone and lost some
of its original charm. The
room is O.K.

MONDAY, MARCH 6; MARCH 7–8

Christopher Makos wakes me up. I didn't know he was here.
He says he'll meet us and show us around a little 'cause he's
leaving tomorrow. He's been given a car and driver. At the
hotel he introduces me to this crazy rich Japanese woman
who is on her way to have lunch with the king. She is dressed
in her "golfing outfit"—pink tights, red platform shoes, a
flowered cape, big flowery hat and *tons* of tacky jewelry (all
of which is supposed to be real diamonds, etc.). She gives me
a bag full of magazines and books. All of them are about her.
She's a walking media mogul. It seems like she lives for her
self-promotion. The books have photos of her with every fa-
mous person she's met and every place she's been. She travels
with 50 pieces of luggage—many of which are probably full
of these promotional packages. She has a photographer and
a man with a video system with her. Our entire meeting is
well documented. I autograph her golf bag and she leaves.

Andy would love her. She's like a one-woman show—the ultimate self-promotion maven.

After this we went with Christopher to the home of an 80-year-old friend of his so he could say goodbye to her. She was like an aging movie starlet in her Moroccan hideaway. It's amazing how beauty shows through, even in a body that has completely aged.

I'm not sure what it was like when Brion was here. He said it had changed drastically, but somehow it must have still been similar. I haven't gotten any sense of curiosity or inspiration yet. But that again is also making me feel insecure and stupid. I'm not drawing and don't really feel like drawing. I suppose it is supposed to be vacation, but somehow I feel guilty about it. Sometimes I doubt my entire existence is worth very much. It all seems so fake and as if I am just acting out a role. The problem is I don't even understand what that role is anymore. It is really hard for me to accept the fact that I've totally lost my sexuality. If I had been here a year ago, I would already have had at least two or three Moroccan boys. Now, with KS spots all over me, I am afraid to even attempt to have any kind of contact with them.

I've totally lost the ability to seduce and enjoy the art of seduction—the source of much of my inspiration to work and live. It sounds ridiculous that something like sex could hold such high importance in someone's life who supposedly has "the profound gift of artistic invention," but it does and always has. Maybe that is the source of some of my guilt about my incompetence. It was always impossible to separate art and life for me and life was inevitably dominated by sexuality. It is probably the driving force behind all of my work. Now, isn't that pathetic? Or is it? Maybe, just maybe, it is not so uncommon and even quite normal.

The ludicrous situation of traveling with someone who I

am desperately in love with who is not, and can never be, my lover is starting to take its toll.

I try to understand and to keep telling myself rationally that this is a healthy relationship somehow, but every day seems like it hurts more somehow. It's not really his fault. I started the whole thing and I let it continue and build itself up in my mind to the point where I had created the entire picture myself. I feel like I'm getting exactly what I wanted. But how can this be what I wanted? How could I have ever thought I could change myself to the point where I can accept the fact that my life is being run by someone else? Or that my destiny predetermines my existence?

I totally "understand" that I have to love Gil as a friend, and I do. I know that somehow there is something good coming out of this "friendship." I have tried to accept the fact that sex of any kind is not part of this relationship. Except I've never had a relationship without sex before, and I've never loved someone so much without the reaffirmation of that love that comes from a physical relationship. I'm sure if I become an old man, I'd have to deal with the same thing, but I don't feel like an old man yet. I'm turning bald, which helps me realize I'm getting old, but inside I still feel like a kid. I don't know how to change. Maybe I don't have any right to complain. I've had an incredible life and had enough sex in ten years for an entire lifetime, but it doesn't work like that. It's not a rational thing that can be explained away. No matter how I look at it, it comes out the same. Rationally, the time I'm spending with Gil is helping me to adjust to the situation I've found myself in since I've become sick. He's encouraging me to take myself seriously and to work at staying in shape physically and mentally. He is good company and a good way to reflect my self to myself. We actually do have a good time together quite often. He seems like a genuine friend; I feel like I'm teaching him something. He is also, and maybe this is the main problem, still incredibly beautiful and

almost the exact image of what I always thought I wanted in a partner. He would make the perfect lover.

Except that he would make the worst lover because he would never love me entirely. He will always prefer women and even if we were lovers he'd still return to women. So, again rationally, it makes more sense to me to keep unattached emotionally because there is no pretty ending. No matter what happens it can't be a happy story. The fact that it kept on this long and got to this point shows me something about how ignorant and how vulnerable I've become. Maybe it also shows me the power of love, even love like this. There is a certain kind of beauty in this relationship because it is based on some kind of respect. It is genuine. Sometimes I feel like it's just my immaturity that won't let me accept my life and appreciate the goodness. I am, after all, just a big baby. I want to be loved and I don't know how. I am desperately determined to make some sense out of all this. I think I owe it to myself to at least feel good about myself.

SATURDAY, MARCH 11

YES! I'm out of that depressing mood! I've spent the last couple of days trying to see more of Marrakech's surroundings and enjoying it.

We drove up to the mountains the other day. The colors here seem more vivid because of the light. At sundown—everything glows. Most of the colors are based on the mud-red from the earth that all of the buildings are made from, so whenever a contrasting color is put into that scheme, it really pops.

There is a whole different sense of "time" here. As soon as you leave the hotel, you enter another dimension of time. People are governed by different things and different values. You see people sitting, contemplating, enjoying quiet moments alone—quite often. Even in the city (although it is

hardly a busy cosmopolitan city) there is a relaxed feeling of "desert" time. Maybe it's the heat. That would be enough to slow anybody down.

I've done very little of anything since I've been here. I don't read, draw, write, call anyone—I just think a lot and eat and sleep and smoke hash. I guess that's why they call it vacation.

SUNDAY, MARCH 12

We drove up to a place near the mountains to have lunch yesterday. It was really beautiful and peaceful.

I got a plane reservation to Paris for Monday and changed my reservations for the hotels.

We ate dinner last night with Nicola [Guiducci] in a tacky but awesome Moroccan restaurant. They had belly dancers, musicians, and bad food. The decor is good enough to make up for the food. Every inch is covered with intricate mosaic geometric patterns. The ceiling, walls, pillows, pillars, doorways, etc., etc., are a wild mish-mash of shapes and colors. Many of the colors used here are bold and aggressive, so your eye is being lured in every direction. Because of the architecture, the spaces feel intimate even in a large room through the careful use of pillars and varying ceiling heights to give the illusion of separate "spaces."

It seems like the perfect place to take mushrooms and sit for hours contemplating the universe. With the least bit of stimulation (hash, tea, etc.) your eyes are set into motion. It seems to encourage meditation and introspection. It would be easy to imagine a relationship between these surroundings and the subconscious. They invite you to look inside yourself. The casual decorator's misuse of these powerful images in hotels like La Mamounia (and tons of other tourist-based enterprises) does much to discredit and remove the potential

magic from these objects. When something is redone, attempting to "improve" on the original manifestations, without an understanding or sensitivity to the original's intended function—the result is usually awful. The only interesting things in my room at La Mamounia are the doors to the bathroom. They are intricately painted and carved, probably the only original thing left in the room after the redecoration a few years ago. They have all these little interlocking and overlapping lines that are starting to reveal themselves to me the more time I spend there. I think one could find a multitude of ideas within these patterns. I've used these kinds of lines before, often, and am starting to pick apart certain ones and deciphering them. People take borders here *very* seriously.

I'm going to work out now. We've worked out every single day of this trip and you can actually see the results. I should try to continue this at home. We'll see . . .

LATER

Yesterday driving to the mountains I was randomly thinking and daydreaming and wondered to myself about Robert Mapplethorpe. I imagined finding out how he had died. I think I imagined reading it in a newspaper. And I wondered to myself—or imagined—his funeral with his coffin being carried by six huge muscular black men and then I thought no, maybe he wouldn't be buried—he'd be cremated.

Tonight I opened the *Herald Tribune* and read his obituary.

It seems like every time someone I know dies, I know it or feel it subconsciously while it is happening.

This happened with Yves, also. Gil and I had been talking about him and I was remembering stuff we had done together. Later, we found out that this was almost exactly the same time he died. Denise, Yves' friend from London, told us

she had an incredible nosebleed that night at the same time. She hadn't had one in years. Things like this happen.

I swear, I had imagined even the way the obituary looked on the page of the *Herald Tribune*. Now, looking back, it seems as if I had imagined this whole moment (now) yesterday.

The color here is so remarkable! Every day when the sun starts to go down, everything starts to come alive. The colors at sundown seem to jump at you and compete for your attention. No matter where you are, everything is beautiful at this time of day.

MONDAY, MARCH 13

We woke up, hung out in the hotel and flew to Paris.

George was home and we went to see his new apartment/ studio and went to dinner nearby with Claude and Sydney Picasso. It was hysterical and inspirational as usual.

We went back to the apartment and looked at paintings and listened to music for a while. My mind is traveling a million miles a minute.

TUESDAY, MARCH 14

Get up and call François Benichou. He wants to work on the lithos. I agree to go directly to the printer and make drawings. Since I haven't really worked since Barcelona, the drawings come out very easily and are pretty interesting. I use the sketches I did in Morocco of the interlocking lines and borders to work from.

After this we go to dinner at La Coupole and to Bains Douches and then to an Acid House party at the Palace. They have an incredible light show with many projectors and lasers and overlapping images. Gil meets a girl and I go home.

Get up (with hangover) at 9:00 AM to return to the printer to do the second color for each print. We have invitations for Patrick Kelly's show at 4:00 PM and we arrive just on time. I run into lots of people at the show. The show is fun. Iman, Beverly Johnson and Toukie Smith are modeling. L'Ren, the girl I painted in Monte Carlo for the cover of the Swiss magazine, is in the show as Jessica Rabbit. We go backstage and see Patrick. Then we go on to another show, but it is painfully boring and we leave halfway through.

We take a subway back to the hotel and call George. There is a message from Princess Gloria TNT. I call Gloria and arrange to meet for lunch tomorrow. We go to Claude and Sydney Picasso's house for dinner. Interesting conversations, but somehow everyone was a little bit pensive. I still feel my hangover and am tired.

Gil and I go out to Bains Douches again and run into L'Ren. She's doing the Mugler show tomorrow and says we should come. It could be fun. There are some extravaganzas in the show vogueing. We go to Palace again and then home.

We arrange a car and driver. It will be impossible to do all the things we want without a car—taxis are shit in Paris.

Jean Tinguely's show again. It's even better the second time. We could stay for hours, but we are running late.

Then to a record store (Bonus Beat) for Gil to buy records.

Back to the hotel. We are one hour late to meet François and the printer to see proofs; a guy wants to trade a Gaultier vest for a drawing on his jacket; the DJ who wants us to do an interview for Radio Nova. They are all waiting in the

lobby. We go to the room, drink champagne, check the proofs, do the drawing and rush out.

We go to David Galloway's house to do the interview and rush to the Thierry Mugler show. We are a little late, but we see most of it. The best was Iman vogueing with two extravaganzas!

They must have been in heaven!

We take mushrooms and are tripping at Mugler. I see lots more people I know—Andrée Putman, Larissa, etc.

We go to the hotel, laughing hysterically, and then to Bains Douches to have dinner with Iman. Then we run into Gil's "girlfriend" and drink champagne and take more mushrooms and go to another club.

There is a London party with Fat Tony DJ'ing. It's O.K. Gil leaves without telling me and I go home to find him and his friend in the hotel drinking Dom Pérignon. Not fun . . .

4:00 AM I go to sleep after a talk with Gil and after she leaves (7:00) he comes to bed and is real upset. I still love him, even more than before. Sometimes this is really fucking weird, but somehow I'm proud of how I'm dealing with it. I can actually see the results of what I've learned, like I can see the results of working out every day. I think it has been really good for me.

I am happy.

FRIDAY, MARCH 17

9:00 AM: François comes to show me the final proof. We taxi to the airport and now I'm on the Concorde about to land in New York. It has been an incredible trip and I am really relaxed, really happy, and feel like I've really learned something.

This is good.

NYC: Went to White Castle and then dropped off Gil at home. This is not good.

Concorde, New York to Paris. Arrive 10:25 PM Paris time. See Claude Montana's boyfriend, Butz, in airport. He's going to Gloria's party, too.

Taxi to Ritz. Call George. No answer. Call Alain. Arrange to meet at 2:00 AM. We go to gay bar (Boy) till 5:30 AM. Sleep (alone).

Sleep late. Meet François at 3:00 PM. We go to his office to sign lithos. Sign whole edition—five prints—90 in edition and proofs, etc.

Call Condo—arrange to meet for dinner. Finish signing—taxi to Ritz. Call Debra in Monte Carlo. Go to restaurant to meet Condo, Anna, and Miguel Barcelo at L'Ami Louis. Huge meal. Back to Condo studio. Hash, vodka, Dylan, Hendrix, Neil Young, etc. Force myself to leave and return to hotel. Long talk with George about my "situation" (death, etc.).

9:00 AM flight to Munich—taxi to Julia's friend's house. Return to airport and meet Debra. We are taken to Regensburg by van and check in at Ramada Hotel. Lunch in Regensburg and hang out in hotel to wait for party.

Dress in tuxedo (turquoise) made by Hector and taxi to Palace with Julia and Debra.

At entrance is huge curtain blown up from record cover. Eyes of bird are still blue—the printers' mistake . . . and now it's on the banner. The mistake has turned into a statement.

Inside. Incredible. Too much to explain about the decor. See a book. Everything you've always imagined in Cinderella and other fairy tales. At the party I am the center of attrac-

tion. It seems they've used the invitation as the basis for the decor for the whole evening. There are big cut-outs made from the record design and plates made like the record at each table setting. Andre-Leon Talley shows me May *Vogue* with Madonna on cover and her house inside with my collage in it.

See Jeff Koons, George Condo, Bruno Bischofberger, Lüpertz, Immendorf, Templon, etc., etc. Artists, musicians, tennis stars (Boris Becker) and tons of jet-set socialites (mostly from Brazil). Spoiled brats, etc., etc., and of course, Billy boy (wearing a see-through body suit with a codpiece).

I spent most of the evening autographing plates for people. People kept stealing other people's plates. It was a major scene.

Debra got drunk and obnoxious. Julia returned to Munich. I ended up taking Debra home to the hotel and forcing her to go to sleep. I returned to the party. By then I had met this whole group of kids (young adults?) who were doing Ecstasy and were all horny as hell. One thing led to another and I ended up jerking off with this big Italian guy in the toilet. It was a very decadent evening, to say the least.

SUNDAY, APRIL 16

We woke up and returned to the Palace for brunch. It was brighter, calmer, more intimate and maybe even more fun than the night before. I did lots more plates for Gloria for people who had theirs stolen and spent a while drawing with Albert. He's five years old and really brilliant. He kept calling me Keith *Haring*, never just Keith. He loves to draw and we do really good drawings together.

We say goodbye to everyone and leave for Munich to make Debra's plane. We get a lift with Roberto (the Italian from the bathroom), his friend Cristina, and in the back

seat—me, Debra, and this guy who calls himself Joey the Toon.

On the way to Munich Joe takes off his pants to show us his boxer shorts. He's wearing a shirt, tie and jacket and boxers. We stop at a highway gas station and he goes in like that. We couldn't stop laughing.

He does it again in Munich at a busy sidewalk café. People are amused and politely ignoring it (sort of).

Debra goes to airport. We go to hotel. They go to Milano. I check in hotel and call Julia and go eat with her and her friend and then to a sort of hustler bar and have a drink.

Home to hotel and call Gil. Talk for a while and go to sleep.

MONDAY, APRIL 17

Sign prints.
Go see show of James Ensor.
Fly to Düsseldorf w/Julia.
Hans picks us up at airport.
Dinner for me at Hans's house.
Meet several important people.
Ride to hotel with David Galloway.

TUESDAY, APRIL 18

See exhibition of Max Ernst collages w/man who
 curated it.
To factory to see new sculpture.
To paint factory to see progress.
To museum (Island) outside Düsseldorf.
To dinner w/collectors and Hans.
To Hans's gallery to do interview w/Gabriele Henkel.
To hotel—to gay bookstore—to hotel.

To Hans's gallery.
Drive with Klaus Richter to Amsterdam.
To Stedelijk Museum for Malevich show.
See Doreen and Helena.
Fly to Paris.
Taxi to Ritz.
Dinner for me at Claude Montana's house.
Meet Alain.
Hang out with Ludovic and Alain.
To Bains Douches and back to Montana.
To Boy till 6:00 AM.

Wake up late.
Lunch in hotel.
To Galerie to see "fake" KH painting and sculpture
 by LAZ.
Buy purses in street (Anne).
To Templon to sign sculpture.
To dinner w/Alain, Ludovic, etc., etc.
Meet young book publisher, Stephane.
Drawing in guest book.
To Bains Douches (see Cyril Putman).
To Boy till 5:00 AM.
Call Gil, talk till 6:00 AM.

Meeting w/Airship people and city of Paris people at
 Hôtel Crillon.
Maître d' turns me away (no coat).
Run into Sandra Bernhard in lobby.

Lunch—meeting Airship project—great!

Run into Ludovic in restaurant, he drives me to hotel.
Comes to room—drives me to meet Claude Picasso
at Bon Marché.

Buy paint, brushes. Paint door for Jasmine Picasso.
Claude offers me a Picasso drawing. Incredible.

Meet George and Anne for dinner.

Picassos, Condos and Haring to new disco.

Totally cool—very funky—major boys!

See people wearing my stuff (hat, button, etc.)—meet
Sabrina (girl from Florence), Alain, etc.

To Boy—to hotel—too drunk.

SATURDAY, APRIL 22

··

Wake up late.

Meet with book publisher Stephane.

Alain picks me up at hotel.

To Hermès—shop for Gil.

Return to hotel

Grace Jones and Paolo in hotel—hang out with Paolo
in room.

Picassos arrive to take us to Jean-Charles de
Castelbajac's house.

Birthday party for his son (10).

Draw on purses for Grace, Anne.

Play with kids.

Condos, Alain, Grace to dinner.

To Condos' house with all above.

Taxi to hotel.

Sleep.

SUNDAY, APRIL 23

··

Concorde to New York.

I've been in Europe since last Thursday. I first went to Antwerp for an exhibition of five paintings and a few drawings at Gallery 121. It was packed full of kids (mostly autograph-seekers) at the opening. As usual, I signed shirts, jeans, books, etc., and the occasional driver's license or passport. I signed for two hours straight and when I stopped there were still many people, but the gallery was closing and I'd had enough.

Debbie Arman came from Monte Carlo for the opening. I had a small dinner for me (about 50 people) at the house of a friend (and collector) afterward. Belgium is like a second home to me. It's a very "family-like" atmosphere. Lots of friends from the last couple of years. Jan and his friends came from Amsterdam. We hung out at a bar later and talked for hours. Jan is really like a student (or as I remember myself as a student), idealistic and rebellious. But I've seen too much and learned too much about "reality" to be that idealistic. Anyway, it's good to be grilled and answer questions for inquisitive and sincerely interested people. I feel more like a teacher all the time. Like in Chicago and also here the last week, I keep finding myself sitting with little groups of "students," answering questions for hours. I like it.

I spent the weekend in Knokke. As usual it was really incredible. I stayed in the Dragon as usual. I ate incredible meals every day cooked by Roger (the best chef in Europe). I went on the sea on a catamaran for two hours with Xavier and Frank and Alexander. I saw all my wind-surfer friends at Paradise Surf. I hung out with all my Belgian friends who came to visit me there, but mostly I just enjoyed Knokke. Peaceful, beautiful and full of love. I really feel at home there.

I drove to Paris yesterday with Roger's daughter and checked into the Ritz. Kwong Chi is in the room next to mine. I called New York, Munich, Monte Carlo, Milano, etc. Yoko called. She's in Paris. I just ran into her a few minutes

ago at the gallery where she's in a Fluxus show. We'll have lunch tomorrow. I arrived in the gallery as the TV was interviewing her, so they got us to be on together.

Last night I went to dinner for Ludovic (new friend—my French Gil) for his birthday, with Claude Montana and a few friends. I saw Futura and CC at Bains Douches afterwards. Also I ran into L'Ren. Paris is fun and exciting as usual. Too much to do.

Every time I come to Europe I think I'm going to live forever. I'm across the street from George Condo's house 'cause I've got to go meet his assistant to help me make a big brush out of two smaller ones so I can paint the blimp with a 35-cm line. I saw the space where I'll paint it this morning, and now I know exactly what to paint. As soon as I saw the actual size of the painting and the scale and shape of it I knew immediately. I decided to paint it directly, instead of drawing a double line first, since it is smaller than I imagined it. It is about 11m × 32m. I can handle that. No problem. George is back now, so I'm going over there.

WEDNESDAY, JUNE 7

Yesterday I went to George's studio and as usual it was full of amazing new things. There is this one painting of a crucified Easter egg that is really incredible. I really want it. I've got to call Bruno Bischofberger (he owns it already) to try to buy it.

I had dinner with Alain and his 18-year-old gorgeous Icelandic boyfriend and François Bénichou and Kwong Chi.

Today was incredible. I had lunch with Yoko and Sam Havadtoy and then went shopping for a vase for her performance tonight. And I got a "litter box" to use as a paint holder for tomorrow. We went to see an incredible installation by Nam Jun Paik at the MoMA of Paris. It's amazing what images he gets out of a TV screen and the speed with

which they change. This is what television as an art form is all about. It was a real treat for my eyes and brain (working overtime) absorbing information at such high density and speed.

I returned to the hotel, went swimming and met Claude and Sydney Picasso at the Fluxus opening and waited to see Yoko. The press was really obnoxious so she was getting claustrophobic. We hung out backstage at the Beaux-Arts and waited for the performances to begin. At the last minute they needed a pianist to accompany Charlotte Moorman on the cello. This other guy and I played with her. The crowd was full of drunk art students and quite rude and obnoxious. It was a shame to see some great people like Allison Knowles get booed and heckled. It was a pretty ignorant audience. They took a break and cleared the room in the middle to calm people down. Yoko did two pieces. I assisted her in the piece where she breaks a vase (I held it under a shirt to keep the pieces from flying about), and invites people to each take a piece of it and all return in ten years to put it back together again.

The whole evening was pretty amazing—a lot of interesting conversations. It really made me rethink the stuff I was doing when I was involved in performance in New York in 1979–80. I was going to see all these people's works then and also doing some myself. Somehow I think the spirit of this work is still alive in my work. I really feel an affinity to this group almost as strongly as to the Burroughs/Ginsberg/poetry/writing group. It all overlaps and I certainly learned a lot of things from both of them. It was nice to rediscover it.

MONDAY, JUNE 12: LINATE AEROPORTO MILANO

I'm in Milan waiting for the connection to Pisa. We flew from Brussels today and had a two-hour visit in Milan. We saw Nicola and drove around a little.

Thursday and Friday in Paris was fun. Thursday I did the painting for the airship. After waiting for the paint to arrive (two hours late) I painted the whole thing in four and a half hours. My hand still hurts. I think it's one of the better paintings I ever made. The size of the brush (35 cm) made it an interesting challenge. It was physically difficult (holding the brush) but actually very, very easy to choreograph.

After the painting we returned to the hotel and I made phone calls for two hours.

Then we ate, I called George and Anna and then went out to this club Sardine. Lots and lots of cute boys. It looks exactly like New York, except the Puerto Ricans are Moroccan here. Good music, smoked and danced till late.

Friday I had a "press lunch" with the airship people (boring and trivial). Then went to Futura's exhibit and bought a nice new painting. Met David Galloway there. He came to Paris to interview me for the book Hans Mayer is doing on my sculptures. Went with David to see the airship painting again and do photos. We talked a lot and by the time we got to the hotel the conversation got deeper and continually off the "subject."

Did some photos for a German spaghetti book. (Portrait of me with a drawing I made out of spaghetti we ordered from room service.) I talked with David till it was time for dinner at Marcel Fleiss's house with Yoko and Sam. Nice quiet dinner and then returned to hotel with David to talk till 1:30.

I went out to Bobino. It was packed. I ran into Futura and CC. A few people wanted autographs and I met some fun people. Stayed out till 5:00 AM.

A car picked us up at noon to go to Knokke. Knokke was great as usual. Kwong Chi loved it. I saw my surfer buddies and relaxed a little. Sunday we went to Katia Perlstein's wedding. It was my first Jewish wedding. Tony was there. We talked a little. I had fun dancing with everyone.

I really love Knokke. It feels really clean and natural. I always eat well and feel really happy. In the morning the birds are always singing. Played with the dog on the trampoline. (He didn't like it very much.) Today we drove to Brussels with Sylvaine (Roger's daughter) and went to see her homeopathic doctor. He prescribed me a program of daily capsules. I'm anxious to see what happens. A lot of people have told me about homeopathic medicine and it's really frustrating watching the KS lesions accumulate with no visible results from the AZT. Maybe this will help. Something has to.

So, now we're in Milano. I'm getting restless and anxious to be in Pisa.

SUNDAY, JUNE 19, 1989

Pisa has been amazing. I don't know where to start. I realize now that this is one of the most important projects I've ever done. The wall is really part of the church. It's attached to the building the friars live in. I had dinner with the friars the other night and visited the chapel. All of the experiences around this painting (the assistants, the friars, the journalists and photographers, the groups of kids from Pisa) have been really positive. B-boys from Pisa, etc., etc. The people here are really nice, a little aggressive sometimes, but basically really sweet. Jan came from Amsterdam to help paint—Rolf and Franz (the animators) came from Zurich yesterday. The weather has been great and the food better. The painting took four days. At certain points there were huge crowds of people. I'm staying in a hotel directly across from the wall, so I see it before I sleep and when I wake. There is always someone looking at it (even at 4:00 AM last night). It's really interesting to see people's reaction to it.

I had music hooked up to a big speaker while I was painting. Every day was like a block party. One day (the last day

of painting) we had a DJ and a crowd dancing at the wall. Constant autographs and photographs. There are some of the most beautiful boys here I've ever seen in my life. We met a posse of military kids (parachute jumpers) who come every day and hang out. Kwong Chi has been taking tons of rolls of film.

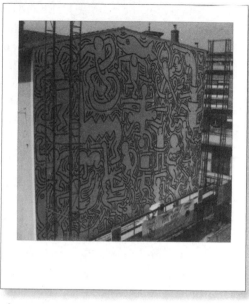

T-shirts, posters, postcards, and general hysteria. Barbara Leary is here, too.

Interviews constantly. I think I'm only happy when I'm surrounded by all this madness. I enjoy it, actually. It seems to bother me sometimes, but when it stops, I miss it. It takes a lot of patience, though.

This is really an accomplishment. It will be here for a very, very long time and the city really seems to love it. I'm sitting on a balcony looking at the top of the Leaning Tower. It's really pretty beautiful here. If there is a heaven, I hope this is what it's like.

THURSDAY, JUNE 22: PARIS (THE RITZ)

I'm in Paris and the blimp is not. I found out Tuesday night in Pisa (right before the inauguration of the wall) that the launch was canceled due to "political" maneuvering. It's complicated, but I'm hoping it will be resolved *before* I leave for the U.S. so we can do photos. I still haven't really seen it except for it being on the ground while I painted it.

Pisa was incredible. Debbie Arman came for the party on Monday night. As well as Julia and Tobias and David Neirings. Also, of course, Viken Arslanian and Jason from Antwerp.

The painting got finished on Saturday with five guys helping me to fill in the color. It was amazing. When we finished we would've been in the dark, but we were lit by movie lights and some others the city had installed to permanently light the mural. There was loud cheering, applause, and champagne as the final color was finished. The whole reception by the town was really overwhelming. The church, the neighbors, the B-boys, all the kids and supporters from all around Italy. It was really one of my best projects ever. We had one final dinner and then rushed to the train station with Roberto and Piergiorgio (who've been amazing through this whole thing) and the "parachuters" and David and Franz and Rolf. Emotional departures as the train pulled out of the station.

I woke up the next morning depressed to be arriving in France. Missing Italy already. But now it's O.K. Samantha [McEwen] is here. I'm working on lithos with Otto Hahn's wife, Nicole, in a great studio and I met with people about doing a watch. All my time is scheduled already. In fact, I'm going to be late for dinner now with Samantha and James Brown—gotta run . . .

JUNE 29: FLIGHT FROM ROME TO PARIS

Paris was great, but really busy. Did one interview for *Paris Match;* did some lithos on the stone at Bordas Studio in Bastille; went out Thursday, Friday and Saturday nights; met an acrobatic graffiti artist (very cute) who wants me to come see him perform in the park; painted two vases for Jean-Charles de Castelbajac at his house and spent time with his wife and kids who are quickly becoming friends; meetings about a watch project and a book project; walking through the

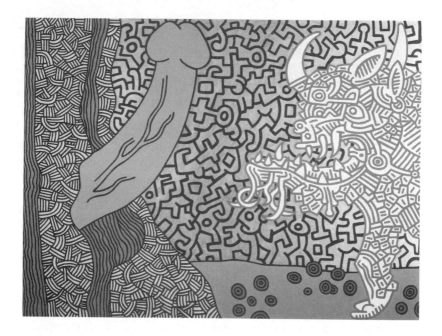

Tuileries at sunrise; confirmed with Bruno Bischofberger that I was buying the Condo painting of the crucified Easter egg; called many times to Nersi to confirm the arrival of the blimp (to no avail). Talked to Claude and Sydney Picasso, etc., etc., etc. Every time I'm in Paris it's almost as busy as New York. I should really have an apartment here.

On Saturday Gil arrived on the Concorde at 11:00 PM. We stayed out all night and slept for one hour before we were picked up to go to Knokke at 8:00 AM.

Kwong, Gil and I went to Knokke for the opening of George Segal's exhibition and the big party at the Nellens' house. We stayed in the Dragon. Jean Tinguely came. It was great as usual. Fun to be at the Nellens' house, always!

Monday morning we left for the airport in Brussels very late. Sylvaine drove us at 100 mph to the airport. We made the plane, but when we got to Roma, our luggage didn't. The hotel was depressing after the Ritz. I'm too spoiled now. We

couldn't find any other, though, and it actually turned out to be O.K.

We met Daniela and Piergiorgio from Pisa and Andrea from the video crew. Everything turned out better. I saw Stefania Casini; worked on incredible computer graphics (drawing on top of photos from Pisa); ate great food; went to see Stevie Wonder in Rome with VIP tickets and got to meet him backstage afterward. He said he had heard about my art. I gave him a T-shirt and some Free South Africa buttons. The concert was amazing. He played for three and a half hours. I cried. I always wanted to see him, and I didn't think I'd have to go to Rome to do it.

I worked on the computer all day yesterday. We went to see the Sistine Chapel (nearly restored) in the morning. It's pretty amazing. It's devastating to see the accumulation of wealth of the church and the power it represents. It never ceases to amaze me: the hypocrisy of the church, especially the Catholic Church. Most of this wealth was *stolen* in the name of God. The art is totally homoerotic. The whole church seems to be controlled by a very ancient and very omnipresent *gay* hierarchy. The choir in the Sistine Chapel used to consist of castrated 16- and 17-year-old boys who probably had many talents other than singing.

All the sculptures are about sexual beauty (asses, hands, feet, cocks) in a very *male* way.

Everyone knows, but everyone pretends not to see. Italians are obsessed with *cazzos*. There are dicks drawn everywhere as graffiti. I saw a beautiful drawing on the wall in Firenze with a huge dick and perfect head. It was really perfect—the curve of the head of the dick just where it meets the shaft. Whoever drew it obviously appreciates the beauty of a perfectly shaped cock head. I wish I had a camera with me.

It was great to be in this ancient city and be working with super-high technology on the computer graphics.

Every time I use a graphic paintbox, I rethink the whole

concept of an "image." The computer has totally changed the whole concept of what composes and defines a "picture space." The whole relation between the creator and the viewer has changed. The relationship between the physical gesture of drawing and the resultant image has changed. It is totally abstract now, with very little relation to the original "act" of drawing or painting. Images can be moved, stretched, multiplied, shrunk, enlarged, recolored, altered, rotated, flipped, digitized, edited, refined and obliterated in fractions of a second. The image has been reduced to electronic information (programmable) that is totally lucid and malleable.

Illusion is everything. This paintbox I was using in Rome could mix colors just like a palette as well as pick up colors from the photos and duplicate them. It was just like mixing paint, except no mess. It's only electrons and light.

I did some simple animations also. Really great. My style of drawing is very adaptable to this technology.

It's really primitive high-tech. It has totally revolutionized the notion of *art* and the image—why hasn't anyone noticed?

Last night we went to dinner with the video people and met Francis Ford Coppola at dinner. We exchanged drawings. He used some of my stuff as props in his last film. I gave the whole table buttons.

Later we went with Kwong Chi to do his night shots at the Colosseum. Gil and I hung out with some guys

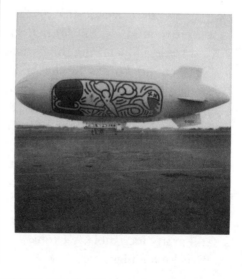

playing soccer and smoked hash with them. They were really crazy, but fun.

Now, we're on our way back to Paris for three days. The blimp is supposed to arrive tomorrow. I'll believe it when I see it . . .

TUESDAY, JULY 4: L.A. (BEL-AIR HOTEL)

Paris was fun. Immediately upon check-in the madness begins. Gloria TNT calls us. We have tea with her upstairs in her suite. She wants to commission a playground for Regensburg.

The next day I go to Galerie Beaubourg with Gil to discuss show of mural from New York (91st) FDR Drive Mural (1984), which has been "rescued" and shipped to Paris. It is in really bad shape, but somehow this makes it look even better.

Went to Beaubourg (Pompidou) to see Matisse drawing show. The original paper cut-outs for the "Jazz" series were there—really beautiful. Yesterday in a mall in Beverly Hills we saw sweaters knitted out of these designs. Funny.

Saw the "Magicians of the Earth" show (a pseudo-primitive/modern exposé) that had a few interesting things and some really boring things as well.

Went to Bordas Studio and finished drawing on litho stones and signed last week's prints.

By Saturday blimp has arrived in Calais (two hours north of Paris). Kwong and I drive up to do photos since I leave tomorrow and hadn't seen it yet. It was pretty incredible.

We went up in a small plane and took aerial photos (very scary). The blimp looks great except I keep thinking I would rather have painted the whole thing. The banner is just the wrong proportion to the shape and size of the blimp. But it's still pretty incredible. We took lots of photos and returned to Paris by midnight.

Saturday we went to Bobino. Fun. Nina Hagen was there, we hung out. She sang (rapped) to me for a long time. Gil got tired (who's 19? who's 31?), went home.

Sunday we flew on the Concorde to New York. I went to the studio to go through mail and then went to the movies to see [Spike Lee's] Do the Right Thing with Lysa and Liz and Juan.

I'm still really distressed about this movie. I don't know if it's going to be misunderstood by the very people it needs to reach the most. I'm going to see it again. It's filmed brilliantly, though, and pretty hysterical. Went to Jason and Liz's roof and drank Pimm's with fruit chunks and smoked pot (of course). Ate Colombian food and walked home. Ran into Rick and Loudie on the street. Walked around a little, loving New York again (except the smell) and went home.

Packed quickly Monday morning and got 10:15 MGM flight to L.A. Tony was on the same flight. Got car (red Jaguar convertible) and checked in Bel-Air. Call everyone I know in L.A. I want to talk to and leave messages on machines.

Sandra Bernhard invited us to dinner at her house. Madonna, Warren Beatty, Shaun (Sandra's girlfriend and writer for Flash Art) and some others. Fun dinner.

Today [July 4] is Gil's birthday. We're going to the beach and then to Dennis Hopper's house in Venice Beach for dinner (another newlywed) and then go to Warren Beatty's barbecue. L.A. L.A. L.A.

JULY 9, 1989: MGM GRAND TERMINAL

We're flying back to New York. This week we did lots of L.A. things:

Went to Venice Beach, went to Malibu, went to see Batman at Grauman's Chinese Theatre, went to see Do the Right Thing again, went to eat hot dogs at Pinks, went to lots of

L.A. clubs, saw Barbara and Tim Leary, went to see Pee Wee on the set in Culver City, went to Pee Wee's house in Hollywood Hills, etc., etc., etc.

The installation of the sculpture (which was supposed to be the reason for this whole trip) was a disaster. The helicopter couldn't hold the weight of the sculpture and dropped it almost immediately. It smashed a concrete wall and got seriously damaged (scratches, etc.).

Now it has to be put in with a crane. I don't know why this wasn't done in the first place. Someone had a brilliant idea that it would be easier with a helicopter . . . so much for that. Anyway, now it's being installed on Monday. I won't see it. I've got to get back to New York and get back to work and try to get my life together. Good luck.

I don't know if I'm looking forward to being in New York this summer or not. It's hot and disgusting and I can't even go to the pool. It could be interesting or it could be horrible.

I probably won't be there long, anyway . . . I should go to Santa Fe for the Burroughs/Haring exhibition of the Apocalypse prints and then to Europe in August. Oh well . . .

FRIDAY, SEPTEMBER 1, 1989: ROMA

I'm in the airport in Rome. I have an hour to kill and since I haven't been keeping a diary on this trip so far, I guess I might as well write a little bit now in this book I bought.

I've been in Europe for two weeks. I went to Switzerland first to be a judge on a jury for a comedy film festival. Grace Jones was also a judge, which made it bearable, but just barely.

She came with Angelo and Paolo (her son, who is now nine) and her nephew Petie (Pee-tee?), who is eleven years old and completely hysterical. I spent most of the week hanging out with the kids, which was fun. The films were all shit,

except the English one and the American one. The English one (*How to Get Ahead in Advertising*) was really great and the other (*Sidewalk Stories*) was good, too. It was shot in New York (a lot of it across from my apartment) and had my Free South Africa poster in one long scene. Both of these films won awards. I hung out with Pierre Keller and this French actress, Isabelle Pasco, most of the time. They were judges, too.

I saw Jean Tinguely in his new studio, and finally chose a great sculpture for our trade. It is really a good one and just in time for my new apartment.

The apartment, by the way, is well under way with Sam [Havadtoy] sending me fabric samples, Polaroids of my bed, marbleized molding samples, etc. It's actually amazing to me that it's happening.

After a week in Switzerland I went to Monte Carlo where I immediately painted a mural at Princess Grace Hospital. This was all prearranged and wonderfully organized with *major* press (*Time, People*, AP, Sygma, Gamma, etc.) and a luncheon with the princess (Caroline) and Helmut and June Newton and Josh Segal (son of Ali McGraw) at the Monte Carlo Beach Club and a dedication of the mural complete with "unveiling" and champagne and cakes, covered by local TV and Eurovision and major paparazzi. The whole thing went pretty smoothly. (And the mural looks great.)

Hanging out with Debra and Bea (the German nanny from two years before who shared an Ecstasy "experience" with Grace, Yves, Debra, and me).

I hate Debra when she gets drunk, and we had some unpleasant experiences, but every morning everything was O.K. Madison is so beautiful it's hard to believe. Constantly laughing and babbling on about nothing. She's really the reason I came anyway. This is sort of a continuation of my see-the-godchildren trip that started in the Hamptons with Zena Scharf, to Kutztown to baptize Kermit's baby, to big Haring

picnic at Aunt Sissy's house, to Monte Carlo to see Madison, and now off to Italy to see the Clemente kids.

I went to visit Carmel and Bruno Schmidt and Mattias (the new baby) and Samantha for one day also. That was really sweet and it really feels like my family (the original New York family).

I went with Bea to see the chapel Matisse designed in Vence. It was fucking incredible. Totally inspirational. Why haven't I painted on ceramic tiles yet? It's perfect for me. I think I'd really love to design a church even though I don't really feel too strongly about organized religion. Or rather, I do feel strongly about opposing *organized* religion. But I'd love to design a place for people to go and be quiet and reflect and think and feel totally comfortable—more like a shrine or a temple, I suppose. There's all this stuff I've been thinking about on this short trip that I really want to try to do.

I still *really* want to design a pair of sneakers. I have all these new painting ideas and sculpture ideas that I can't wait to start. I made drawings in Switzerland and Monte Carlo. That was great, but not enough. I really want to go back and try to heal myself by painting. I think I could actually do it.

I'm reading this book Swen Swenson gave me about healing yourself and love and medicine. I've been injecting myself with alpha interferon every day. That's pretty weird, but I've adjusted pretty easily. I hope it's helping. I'd really like to paint it away. It's hard to think of anything else every time I'm near a mirror.

We went on a yacht the other day with a man who owns the Ritz and Harrods of London (among other things). Can you imagine?

I think my plane might be landing now.

It wasn't.

There's a huge cockroach (water bug) crawling around in front of me. Everyone is just sort of "watching" it. There's a beautiful (of course) Italian boy sitting across from me watching with amusement, contemplating the fate of the . . . oops! . . . somebody stepped on it. They didn't even see it.

I was supposed to fly to Naples by helicopter (aren't I extravagant?) but the rain forced me to take a plane, or rather two planes, and now I'm in Rome waiting for my connecting flight to Napoli.

God, I love Italy. This is really one of my favorite places in the world. It just "feels" right here.

TUESDAY, SEPTEMBER 5: AMALFI

Italy is totally amazing. The entire time here has been like a dream. One event after another. Amalfi is really beautiful. Built in cliffs overlooking the clearest ocean I've ever seen. We went to Naples Saturday for a party at Philip Taaffe's villa. I've never seen anything like it: huge villa right on the ocean restored to its original state (with decay). Diego Cortez, Ricki Clifton (yecch!), Maximilian, etc., etc.

It was pretty amazing. Massimo is doing a film in Napoli and has been auditioning typical Neapolitan boys. He has an extensive Polaroid collection of every age boy (shirtless) available.

I had the best pizza I've ever eaten in my life with Francesco and Alba [Clemente].

In Amalfi before we went to Naples (the night before) we took a boat to Francesco's studio and saw the paintings he did here. Really sweet. The paint meshes with the surface

and just sits there like it grew there. It looks like skin. His friend and assistant Claudio (who restores old masterpieces) helped him create all kinds of paints and special surfaces. The paintings are really beautiful and the whole trip to get there and back on the little boat with Alba, Chiara, Nina and their cousin was equally enchanting.

I think riding on the front of this boat (lying down with Nina's head on my arm), with warm water splashing my hand, the cool ocean breeze and the landscape of the cliffs of Amalfi lit up like an opera set, was one of the most incredible moments of my life. This is why I want to be alive, for moments like this.

MONDAY, SEPTEMBER 19
..

6:00 AM: I arrive in Paris and have an hour wait to change for my plane to Milano. I sit across from the "collection box" I designed for the Paris airports. The piece is made well and looks great standing in the airport. The money is supposed to go to some French charity directed toward children. I notice several people stop and read the sign on the box, but I didn't see anyone put any change in it. Maybe it's too early in the morning for charity.

I take a plane to Milano. It is full of French businessmen. I don't think I'll ever get used to these people. They (businessmen) seem subhuman to me. I'm reading the chapter on Sun City, the retirement community, in *Cities on a Hill*. It's interesting to realize that old age is a relatively "new" phenomenon that my generation takes completely for granted. The generation of people growing old now is one of the first, ever. Due to advances in medicine, etc. The book is quoting average life spans in the 17th, 18th and 19th centuries, and all the time I'm reading this I keep thinking about dying. I mean, maybe it's not as "unfair" as I think.

Many people at many times only lived to 30 or 40. If I was born in another place or time, maybe I would have died at war or in another disaster. AIDS is the new plague. Why do I think I should be exempt? Why not me? There is an illusion of "safety" in the world I live in. Because of medicine, science and financial security, we tend to believe that we are "safe." But, as I must now realize, it is no more safe now than it was in the 17th century. Nothing lasts forever. And nobody can escape death.

WEDNESDAY, SEPTEMBER 21

I've debated for a while whether or not I should write about Gil in this diary. But since I don't feel guilty, and I don't want to hide anything since I'm not doing anything I think is wrong, why should I hide it? I love Juan very much and don't want to hurt him, but I hope that if he ever reads this he'll understand even more because I wrote and explained it. It's a little bit complicated, but to me it makes perfect sense. I love traveling with Juan, and I have several times in Europe, but our relationship has grown in different ways. And although it is better in many ways, I need to have a kind of input that only a fresh outlook can give me. I really want to have the experience of showing Gil Europe. I know it will be important for him and I think it's even important to me. A few weeks ago I was sure I was going to bring him, and then I changed and re-changed my mind several times at the last minute. I didn't want to jeopardize my relationship with Juan, and I know Juan well enough to know he could never understand or accept why I need to have this experience. So, it inevitably has to be done behind his back to avoid hurting him, unfortunately.

In light of the new information I received last week about my health, I know I owe it to myself to think for myself for a

change, and not only about everyone else. I know I will learn and enjoy traveling with Gil as much as he will with me. It's really not even about sex, although he's very beautiful. It's much more about intellectual companionship. I'm sure that there is a very good chance we won't have sex ever. All of the indications say no. But I really enjoy being his friend and sharing and caring like a big brother more than a lover. It's impossible to have that kind of experience with Juan, because he is my lover. I've always had friends like this and I hope I always will. But this morning on the way to the airport I am feeling really guilty and missing Juan a lot. I arrive at the airport and have to wait two hours for Gil to land (TWA is late, of course). I call Juan from the airport and he is just getting home from Trax (4:00 AM) and has Johnny with him. We talk and I feel better because I miss him and he misses me. I also felt jealous of Johnny so I don't feel as guilty. I am starting to think I made a big mistake. However, when Gil arrives I think maybe I'll get over it.

We go to Milano, and go directly to the hotel and then to Al Grissini for lunch. Walk around Milan, to the cathedral, which provoked a conversation about the power and misuse of power of the Catholic Church and misdirected influence of religion.

We return to the hotel to call Nicola and meet him and Marco to go to the opening of the Triennale. It was supposed to be about the "modern city" or the future metropolis.

I visited the Miami exhibition, which looked great, except my "dog maze" should have been drawn on the wall. I mentioned it to Germano Celant, offering to do it tomorrow (my last day in Milano). As I expected, he made it sound *very* difficult.

We go to dinner and see people I met before in Milano. Gil is tired, so we drop him off at the hotel and go for a drink at a Mexican restaurant. Then we go to Plastico, where I hang out with Peter Kea and other people I know from dif-

ferent parts of the world and (even though I am tired from last night) end up staying out till 3:30.

THURSDAY, SEPTEMBER 22
...

Walk around Milano, shopping (sort of) and talking. A call comes from Roberto in Pisa to assure me they are ready for my arrival in Pisa.

NOTE:

I can see that I'm never going to catch up to my day-by-day account, so I just take notes, hoping that I'll sometime go back and read the notes and be able to talk about and remember it.

Some highlights: Pisa

It seemed incredible that all because of some people I met in the street in New York, this whole big exhibition is being organized. They are seriously interested and offering me both a wall for a mural or fresco and an exhibition in a 1,000-year-old building. The exhibition could be incredible since it will force me to place my art in a variety of historical contexts and contrasts. The restored building has different levels of history revealed in different parts and a well-curated and impeccably hung show would really enhance both the building and the art. Pisa itself is really beautiful, too. The tower is remarkable. We saw it in daylight and then in the light of the full moon. It is really major and also hysterical. Every time you look at it, it makes you smile.

Keith Haring died on February 16, 1990.

1989

Solo Exhibitions

Gallery 121, Antwerp, Belgium
Casa Sin Nombre, Santa Fe, New Mexico, with William Burroughs
Fay Gold Gallery, Atlanta, Georgia, with Herb Ritts
Galerie Hete Hünermann, Düsseldorf, Germany

Group Exhibition

Exposition Inaugurale, Fondation Daniel Templon, Frejus, France

Special Projects

Paint mural in Barrio de Chino, *Together We Can Stop AIDS,* Barcelona, Spain

Design invitations and plates for Gloria von Thurn und Taxis's birthday celebration, Regensburg, Germany

Design mural to be executed by students at Wells Community Academy, Chicago, Illinois

Artist-in-residence for Chicago Public Schools and Museum of Contemporary Art mural project: painted 520-foot mural with 300 high-school students, Chicago, Illinois

Painted two murals at Rush Presbyterian—St. Luke's Medical Center, Chicago, Illinois

Design logo and T-shirts for *Young Scientists Day* at Mt. Sinai School of Medicine, New York City

Artist-in-residence and mural project, Ernest Horn Elementary School, Iowa City, Iowa

Paint mural at The Center, a lesbian and gay community services center, New York City

Keith Haring Progetto Italia. Commissioned by the City of Pisa to paint permanent mural on exterior wall of Sant'Antonio church

Painted banner for airship intended to be flown over Paris as part of *Galerie Celeste,* a project with Soviet painter Eric Bulatov commemorating the bicentennial of the French Revolution. Complications eventually prevented the launch of the airship.

Book

Eight Ball. Keith Haring (Kyoto Shoin, Tokyo, Japan)

THE KEITH HARING FOUNDATION

Keith Haring (1958–1990) generously contributed his talents and resources to numerous causes. He conducted art workshops with children; created logos and posters for public service agencies; and produced murals, sculptures, and paintings to benefit health centers and disadvantaged communities. In 1989, Keith established a foundation to ensure that his philanthropic legacy would continue indefinitely.

The Keith Haring Foundation makes grants to not-for-profit groups that engage in charitable and educational activities. In accordance with Keith's wishes, the Foundation concentrates its giving in two areas: the support of organizations that provide educational opportunities to underprivileged children and the support of organizations that engage in research and care with respect to AIDS and HIV infection.

Keith Haring additionally charged the Foundation with maintaining and protecting his artistic legacy after his death. The Foundation maintains a collection of art along with archives that facilitate historical research about the artist and the times and places in which he lived and worked. The Foundation supports arts and educational institutions by funding exhibitions, educational programs, acquisitions, and publications that serve to contextualize and illuminate the artist's work and philosophy.

1990

Selected Solo Exhibitions

Tony Shafrazi Gallery, New York City
Keith Haring: Future Primeval, Queens Museum of Art, New York
Tony Shafrazi Gallery, New York City, with Jean-Michel Basquiat

Selected Group Exhibitions

Divergent Style: Contemporary American Drawing, University College of
 Fine Arts, University of Florida, Miami, Florida
*Cornell Collects: A Celebration of American Art from the Collection of
 Alumni and Friends*, Herbert F. Johnson Museum of Art, Cornell
 University, Ithaca, New York

Selected Books & Catalogues

Keith Haring: A Memorial Exhibition. Introduction: Tony Shafrazi (Tony
 Shafrazi Gallery, New York City)
Future Primeval. Barry Blinderman and others (University of Illinois,
 Normal)
Against All Odds. Text and drawings: Keith Haring (Bébert Publishing,
 Rotterdam, Holland, and Mr. and Mrs. Donald Rubell, New York City)
K. Haring. Introduction: Sam Havadtoy (Gallery 56, Geneva, Switzerland)

1991

Selected Solo Exhibitions

Hete Hünermann Gallery, Düsseldorf, Germany

Keith Haring: Future Primeval, University Galleries, Normal, Illinois;
Tampa Museum of Art, Tampa, Florida

Museum of Modern Art, Ostend, Belgium

Haring, Disney, Warhol, Phoenix Art Museum, Phoenix, Arizona; Tacoma
Art Museum, Tacoma, Washington; The Corcoran Gallery of Art,
Washington, D.C.; Worcester Art Museum, Worcester, Massachusetts

Selected Group Exhibitions

Myth and Magic in America: The 80s, Museo de Arte Contemporaneo de
Monterrey, Monterrey, Mexico

Les Couleurs de l'Argent, Musée de la Poste, Paris, France

Biennial, Whitney Museum of American Art, New York City

*Compassion and Protest: Recent Social and Political Art from the Eli Broad
Family Foundation Collection*, San Jose Museum of Art, San Jose,
California

Devil on the Stairs: Looking Back on the Eighties, Institute of Contemporary
Art, Philadelphia, Pennsylvania

Echt Falsch, Fondation Cartier, France

Selected Books & Catalogues

Keith Haring: The Authorized Biography. John Gruen (Simon & Schuster,
New York City)

1992

Selected Solo Exhibitions

Tony Shafrazi Gallery, New York City

Selected Group Exhibitions

Allegories of Modernism, Museum of Modern Art, New York City

The Power of the City / The City of Power, Whitney Museum of American Art, Downtown Branch, New York City

From Media to Metaphor: Art About AIDS, Emerson Gallery, Hamilton College, Clinton, New York; Center of Contemporary Art, Seattle, Washington; Sharadin Art Gallery, Kutztown University, Kutztown, Pennsylvania; Musée d'Art Contemporain de Montreal, Montreal, Canada; Grey Art Gallery and Study Center, New York University, New York City

Selected Books & Catalogues

Keith Haring. Barry Blindermann, William S. Burroughs: Reprint of *Future Primeval* exhibition catalog (Abbeville Press, New York City)

Keith Haring, Andy Warhol, Walt Disney. Bruce Kurtz (Phoenix Museum of Art, Phoenix, Arizona)

Keith Haring. Germano Celant (Prestel Verlag, Munich, Germany)

1993

Selected Solo Exhibitions

...

Queens Museum of Art, New York
DIA Art Foundation, Bridgehampton, New York
Keith Haring: A Retrospective, Mitsukoshi Museum of Art, Tokyo, Japan

Selected Group Exhibitions

...

Socrates Sculpture Park, Long Island City, New York
Coming from the Subway: New York Graffiti Art, Groninger Museum, Groningen, Holland
American Art in the Twentieth Century: Painting and Sculpture, Martin Gropius Bau, Berlin, Germany; Royal Academy, London, U.K.
Art Against AIDS, Peggy Guggenheim Museum, Venice, Italy: Guggenheim Museum, SoHo, New York
Extravagance, Tony Shafrazi Gallery, New York City; Russian Cultural Center, Berlin, Germany

Selected Books & Catalogues

...

Keith Haring: A Retrospective. Germano Celant (Mitsukoshi Museum of Art, Tokyo, Japan)
Apocalypse. Keith Haring and William Burroughs (Le Dernier Terrain Vague, Paris, France)
Keith Haring, Complete Editions on Paper, 1982–1990. Klaus Littmann and Werner Jehle (Cantz Publishing, Stuttgart, Germany)

1994

Selected Solo Exhibitions

Keith Haring Retrospective, Castello di Rivoli, Turin, Italy; Malmö
 Konsthall, Malmö, Sweden; Deichtorhallen, Hamburg, Germany;
 Tel Aviv Museum, Tel Aviv, Israel
Tony Shafrazi Gallery, New York City

Selected Group Exhibitions

Outside the Frame, Cleveland Center for Contemporary Art, Cleveland,
 Ohio
Power Works from the MCA Collection, Museum of New Zealand
Art's Lament: Creativity in the Face of Death, Isabella Stewart Gardner
 Museum, Boston, Massachusetts
New York Realism Past and Present, Tampa Museum of Art, Tampa,
 Florida, and Japan tour
Art in the Age of AIDS, National Gallery of Australia
Significant Losses, University of Maryland Art Gallery, College Park,
 Maryland

Selected Books & Catalogues

Keith Haring. Germano Celant (Exhibition catalogue—Italian, Swedish,
 German, Hebrew/English, and Spanish editions. Charta Publishing,
 Milan, Italy)

1995

Selected Solo Exhibitions

Keith Haring Retrospective, Fundacion La Caixa, Madrid, Spain; Kunsthaus
 Wien, Vienna, Austria
Keith Haring: Works on Paper 1989, Andre Emmerich Gallery, New
 York City
Hans Mayer Gallery, Düsseldorf, Germany

Selected Group Exhibitions

Matrix is 20!, Wadsworth Atheneum, Hartford, Connecticut
A New York Time: Selected Drawings of the 80s, Bruce Museum,
 Greenwich, Connecticut
Recent 20th-Century Acquisitions, The Bass Museum of Art, Miami, Florida
Americans in Venice: The Biennale Legacy, Arizona State University Art
 Museum, Nelson Fine Arts Center, Tempe, Arizona
Unser Jahrhundert: Menschenbilder-Bilderwelten, Museum Ludwig,
 Cologne, Germany
Temporarily Possessed: The Semi-Permanent Collection, The New Museum
 of Contemporary Art, New York City

Selected Books & Catalogues

Keith Haring: Works on Paper 1989. Essay by Alexandra Anderson-Spivy
 (Exhibition catalogue, Andre Emmerich Gallery. Published by the Estate
 of Keith Haring, New York City)
Keith Haring. Germano Celant (Exhibition catalogue—English edition,
 Charta Publishing, Milan, Italy)

1996

Selected Solo Exhibitions

Andre Emmerich Gallery, New York City
The Ten Commandments, Bruderkirche and Museum Fridericianum, Kassel,
 Germany
Keith Haring Retrospective, Museum of Contemporary Art, Sydney,
 Australia

Selected Group Exhibitions

Private Passions, Musée d'Art Moderne de la Ville de Paris, France
Thinking Print: Books to Billboards, 1980–95, Museum of Modern Art,
 New York City
Ports of Entry: William S. Burroughs and the Arts, Los Angeles County
 Museum of Art

Selected Books & Catalogues

Keith Haring Journals. Preface by David Hockney. Introduction by Robert
 Farris Thompson (Viking Penguin, New York City)
Keith Haring: The Ten Commandments. Introduction by Tilman Osterwold
 and various authors (Exhibition catalogue, Museum Fridericianum,
 Kassel, Germany)

1997

Selected Solo Exhibitions

Keith Haring: A Retrospective, Whitney Museum of American Art, New
York City; Art Gallery of Ontario, Toronto, Canada
Keith Haring on Park Avenue, Installation of thirteen sculptures on the Park
Avenue Malls between Fifty-third and Seventy-fourth streets, sponsored
by the Public Art Fund, New York City
Andre Emmerich Gallery, New York City
Tony Shafrazi Gallery, New York City

Selected Group Exhibitions

End of the Century: Prints since 1970 from the Collection, Los Angeles
County Museum of Art
*Multiple Identity: Amerikanische Kunst 1975–1995 Aus Dem Whitney
Museum of American Art*, Kunstmuseum, Bonn, Germany
Goodbye to Berlin? 100 Jahre Schwulenbewegung, Schwules Museum-
Akademie der Kunste, Berlin, Germany

Selected Books & Catalogues

Keith Haring. Foreword by David A. Ross. Essays by Elisabeth Sussman,
David Frankel, Jeffrey Deitch, Ann Magnuson, Robert Farris Thompson,
Robert Pincus Witten (Exhibition catalogue, Whitney Museum of
American Art, New York, New York, and Little, Brown & Co., Boston,
Massachusetts)
Keith Haring Journals. (Paperback edition). Preface by David Hockney.
Introduction by Robert Farris Thompson (Penguin, New York City)

Keith Haring: I Wish I Didn't Have to Sleep. (Adventures in Art series).
 Desiree la Valette (Prestel Verlag, Munich, Germany)
Keith Haring, Jean-Michel Basquiat, Kenny Scharf: In Your Face. Essay by
 Richard Marshall (Malca Fine Art, New York City)
Keith Haring on Park Avenue. Introduction by Tom Eccles and Susan
 Freedman. Essay by David Galloway (Andre Emmerich Gallery, New
 York City)

1998

Selected Solo Exhibitions

Keith Haring: A Retrospective, Museum of Contemporary Art, Miami, Florida; San Francisco Museum of Modern Art, California; Musée des Beaux-Arts, Montreal, Canada

Keith Haring in San Francisco, Installation of ten sculptures in San Francisco, sponsored by the San Francisco Art Commission

Keith Haring in West Hollywood, Installation of ten sculptures along the Santa Monica Boulevard median, sponsored by the City of West Hollywood

Selected Group Exhibitions

The Prophecy of Pop, Contemporary Arts Center, New Orleans, Louisiana

Concept/Image/Object, Art Institute of Chicago, Illinois

Art Performs Life, Walker Art Center, Minneapolis, Minnesota

Selected Books & Catalogues

BIG (Hyperion Books for Children, New York City)

TEN (Hyperion Books for Children, New York City)

1999

Selected Solo Exhibitions

Keith Haring Sculptures, Pacific Design Center, Los Angeles, California
Keith Haring: A Retrospective, City Gallery, Wellington, New Zealand
Keith Haring Sculptures, Museum of Science and Industry, Chicago
Galerie Jérôme de Noirmont, Paris, France
Keith Haring: Made in France, Musée Maillol, Paris, France
Casino Knokke, Knokke-Heist, Belgium
Deitch Projects, New York City
Palazzo Lanfranchi, Pisa, Italy

Selected Group Exhibitions

Auffrischender Wind aus wechselnden Richtungen, Museum der
 Kunstsammlungen zu Weimar, Germany
The Virginia and Bagley Wright Collection, Seattle Art Museum,
 Washington
Les Champs de la Sculpture 2000, Avenue des Champs-Élysées, Paris,
 France
The American Century: Art and Culture 1900–2000, Whitney Museum of
 American Art, New York City
Rock Style, Costume Institute, Metropolitan Museum of Art, New
 York City

Selected Books & Catalogues

Keith Haring (Exhibition catalogue, Art Life Ltd., Tokyo, Japan)
LOVE (Bulfinch Press, New York City)

DANCE (Bulfinch Press, New York City)

Keith Haring (Exhibition catalogue, Peter Gwyther Gallery, London, U.K.)

Keith Haring—12 Sculptures (Exhibition catalogue, Galerie Jérôme de Noirmont, Paris, France)

Keith Haring: Made in France (Exhibition catalogue, Musée Maillol, Paris, France)

Souvenir of Keith Haring (Exhibition catalogue, Casino Knokke, Belgium)

Keith Haring (Exhibition catalogue, Palazzo Lanfranchi, Pisa, Italy. Electa Milano)

2000

Selected Selected Solo Exhibitions

Keith Haring: The SVA Years, School of Visual Arts, New York City
Keith Haring: Sculptures on the Kurfürstendamm, Berlin, Germany
Ludwig Forum für Internationale Kunst, Aachen, Germany
Paradise Garage, Deitch Projects, New York City
Chiostro del Bramante, Rome, Italy

Selected Group Exhibitions

Den Haag Sculptuur 2000, Lange Voorhout, The Hague, Holland
Rock Style, Rock and Roll Hall of Fame, Cleveland, Ohio; Barbican Gallery,
 London, U.K.
DIRE AIDS: Art in the Age of AIDS, Castello di Rivoli, Torino, Italy
Around 1984: A Look at Art in the Eighties, P.S. 1 Museum, Long Island
 City, New York
Art at Work: 40 Years of the Chase Manhattan Collection, Queens Museum
 of Art, New York

Selected Books & Catalogues

Keith Haring (Exhibition catalogue, Isetan Museum, Tokyo, Japan)
Keith Haring (Exhibition catalogue, Amos Anderson Museum, Helsinki,
 Finland)
Keith Haring: The SVA Years 1978–1980 (Exhibition catalogue, School of
 Visual Arts, New York City)
BABIES (Bulfinch Press, New York City)
DOGS. (Bulfinch Press, New York City)

Keith Haring (Exhibition catalogue, Ludwig Forum, Aachen, Germany. Electa Milano)

Keith Haring (Exhibition catalogue, Chiostro del Bramante, Rome. Electa Milano)

Keith Haring. Art e Dossier. Renato Barilli (Giunti, Florence, Italy)

2001

Selected Solo Exhibitions

Keith Haring Sculptures, Rome, Italy
Skarstedt Fine Art, New York City
The 10 Commandments, Wapping Power Station, London, U.K.
Keith Haring: Heaven and Hell, Museum für Neue Kunst/ZKM, Karlsruhe,
Germany

Selected Group Exhibitions

Mythic Proportions: Painting in the 1980s, Museum of Contemporary Art,
Miami, Florida
Aperto 2001, 4th International Sculpture Installation, Biennale di Venezia,
Italy
Jasper Johns to Jeff Koons: Four Decades of Art from the Broad Collections,
Los Angeles County Museum of Art, California (and tour: Corcoran
Gallery of Art, Washington, D.C.; Museum of Fine Arts, Boston,
Massachusetts)
One Planet Under A Groove: Hip Hop and Contemporary Art, Bronx
Museum of the Arts, New York
Tele[visions], Kunsthalle Wien, Austria

Selected Books & Catalogues

Keith Haring Diarios (Galaxia Gutenberg, Barcelona, Spain)
Keith Haring Diari (Mondadori Editore, Milan, Italy)
Keith Haring: Heaven and Hell (Exhibition catalogue, Museum für Neue
Kunst, Karlsruhe, Germany. Cantz, Stuttgart, Germany)

2002

Selected Solo Exhibitions

Neue Galerie der Stadt Linz, Austria
Keith Haring: Heaven and Hell, Museum Boijmans van Beuningen,
 Rotterdam, Holland
The Sex Show, Galerie Jérôme de Noirmont, Paris, France

Selected Group Exhibitions

La Parade des Animaux, Monte Carlo Casino Gardens, Monaco
PopJock: Warhol–Murakami, Museum of Contemporary Art, Denver,
 Colorado

Selected Books & Catalogues

Keith Haring: Heaven and Hell (English edition. Exhibition catalogue,
 Museum für Neue Kunst, Karlsruhe, Germany. Cantz, Stuttgart,
 Germany)
Keith Haring: Short Messages; Posters 1982–1990 (Prestel Verlag, Munich,
 Germany)

2003

Selected Solo Exhibitions

Pop Figuration, Deitch Projects, New York City
Tony Shafrazi Gallery, New York City
Four Sculptures, American Academy, Rome, Italy
Two Sculptures, Parco della Musica, Rome, Italy
Keith Haring, Centro Cultural Banco do Brasil, São Paulo; CCBB, Brasília,
 Brazil

Selected Group Exhibitions

Parthenogenesis, Museum of Contemporary Art, Sydney, Australia
Splat Boom Pow! The Influence of Cartoons in Contemporary Art,
 Contemporary Arts Museum, Houston, Texas; Institute of Contemporary
 Art, Boston, Massachusetts
From Picasso to Keith Haring, National Museum of Fine Arts, Havana, Cuba
The Daimler Chrysler Collection, Museum für Neue Kunst/ZKM, Karlsruhe,
 Germany
Crimes and Misdemeanors: Politics in U.S. Art of the 1980s, Contemporary
 Arts Center, Cincinnati, Ohio
Beautiful Losers, Yerba Buena Center for the Arts, San Francisco, California;
 Contemporary Arts Center, Cinicinnati, Ohio; Orange County Museum
 of Art, Newport Beach, California (through 2005)

Selected Books & Catalogues

Keith Haring in Pisa: Chronicle of a Mural. Texts by Omar Calabrese,
Roberta Cecchi, Piergiorgio Castellani; photography by Antonio Bardelli,
Cippi Pitschen (Edizioni ETS, Pisa, Italy)

Keith Haring. Text by Joshua Decter (Exhibition catalogue, Centro Cultural
de Banco do Brasil, São Paulo)

2004

Selected Solo Exhibitions

Keith Haring, Centro Cultural Banco do Brasil, Rio de Janeiro, Brazil; Culturgest, Lisbon, Portugal; Galerie im alten Rathaus, Prien am Chiemsee, Germany

Keith Haring: New Wave Aztec, Sackler Center for Arts Education, Solomon R. Guggenheim Museum, New York

Selected Group Exhibitions

American Art of the 1980s: Selections from the Broad Collections, Washington University Gallery of Art, St. Louis, Missouri

Moi! Self-Portraits of the 20th Century, Musée du Luxembourg, Paris, France; Galleria degli Uffizi, Florence, Italy

Gyroscope, Hirshhorn Museum and Sculpture Garden, Washington, D.C.

Beauty and the Beast: The Magic of the Instinctual in Art, Museum of Modern and Contemporary Art, Rovereto, Italy

A Collection's Vision, Museum der Moderne Salzburg, Austria

East Village USA, New Museum of Contemporary Art, New York City

Selected Books & Catalogues

Keith Haring. Alexandra Kolossa (Taschen, Cologne, Germany)

2005

Selected Solo Exhibitions

Keith Haring Sculptures, Deitch Projects, New York City
Galleria Salvatore Ala, Milan, Italy
Keith Haring: Urban Memory, Fundación ICO, Madrid, Spain
Five Keith Haring Sculptures, Somerset House, London, U.K.
Ben Brown Gallery, London, U.K.
Three Keith Haring Sculptures, Lever House, New York City
L'Art a la Plage #4: Keith Haring, St. Tropez, France
The Keith Haring Show, La Triennale di Milano, Milan, Italy
Tony Shafrazi Gallery, New York City
Keith Haring: Against All Odds, Rubell Family Collection, Miami, Florida

Selected Group Exhibitions

20th Anniversary Exhibition, Haggerty Museum, Marquette University,
 Milwaukee, Wisconsin
Beautiful Losers, Orange County Museum of Art, Newport Beach,
 California
Daumen Kino: The Flip Book Show, Kunsthalle Düsseldorf, Germany
Perfect Painting: 40 Years, Galerie Hans Mayer, Langen Foundation,
 Düsseldorf, Germany
Picturing America: Selections from the Whitney Museum of American Art,
 Nagasaki Prefectural Museum, Japan; Fuchu City Museum, Japan; 21
 Century Museum of Contemporary Art, Japan; Katakyushu Municipal
 Museum of Art, Japan; Koriyama City Museum, Japan
Drawings from the Modern, 1975–2005, Museum of Modern Art, New
 York City

Dance of the Avant-Garde: Paintings, Sets, and Costumes from Degas to Picasso, from Matisse to Keith Haring, MART, Rovereto, Italy

Selected Books & Catalogues

On the Fence: Keith Haring's Mural for the Haggerty, 1983. Curtis L. Carter (Exhibition catalogue, Haggerty Museum of Art, Marquette University, Marquette, Wisconsin)

Keith Haring: Memoria Urbana (Exhibition catalogue, Fundación ICO, Madrid, Spain)

Keith Haring Sculptures. David Galloway (Deitch Projects, New York, and Galerie Jérôme de Noirmont, Paris, France)

L'Art a la Plage #4: Keith Haring. David Galloway, et al. (Exhibition catalogue, Galerie Enrico Navarra, Paris, France)

Keith Haring. David Galloway (Ben Brown Fine Arts, London, U.K.)

The Keith Haring Show. Various authors (Exhibition catalogue, Skira Editore, Milan, Italy)

Keith Haring a Milano. Alessandra Galasso (Johan & Levi, Milan, Italy)

Keith Haring Coloring Book Drawings. David Shapiro (Exhibition catalogue, Briggs Robinson Gallery, New York, New York)

Dance of the Avant-Garde: Paintings, Sets, and Costumes from Degas to Picasso, from Matisse to Keith Haring. Various authors (Exhibition catalogue, Skira Editore, Milan, Italy)

2006

2007

Selected Solo Exhibitions

Keith Haring: Editions on Paper, Egon Schiele Centrum, Cesky Krumlov, Czech Republic
Keith Haring: Life as a Line, Ludwigmuseum, Koblenz, Germany

Selected Group Exhibitions

Art in America: 300 Years of Innovation, National Art Museum of China, Beijing; Museum of Contemporary Art, Shanghai; Guggenheim Museum, Bilbao, Spain
Personal Jesus: The Religious Art of Keith Haring and Andy Warhol, The Andy Warhol Museum, Pittsburgh, Pennsylvania
War and Discontent, Museum of Fine Arts, Boston, Massachusetts
Panic Attack! Art in the Punk Years, Barbican Art Gallery, London, U.K.

Selected Books & Catalogues

Keith Haring. Various authors (Exhibition catalogue, Fondation L'Independence, Luxembourg; JGM Galerie—Monumental Art Project, Paris, France; Galerie Enrico Navarra, Paris, France)
Keith Haring Graphics. Various authors (Exhibition catalogue, Egon Schiele Centrum, Cesky Krumlov, Czech Republic)
Keith Haring: Il Murale di Milwaukee. Curtis L. Carter, Enrico Mascelloni (Skira Editore, Milan, Italy)
Keith Haring: The Authorized Biography. John Gruen (Baldini Castoldi Dalai Editore, Milan, Italy)

Il Grande Libro delle Piccole Cose (Nina's Book of Little Things). Keith Haring (Mondadori, Milan, Italy)

Keith Haring: Life as a Line. Various authors (Exhibition catalogue, Ludwigmuseum Koblenz. Prestel Verlag, Germany)

2008

Keith Haring Retrospective, Museum of Contemporary Art, Lyon, France

Keith Haring Houston Street and Bowery Mural Recreation, Deitch Projects, New York City

Keith Haring, Skarstedt Gallery, New York City

Keith Haring, Ludwigmuseum, Budapest, Hungary

The Ten Commandments, Deitch Studios, Long Island City, New York

Against All Odds: Keith Haring in the Rubell Family Collection, Palm Springs Art Museum, Palm Springs, California

Two Sculptures, UNAIDS World Headquarters, Geneva, Switzerland

Selected Group Exhibitions

Artists Intervene—Politically Committed Poster Art from Picasso to the Present Day, Käthe Kollwitz Museum, Cologne, Germany

Now's the Time, Dublin City Gallery/The Hugh Lane, Dublin, Ireland

Major Americans, Kunsthalle Weishaupt, Ulm, Germany

Selected Books & Catalogues

Keith Haring. Various authors (Exhibition catalogue, Museum of Contemporary Art, Lyon, France. Skira-Flammarion, Milan, Italy)

Keith Haring. Guillaume Morel (Special exhibition supplement, Museum of Contemporary Art, Lyon, France. Connaissance des Arts, Paris, France)

Keith Haring. Elisabeth Sussman (Exhibition catalogue, Skarstedt Gallery, New York City)

Keith Haring: Houston & Bowery Mural. Text by Keith Haring; photos by
 Tseng Kwong Chi (Deitch Projects and Goldman Properties, New
 York City)

Keith Haring. Jeffrey Deitch, Suzanne Geiss, Julia Gruen (Rizzoli, New
 York City)

Against All Odds: Keith Haring in the Rubell Family Collection. Mark
 Coetzee (Exhibition catalogue, Palm Springs Art Museum, California
 and the Rubell Family Collection, Miami, Florida)

2009

SELECTED PUBLIC COLLECTIONS

Museum of Contemporary Art, Los Angeles, California
Los Angeles County Museum of Art, California
Broad Family Foundation, Los Angeles, California
Museum of Contemporary Art, San Diego, California
Grace Cathedral, San Francisco, California
The Denver Art Museum, Colorado
The Bruce Museum, Greenwich, Connecticut
Rubell Family Collection, Miami, Florida
The Bass Museum of Art, Miami, Florida
Norton Museum of Art, West Palm Beach, Florida
Tampa Museum of Art, Florida
Art Institute of Chicago, Illinois
University of Michigan Museum of Art, Ann Arbor, Michigan
Gateway Foundation, Citygarden, St. Louis, Missouri
The Museum of Modern Art, New York City
The Whitney Museum of American Art, New York City
Cathedral of St. John the Divine, New York City
Emily Fisher Landau Foundation, New York City
Chase Manhattan Bank Collection, New York City
Taft Museum of Art, Columbus, Ohio
The John and Mildred Putnam Sculpture Collection, Case
 Western University, Cleveland, Ohio
Carnegie Museum of Art, Pittsburgh, Pennsylvania
The Andy Warhol Museum, Pittsburgh, Pennsylvania
Haggerty Museum, Marquette University, Milwaukee, Wisconsin
Museum of Contemporary Art, Sydney, Australia
Albertina Collection, Vienna, Austria
Museum der Moderne Salzburg, Austria

Neue Galerie der Stadt Linz, Austria
Museum of Modern Art, Rio de Janeiro, Brazil
Art Gallery of Ontario, Toronto, Ontario, Canada
National Gallery of Canada, Ottawa, Ontario, Canada
Centre Georges Pompidou, Paris, France
Musée d'Art Moderne et Contemporain, Nice, France
Musée d'Art Moderne de la Ville de Paris, France
CAPC Musée d'Art Contemporain, Bordeaux, France
Église St. Eustache, Paris, France
Museum Ludwig, Cologne, Germany
Marx Collection, Berlin, Germany
ZKM/Museum für Neue Kunst, Karlsruhe, Germany
Kunsthalle Weishaupt, Ulm, Germany
Neues Museum Weimar, Germany
Stedelijk Museum, Amsterdam, Holland
Groninger Museum, Groningen, Holland
Museum Boijmans van Beuningen, Rotterdam, Holland
Ludwig Collection, Budapest, Hungary
Museum of Contemporary Art, Jerusalem, Israel
Museum of the American Friends of Israel, Jerusalem, Israel
François Pinault Collection, Palazzo Grassi, Venice, Italy
Museum of Contemporary Art, Hiroshima, Japan
Hiroshima City Museum of Contemporary Art, Japan
The Museum of Art, Kochi, Japan
Benesse House, Naoshima, Japan
Nakamura Keith Haring Collection, Kobuchizawa, Japan
Rooseum, Malmo, Sweden
Museum of Modern and Contemporary Art, Geneva,
 Switzerland
HausBill, Zumikon, Switzerland
Fondation Edelman, Lausanne, Switzerland

LIST OF ILLUSTRATIONS

frontispiece: Self-portrait, New York City, 1980.

NOTES TO THE INTRODUCTION

1. Robert Hunter, *A Box of Rain* (New York: Penguin, 1990), p. 28.
2. David Sheff, "Keith Haring," *Rolling Stone* (August 10, 1989), p. 59.
3. Interview with Erwin Gruber in Düsseldorf, late November 1994.
4. Marguerite Yourcenar, *That Mighty Sculptor: Time* (New York: Farrar Straus & Giroux, 1992), p. 39.
5. Andy Warhol, *The Andy Warhol Diaries*, ed. Pat Hackett (New York: Warner, 1989).
6. Jonathan Fineberg, *Art Since 1940: Strategies of Being* (New York: Prentice-Hall, 1995), p. 448.
7. Bruce O. Kurtz, "Haring's Place in Homoerotic American Art," in *Keith Haring*, ed. Germano Celant (Munich: Prestel Verlag, 1992), p. 19.
8. Peter Belsito, *Notes from the Pop Underground* (Berkeley: The Last Gasp of San Francisco, 1985), p. 105.
9. Quoted in Robert Farris Thompson, "Requiem for the Degas of the B-boys," *Artforum* (May 1990).
10. Celant, ed., op. cit., plate 14.
11. In conversation with the author, late November 1994.
12. Harold Bloom, *The Western Canon* (New York: Harcourt Brace & Co., 1994), p. 20.
13. William Rubin, *Frank Stella, 1970–1987* (New York: The Museum of Modern Art, 1987), p. 48.
14. Ph. Huisman and M. G. Dortu, *Lautrec par Lautrec* (Lausanne, Switzerland: Edita, 1964), p. 263.

15. Quoted in a review by Robert Farris Thompson of John Gruen's *Keith Haring: The Authorized Biography, Artforum* (December 1992), p. 87.

16. Fineberg, op. cit., p. 161.

17. Ibid.

18. Serge Faucherau, *Fernand Léger: A Painter in the City* (New York: Rizzoli, 1994), p. 23.

19. Ibid., plates 100, 112, 125.

20. John Gruen, *Keith Haring: The Authorized Biography* (New York: Simon & Schuster, 1991), p. 234.

21. Celant, ed., op. cit., plates 143–46.

22. Ibid., plate 180.

23. *Dubuffet* (Matigny, Switzerland: Fondation Pierre Giannada, 1993), plate 100.

24. Cf. Lowery Sims, ed., *Stuart Davis* (New York: Metropolitan Museum of Art, 1992), p. 165.

25. From a conversation with Keith Haring in New Haven, Connecticut, 1987. Cf. William Rubin, *Pablo Picasso: A Retrospective* (New York: The Museum of Modern Art, 1980), p. 148.

26. From a conversation with Monique Nellens in Knokke, Belgium, late November 1994. I am grateful to her for a tour of the Dragon and the Nellenses' collection of Haring's works of the summer of 1987.

27. Celant, ed., op. cit., back cover.

28. Bonnie Nadell and John Small, *Break Dance* (Philadelphia: Running Press, 1984), p. 59.

29. Ibid., p. 58.

30. Quoted in Robert Farris Thompson, "Requiem . . . ," *Artforum* (May 1990).

31. Ibid.

32. Ibid.

33. *Art in Transit: Subway Drawings by Keith Haring* (New York: Harmony Books, 1984). This book has no pagination, but the electric boogie figure illuminating a light bulb, approximately in the middle of the volume, is not difficult to find. A frieze of

radiant babies appears at his feet, a comment on the essential optimism of this choreographic style.

34. Thompson, "Requiem. . . ."
35. Ibid., illustration in review.
36. *Keith Haring 1988* (Los Angeles: Martin Lawrence, 1988), p. 17.
37. Ibid., p. 25.
38. Ibid., p. 27.
39. Cf. Rosalind E. Krauss, *The Optical Unconscious* (Cambridge, Mass.: MIT Press, 1993), p. 283.
40. *Keith Haring 1988*, p. 23.
41. Ibid., p. 29.
42. Ibid., p. 31.
43. Mr. Fresh and the Supreme Rockers, *Breakdancing* (New York: Avon, 1984), p. 63.
44. Celant, ed., op cit., plate 172.
45. From a filmed interview with Keith Haring conducted by Robert Farris Thompson for the BBC in Haring's studio, November 1988.

INDEX

Page numbers in *italics* indicate illustrations.